CREATING
SYMMETRY

CREATING SYMMETRY

The Artful Mathematics of Wallpaper Patterns

Frank A. Farris

Princeton University Press • Princeton and Oxford

Published by Princeton University Press, 41 William Street,
Princeton, New Jersey 08540
In the United Kingdom: Princeton University Press, 6 Oxford Street,
Woodstock, Oxfordshire OX20 1TW

press.princeton.edu

Kaiser Peach, a morphing frieze with inset, by Frank A. Farris, 2012.

Library of Congress Cataloging-in-Publication Data

Farris, Frank A.
Creating symmetry : the artful mathematics of wallpaper patterns / Frank A. Farris.
 pages cm
Includes bibliographical references and index.
ISBN 978-0-691-16173-0 (hardcover : alk. paper)—ISBN 0-691-16173-9 (hardcover :
alk. paper) 1. Symmetry (Mathematics) 2. Symmetry (Art) I. Title.
QA174.7.S96F37 2015
516′.1—dc23
 2014040468

British Library Cataloging-in-Publication Data is available

This book has been composed in Minion, Bauhaus & Avenir

Printed on acid-free paper. ∞

Typeset by S R Nova Pvt Ltd, Bangalore, India
Printed in Canada

1 3 5 7 9 10 8 6 4 2

Contents

Preface

Figure 1. *Kaiser Peach*, an offering of mathematical art.

The word *symmetry* often evokes simple bilateral symmetry, as in an idealized human face or the two wings of a butterfly. For mathematicians, the concept is richer and more fun, ranging from the patterns of wallpaper to the symmetries of a molecule or crystal.

Indeed, the concept of symmetry offers an attractive gateway to mathematics— or perhaps to a part of mathematics you haven't encountered yet. The natural delight we take in images like Figure 1 inspires us to ask what sparks that feeling of recognition, to want to know more about how they are made. This book is my attempt to address those yearnings. I hope that the patterns I show—as beautiful as I know how to make them—will help you connect more deeply to mathematics, at whatever level you are working.

What does "creating symmetry" mean? A child can create symmetry by repeatedly stamping out a pattern with a carved potato, but mathematics gives us far more powerful and satisfying tools than a potato stamp.

Dissatisfied by reading so many treatments of symmetry that express patterns as things broken up into pieces—those potato stamps—I have developed methods to construct mathematical objects whose very nature is symmetry. I use the vocabulary of functions, in particular *wave functions*, which you can picture as the long, regular waves in the deepwater ocean. When these are combined in just the right ways, we can construct functions with any imagined type of symmetry, functions that, as their essence, dance along in step as if to a perfectly symmetric tune. This is creating symmetry.

This is at once a story of freedom and constraint: We can create images of dazzling variety, using photographs to incorporate colors and textures from the world around us. On the other hand, there are mathematical restrictions on pattern types, restrictions imposed by any sort of requirement that a pattern repeat itself in some given way. It may surprise you, but every regular pattern created by any human at any time in history—as long as it really is regular—can be classified according to a rather rigid classification scheme. For instance, if you want to make a wallpaper pattern with 6-fold rotational symmetry, as in the left-hand strip of Figure 1, it will always turn out to be one of the two 6-fold types I will show you how to make. No one can make a type that is not on the list.

The classification of patterns by their symmetry is ideal for a first encounter with the mathematical concept of *group*, or for deepening your understanding if you've already met this technical mathematical structure. In designing *any* pattern, there is a significant constraint: If you plan to have some symmetries in a pattern, you must necessarily have specific others, which come along with the planned ones as baggage. For me, this limitation exemplifies a sort of "platonic suchness": It's easy for me to view the short list of pattern types as a mathematical object that exists independent of human inquiry, something that is there, waiting to be discovered. As you learn more about the group concept, I hope you will see what I mean.

Finally, by "creating symmetry" I mean the artistic process of making choices among the vast infinity of these mathematical patterns—free to wave and curve but constrained by the limitations of pattern type. The choices include selecting a photograph to be married with a mathematical process to create something new. I refer to the human, even emotional, encounter with those special examples that demand to be shared with others, to be put on the wall or printed on fabric and offered, not just as mathematics but as art.

As we learn to create symmetry, I offer my personal take on artistic choice and show you how to experiment for yourself. Perhaps you too will create an image like Figure 2.

Ways to Read This Book

On one hand, the mathematical content of this book is rather sophisticated; on the other, everything can be approached from an elementary point of view. In preparing each chapter, I have done my best to provide access for those who may be learning concepts for the first time and to offer a helpful first experience with things like groups, projection operators, eigenfunction expansions, and so on. These rather elevated mathematical concepts are not so scary when illustrated

Figure 2. Created symmetry, from a photograph (Figure 24.3) of peppers and greens on a cutting board.

in specific examples, especially when we can *see what they look like* in what I think are attractive illustrations.

As I wrote, I kept in mind three types of readers: the working mathematician, the advanced undergraduate, and the brave mathematical adventurer. I do believe that readers without extensive mathematical background beyond calculus—who are hooked by the artwork and willing to learn—can have a fine experience working through my story of symmetry.

FOR THE LESS EXPERIENCED READER. I am eager to share my favorite mathematical concepts with you. Getting to know them requires some work, but help is abundantly available. There are many places where I invite you to skip over some technicalities. Save something for a second reading!

The mathematical prerequisite is some knowledge of calculus—we will compute derivatives of functions and, to a lesser extent, talk about some integrals. No knowledge of abstract algebra or analysis is required; everything we need will be built slowly as we go. I write for readers willing to apply their knowledge of number systems, calculus, and elementary geometry, willing to work vigorously toward some rather sophisticated ideas, with refreshment provided by the visual beauty of symmetry. If this is you, exercises marked with one or two asterisks might best be skipped on a first reading. On the other hand, be sure to do the unflagged exercises to test your understanding.

FOR THE ADVANCED UNDERGRADUATE. Some of the first chapters of this book may be easy for you. Consider them a review of parametric equations, complex numbers, and basic group theory, all applied in situations you probably have not studied. As the book progresses, you will meet many topics in the standard undergraduate curriculum. If you have seen them before, it was surely not in this context; if you haven't, you'll get an excellent preview for future study.

My idea is that our first view of any mathematical structure should be in concrete, specific settings. We should not rush off to the most abstract levels before we appreciate the simplest examples. Undergraduate mathematics students might skip only the exercises marked **; these are problems that I could not resist including but that go beyond ordinary exercise. I hope that the presentation here will ground you with memorable experiences, stories that will serve you well as you grow to more advanced levels of abstraction.

My goal has been to create a book that I would have liked to read as an undergraduate; I hope that you enjoy it.

FOR THE WORKING MATHEMATICIAN. Whatever your field, I bet that you have not seen the elements in this book combined in the way they occur here. Even if you know harmonic analysis and representation theory, partial differential equations and quadratic number fields, I doubt you have seen these arise naturally in the service of making art.

You could very well use this book for a one-semester senior seminar or as summer reading for a talented student. There are several suggestions for projects, large and small. Probably the most significant investment of preparation time would be to set up the right image-making technology. (This makes an excellent project for a computer science major; that is how I did it!) If a course is not in the works, this book can still help you teach most any advanced undergraduate course.

If you are preparing to teach abstract algebra, the information about frieze and wallpaper groups can supplement what's in any text. Did you know that the frieze groups can act on the complex plane—translations converted to rotations—to create seven categories of rosettes? Did you know that color-reversing symmetries give a natural way to introduce normal subgroups? In analyzing the point groups of wallpaper groups, there's even a chance to see some short exact sequences.

Even if you've taught Fourier series many times, I don't imagine you have computed the Fourier series for a function that parametrizes a regular pentagon. It's fun!

Teaching systems of orthogonal functions for partial differential equations? Please use my wallpaper waves as examples. And there's an outline for a project about spherical harmonics, in case you'd like to assign something to keep a talented student engaged.

Almost anything you teach at the undergraduate level can be enriched by these explorations of symmetry. Even in many graduate courses, these topics might well lighten the atmosphere, with some down-to-earth examples that humans can visualize.

And apart from teaching, there's the development of breadth. Working in a field as large as mathematics, we all struggle to feel connected to areas far from our own. I hope this book will give you new ways to see the surprising, inevitable connectedness that seems to characterize mathematics.

The Structure of the Book

Let's take a quick walk-through in case you want to skip to a particular part of the book. In Chapter 1, basic material about plane curves leads us to notice a particular curve, whose symmetry seems unexplained by its mathematical formula. The next few chapters explain the phenomenon, while developing some basic ideas about complex numbers, superposition of waves, and the group concept.

In Chapter 6, we leave curves behind to talk about functions on the plane, where the idea of using a photograph to color the plane first finds application. In Chapter 7, we study rosette symmetry and pause to talk about artistic choices. Friezes are often considered the next natural object of study after rosettes. Chapter 8 shows how to construct them by "unwinding" rosettes onto the plane.

Over the next few chapters, we develop the concept of a *wallpaper wave*, the protagonist of this book. It is conceivable that readers with a strong background could begin reading with Chapter 10, where we first create wallpaper, starting with 3-fold symmetry as an example. We examine this special case slowly, discussing algebra and analysis in separate chapters. Then the pace picks up. Chapters 15–18 complete the details to explain how to combine the right waves to make any type of wallpaper pattern whatsoever. The details of these wave combinations, which I call *recipes*, are summarized in Appendix B for easy reference.

Color-reversing and color-turning symmetries lead us to new concepts in algebra, as well as more opportunities for artistic choice, in Chapters 19 and 20. Chapter 21 is the most abstract in the book, using the concept of a *point group* to examine, in baroque detail, just what is involved in knowing for certain that we have found all possible wallpaper types. The abstraction continues in Chapter 22 with a nod to quadratic number fields, whose structure arises naturally as the way to analyze some apparent *local symmetries* in wallpaper. We complete this algebra-intensive group of chapters by cleaning up some of the mathematics of frieze patterns, which was skimmed in the earlier chapter.

The rest of the book offers new areas for enjoyment, applying our techniques to new situations: Polyhedra and a non-Euclidean toy universe give us new playgrounds for creating symmetry. The last chapter explains the figure that opens this preface—an homage to M. C. Escher. Appendices give diagrams useful for recognizing wallpaper types, as well as a gallery showing one representative for each of the 46 possible color-reversing symmetry types.

Reading a mathematics book should not be a passive experience. I hope you will accept my various invitations to check things for yourself. I also provide a range of exercises, from small chances to test your understanding to major projects that might keep an undergraduate mathematics major busy for a few weeks. Those flagged with an asterisk (*) require mathematics at the undergraduate level that

may be one notch higher than the minimal prerequisite for reading this book. Those with two asterisks are for the special reader who wants a challenge. The unflagged exercises give every reader the chance to check that we understand one another before going on. Answers to selected exercises are given. In some cases, the exercise walks the reader through a solution, so no additional material seems necessary.

The Backstory

In Fall 2011, I accepted an invitation, thanks to Steve Kennedy, to teach for a term at Carleton College in Northfield, Minnesota. Carleton requires each mathematics major to undertake a comprehensive project in the senior year. Steve had heard me speak about symmetry at MathFest 2010, and we agreed that a senior seminar course on symmetry could start a group of students off on their projects. I called the course Creating Symmetry and enjoyed working with an eager group of ten students, who did a terrific amount of work.

On the first day, I presented them with a list of twenty questions (many of which now introduce chapter topics) and proposed that we work together to answer one question each day. With Carleton's brief quarter—about twenty-eight class days—this was about the right number. For each question, each student wrote a "chapter," meaning a very brief statement of the question with a concise answer. By the course's end, each had written a condensed version (perhaps sixty pages) of this book, or at least a part of it. I evaluated each of their notebooks individually twice before they turned in final versions. That time-consuming but enjoyable activity taught me a lot about how various kinds of young people see this material.

As the students experimented, making images with the software I provided, we decided to have art contests as a regular feature of class time. Students would email me their images and I would put them into a slideshow that preceded our voting. The "valuable prizes" I offered turned out to be only the enjoyment of knowing that your colleagues picked your submission. The contests helped me understand various difficulties we face as we try to choose images that others will find attractive.

Alas, my software—a package written in C++, described in Chapter 26—is not officially available at this time. I am happy to correspond with readers and even send the code to people who promise not to complain about it, but I make no claim to support the software, and it is does require care and feeding to get it to work properly.

THE VERY BEGINNING. How did I get involved with this circle of ideas? As an undergraduate at Pomona College, I had a deep and moving experience with eigenfunction expansions and linear analysis in general, thanks to a lovely course taught by my mentor Rick Elderkin during his first year teaching. At MIT, linear analysis met the geometry of manifolds, thanks to my adviser, Richard Melrose. Working with Tom Banchoff, during a postdoctoral job at Brown University, connected me to his passion for visualization. Teaching diverse courses at Santa Clara University led me to find novel visualizations, the first of which were created with a Commodore 64 I bought at a toy store in 1984.

But what led me to wallpaper? There was an instigating event: When I was teaching a survey of geometry course, something inside me snapped when I read a definition that described a wallpaper pattern as "a set of points" invariant under a certain type of group. Set of points? When I looked at wallpaper patterns, I saw

much more than mere sets of points. I had to address the conflict between this definition and what I saw in the patterns all around me. Years of inquiry have led me here, to the start of this book.

On the artistic side of things, some sensibilities derive from my mother, a musician and watercolorist. You might glimpse her paintings in some of the photographs I use. Other inspirations to mention are Georgia O'Keeffe and Joni Mitchell. In some sense, the world told each of these women, "This is not how it's done." Each found her way to say, "Oh? This is how *I* do it."

Finally, a word about beauty and mathematics. I worship with a Unitarian-Universalist congregation in San Jose, where our mission statement expresses our commitment to "make Love visible." Yes, I am writing because I simply love this stuff. I love to think that it brings solace in a difficult time. This belief that my motivation deserves mention moves me to call this a *postmodern* mathematics book. By contrast, *modern* mathematics books were written in the twentieth century by intentionally voiceless authors for an intended audience of "the hypothetical anybody," which made the books feel cold and inaccessible, at least to me. Postmodern books are situated in time and place, taking into account the identities of both reader and author. Here I am, writing to reach you; please join me.

Writing about motivations and purposes recalls a hymn we use at our church, a version of one that my parents taught me long ago, included here as a dedication:

> For the Beauty of the Earth
> For the glory of the skies
> For the Love which from our birth
> Over and around us lies.
> Source of all to thee we raise
> This our hymn of grateful praise.

Acknowledgments

Thanks to my teachers and mentors: Rick Elderkin, Richard Melrose, Tom Banchoff. Thanks to helpful colleagues: Jerry Alexanderson, Glenn Appleby, Rick Scott (who is also a former student). I appreciate the support of Santa Clara University, providing summer support for undergraduates Rima Lanning, Cameron Wong, and Nida Kazi to assist me in various parts of the research. Brown University sheltered me for three sabbatical leaves, during the middle of which I created my first hyperbolic wallpaper, with help from Jeffrey Hoffstein and Siman Wong. The University of Minnesota hosted my most recent sabbatical, when I completed research on the tricky material in the last chapters.

Thanks to Stephen Kennedy for bringing me to Carleton and to all my hard-working students there. Margeret Pezalla-Granlund and Aisling Quigley, the power team behind the Carleton exhibition, and to Saewon Eum for the beautiful images she contributed to the show. Thanks to Kathy Sheldon and Rick Elderkin for extraordinary help in bringing "Seeing Symmetry" to Pomona College. I am grateful to Kitty Kameon and Dianne Saichek for design advice and to the staff at Priceton University Press, especially Vickie Kearn, for their excellent work to make this book beautiful.

Finally, thanks to my partner, William O. Beeman. No matter what image I showed him, he would tell me it was the most beautiful yet.

CREATING
SYMMETRY

Chapter 1
Going in Circles

Question: How do you make a circle (and other curves)? The ancients knew how to make a circle using a compass or its equivalent. I like to imagine an early genius tying a piece of charcoal to one end of a string of plant fiber and drawing the charcoal along a flat rock face while holding the other end of the string fixed. You can still do that, but suppose that we want to enjoy modern technology and draw a circle on a computer screen—a problem not faced in antiquity. How do we make a circle?

If you ask most people for the equation of a circle, you will probably hear

$$x^2 + y^2 = 1 \text{ or perhaps } (x - h)^2 + (y - k)^2 = R^2$$

for a circle with center (h, k) and radius R. This is fine, but it represents a *static* view of a circle, which is not the simplest way to direct the drawing of one.

The simplest way to instruct a machine to draw a circle uses a *parametric* form, also known as a *vector-valued function*:

$$\gamma(t) = (\cos(t), \sin(t))$$

for the unit circle and

$$\gamma(t) = (h + R\cos(t), k + R\sin(t))$$

for a more general one. In either case, as the time parameter t advances from 0 to $\pi/2$, we climb the upper-left quadrant of the circle in a counterclockwise fashion. It takes 2π units of time to return to our starting point and complete the drawing.

The given formula parametrizes the circle in one particular way. If we need to be more flexible, wanting to specify motion around a circle that starts at a particular point and goes a particular direction, we can tweak the formula, perhaps by swapping the coordinates or introducing minus signs, as in the following example.

Example: A Rolling Quarter

Place two quarters flat on the table with one above the other, both oriented right side up. If the top one rolls without slipping around the other, find a formula for the motion of the point that was originally at the bottom edge of the top circle.

Figure 1.1 shows the configuration before and after the quarter has rolled about 60°. We use a letter F, as well as some dashed construction lines, to help you follow the solution.

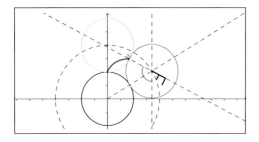

Figure 1.1. Top: Initial position of rolling quarter. Bottom: The quarter has rolled a bit and point X has traced some of our curve, as if it dribbled a dot of red ink on each point it passed over.

*** EXERCISE 1**

Apply the formula $L = \int_0^{2\pi} |\gamma'(t)|dt$ to show that the arc length of the path of the rolling quarter from our first example is 16 units.

SOLUTION. Suppose the quarter has radius 1 and has rolled so that the arc length rolled out on each quarter is t. The position of the center of the rolling quarter is then $(2\sin(t), 2\cos(t))$. This is what we meant by tweaking the formula: When no arc length has been rolled out ($t = 0$), this vector should be pointing straight up, and when t is small and positive, the x-value should be increasing. The formula matches.

Similarly, it takes a little work to figure out that the position of the rolling point relative to the center of the rolling quarter is $(-\sin(2t), -\cos(2t))$. Here are a few steps: In the diagram, the dashed lines might help you locate certain transversals. These are key to showing that the angle up from the vertical is twice the angle t.

Adding the two vector displacements, we find that the desired vector motion is

$$\gamma(t) = (2\sin(t) - \sin(2t), 2\cos(t) - \cos(2t)),$$

drawn on the top in Figure 1.2.

BEYOND THE ROLLING QUARTER. The path of the rolling quarter is an example of a curve called an *epicloid*, the curve produced by rolling one circle around another. In general, if the fixed circle has radius a and the rolling circle has radius 1, the formula for the moving point is

$$((a + 1)\sin(t) - \sin((a + 1)t), (a + 1)\cos(t) - \cos((a + 1)t)).$$

(You may wish to show this as an exercise.)

Figure 1.2 shows two examples, the first with both circles the same size and the second with one circle twice as large as the other.

Wheels on Wheels on Wheels

Let's think of the epicloid as representing one particular kind of superposition of circular motions, where we insist that the circles roll without slipping. If we remove that restriction, we open the discussion to any sum of vector functions, each of which represents a circular motion, possibly tweaked to turn a different direction. I call this an instance of "wheels on wheels on wheels."

To create a particular example, I chose some more or less random wheels of different sizes and set them to turn at various rates, adding the vector displacements to form the function

$$\mu(t) = \left(\cos(t) + \frac{\cos(6t)}{2} + \frac{\sin(14t)}{3}, \sin(t) + \frac{\sin(6t)}{2} + \frac{\cos(14t)}{3}\right).$$

The first term in each component is our familiar unit circle; the other terms represent smaller wheels, one turning 6 times as fast, another 14 times as fast and altered somehow (the sine and cosine functions are swapped). The result is rendered in Figure 1.3. Take a moment to trace it with your eye and enjoy its dancing undulations, realizing that probably none of us has the patience to draw it without the aid of technology.

I hope that the figure—the "mystery curve"—surprises you. Nothing about the numbers 6 and 14 prepares for the evident *rotational symmetry*, which means that the figure is unchanged if we rotate it through 72°. Our next agenda item is to answer the question: What causes this curve to have 5-fold rotational symmetry?

OUR COMPUTATIONAL PARADIGM. The formula for the mystery curve assigns one point of the Cartesian plane to every one of the infinitely many values of the time parameter *t*. When I ask a computer to draw the curve, modern software frees me from the need to figure out exactly how to instruct the computer to select a mere finite few time values for which it places blobs of ink on the page or lighted pixels on my screen. The details of computer graphics are lovely but are not the purpose of this book; here, I invite us to be consumers, rather than inventors of computer graphics.

In the instance of the mystery curve, a close examination of Figure 1.3 suggests that I could have been a slightly more demanding consumer: At a few places on the curve, I can detect that the machine has approximated the perfectly smooth shape by some line segments. Since I know the curve bends smoothly, I don't object to this imperfection. I enjoy the availability of technology that can do as well as it did. And if I wanted a finer rendition, I could have instructed the machine to use more points in its drawing routing.

From the relatively simply mystery curve to the most complicated color image in this book, the paradigm is the same: We look for mathematical objects, which we will call *smooth functions*, that have some symmetry that we wish to illustrate, perhaps the rotational symmetry of the mystery curve, perhaps something else. Directing computers to make images of the discovered objects is not really the interesting part of the process; it's the finding of the class of symmetrical things. This is what creating symmetry means to me: finding the formulas like the one for the mystery curve—with its enigmatic 6 and 14—that will display symmetrical images when rendered by software. It is not so much about the method of computer rendition but the *mathematical* theory of what makes things dance in the dazzling variety of patterned ways that we see in every tradition of decorative art.

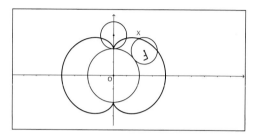

Figure 1.2. Two epicycloids: On the top is the locus generated by the point on the rolling quarter; in the bottom epicycloid, the rolling circle has half the radius of the stationary one.

Some Ancient Mathematics

The trigonometric functions are not the only way to parametrize the circle. There is some evidence that the ancient Babylonians knew a different way. It appears that they knew how to find pairs of rational numbers x and y that solve the equation $x^2 + y^2 = 1$, which, when we clear denominators, become what we know as Pythagorean triples.

Much has been written about the history of a mysterious tablet called Plimpton 322, which lists, without any commentary that we can understand today, a baffling array of Pythagorean triples [15]. Here we remark only that the vector function

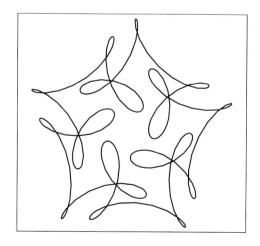

Figure 1.3. The mystery curve: What causes its symmetry?

$$\gamma(t) = \left(\frac{1-t^2}{1+t^2}, \frac{2t}{1+t^2} \right) \tag{1.1}$$

parametrizes the circle, as you can check with algebra, and that each coordinate is a rational number if t is rational. We could do the arithmetic by hand, but I found it simpler to ask a machine to plug in $t = 54/125$ to produce the Pythagorean triple

$$12,709^2 + 13,500^2 = 18,541^2.$$

This fact was apparently known to the Babylonians about 3800 years ago!

ANSWER FOR EXERCISE 1

Simplifying the square length of the velocity vector gives $L = \int_0^{2\pi} 2\sqrt{2 - 2\cos(t)}\,dt$. Things look grim until we remember the trigonometric identity that allows us to simplify the square root: $L \int_0^{2\pi} 4\sin(t/2)\,dt = -4 \cdot 2\cos(t/2)|_0^{2\pi} = 16$ units.

Chapter 2
Complex Numbers and Rotations

Question: How do complex numbers make it easier to keep track of circles, curves, and rotations? The *complex numbers*, denoted \mathbb{C}, are simply a way to express the Cartesian ordered pair of real numbers, (x, y), compactly as a single number

$$z = x + iy.$$

It is as if the symbol i creates an extra shelf on which to set the second number of the ordered pair; we call the part set next to i the *imaginary part* of z, written $\text{Im}(z)$ and the other part the *real part*, $\text{Re}(z)$. The plus sign is a hint that we will be doing algebra with these newly formed expressions. Indeed, to add two such expressions, we simply add the real and imaginary parts separately. To multiply by a scalar real number, we distribute the real multiple through real and imaginary parts.

To multiply complex numbers, use the definition

$$i^2 = -1$$

and all the usual rules of algebra (multiplication is commutative and distributes over addition). Algebraic expressions using complex numbers serve us best when we clean them up by gathering the real and imaginary parts. For instance, check that

$$z^2 = x^2 - y^2 + i2xy.$$

Reflection across the x-axis turns out to play a particularly important role in the complex numbers, so we give it a name. The number

$$\bar{z} = x - iy$$

is the *complex conjugate* of $z = x + iy$. Since conjugation simply negates the y-value of a number, we recognize it as reflection across the x-axis.

One quick way to see the utility of the conjugate is to compute the multiplicative inverse of a nonzero complex number z as

$$\frac{1}{z} = \frac{\bar{z}}{z\bar{z}} = \frac{x}{x^2 + y^2} - i\frac{y}{x^2 + y^2}.$$

Another fruit of this computation is the fact that the *norm* of a complex number $z = x + iy$, which is the same as the distance from the Cartesian point (x, y) to the origin, is

$$\sqrt{x^2 + y^2} = \sqrt{z\bar{z}}.$$

If you skipped the preface, this might be a good time to return to the section "Ways to Read This Book." Some readers will be learning about complex numbers for the first time; others may enjoy seeing what I have to say about them; others may simply skip ahead.

CONNECTIONS TO ABSTRACT ALGEBRA AND NUMBER THEORY. The complex numbers exemplify several famous algebraic structures, which we will meet as we go on. If you do not yet know the terms in the following sentences, rest assured that they will become familiar in subsequent chapters. When we think only of adding complex numbers, the set \mathbb{C} has the structure of a *group*, which is a set closed under an operation that is nice in a certain technical sense. When we also consider that we can multiply complex numbers by real numbers, they take on the structure of a *real vector space* with a *basis* that consists of 1 and i. All this means is that every complex number is written uniquely as a sum of real multiples of 1 and i. When we include the multiplicative structure, \mathbb{C} is a *ring* (closed under an additional operation, multiplication) and also a *field*, since every nonzero element has a multiplicative inverse. To study any of these abstract structures, it can be helpful to have \mathbb{C} in mind as a concrete example.

We pause for some practice with complex multiplication, which allows us to mention a connection to number theory. Verify the following products:

$$(9 + i2)(9 - i2) = 81 + 4 = 85 \text{ and } (7 + i6)(7 - i6) = 49 + 36 = 85.$$

It is curious that two different products give us the same real integer. The *Gaussian integers* are expressions of the form

$$a + ib, \text{ where } a, b \in \mathbb{Z}.$$

These Gaussian integers form a ring with identity 1. Investigating the similarities between this ring and the iconic ring of integers, \mathbb{Z}, offers fine adventures in number theory.

The two rings are strikingly different in some ways. For instance, the only invertible elements in \mathbb{Z}, called *units*, are 1 and -1, but the Gaussian integers have 1, -1, i, and $-i$. The fundamental fact about \mathbb{Z} is that every integer has a unique factorization in terms of primes. We say that \mathbb{Z} is a *unique factorization domain*. (Uniqueness is understood as being unique up to units, forgiving the double representation of 6 as $2 \cdot 3$ and $(-2) \cdot (-3)$.)

Our sample computation might suggest that 85 has multiple factorizations, but, in fact, the Gaussian integers are known to be a unique factorization domain. How can we reconcile this with our computation? Here is a suggestion: The conventional prime factorization of 85 is $85 = 5 \cdot 17$, but 5 and 17 can be factored further in the Gaussian integers, and so are *not* primes! (Hint: $5 = (2 + i)(2 - i)$.) To understand this better, show the four prime factors of 85, which are defined

only up to multiplication by units; reassemble them in different ways to get $9 + 2i$, and so on.

Making Circles and Curves with the Euler Formula

Using the new notation for Cartesian pairs, our parametrization of the circle becomes

$$\gamma(t) = (\cos(t), \sin(t)) = \cos(t) + i \sin(t).$$

If this seems unremarkable, a surprise is in store. The right-hand side of this equation has a celebrated, concise equivalent via the *Euler formula*. We take a circuitous route, perhaps imitating the style of Euler himself.

Euler knew that the trigonometric functions were not polynomials but found that they behaved like long polynomials—infinitely long. These are called *power series*, and they build on ideas of approximation. For instance, $\sin(t)$ is very like the polynomial t for small values of t, even more like $t - t^3/3!$, and so on forever. Replacing the sine and cosine functions by their power series, which are known to converge for all values of t, we find that

$$\gamma(t) = 1 - \frac{t^2}{2!} + \frac{t^4}{4!} - \cdots + i\left(t - \frac{t^3}{3!} + \frac{t^5}{5!} - \cdots \right).$$

In a flash of imagination, realizing things like $i^3 = -i$ and ignoring the convention about putting real parts first and imaginary ones last, we write this as

$$\gamma(t) = 1 + (it) + \frac{(it)^2}{2!} + \frac{(it)^3}{3!} + \frac{(it)^4}{4!} + \frac{(it)^5}{5!} + \cdots.$$

We recognize formal similarity to the real power series for e^t and *define* the symbol e^{it} by the series (which can be shown to converge absolutely for all t),

$$e^{it} = 1 + (it) + \frac{(it)^2}{2!} + \frac{(it)^3}{3!} + \frac{(it)^4}{4!} + \frac{(it)^5}{5!} + \cdots.$$

The definition is a responsible one, in that it generalizes the meaning of the real function e^t.

Without going too far astray, we can mention that this definition is the start of a long path of generalization; the next step would be to define e^{At}, where A is a matrix, using a power series. Definitions like these exemplify a very abstract idea: the exponential mapping from a Lie algebra to its Lie group. Let us return to safer ground and connect back to circles.

Since the convergent power series for e^{it} matches the series for $\gamma(t)$, we conclude

$$e^{it} = \cos(t) + i \sin(t), \tag{2.1}$$

which is the celebrated Euler formula. (For those interested in foundational questions of analysis, here we have used the fact that one can rearrange terms in an absolutely convergent power series.) One could view this as nothing more than a concise way to encode our formula for going around a circle, $\gamma(t)$, in three symbols instead of twelve.

The same economy can be brought to the formula for the mystery curve from Figure 1.3:

$$\mu(t) = \left(\cos(t) + \frac{\cos(6t)}{2} + \frac{\sin(14t)}{3}, \sin(t) + \frac{\sin(6t)}{2} + \frac{\cos(14t)}{3} \right).$$

The first two terms in each side of the ordered pair fit together as e^{it}, and the middle two terms are easy to put together into $e^{6it}/2$, which is just a smaller circular motion with a frequency 6 times as fast as the original. The final terms in each sum take a little more work. Let me do it for you, as you check the steps of distributing the i and using basic identities like $\sin(-\theta) = -\sin(\theta)$:

$$\frac{i}{3}e^{-14it} = \frac{i}{3}\left(\cos(-14t) + i\sin(-14t) \right) = \frac{1}{3}\left(\sin(14t) + i\cos(14t) \right).$$

This last term is a backward circular motion with frequency 14, rotated counterclockwise and shrunk by a third. Our mystery curve can be written concisely as

$$\mu(t) = e^{it} + \frac{1}{2}e^{6it} + \frac{i}{3}e^{-14it}.$$

A Personal Note. In some sense, all my work in symmetry started with this curve. I was planning an exercise for calculus students studying parametric equations and picked this curve as an example. Jerry Alexanderson, looking over my shoulder in the computer lab, asked, "What did you do to make it so nicely symmetrical?" At the time I had no idea; it was a happy accident. In the next chapter, we discover the answer.

Complex Numbers and Rotation

To study the rotational symmetry of the mystery curve, or indeed any curve in the plane, we need tools to express rotation. To begin as concretely as possible, we consider Figure 2.1, where the point X with Cartesian coordinates (x, y) has been rotated about the origin, O through an angle θ to a point X'. We will use r for the distance from O to X

We suppose that the ray \overrightarrow{OX} makes an angle α with the positive x-axis, so that ray $\overrightarrow{OX'}$ is inclined at angle $\theta + \alpha$. If A and B are the feet of perpendiculars from X' and X, then simple trigonometry tells us that the x-coordinates of A and B are $r\cos(\theta + \alpha)$ and $r\cos(\alpha)$. Similarly, the y-coordinates are given in terms of sines of the same angles.

Apply the angle addition formula to find that

$$r\cos(\theta + \alpha) = r\cos(\alpha)\cos(\theta) - r\sin(\alpha)\sin(\theta) = \cos(\theta)x - \sin(\theta)y.$$

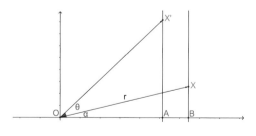

Figure 2.1. Working out the rotation formulas.

Reasoning similarly for the y-coordinate of X', we arrive at the standard rotation formulas: The coordinates (x', y') of the point X', which is the image of (x, y) rotated about the origin, O through an angle θ, are

$$x' = \cos(\theta)x - \sin(\theta)y, \qquad (2.2)$$
$$y' = \sin(\theta)x + \cos(\theta)y.$$

In complex notation, the point X' is written as

$$x' + iy' = \cos(\theta)x - \sin(\theta)y + i(\sin(\theta)x + \cos(\theta)y).$$

It takes only a bit of squinting of the eyes to see that this is the same as

$$x' + iy' = e^{i\theta}(x + iy).$$

Complex notation allows us to express rotation as nothing more difficult than complex multiplication. Once we are used to it, this is certainly simpler than the Cartesian rotation formulas we developed.

More can be said: Maintaining the notation for the angle and radius of the point X, we could have written that point in polar form as

$$x + iy = re^{i\alpha}.$$

Lurking in the proof of the rotation formulas (Figure 2.1) is the formula

$$e^{i(\alpha+\theta)} = e^{i\alpha}e^{i\theta}.$$

This shows that the new exponential function we defined indeed obeys the familiar algebraic rule for exponentiating a sum. We could have started by proving this and deriving the rotation formulas from there, but the constructive approach seems more attractive.

To touch base with our example of circular motion, verify that

$$\gamma(t + \theta) = e^{i(t+\theta)} = e^{i\theta}\gamma(t),$$

so that advancing time by θ units is the same as rotating through an angle of θ for any value of t.

It is possible to extend the exponential function beyond purely imaginary numbers. The formula

$$e^z = e^{x+iy} = e^x\left(\cos(y) + i\sin(y)\right)$$

defines a particularly beautiful function of the complex variable z, often the star of a course in complex variables. We abandon it for now, though it will find utility in Chapter 8.

CONNECTING TO LINEAR ALGEBRA. If you are familiar with matrix manipulations, you may wish to assemble the rotation formulas (2.3) in an array to find

EXERCISE 2

Show, by the trick of multiplying numerator and denominator by $1 - it$, that

$$\gamma(t) = \frac{1 + it}{1 - it}$$

is the rational parametrization of the circle, (1.1), from the previous chapter. The fact that $\gamma(t)$ is *on* the unit circle is observed by computing that both numerator and denominator have magnitude $\sqrt{1 + t^2}$, giving the fraction a magnitude of 1.

EXERCISE 3

Show that the epicycloids in the previous chapter can be expressed in complex form as

$$(a + 1)ie^{-it} - ie^{-(a+1)it}.$$

The abundance of minus signs arises from the original choice to start the rolling quarter in a position atop the other and send it clockwise.

the standard rotation matrix:

$$\begin{pmatrix} x' \\ y' \end{pmatrix} = \begin{pmatrix} \cos(\theta) & -\sin(\theta) \\ \sin(\theta) & \cos(\theta) \end{pmatrix} \begin{pmatrix} x \\ y \end{pmatrix}.$$

If you were intrigued by the remark about exponentiating matrices, try using power series to write the rotation matrix as

$$\exp\begin{pmatrix} 0 & -\theta \\ \theta & 0 \end{pmatrix} = I + \begin{pmatrix} 0 & -\theta \\ \theta & 0 \end{pmatrix} + \frac{1}{2}\begin{pmatrix} 0 & -\theta \\ \theta & 0 \end{pmatrix}^2 + \cdots.$$

ANSWER FOR EXERCISE 2

This is just a test of complex algebra:

$$\gamma(t) = \frac{1 + it}{1 - it} \cdot \frac{1 + it}{1 + it} = \frac{1 - t^2}{1 + t^2} + i\,\frac{2t}{1 + t^2}.$$

From this, we pick out the x- and y-coordinates of the rational parametrization (1.1).

** EXERCISE 4

Many twentieth-century calculus texts included sections on the *general conic*, teaching students how to graph the set of points (x, y) that satisfy

$$Ax^2 + Bxy + Cy^2 + Dx + Ey + F = 0.$$

First the case $B = 0$ is studied, leading to ellipses, hyperbolas, and parabolas, with some degenerate cases. I hope that these are familiar to the reader; if not, modern calculus texts treat this case. The next step involved *rotation of coordinates*, an idea that has been dropped from most texts. It involved finding a special angle α through which to rotate the axes so that the rotated conic equation would have no xy-term.

We sketch how this looks in complex notation, just for practice. First show that if A, B, and C are real numbers, then

$$Ax^2 + Bxy + Cy^2 = (A - C - Bi)\frac{z^2}{4} + (A + C)\frac{z\bar{z}}{2} + (A - C + Bi)\frac{\bar{z}^2}{4} = f(z, \bar{z}). \tag{2.3}$$

The actual exercise comes in two parts:

1. Suppose α, β, and K are real numbers. Translate the equation

$$\alpha(z^2 + \bar{z}^2) + \beta z\bar{z} = K \tag{2.4}$$

 into (x, y)-coordinates, observe that there is no xy-term, and use your knowledge of conic sections to show that this equation defines an ellipse when $\beta^2 - 4\alpha^2 > 0$ and a hyperbola when $\beta^2 - 4\alpha^2 < 0$, discounting degenerate cases, such as when $K = 0$.
2. Check that the pure quadratic expression in (2.3) matches the form we just analyzed if and only if $B = 0$. Suppose we start with a quadratic expression where $B \neq 0$. Write $A - C + Bi$ in polar form as $Re^{2\alpha i}$. (The 2 in the exponent will be vindicated in the computation, and, yes, that is the coefficient of \bar{z}^2 from 2.3, not z^2.) Check that this conforms to the recipe in the old texts,

$$\cot(2\alpha) = \frac{A - C}{B},$$

 and compute the coefficients of the rotated polynomial $f(e^{i\alpha}z, e^{-i\alpha}\bar{z})$. Observe that they match the form in (2.4). This means that, after we rotate our frame of reference, we can use simple routines to sketch our curve.

Chapter 3
Symmetry of the Mystery Curve

Question: Why does the mystery curve have 5-fold symmetry? The mystery curve, an example carried through earlier chapters, can be written in complex notation as

$$\mu(t) = e^{it} + \frac{1}{2}e^{6it} + \frac{i}{3}e^{-14it}.$$

The frequencies in this superposition of circular motions (this wheel on a wheel on a wheel) seem randomly selected, and yet the curve in Figure 3.1 displays evident 5-fold symmetry. What do 1, 6, and −14 have to do with 5?

To investigate the symmetry, observe that the curve does essentially the same thing five times, where *essentially* is interpreted as *rotated by a suitable angle*. Repeating this rotation 5 times brings us around to the start, so the angle is 72°, or $2\pi/5$ radians. If we chop the time domain of the curve into 5 equal pieces, we suspect that the curve must repeat itself, though turned by 72°, in each piece. (Each fifth of the time domain has been colored differently to help illustrate this.) An equation that expresses this suspicion is

$$\mu\left(t + \frac{2\pi}{5}\right) = e^{2\pi i/5}\mu(t). \tag{3.1}$$

In words, this reads as advancing the time parameter of μ by a fifth of the full 2π is the same as rotating $\mu(t)$ through 72°. Let us check to see that this is so:

$$\mu(t + 2\pi/5) = e^{i(t+2\pi i/5)} + \frac{1}{2}e^{6i(t+2\pi i/5)} + \frac{i}{3}e^{-14i(t+2\pi i/5)}$$

$$= e^{it}e^{2\pi i/5} + \frac{1}{2}e^{6it}e^{12\pi i/5} + \frac{i}{3}e^{-14it}e^{-28\pi i/5)}$$

$$= e^{2\pi i/5}\mu(t).$$

For the last step, we used the fact that $e^{i(\theta+n2\pi)} = e^{i\theta}$ for any integer n, along with $6 \cdot 2\pi/5 = 5 \cdot 2\pi/5 + 1 \cdot 2\pi/5$ and $-14 \cdot 2\pi/5 = -15 \cdot 2\pi/5 + 1 \cdot 2\pi/5$. The thing that mattered was the coefficients 6 and −14 being 1 more than a multiple of 5. We say they are *congruent* to 1 modulo 5.

Figure 3.1. The mystery curve: What causes its symmetry?

In case the reader is unfamiliar with modular arithmetic, we include the relevant definition. For integers a, b, and m, we write

$$a \equiv b \pmod{m} \text{ to mean that there is some } k \in \mathbb{Z} \text{ with } a - b = mk.$$

In words, a and b are congruent modulo m when they differ by a multiple of m.

The mystery curve meets the symmetry condition in (3.1) because the frequencies 1, 6, and -14 are all congruent to 1 modulo m. Notice that the coefficients 1, $1/2$, and $i/3$ mattered not at all in the symmetry condition, though of course they affect the appearance of the curve. Figure 3.2 shows two other curves in the family

$$ae^{it} + be^{6it} + ce^{-14it}, \text{ where } a, b, c \in \mathbb{C}. \tag{3.2}$$

Looking ahead to design principles, we note that including equal amounts of all frequencies seems to produce a more confusing, even scribbly, figure, on the left, while using smaller amounts of higher frequencies leads to a more pleasant design.

The alert reader might wonder what happens if all the frequencies are congruent to 2 modulo 5. In Figure 3.3, we show curves obtained from each of our examples by adding one to every frequency. For instance, the mystery curve has been "bumped up" to

$$e^{2it} + \frac{1}{2}e^{7it} + \frac{i}{3}e^{-13it}, \ 0 \le t \le 2\pi.$$

It seems impossible to move one's eye along the middle curve, where the high-frequency terms are so large, but when we trace the other two we see that advancing time by $2\pi/5$ rotates the shape by $4\pi/5$, a different kind of 5-fold symmetry condition! Similar situations arise with frequencies congruent to 3 and 4, but if all frequencies are multiples of 5, then the curve might appear to have no particular symmetry, since all it does is trace over the exact same shape 5 times.

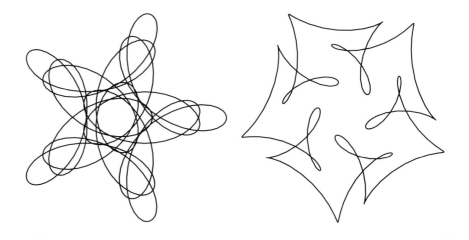

Figure 3.2. Choosing (a, b, c) as $(1, 1, 1)$ and $(1, -1/2, -i/3)$.

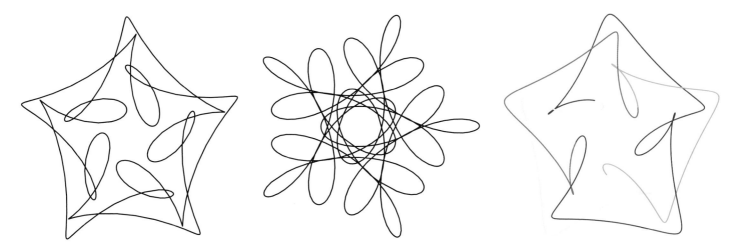

Figure 3.3. The same curve formulas, but with all frequencies increased by 1. The rightmost figure has been colored to show how these examples are different.

The General Symmetry Condition

The computation behind the general case differs so little from the preceding one that we simply state it as a theorem and declare it to be proved.

Theorem 1. *Suppose that m and k are integers and that all the frequency numbers n_j in the finite sum*

$$f(t) = a_1 e^{n_1 it} + a_2 e^{n_2 it} + \cdots + a_M e^{n_M it}$$

have

$$n_j \equiv k \pmod{m}.$$

Then, for any choice of the complex coefficients a_j, f satisfies the symmetry condition

$$f\left(t + \frac{2\pi}{m}\right) = e^{2k\pi/m} f(t), \text{ for all } t.$$

It remains, however, to interpret this as a symmetry condition. For example, one might choose frequencies all congruent to 2 modulo 6, as in

$$f(t) = e^{2it} + \frac{1}{2} e^{8it} + \frac{i}{3} e^{-10it}.$$

The curve does satisfy what technically qualifies as a 6-fold symmetry condition: $f(t + 2\pi/6) = e^{4\pi/6} f(t)$. It is true that advancing time by a sixth of a full 2π does the same as rotating the curve by 120°, but Figure 3.4 shows no suggestion of 6-fold symmetry. The problem is that a different curve, $g(t) = f(t/2)$, traces the same set of points as f but does it twice. The frequencies in g are all congruent to 1 modulo 3. This curve has 3-fold symmetry.

This is our first example of what we might call *accidental symmetry*. We meant to create a curve with 6-fold symmetry, but we chose the coefficients in a way

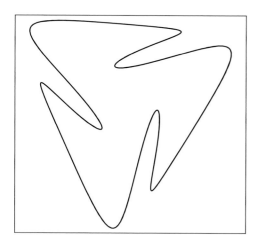

Figure 3.4. A curve with all frequencies congruent to 2 modulo 6—"accidental" 3-fold symmetry.

that created a shape with 3-fold symmetry traced twice. This phenomenon will appear in anyone's efforts to create symmetry. Here we note the generalization and caution those who wish to make their own curves to avoid choices like this example.

The problem in the example arises because 3 and 6 share a common divisor: $\gcd(6, 3) = 2$. This means that we can define g by tracing f twice as fast and produce a curve with period 2π, which is perhaps the one we ought to have analyzed to begin with. We encode this cautionary tale in a general definition.

Definition 1. Suppose that m and k are relatively prime positive integers, so that $\gcd(k, m) = 1$. To say that a curve $f(t)$, periodic with period 2π, has *m-fold symmetry of type k* is to say that

$$f\left(t + \frac{2\pi}{m}\right) = e^{2\pi k/m} f(t).$$

In light of the theorem, this means that f has m-fold symmetry of type k exactly when all of its frequencies are congruent to k modulo m (where k and m have no common factor). In the next chapter, we investigate the mathematical structure of the set of all curves with a given symmetry type. (Note: We are actually claiming that the converse of our theorem is true, and it is: Only the functions whose frequencies satisfy the congruence conditions have the desired symmetry. However, proving this requires some concepts about vector spaces and linear independence, which we describe in the next chapter.)

Mirror Symmetry

The first curve in Figure 3.2 and the second in Figure 3.3 have mirror symmetry about the x-axis. The reason for this is not nearly as interesting as the m-fold symmetry conditions: We chose all the coefficients to be real in those examples, forcing

$$f(-t) = \overline{f(t)}.$$

This means that reversing time is the same as flipping the curve about the x-axis.

One might imagine that interesting conditions arise when we consider mirrors about other axes. Alas, no. When every coefficient is a real multiple of $e^{i\alpha}$, the curve satisfies

$$f(-t) = e^{2\alpha i}\overline{f(t)},$$

and the right-hand side is the correct expression for reflection across the line through the origin inclined at angle α, as the reader may wish to check. If one wants curves with slanted mirrors, simply find a curve symmetric about the x-axis and tilt it.

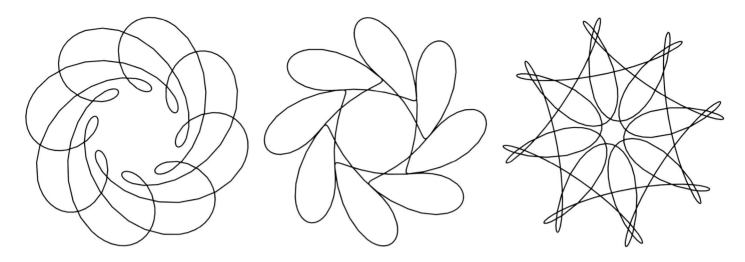

Figure 3.5. Efforts to create beautiful curves—rejects.

A Pause for Art

The symmetry theorem illustrates the typical situation in this book: Once we have decided we wish to create a curve with a given symmetry, there are fantastically infinitely many choices possible. Which of them will be beautiful? This is the art of the matter. We take a break from the mathematics to consider aesthetic questions.

To show the process, I set out to create a curve with 8-fold symmetry of type 3. According to the theorem, each of my frequencies must be 3 more than a multiple of 8. Since the mystery curve $\mu(t)$ (Figure 3.1) had a lovely rhythm, I try imitating it and choose

$$f(t) = e^{3it} + \frac{1}{2}e^{11it} + \frac{i}{3}e^{-5it}.$$

Figure 3.5 (left) shows the result. The simplicity is attractive—a stylized flower—but the looping rhythm of the mystery curve was far more interesting. I tried swapping the 11 and −5 just to see what would happen and saw the curve in Figure 3.5 (center). I find this wonderful to look at but would not offer it to someone who wants to see this type of symmetry: You cannot tell how the curve is traced because of the way tangent vectors seem to line up at crossings. Next, I decided to replace the −5 with a higher frequency that still fits the symmetry requirement: −13. The mirror symmetry of the resulting curve, Figure 3.5 (right), was quite a surprise. In light of the previous chapter, we should be able to factor out a common multiple of $e^{i\alpha}$ from every term in this curve and find that the remaining coefficients are real. We leave the curious question of what α is as a puzzle for the reader. (Hint: A shift in the time domain—find a suitable angle—should make the common factor evident.)

I decided to break the mirror symmetry by changing the last coefficient to $(i - 1)/3$, which gave Figure 3.6 (left), which is nice, but then I decided to reduce the amount of that last term. In case you've lost track, that takes us to

$$f(t) = e^{3it} + \frac{1}{2}e^{-13it} + \frac{i - 1}{4}e^{11it},$$

EXERCISE 5

Suppose that f is periodic with period 2π and also satisfies the condition

$$f\left(t + \frac{\pi}{2}\right) = \frac{i}{2}f(t) \text{ for all } t.$$

What can you say about f?

EXERCISE 6

Identify the symmetry type of the curve shown in Figure 3.7.

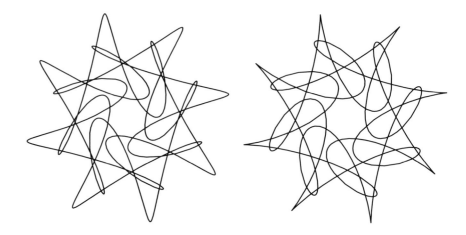

Figure 3.6. Efforts to create beautiful curves—near winner and winner.

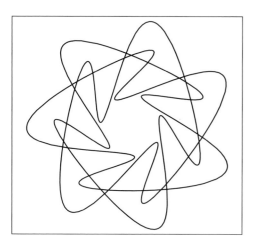

ANSWER FOR EXERCISE 5

Apply the condition four times to find that $f(t + 2\pi) = f(t) = -\frac{1}{16}f(t)$, so that f is constantly 0. There is only one periodic curve that satisfies the condition! However, if we do not require periodicity, a spiral curve will work:

$$g(t) = e^{it - (2\ln 2)t/\pi}.$$

Figure 3.7. What is the symmetry type?

ANSWER FOR EXERCISE 6

This is 7-fold symmetry of type 3, meaning that all coefficients are congruent to 3 modulo 7. To confirm this, start at one of the outermost points and trace counterclockwise until you arrive at the next point where the patterns looks the same. Your angle measure relative to the origin will have changed by $2\pi \cdot \frac{3}{7}$.

which is Figure 3.6 (right). One cannot continue forever, so I declare the result a success. I like the cusps, which are places where the velocity vector of the curve vanishes at a point. I like the way the curve traces itself between those cusps, hitting every third compass point. It is quite a reasonable stopping point. Do you wonder, What if I try ... ? Please do; surely you can find more beautiful curves.

A final point about art: One of my students brought to class a rather lovely curve that was not, in fact, symmetrical at all. He had included in a superposition of circular motions a small amount of a frequency with the wrong congruence class, giving the curve an off-kilter rhythm that the class really liked. Give this a try if you wish. Throughout the book, I restrict our attention to patterns with perfect symmetry, knowing that sometimes viewers might prefer a pattern with just a small amount of a spicy ingredient that breaks symmetry.

MORE ABOUT TECHNOLOGY. It goes without saying that I am not drawing these curves by hand. I use *Maple*, but many choices are possible, including *Mathematica* and *Sage*. The need to experiment with curves could be a nice motivation for learning to use one of these products. One needs to figure out how to graph parametric equations and how to get the machine to take the real and imaginary parts of complex exponentials—it is possible, but unpleasant, to do that by hand. The real issue with curves, and indeed with all the art we describe, is finding an easy way to see how one's choices change the design.

Chapter 4

Mathematical Structures and Symmetry:
Groups, Vector Spaces, and More

Question: What algebraic and analytic structures best describe our progress so far? The families of curves we have constructed so far exemplify several celebrated mathematical structures. These will become more and more useful as we enter new realms of symmetry, so let us pause to clarify vocabulary. We will see how our work to this point has already introduced the main players in our study of symmetry: groups, function spaces, and how they interact.

Some people enjoy diving into abstraction directly; it seems to me that we learn mathematical concepts better when we have a reason to make friends with concrete instances.

Spaces of Functions
A Small Vector Space

In the previous chapter, we showed three curves in the set

$$\mathcal{S} = \{ae^{it} + be^{6it} + ce^{-14it} \mid a, b, c \in \mathbb{C}\}.$$

We saw how any curve constructed with these building blocks will have the same type of 5-fold symmetry.

We can add any two such exponential sums to get a third of the same type, grouping like terms. We can also multiply through by any complex number and remain in \mathcal{S}; doing so may turn and enlarge or shrink the curve. These two operations—adding and scaling—together give the set the structure of a *complex vector space*. The word *vector* does not refer to a physical vector in 3-space but becomes a metaphor for a point in \mathcal{S}, which is, in fact, one of the curves.

The utility of this idea is not so much that we really wish to add two curves. In Figure 4.1, little more than a "gee-whiz" comes from knowing that the sum depicted corresponds to the coefficient sum

$$\left[1, \frac{1}{2}, \frac{i}{3}\right] + \left[1, \frac{9i}{10}, \frac{1}{6}\right] = \left[2, \frac{5 + 9i}{10}, \frac{2i + 1}{6}\right].$$

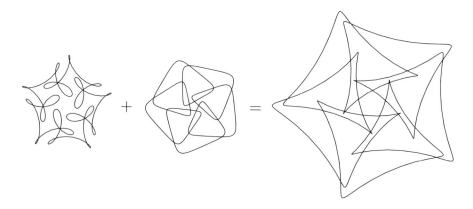

Figure 4.1. The sum of two curves.

The utility lies rather in a fundamental idea about vectors spaces: We can write general vectors as a superposition of special ones, called *basis vectors*. It is a dull observation that every element of S can be written as a sum of multiples of the vectors e^{it}, e^{6it}, and e^{-14it}. After all, that is how we defined this set of curves. Things become much less dull when we ask: might fewer than three vectors suffice?

It seems to take three complex numbers—the coefficients—to specify an element of S, so we think of that vector space as having (complex) dimension 3. How do we know that some clever person might not be able to express the exact same set as a superposition of only *two* vectors? The answer is to show that the three vectors e^{it}, e^{6it}, and e^{-14it} are *linearly independent*, meaning that the only constants c_1, c_2, and c_3 that can make

$$c_1 e^{it} + c_2 e^{6it} + c_3 e^{-14it} = 0 \tag{4.1}$$

are $c_1 = c_2 = c_3 = 0$. We leave this as an exercise to the reader with a hint: Plug in $t = 0$ to find one relationship among the c's; do the same for $t = \pi$ and $t = \pi/3$.

Why does (4.1) reflect anything about independence? Well, if any one of the vectors could be expressed as a sum of multiples of the other two—if it were *dependent* on those other two—then we could take that expression and put everything on one side of an equation to achieve (4.1) with nonzero coefficients. Thus, the nonexistence of nonzero constants to make that sum 0 makes sense as a condition for linear independence.

Vector Spaces of Higher Dimensions

Our first step in the direction of generalization is to fix an integer M and define a set of exponential sums

$$\mathcal{F}_M = \left\{ \sum_{n=-M}^{M} a_n e^{int} \mid a_n \in \mathbb{C} \right\},$$

where it is understood that n, the index of summation, is an integer. The preceding discussion should convince you that \mathcal{F}_M is a complex vector space of (complex) dimension $2M + 1$. (The "+1" counts the term where $n = 0$, a constant curve.)

If our goal is to create curves with given symmetries, \mathcal{F}_M could be viewed as our design space: Each point in this space is a potentially lovely curve. However, it is inconvenient to specify M in advance: Do you really want to have an absolute limit on the frequencies you are allowed to choose? For more flexibility, we define

$$\mathcal{F}_{\text{finite}} = \left\{ \sum_{n=-M}^{M} a_n e^{int} \mid a_n \in \mathbb{C}, M \in \mathbb{Z} \right\},$$

the union of all the sets \mathcal{F}_M. The subscript *finite* refers to the fact that each vector in the space is a finite, though possibly large, sum of terms. One cost of the generalization is that we now have an infinite-dimensional vector space. We will see that this not too great a difficulty, but we need some other developments before we learn more.

Looking ahead to how we might state the symmetry theorem from the previous chapter in terms of function spaces, we define, for integers k and m, the spaces

$$\mathcal{F}_{k,m} = \left\{ \sum_{n=-M}^{M} a_n e^{int} \mid M \in \mathbb{Z} \text{ and } a_n = 0 \text{ unless } n \equiv k \pmod{m} \right\} \subset \mathcal{F}_{\text{finite}}.$$

By our theorem, every function f in $\mathcal{F}_{k,m}$ has m-fold symmetry of type k, assuming $\gcd(k, m) = 1$. Each of these spaces provides a place where we could spend hours searching for beautiful curves.

Groups

Analyzing the mystery curve led us to notice, rather inevitably, the set of complex numbers corresponding to rotations through multiples of $72°$, of which there are exactly 5:

$$C_5 = \left\{ e^{2\pi i/5}, e^{2\cdot 2\pi i/5}, e^{3\cdot 2\pi i/5}, e^{4\cdot 2\pi i/5}, 1 \right\}.$$

Since the product of any two elements in C_5 is also an element of C_5, we say this set is *closed* under the operation of multiplication. Since C_5 contains the multiplicative identity 1, as well as the multiplicative inverse of every one of its elements (take a moment to check), C_5 satisfies the requirements to be called a *group*. The formal definition of this word also requires that the operation be associative, which complex multiplication certainly is.

To summarize: A group is a set with an associative operation, which is required to contain an identity as well as the inverse of every element, and is required to be closed under the operation. The group C_5 is an easy example to keep in mind. We say C_5 has *order* 5 to indicate that it has 5 elements. We can apply the same word—*order*—to elements: The order of $e^{2\pi i/5}$ is 5, because its fifth power is the first power that brings it around to 1, the identity.

Another player in our analysis was the idea of translating the t-variable by $2\pi/5$. In geometric terms, we are really talking about rotation, since we are increasing the measure of the angle t by $2\pi/5$, but we would rather emphasize the algebraic nature of addition, so we stick with the term *translation*. Translating 5 times in a

row by $2\pi/5$ changes t to $t + 2\pi$. If we are thinking of t as an angle, the extra 2π comes out in the wash, and we end up back where we started.

The technical structure to handle this identification of t with $t + k \cdot 2\pi$ is called an *equivalence relation*. If we say $t \sim t + k \cdot 2\pi$ for any $k \in \mathbb{Z}$, then the relation \sim shares enough of the formal properties of $=$ to allow us to lump together real numbers into *equivalence classes*, sets of all the things equivalent to one another. For instance, the angle $\pi/4$ becomes, in technical terms, the equivalence class $\{\ldots, -7\pi/4, \pi/4, 9\pi/4, \ldots\}$.

With the understanding that t represents not a real number but an angle, we define a translation function for any angle θ

$$T_\theta(t) = t + \theta$$

and a set of translations

$$\mathcal{T}_5 = \left\{ T_{2\pi/5}, T^2_{2\pi/5}, T^3_{2\pi/5}, T^4_{2\pi/5}, T^5_{2\pi/5} = T_0 \right\},$$

where, for instance, $T^2_{2\pi/5}$ is shorthand for the translation $T_{2\pi/5}(T_{2\pi/5}(t))$. The last element in the list is translation through an angle 0, meaning changing t not at all, just as multiplying by the last element of \mathcal{C}_5 does nothing.

Our two groups seem suspiciously similar. Each has 5 elements, and the multiplications seem related. This is because the two groups are *isomorphic*—a technical term for "essentially the same." We exhibit this with a simple matching, called an *isomorphism*, $\phi : \mathcal{T}_5 \rightarrow \mathcal{C}_5$. To make the definition simpler, we write $\omega_5 = e^{2\pi i/5}$. Then we can define

$$\phi(T_{2\pi/5}) = \omega_5, \ \phi(T^2_{2\pi/5}) = \omega_5^2, \ \phi(T^3_{2\pi/5}) = \omega_5^3,$$

$$\phi(T^4_{2\pi/5}) = \omega_5^4, \ \phi(T^5_{2\pi/5}) = 1. \tag{4.2}$$

Rarely do we want to write out a matching like this as a list, so we could summarize by defining

$$\phi(T_{2\pi/5}) = \omega_5,$$

extending ϕ by the requirement that

$$\phi(g_1 \circ g_2) = \phi(g_1)\phi(g_2).$$

This last condition is the essence of a *homomorphism*, a special kind of map between groups; the equation says that the mapping from one group to the other respects the group operation, in that operating before the mapping is the same as operating after. An isomorphism is just a homomorphism that is also a one-to-one correspondence.

The matching in (4.2) is not the only way to bring \mathcal{C}_5 and \mathcal{T}_5 into correspondence. If $k = 1, 2, 3$, or 4, each mapping defined by setting

$$\phi_k(T_{2\pi/5}) = \omega_5^k,$$

and extending via the homomorphism condition, does give an isomorphism. This requires some checking, but it is easy. For instance,

$$\phi_k(T_{2\pi/5}^5) = (\phi_k(T_{2\pi/5}))^5 = (\omega_5^k)^5 = 1,$$

so the identity in one group goes to the identity in the other.

The element $T_{2\pi/5}$ is called a *generator* of \mathcal{T}_5 because every element of the group can be expressed as powers (in the sense of function composition) of this element. We will have occasion to use the notation

$$\mathcal{T}_5 = \langle T_{2\pi/5} \rangle$$

to indicate that the group is generated by the given element.

Sometimes groups are generated by the powers of more than one element, but \mathcal{T}_5 requires only one. We call a group that can be generated by a single element a *cyclic group*. There are actually four different possible generators for \mathcal{T}_5 and, similarly, four for \mathcal{C}_5. Our four isomorphisms arise by sending a particular generator of \mathcal{T}_5 to each of the possible four generators of \mathcal{C}_5.

There is a fifth way to map $\mathcal{C}_{2\pi/5}$ to \mathcal{T}_5, namely, $\phi(e^{2\pi/5}) = T_{2\pi/5}^5$. This is a trivial mapping, where every element of $\mathcal{C}_{2\pi/5}$ ends up at the identity element of \mathcal{T}_5. Still, the map is a homomorphism, and eventually our classification of possible symmetries will involve all possible homomorphisms between specific groups. For now, we turn our attention back to the symmetry condition.

Groups and Symmetry of Curves

For $k = 1, 2, 3$, or 4, a function f has 5-fold symmetry of type k exactly when

$$f\left(T_{2\pi/5}(t)\right) = \omega_5^k f(t).$$

It can become even more elegant if we use \circ for function composition and suppress the t-argument: $f \circ T_{2\pi/5} = \omega_5^k f$. Test your love of abstraction by deciding whether you prefer this elegant shorthand to the longer, more concrete version presented originally. I like them both.

We can use the function spaces defined at the end of the previous section, along with the abbreviation $\omega_m = e^{2\pi i/m}$, to restate the symmetry theorem in a similarly elegant fashion:

Theorem 2. *If m and k are integers with $\gcd(k, m) = 1$, then the functions f in $\mathcal{F}_{k,m}$ are exactly the finite exponential sums that satisfy the m-fold symmetry condition of type k:*

$$f \circ T_{2\pi/m} = \omega_m^k f. \tag{4.3}$$

Comment: Proving that the sums in $\mathcal{F}_{k,m}$ satisfy the given condition is a simple computation. We leave as an exercise for the hardy—a workout in linear algebra—to prove that the only nonzero coefficients a_n in an exponential sum that satisfies the k, m-symmetry condition (4.3) must have $n \equiv k \pmod{m}$.

As we look forward to generalizing our concept of symmetry to other situations, let us give language to what we have done. The group \mathcal{T}_5 is said to *act* on the set of angles, which is the domain of our periodic functions f. All this means is that each element of the group defines a way to map the set to itself, and that the group operation corresponds to the composition of those mappings. In this case, it is obvious that translating by two angles in succession is the same as translating by the sum of those angles.

Similarly, the group \mathcal{C}_5 acts on the range of the periodic functions in the symmetry theorem, as multiplication of complex numbers. The symmetry condition is sometimes called an *intertwining condition* because it identifies functions for which the action on the domain carries over to the action on the range. The general story of symmetry involves myriad situations where one group acts on the domain and the other acts on the range. Whenever we have a homomorphism from one group to the other, we can ask for functions that behave nicely with respect to that homomorphism. But this is very abstract, so we retreat to more concrete discussions.

EXERCISE 8

Shed light on the requirement that $\gcd(k, m) = 1$ in the symmetry theorem by writing out some exponential sums

$$\sum a_n e^{nit} \text{ where all nonzero coefficients have } n \equiv 4 \pmod 6.$$

Prove that any such function actually has 3-fold symmetry of type 1. Similarly, show that any function

$$f(t) = \sum a_n e^{nit} \text{ with } n \equiv 0 \pmod m$$

can be rewritten as a generic function in \mathcal{F} by rescaling the time domain.

*** EXERCISE 9**
A Vector Space of Polynomials

For any fixed positive integer N, define the vector space of polynomials of degree at most N to be

$$\mathcal{P}_N = \{a_N x^N + a_{N-1} x^{N-1} + \cdots + a_1 x + a_0 \mid a_j \in \mathbb{R}\}.$$

Show that the dimension of \mathcal{P}_N as a *real* vector space is $N + 1$ by showing that the vectors $x^N, x^{N-1}, \ldots, x, 1$ are linearly independent. In other words, check that that

$$a_N x^N + a_{N-1} x^{N-1} + \cdots + a_1 x + a_0 = 0 \text{ for all } x \to a_j = 0 \text{ for all } j = 0, 1, \ldots, N.$$

A polynomial $f \in \mathcal{P}_N$ is called *even* when $f(x) = f(-x)$ and *odd* when $f(x) = -f(-x)$. Find an easy condition to identify the subspace of \mathcal{P}_N consisting of even functions and the one consisting of odd functions. Find a way to write any such f as a sum of one even function and one odd function. (Hint: Investigate $(f(x) + f(-x))/2$.) This last process previews the concept of *projection operators*, which we introduce in Chapter 5.)

ANSWER FOR EXERCISE 8

Suppose that n is any frequency that appears with a nonzero coefficient in the series for f and that $n \equiv 4 \pmod 6$. Then $n = 4 + 6k$ for some integer k. Rearranging gives $n = 1 + 3(2k + 1)$, so all nonzero coefficients in the sum have $n \equiv 1 \pmod 3$. The function actually has 3-fold symmetry of type 1. This is why we ask that $\gcd(k, m) = 1$: If the condition is not met, we can reduce to a simpler symmetry condition.

For the second part, $n \equiv 0 \pmod m$ means that $n = km$ for some integer k. We may as well index the terms by k and rescale the time domain.

ANSWER FOR EXERCISE 9

To prove linear independence, start at the bottom: Set $x = 0$ in the given equation to find that $a_0 = 0$. Differentiate once and set $x = 0$ to find $a_1 = 0$, and so on. You can formalize this with induction.

Evidently any polynomial whose only nonzero coefficients are indexed by odd numbers will be an odd function. Similarly, the even polynomials are those whose nonzero coefficients are indexed by even numbers. For instance, $1 + x^2 + 7x^4$ is even.

For the third part, use the definitions $f_e(x) = (f(x) + f(-x))/2$ and $f_o(x) = (f(x) - f(-x))/2$ to define projections from \mathcal{P}_N to its subspaces of even and odd functions. Check that $f = f_e + f_o$.

Chapter 5

Fourier Series: Superpositions of Waves

Question: Which periodic motions occur as superpositions of circular motions? The folk wisdom that everything is a superposition of waves has its origins in some specific and beautiful mathematics: Fourier theory. In earlier chapters, we have learned that certain lovely curves can be expressed as linear combinations—scaled superpositions—of periodic motions. Why not call these periodic motions *waves*, to acknowledge their repetitive nature, like waves on the ocean?

The surprise in this chapter is that, in a suitable sense, *every* periodic curve in the plane can indeed be written as a superposition of waves, though infinitely many are required in general. Being told that this is so could be enough about Fourier series to allow you to enjoy the rest of the book; if you wish to skip this chapter, you will lose only a little. To learn the details, read on. We review the role of the dot (or scalar) product in vector projection in Euclidean 3-space and develop a beautiful generalization to the spaces of functions we met in the previous chapter.

Review of Vector Projection

The nice thing about the three vectors

$$A = \left(1, -\frac{1}{2}, -\frac{1}{2}\right), \ B = \left(0, \frac{\sqrt{3}}{2}, -\frac{\sqrt{3}}{2}\right), \text{ and } C = (1, 1, 1)$$

is that they are pairwise orthogonal, as is easily checked using dot products. It is somewhat inconvenient that their lengths are different:

$$|A| = |B| = \sqrt{\frac{3}{2}} \text{ and } |C| = \sqrt{3}.$$

For possibly eccentric purposes, we wish to be able to write an arbitrary vector X as a linear combination of A, B, and C. How can this be done?

The answer comes from dot products, which help us exploit the happy feature of mutual orthogonality. If

$$X = aA + bB + cC,$$

then, dotting each side with A, B, and C gives three equations,

$$X \cdot A = a|A|^2, \ X \cdot B = b|B|^2, \text{ and } X \cdot C = c|C|^2,$$

from which we easily detect the correct coefficients a, b, and c. Since

$$X = \frac{X \cdot A}{|A|}\frac{A}{|A|} + \frac{X \cdot B}{|B|}\frac{B}{|B|} + \frac{X \cdot C}{|C|}\frac{C}{|C|},$$

we call $X \cdot A/|A|$ the *vector projection of X onto A*. The terminology is reinforced by the formula $X \cdot A/|A| = |X| \cos(\theta)$, where θ is the angle between X and A. (If this is obscure, draw a right triangle with X as the hypotenuse and a leg along the direction of A.)

Let's check an example:

$$(1, 2, 4) = -2 \cdot \frac{2}{3}A - \sqrt{3} \cdot \frac{2}{3}B + 7 \cdot \frac{1}{3}C.$$

This computation represents a general idea about 3-dimensional space: We can *resolve* any vector in terms of these three mutually orthogonal ones, meaning we can show how it is made from A, B, and C. It might have been more convenient if we had *normalized* them before the computation began, meaning we might have divided each vector by its length to produce a triple of unit vectors. In some situations it is more convenient to live with a system of nonunit vectors.

In any case, if we wish to find the projection of any given X onto the plane spanned by, for instance, A and B, we could simply omit the part of the sum in the direction of C. Check that the projection of $(1, 2, 4)$ onto that plane is $(-\frac{4}{3}, -\frac{1}{3}, \frac{5}{3})$ and that the difference between $(1, 2, 4)$ and the proposed projection is indeed a multiple of $(1, 1, 1)$.

The important thing to take forward from this example is how central the dot product is to our ability to pick out the component of one vector in the direction of another.

> *** EXERCISE 10**
>
> Continue to analyze the example, as follows: The mapping $P(x, y, z) = (z, x, y)$ from $\mathbb{R}^3 \to \mathbb{R}^3$, called *cyclic permutation of variables*, generates a group with three elements, since performing the permutation 3 times leaves the variables back in place. Observe that the vector C is invariant under P. Use graphing software to create a polygon in space whose vertices are
>
> $$\pm A, \pm P(A), \pm P^2(A).$$
>
> If you connect them in the right order, you should find a regular hexagon. What is its relation to the cube with vertices $(\pm 1, \pm 1, \pm 1)$?

A New Dot Product

Returning to our context of curves, we may wish to pick out the degree to which a periodic motion can be produced by a particular wave function e^{int}. A surprise is in store: Just as a dot product reveals the degree to which a vector X can be built from a vector A, a different dot product has the power to reveal the extent to which a given curve f can be built from one of our special curves e^{int}. In the more general setting, the dot product is called an *inner product*. Here it is: The inner product of two (possibly complex-valued) periodic functions of t, f and g, is

$$\langle f, g \rangle = \int_0^{2\pi} f(t)\overline{g(t)}\, dt.$$

This is a lot to digest. First, we must declare that we are talking about functions for which the integral makes sense, so for now let us restrict our attention

to continuous functions. Second, we should ask why this makes sense as a generalization of the dot product. Without becoming too technical, we simply note the key criteria for the formal definition of an abstract inner product: integration is a linear operation ($\langle af_1 + bf_2, g \rangle = a\langle f_1, g \rangle + b\langle f_2, g \rangle$) and $\langle f, f \rangle$, the square length of the vector f, is strictly positive unless f is the zero function. Having these two properties turns out to be enough to ensure that the inner product behaves like the familiar dot product.

If you have never integrated a complex function before, don't worry—we just integrate the real and complex parts separately. For instance, keep in mind that $e^{int} = \cos(nt) + i\sin(nt)$, and use some calculus to find that, for $n \neq 0$,

$$\int_0^{2\pi} e^{int}\, dt = \int_0^{2\pi} \cos(nt)\, dt + i\int_0^{2\pi} \sin(nt)\, dt = \frac{1}{n}\sin(nt)\Big|_0^{2\pi} - i\,\frac{1}{n}\cos(nt)\Big|_0^{2\pi} = 0.$$

On the other hand, we can check that the lovely formula

$$\int e^{int}\, dt = \frac{1}{in}e^{int} + C \qquad (5.1)$$

captures the same idea, which will save us time later.

One insight to gain from this computation is that the continuous summation of the vectors around a circle, whether we go once around or n times around, is always 0.

Let us use the inner product to find the square length of e^{int}, a typical basis vector in our function space $\mathcal{F}_{\text{finite}}$:

$$\langle e^{int}, e^{int} \rangle = \int_0^{2\pi} e^{int}\overline{e^{int}}\, dt = 2\pi.$$

It may be inconvenient that this vector does not have unit length, but at least all the basis vectors have the same length, $\sqrt{2\pi}$.

What can we say about the angle between two basis vectors? We put our two computations together; if $n \neq m$, then

$$\langle e^{int}, e^{imt} \rangle = \int_0^{2\pi} e^{int}\overline{e^{imt}}\, dt = \int_0^{2\pi} e^{i(n-m)t}\, dt = 0, \text{ since } n - m \neq 0.$$

The basis vectors are mutually orthogonal!

This means that if f is a finite exponential sum, $f(t) = \sum a_n e^{int}$, then we can use exactly the trick from our artless example with A, B, and C to find that

$$a_n = \frac{1}{2\pi}\langle f, e^{int} \rangle = \frac{1}{2\pi}\int_0^{2\pi} f(t)e^{-int}\, dt. \qquad (5.2)$$

The quantity a_n in the expression for f is exactly the amount of the basis vector e^{int} in f. The idea of Fourier analysis is to find the amount of a given wave present in a signal by the integral definition in (5.2).

Fourier Analysis

The preceding discussion presumed that f was a finite exponential sum and told us how to compute the coefficients using dot products. Let us try to extend the same idea to a general function f.

If f is any (integrable) function, we define its nth *Fourier coefficient* by the integral in (5.2). We say that the *Fourier series* for f is the exponential sum with these coefficients and write

$$f(t) \sim \sum_{-\infty}^{\infty} a_n e^{int},$$

where \sim indicates that we make no claim at present that the two sides are equal as functions. We have shown that they are equal when $f \in \mathcal{F}_{\text{finite}}$, but that is a weak claim, since $\mathcal{F}_{\text{finite}}$ consists of finite sums.

We will prove that any *differentiable* function is equal to the sum of its Fourier series, but only after computing an example. Stronger results are certainly possible, but the analysis becomes quite fussy.

Example: A Square From Circles

Though it bears no relation at all to the ancient problem of squaring the circle, we compute an amusing example that might be called "circling the square." We compute the Fourier series for a curve that parametrizes a 2×2 square in a manner that looks appalling but is really quite natural. After all, we need to travel the 8 units around the square in 2π units of time, so the coefficient of t has to be $4/\pi$.

Define

$$f(t) = \begin{cases} 1 + i\left(\frac{4t}{\pi}\right) & \text{for } -\frac{\pi}{4} \le t < \frac{\pi}{4} \\ \left(2 - \frac{4t}{\pi}\right) + i & \text{for } \frac{\pi}{4} \le t < \frac{3\pi}{4} \\ -1 + i\left(4 - \frac{4t}{\pi}\right) & \text{for } \frac{3\pi}{4} \le t < \frac{5\pi}{4} \\ \left(-6 + \frac{4t}{\pi}\right) - i & \text{for } \frac{5\pi}{4} \le t < \frac{7\pi}{4}. \end{cases}$$

Software can take the pain from computing various messy integrals we need to find the Fourier coefficients for f. If we remember the symmetry condition, we will realize that $a_n = 0$ except when $n \equiv 1 \pmod 4$ and save time. The nonzero coefficients are

$$a_{4j+1} = (-1)^j \frac{8\sqrt{2}}{(4j+1)^2 \pi^2}. \tag{5.3}$$

Knowing the correct Fourier series for f, we use an experimental approach to see whether it indeed does recreate the function f. Including only the terms for $k = -1, 0$, and 1 (frequencies $-3, 1$, and 5) gives the curve on the left in Figure 5.1, already quite a good approximation! The middle and right curves show sums with k ranging from -5 to 5 and -15 to 15. Although f is not differentiable at the corners, the Fourier series seems to converge to f as n approaches infinity.

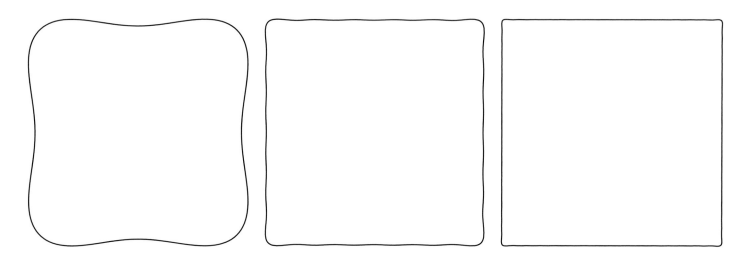

Figure 5.1. Summing 3, 11, and 31 terms in the Fourier series for the parametrization of the square.

PROJECTION OPERATORS. The example of a square provides an opportunity to introduce *projection operators*, an idea that will become powerful later in our study of symmetry. In the formula for the Fourier coefficients of the parametrization of the square (5.3), notice that j even makes $4j + 1 \equiv 1$ (mod 8), while j odd makes $4j + 1 \equiv 5$ (mod 8). This means that if we separate the series for f into two series, one with only the odd values of j and the other with only the even values of j, we find two new functions that have 8-fold symmetry of types 1 and 5, respectively. The new functions are shown in Figure 5.2. (This is meant to remind you of Exercise 9.)

Risking some symbol overload, we make this more formal: For any finite sum of the Fourier series of f, define an operator (a fancy name for a function from one function space to another) that simply removes every other term from the sum. In symbols, define

$$\coprod_{\text{even}} : \mathcal{F}_{1,4} \to \mathcal{F}_{1,8} \text{ by } \coprod_{\text{even}} \left(\sum_{j=-N}^{N} a_{4j+1} e^{(4j+1)it} \right) = \sum_{j \text{ even}} a_{4j+1} e^{(4j+1)it}$$

and

$$\coprod_{\text{odd}} : \mathcal{F}_{1,4} \to \mathcal{F}_{5,8} \text{ by } \coprod_{\text{odd}} \left(\sum_{j=-N}^{N} a_{4j+1} e^{(4j+1)it} \right) = \sum_{j \text{ odd}} a_{4j+1} e^{(4j+1)it}.$$

The powerful thing is that *every* function with 4-fold symmetry of type 1 can be decomposed into a sum of functions with 8-fold symmetry of types 1 and 5, respectively.

The Dirichlet Kernel and Convergence of Fourier Series

This chapter ends with a baroque crescendo through the proof that the Fourier series for f does indeed converge to $f(t)$ for every t, at least when f is

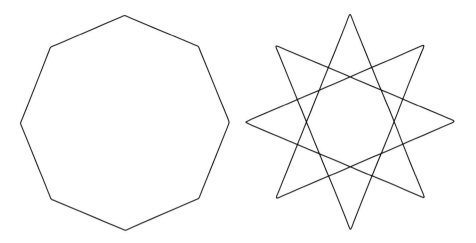

Figure 5.2. Partial sums of the Fourier series for the square can be projected to two new functions, one in $\mathcal{F}_{1,8}$ and one in $\mathcal{F}_{5,8}$ (printed at difference scales).

(continuously) differentiable at every point. The material may certainly be skipped, but how will you know how much mathematics is too much unless you put yourself at risk of wading in too deep? The key ingredients are: a clever rewriting of the Nth partial sum of the Fourier series for f, a comparison of f with that partial sum, a special way to get control over f once we know it is differentiable, and, finally, proof that the difference between f and the Nth partial sum approaches 0 as N approaches infinity. Some of the steps are low-hanging fruit; one of them leaves me wondering how anyone ever thought to do that.

Suppose f is a differentiable, 2π-periodic function of t. We fix a positive integer N and investigate the Nth partial sum of the Fourier series for f, writing the

*** EXERCISE 12**

Assume that the series in Exercise 11 does indeed converge. Set $t = 2\pi/3$ and manipulate both sides of the sum to derive the formula

$$\sum_{k=-\infty}^{\infty} \frac{1}{(3k+1)^2} = \frac{4\pi^2}{27}.$$

This eccentric result is equivalent to the solution of the celebrated Basel problem: to sum the reciprocals of the squares of the integers. Leonard Euler's 1735 solution was one of his early megasuccesses. Show that the sum derived from the Fourier series for the triangle takes us to the solution of the Basel problem:

$$\sum_{n=1}^{\infty} \frac{1}{n^2} = \frac{\pi^2}{6}.$$

Computations like these hold a nonvisual beauty. Strange that this one was hiding in an equilateral triangle.

(Hint: Turn the negative terms around to positive ones and realize that the only terms left out of the sum are indexed by multiples of 3.)

integral definition for the jth coefficient, using a dummy variable s:

$$f_N(t) = \sum_{j=-N}^{N} a_j e^{ijt} = \sum_{j=-N}^{N} \left(\frac{1}{2\pi} \int_0^{2\pi} f(s) e^{-ijs} ds \right) e^{ijt}.$$

The sum is finite, so we are allowed to interchange summation and integration. We do this, move the 2π, and combine the two exponential functions to write

$$f_N(t) = \int_0^{2\pi} f(s) \left(\sum_{j=-N}^{N} \frac{1}{2\pi} e^{ij(t-s)} \right) ds.$$

The sum in parentheses is a function called the *Dirichlet kernel*, evaluated at the point $t-s$. Some easy simplification is possible, once we recognize that the positive

** EXERCISE 13
General Regular Polygons and Star Polygons

The following computation, which I find beautiful but fantastically intricate, is about as complicated as I can possibly do by hand. Test your calculus by giving it a try. Fix an integer m and call, as usual, $\omega = e^{2\pi i/m}$. We will work out the Fourier series for various polygons with m sides. First prove that if a function f has m-fold symmetry of any type, then the integrals that determine the Fourier coefficients for f can be simplified:

$$a_n = \frac{1}{2\pi} \int_0^{2\pi} f(t) e^{-int} dt = \frac{m}{2\pi} \int_0^{2\pi/m} f(t) e^{-int} dt.$$

Next, show that the function

$$f(t) = \left(1 - \frac{mt}{2\pi} \right) + \frac{mt}{2\pi} \omega \text{ for } 0 \le t < \frac{2\pi}{m},$$

extended by the symmetry condition $f(t + 2\pi/m) = \omega f(t)$, parametrizes a regular m-gon with vertices $1, \omega, \omega^2, \ldots$. Finally, and this is the heroic part, compute that the only nonzero Fourier coefficients for f are

$$a_{jm+1} = \left(\frac{m}{\pi(jm+1)} \sin\left(\frac{\pi}{m} \right) \right)^2.$$

(Hint: In addition to the shortcut in (5.1), use integration by parts and a handy trigonometric identity.)

One can go further to replace ω in the definition of f with ω^k to parametrize a star polygon, whose type is usually denoted $\{\frac{m}{k}\}$. Surprisingly, the Fourier coefficients for the new function are simply

$$c_{jm+k} = \left(\frac{m}{\pi(jm+k)} \sin\left(\frac{\pi}{m} \right) \right)^2.$$

Figure 5.3 shows three partial sums in the Fourier series for the $\{\frac{5}{2}\}$-gon.

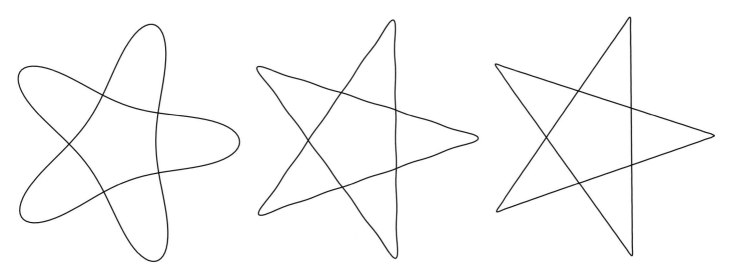

Figure 5.3. Summing 3, 11, and 31 terms in the Fourier series for the parametrization of the pentagram.

and negative values of j can be combined:

$$D_N(u) = \frac{1}{2\pi} \sum_{j=-N}^{N} e^{iju}$$

$$= \frac{1}{2\pi} \left(1 + 2\cos(u) + 2\cos(2u) + \ldots + 2\cos((N-1)u) + 2\cos(Nu)\right).$$

Knowing that the cosine terms integrate to 0 allows us to notice that

$$\int_0^{2\pi} D_N(u)\, du = 1,$$

so the Dirichlet kernel has total mass 1. We summarize by writing

$$f_N(t) = \int_0^{2\pi} f(s) D_N(t-s)\, ds.$$

The next simplification is probably not something that anyone would notice, which makes me admire it all the more. The most recent expression for the Dirichlet kernel uses cosines of successive integer multiples of u. The angle addition formula for cosine allows us to collapse the sum by referring to successive *half-integer* multiples of u, as follows. Since

$$\sin\left(\left(j + \frac{1}{2}\right)u\right) = \sin(ju)\cos\left(\frac{u}{2}\right) + \cos(ju)\sin\left(\frac{u}{2}\right) \text{ and}$$

$$\sin\left(\left(j - \frac{1}{2}\right)u\right) = \sin(ju)\cos\left(\frac{u}{2}\right) - \cos(ju)\sin\left(\frac{u}{2}\right),$$

we can express the jth cosine term in the Dirichlet kernel as

$$2 \cos(ju) = \frac{\sin\left(\left(j + \frac{1}{2}\right)u\right) - \sin\left(\left(j - \frac{1}{2}\right)u\right)}{\sin\left(\frac{u}{2}\right)}.$$

The magic comes from writing the term with a given integer multiple of u in terms of the half-integer above and the half-integer below. Conveniently, terms cancel in pairs, except for the first and last, leaving us with the magical formula

$$D_N(u) = \frac{\sin\left(\left(N + \frac{1}{2}\right)u\right)}{2\pi \sin\left(\frac{u}{2}\right)}.$$

(Where did the first term go? I wrote $1 = \sin(u/2)/\sin(u/2)$, requiring that we temporarily avoid $u = 0$, so that the lower half of the second term cancels the first term. You can check that $D_N(0) = (2N + 1)/2\pi$, which is the limit of our "magical" expression as u approaches 0.)

Here is the heart of the computation: studying the difference between $f(t)$ and $f_N(t)$. The steps are not easy; the first uses the symmetry and periodicity of the Dirichlet kernel, as well as the fact that it has total mass 1.

$$f(t) - f_N(t) = f(t) \int_0^{2\pi} D_N(t - s)\, ds - \int_0^{2\pi} f(s) D_N(t - s)\, ds$$

$$= \int_0^{2\pi} (f(t) - f(s)) D_N(t - s)\, ds.$$

Now we invoke the hypothesis that f is differentiable. An estimate will allow us to cancel the dangerously singular denominator of the Dirichlet kernel with good behavior of f. For $t \neq s$ write

$$\frac{f(t) - f(s)}{2\pi \sin\left((t - s)/2\right)} = \frac{f(t) - f(s)}{t - s} \frac{t - s}{2\pi \sin\left((t - s)/2\right)}.$$

The first factor converges to $f'(t)$, assumed to exist, as t approaches s, while the second approaches $1/\pi$, using a famous limit. Therefore, we can certainly find a number M so that

$$\frac{f(t) - f(s)}{2\pi \sin\left((t - s)/2\right)} \leq M.$$

(We need to mention a technical detail: It is not enough to assume that $f'(t)$ exists, but that it can be bounded uniformly on the interval. When we state the theorem formally, we ensure this by requiring that f' be continuous.)

We are almost finished. Estimate the absolute value of the difference between f and f_N, as follows:

$$|f(t) - f_N(t)| = \left| \int_0^{2\pi} (f(t) - f(s)) D_N(t - s)\, ds \right|$$

$$\leq M \left| \int_0^{2\pi} \sin\left((N + \tfrac{1}{2})(t - s)\right) ds \right|.$$

Computation shows that the last integral approaches 0 as N approaches infinity: When we integrate that sine function, we divide by $N + \frac{1}{2}$.

We have proved the first important theorem of Fourier theory.

Theorem 3. *If f is a 2π-periodic, complex-valued function of t whose derivative is continuous everywhere, then the Fourier series for f converges to $f(t)$ for every t, and this allows us to write*

$$f(t) = \sum_{n=-\infty}^{\infty} a_n e^{int}, \text{ where } a_n = \int_0^{2\pi} f(t) e^{int}\, dt.$$

Many other theorems about convergence of Fourier series are known. We choose the Plancherel theorem as a highlight. It says that the integral of the square magnitude of f over one period is the same as the sum of the square magnitudes of the coefficients:

$$\frac{1}{2\pi} \int_0^{2\pi} |f(t)|^2\, dt = \sum_{n=-\infty}^{\infty} |a_n|^2.$$

This is an infinite-dimensional analog of the Pythagorean theorem. It is not easy to describe the exact space of functions for which it is valid, though it certainly works for differentiable ones. We leave such considerations for a deeper course in Fourier theory.

Chapter 6

Beyond Curves: Plane Functions

Question: How can we extend our curves with m-fold symmetry to functions from \mathbb{C} to \mathbb{C}? How shall we visualize them? Curves are lovely but limited in potential as art. We find new possibilities for color images in extending our symmetric curves to functions from \mathbb{C} to \mathbb{C}. The *domain-coloring algorithm* offers a new kind of depiction, which produces the intricate images that are the heart of this book.

Complex Extensions

Recall the polar form for a complex number:

$$z = x + iy = re^{it},$$

where $r = \sqrt{x^2 + y^2}$ and $t = \tan^{-1}(y/x)$. (Technically, this last is correct only when $x > 0$. Thinking of the angle t as a function of x and y gives a good example of a function that takes on multiple values—the various numbers that represent the same angle; these multiple-valued functions—against the rules in regular calculus—turn out to be very interesting in complex variables). One fruit of the polar formula is the ease with which we can raise complex numbers to powers:

$$z^n = r^n e^{int}.$$

We have named the angle variable t in order to connect this power formula to the Fourier series we studied in the previous chapter (but you may see it called θ elsewhere). With this notation, any Fourier series

$$\sum_{-\infty}^{\infty} a_n e^{int}$$

can be seen as the restriction of a function

$$f_h(z) = \sum_{-\infty}^{\infty} a_n r^n e^{int} = \sum_{-\infty}^{\infty} a_n z^n \tag{6.1}$$

to the unit circle, where $r = 1$. (The subscript h stands for *holomorphic*, to be explained later.)

We pay a price for this extension: Any negative values of the frequency variable n lead to terms in the extension that are undefined for $z = 0$. For example, our mystery curve

$$e^{it} + \frac{1}{2}e^{6it} + \frac{i}{3}e^{-14it} \text{ becomes } f_h(z) = z + \frac{z^6}{2} + \frac{iz^{-14}}{3}, \qquad (6.2)$$

and this function is outrageously undefined at the origin. Still, we will see interesting symmetry in depictions of this extended function, the first of a whole new class of images we can create.

These negative powers of z turn out to be so useful that we want to avoid having to stop and excuse ourselves whenever a function is undefined at 0. We use the notation \mathbb{C}^* to indicate the set of complex numbers excluding the origin. Our first extension of the mystery curve is a very nicely defined function, not on \mathbb{C} but on \mathbb{C}^*.

There is a way to avoid the singularity of (6.1) at the origin, using the complex conjugate of z. This time, there is a different price to pay, but the explanation will come much later. Verify that

$$\bar{z}^n = (re^{-it})^n = r^n e^{-int}.$$

This suggests the extension

$$f_c(z) = \sum_{n \geq 0}^{\infty} a_n z^n + \sum_{n < 0}^{\infty} a_n \bar{z}^n, \qquad (6.3)$$

where the c stands for *continuous*—again, a word choice to be defended soon.

For either extension, you are invited to check as an exercise that a curve with m-fold symmetry of type k—one of the ones whose Fourier coefficients a_n are zero unless $n \equiv k \pmod{m}$—extends to a function f that satisfies

$$f(\omega_m z) = \omega_m^k f(z), \text{ where } \omega_m = e^{2\pi i/m}. \qquad (6.4)$$

Rotating by an angle $2\pi/m$ in the domain changes the output value of the function by a multiple of ω_m^k. What on earth will such functions look like? Before we can answer this, we need to address the whole question of how to picture functions from \mathbb{C} to \mathbb{C}.

Visualizing Complex-Valued Functions in the Plane

Before I started thinking about wallpaper, I believed two things about how we can picture a function $f : \mathbb{C} \to \mathbb{C}$:

- Since it takes 2 dimensions to show the graph of a real-valued function of one variable (like $y = x^2$), it takes 4 dimensions to show the graph of f.
- We should, therefore, unless we can learn to see in 4 dimensions, think of f as a mapping of the plane to the plane and be content to show

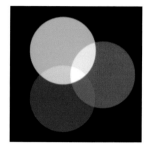

Figure 6.1. Three interpretations of the color wheel.

before-and-after diagrams. For instance, we can show what becomes of a disk or a square after applying the mapping f.

A course in complex variables usually spends a great deal of time developing the second of these ideas, which is indeed powerful. The *domain-coloring algorithm* [4] offers a third possibility. It requires two steps:

1. Assign a unique color to each point of the complex plane. (Of course, we can only approximate this in practice, but it makes sense as an ideal concept.)
2. To depict f on a domain Ω—a set of points in the complex plane where f is defined—color each point $z \in \Omega$ with the color corresponding to the complex number $f(z)$.

For the first step, I favor the artist's color wheel, where hues cycle as we look around the unit circle and where colors fade to white toward the center and darken to black as we move out. These directions can be interpreted in many ways. I show three possibilities in Figure 6.1—each useful in a different way. In any case, when we see white in a domain coloring, we know that the function being depicted is zero, or near zero, at that point in its domain; when we see black, we know that the value of the function is large in absolute value.

You may wonder about the sharp edges in the various wheels. I have tried using wheel concepts where colors blend seamlessly into one another; this seemed like a wonderful idea, but produces fuzzy images that made it impossible to recognize any features of the function I was hoping to illustrate. I have written elsewhere about strategies for various color wheels. For instance, you can read the story of the third wheel in Figure 6.1, which appears to show three colored lights shining on the complex plane, in an article in *MAA Focus* [8].

This may be a good time to ponder the reality that we all perceive color differently. Some people will enjoy viewing the images I offer even in low light; others may benefit from viewing these pages under bright, full-spectrum light. For some, even the *words* for colors can be slightly annoying, and I believe that the mathematical community includes more than its share of people who do not enjoy color. I have taught this material to students with limited color vision, and it seemed to work when they designed their own color wheels made from tones that they could easily distinguish. If the colors I use do not help you to see the shapes of the patterns, perhaps other choices will. Currently, I have no such advice for the reader who does not see patterns at all; surely there is a way for

Figure 6.2. Domain colorings of two extensions of the mystery curve: f_h on the left, f_c on the right.

us to feel color bitmapped graphics with our fingers, but for me it remains a hypothetical possibility.

Returning to domain coloring, let us depict our extensions f_h and f_c. To do this, we need technology that can create an image by calculating the color for each pixel, according to the domain-coloring algorithm. Some details about the C++ code that I use to make images appear in Chapter 26. For now, let us assume that it is possible to create domain colorings for whatever complex function and color wheel choice we have in mind.

What will we see in the images? Since the symmetry of each extension, from (6.4), involves rotating in both domain and range by 72°—that angle so crucial to the symmetry of the mystery curve—our color wheel must help us to notice the rotation visually. The first wheel in Figure 6.1, with its 60° angles, is poorly adapted to this purpose—we will save that one to help us visualize symmetries involving 3- or 6-fold rotations. The middle wheel seems perfect, so we use it with the domain-coloring algorithm to produce Figure 6.2.

Examine each figure to verify that, yes, when we pick a point and remember the color, the color of the 72° rotation of that point about 0 is indeed one-fifth of the way around the color wheel. As we skip around either diagram, advancing the angle by 72° each time, we see red become yellow become green become blue become purple and then red again.

On the left, we count 20 points where the function is zero—called *zeros* of the function. Those who have studied complex variables might recognize this number through an application of the *argument principle* to (6.2): $20 = 6 - (-14)$. On the right, there seem to be 16 zeros, a number for which I have no explanation. Each image correctly suggests that the value of the function approaches infinity as z grows without bound in any direction. The domain coloring tells us a great deal.

The symmetry of this diagram does not fit traditional definitions. I coined the phrase *color-turning symmetry* to capture this situation, where rotation in the domain of a function corresponds to rotation of the color wheel. I cannot say that either image in Figure 6.2 is especially beautiful or interesting. To create better images we need two things: better functions and better color wheels—topics for the next chapter.

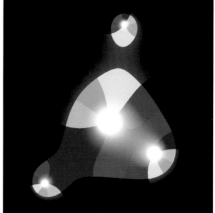

Figure 6.3. Domain colorings of the squaring function (left) and a quartic polynomial (right).

A Crash Course in Complex Variables

Complex analysis might start by extending one's study of calculus to find out what happens when the x in familiar functions is replaced by the complex variable z. Beautiful surprises ensue, both in the elementary investigations and through the highest levels of this rich field. Without any aspiration to replace a course in complex analysis, we pause to show how domain coloring can illustrate some of its principles.

Even the pedestrian function $f(x) = x^2$ leads to something worthwhile. Simple definitions lead to

$$f(z) = z^2 = x^2 - y^2 + i2xy = (re^{it})^2 = r^2 e^{i2t}.$$

The formula in (x, y)-coordinates has algebraic interest; the one using r and t is more useful geometrically: It tells us that we can square a number by squaring its radius and doubling its angle. These features appear in the domain coloring (Figure 6.3 (left)). Check such number facts as $(-1)^2 = 1$ and $i^2 = -1$ by seeing that the point $z = -1$ is colored red, the color of $z^2 = 1$, and so on. I used the left-hand color wheel from Figure 6.1, so that the number whose color is pure green squares to a number colored pure blue.

Figure 6.3 (right) shows the somewhat randomly chosen polynomial

$$f(z) = z - \frac{1+i}{2\sqrt{2}}z^2 - \frac{i}{5}z^4.$$

Find the four distinct zeros in the diagram. About each one, it is possible to observe what Needham [14] calls an "amplitwist." If we look in a small-enough neighborhood of a zero of f, it is as if the function amplifies (or shrinks) the color wheel and turns it somewhat. The wheel is not crumpled or turned back on itself; the colors always progress in the same rotation. Notice also that shapes, though distorted, are preserved in a certain technical sense: Curves that meet at right angles in the color wheel do seem to meet at right angles in the domain

coloring. A function that preserves *angles* is called a *conformal* function. To check the conformal property directly, we would have to show that any two curves that meet at right angles on the color wheel will necessarily meet at right angles in the domain coloring. Fortunately, we will see that there is an easy way to detect whether a polynomial function is conformal or not.

Polynomials like $f(z)$, those with expressions in terms of the complex variable z but *not \bar{z}*, are iconic examples of *analytic* functions of z, also called *holomorphic* functions. For introductory examples, one can stick with polynomials and take derivatives by familiar rules. For now, let it be enough to say that holomorphic functions are those that we write with zs but no \bar{z}s.

Holomorphic functions are known to be conformal, except when the derivative vanishes, as it does for z^2 at the origin: Look at the vertical line colored with shades of cyan and compare it with the horizontal line colored with reds; these meet at right angles in the domain coloring, but they are the same line in the color wheel. So this function is not conformal at that one point. It crinkles the color wheel at the single point 0, the point where the derivative, $(z^2)' = 2z$, is 0.

Our first extension of the mystery curve was called f_h, because the extension is holomorphic, except at the origin. (So we say holomorphic on \mathbb{C}^*.) Look for the conformal property in its domain coloring. A series like (6.1), which includes negative powers of z, is called a *Laurent series*. If all the coefficients for negative exponents were zero, it would be simply a *power series* in z, which, though it may have infinitely many terms, one can often treat like a long polynomial.

The second extension was called f_c because it is a continuous extension—we avoided causing the catastrophe of dividing by 0 at the origin. When powers of \bar{z} are included in a polynomial expression, the conformal property treasured by complex analysts is spoiled: In the domain coloring for f_c, the shape of the color wheel is distorted around the zeros. There is not all that much we can say about functions like these, except that they share the same symmetry as the curve from which they are built.

A Step in the Direction of Art—The World as My Color Wheel

Once we have a program set up to produce domain colorings, there is no particular reason to restrict ourselves to artists' color wheels in the first step of the domain-coloring algorithm. For the quartic polynomial shown in Figure 6.3, I chose a photograph of a moon jelly to play the role of a color wheel. Of course, it is no longer even remotely true that different complex numbers are colored differently. Still, using the jellyfish to color the quartic still allows us to see where the zeros are in Figure 6.4. We can also observe the conformal property and find interesting points where it breaks down: The derivative of the quartic must be zero at that point in the upper quarter of the picture where the tentacles form an X. It makes sense that the derivative of a quartic polynomial has three zeros, of which this is the most obvious in the diagram. One of the others is where two jellyfish heads are mashed together; the other is lost in the blue between distant jellyfish copies.

In the next chapter, we develop the function spaces we need to make the most of this new artistic possibility.

Figure 6.4. The jellyfish is used to color a quartic polynomial.

Chapter 7

Rosettes as Plane Functions

Question: How do you use complex functions to create rosettes, and how are rosette symmetries classified? At last we turn our attention to objects that fit traditional definitions of symmetry, meaning patterns that remain the same when something is done to them. For our purposes, patterns are functions, so our definition of symmetry will involve functions that remain the same when some operation is performed in the domain.

This chapter offers key definitions as well as first examples of the methodology that drives the rest of the book. We define plane symmetry, study a particular class of patterns, the rosettes, and construct spaces of functions that, with the domain-coloring algorithm, allow us rich opportunities for creating symmetry.

Symmetry Defined and Created

We first clarify the language of *transformations* of the plane, which, in their most general form, are simply functions from \mathbb{C} to \mathbb{C} that are one-to-one and onto, meaning that we can always invert a transformation. The main example we have seen so far is

$$\rho_p(z) = \omega_p z, \text{ where, as usual, } \omega_p = e^{2\pi i / p}.$$

This is the rotation of the plane about the origin through $360/p$ degrees. We follow a tradition that uses Greek letters for transformations, with some attempt at mnemonic alliteration: ρ for rotation and τ for translation. Translations are simple sliding maps of the form $\tau(z) = z + a$, for any complex number a.

Rotations and translations are examples of *isometries*, transformations of the plane that preserves all lengths. With this vocabulary, we at last are ready to define the word *symmetry*, at least in the context we are studying.

Definition 2. We call a transformation of the complex plane, $\alpha(z)$, a *symmetry* of the function $f(z)$ if and only if

$$f(\alpha(z)) = f(z), \text{ for all } z \in \mathbb{C}. \tag{7.1}$$

Sometime treatments require symmetries to be isometries, but we do not always require that here.

Let us define a *rosette function with p-fold symmetry* as any function $f : \mathbb{C} \to \mathbb{C}$ that is invariant under the rotation ρ_p. In other words, f obeys

$$f\left(\rho_p(z)\right) = f(z), \text{ for all } z \in \mathbb{C}.$$

This equation implies that f is also invariant under rotations through $2 \cdot 2\pi/p$, $3 \cdot 2\pi/p$, and so on. This might remind you of the discussion on groups in Chapter 4. (An aside for the purist: Some of our functions will be undefined at $z = 0$, so the preciding definitions might require only $z \in \mathbb{C}^*$.)

How shall we find such functions? The functions that arose from curves were constructed so as to kick out a power of ω_p in the range when z is multiplied by ω_p in the domain. These were depicted as *color-turning* functions in the plane. For symmetry, we want functions that do not change at all as we turn. Still, the symmetry condition for curves gives us some insight, telling us that congruence classes of powers modulo p will be key.

The complex extensions from the last chapter involve series, possibly infinite, including either positive and negative powers of z or positive powers of z and \bar{z}. For maximum flexibility we allow both. Let us define a large (slightly ambiguous) space of functions in which to seek symmetry:

$$\mathcal{F} = \left\{ \sum a_{nm} z^n \bar{z}^m \mid a_{nm} \in \mathbb{C}, n, m \in \mathbb{Z} \right\}.$$

The ambiguity comes from failing to specify whether the sums are finite or not. There are situations—recall the Fourier series for the pentagram—where we really would like to add up infinitely many terms. There are several different senses in which we could say that an infinite sum of functions converges: at every point, at every point except finitely many, at every point at the same rate, in the mean (using an integral to measure convergence), and so on. Let us avoid difficulties and assume that the sums are finite until infinite ones are required.

A sum will have symmetry if each individual term behaves correctly under multiplication by ω_p. This is thanks to the *linearity* of the symmetry condition: if two functions, f_1 and f_2, satisfy (7.1), then surely a sum of any multiples of the two satisfies the same equation:

$$(af_1 + bf_2)(\alpha(z)) = af_1(\alpha(z)) + bf_2(\alpha(z))$$
$$= af_1(z) + bf_2(z), \text{ for all } z \in \mathbb{C}.$$

This simple observation is behind much of the power of the method.

So, let us check what happens for one of our function building blocks $z^n \bar{z}^m$, a single term of the sum, when we replace z by $\omega_p z$. We remember that $\overline{\omega_p}$ is the multiplicative inverse of ω_p, and find that

$$(\omega_p z)^n (\overline{\omega_p z})^m = \omega_p^n \omega_p^{-m} z^n \bar{z}^m = \omega_p^{n-m} z^n \bar{z}^m.$$

The only way to make this term invariant under the substitution is to have $n - m$ be a multiple of p, whether positive or negative. Therefore, we have a *sufficient* condition for a sum to be symmetric.

Theorem 4. *If, in the sum*

$$f(z) = \sum a_{nm} z^n \bar{z}^m, \text{ we have } a_{nm} = 0 \text{ unless } n \equiv m \pmod{p},$$

then f is invariant under rotation through an angle of $2\pi/p$. In other words, f is a rosette function with p-fold symmetry.

To select a rosette function that is holomorphic on the whole plane, we restrict our choice of nonzero coefficients to those with the form a_{n0}, for $n \geq 0$. Allowing negative values of n but no powers of \bar{z} makes the function holomorphic on \mathbb{C}^* and hence conformal. If all the nonzero terms correspond to positive powers of n and m, the resulting function will be continuous.

To create a rosette with 5-fold symmetry, we could choose a function of the form

$$f(z) = a_{5,0} z^5 + a_{6,1} z^6 \bar{z}^1 + a_{3,-2} z^3 \bar{z}^{-2} + a_{7,2} z^7 \bar{z}^2, \tag{7.2}$$

where the coefficients may be any complex numbers at all.

For a rosette function with 6-fold symmetry that is conformal, we may pick any coefficients in the sum

$$f(z) = a_{0,0} + a_{6,0} z^6 + a_{12,0} z^{12} + a_{-6,0} z^{-6} + a_{-12,0} z^{-12}. \tag{7.3}$$

We illustrate these functions, but only after an algebraic interlude.

Rosette Groups and Function Spaces

Let us build on the idea that functions invariant under a rotation through $2\pi/5$, say, are also invariant under rotation through $2 \cdot 2\pi/5$. In equations, recalling that ρ_5 is our symbol for the rotation, this just amounts to

$$f\left(\rho_5^2(z)\right) = f\left(\rho_5(\rho_5(z))\right) = f(\rho_5(z)) = f(z).$$

The first step correctly interprets the ρ^2 as function composition—applying the function twice in succession—while the next two just invoke the definition of symmetry, first using $\rho_5(z)$ and then z as the argument.

The same computation proves the following proposition, which is surprisingly useful, considering how vacuous the proof is:

> The composition of any two symmetries is again a symmetry.

This is almost all there is to proving a powerful theorem.

Theorem 5. *If $f(z)$ is a function $\mathbb{C} \to \mathbb{C}$, then the symmetries of f form a group under the operation of composition of transformations.*

Recall that a group is a set that (1) is closed under an associative operation, (2) contains the inverse of every element, and (3) contains an identity element. Closure is verified simply by the artless computation mentioned before: if you do one thing to the function and then another—well, it wasn't changed the first time and so it is unchanged by the composition of the two. Associativity of function

composition is taken as a given; I can't think of anything interesting to say about it: $f(g(h(z)))$ turns out the same whether you imagine it as $f(g \circ h(z))$ or $f \circ g(h(z))$. For inverses, just observe that

$$f(z) = f\left(\alpha(\alpha^{-1}(z))\right) = f\left(\alpha^{-1}(z)\right),$$

so α^{-1} is an symmetry whenever τ is. Finally, $\iota(z) = z$, the identity function, is always a symmetry of every function; if you do nothing, the function is unchanged.

What groups might appear as symmetries of rosette functions? If the rotation ρ_p is a symmetry of f, then, as we have observed, so are ρ_p^2 and all powers of this rotation. Since the pth power is just the identity, we have a finite set of symmetries, exactly p of them. Readers of Chapter 4 will recognize this as being essentially the same as the cyclic group we studied there, but let us avoid tripping over that "essentially the same" and take a moment to be precise.

The cyclic group of order p is the abstract set

$$\mathbf{C}_p = \{a, a^2, a^3, \ldots, a^p = e\},$$

where e serves as identity and multiplication is given by addition of powers. We could also say that \mathbf{C}_p is generated by a single element a and the relation $a^p = e$. There are many situations where this abstract group arises naturally—we have already seen three. It can be confusing to refer to different appearances of the same concept by the name \mathbf{C}_p. For instance, I may be talking about p-fold rotation about the origin, while you wish to have rotations that fix the point 1. Our groups would be isomorphic but probably should not have the same name. Even so, people do it all the time.

If we wish to avoid confusion, we can say that we have a *representation* of \mathbf{C}_p. A representation of a group is a homomorphism from the group to a set of transformations of a space. For our functions with p-fold symmetry, the representation could be specified by $\phi(a) = \rho_p$. We could say that the group of symmetries of our function is an isomorphic copy of \mathbf{C}_p under this representation. Or, we could just bend the rules and call the group \mathbf{C}_p. Why not? For the rest of this book, we will be blurring the lines between the concept of an abstract group and an isomorphic copy of that group represented as transformations of a space. No one will be harmed.

It is not especially useful to talk about the symmetries of an individual function, since it can be tricky to be sure that we have identified *all* the symmetries of a function. (Remember the "accidental" symmetries of some of the curves we created?) Instead, we decide upon a symmetry group, say \mathbf{C}_p (represented as being generated by ρ_p), and try to construct a family of functions that are all invariant under all the transformations in that group.

In light of the theorem about rosette functions, we can easily identify a space of functions invariant under \mathbf{C}_p. Define

$$\mathcal{F}_p = \left\{ f(z) = \sum a_{nm} z^n \bar{z}^m \mid a_{nm} = 0 \text{ unless } n - m \equiv 0 \pmod{p} \right\}$$

and know that any function you choose from \mathcal{F}_p will be a rosette function with p-fold symmetry, that is, invariant under \mathbf{C}_p. It takes a bit of linear algebra (the

functions $z^n \bar{z}^m$ are linearly independent) to prove that the *only* functions in \mathcal{F} with p-fold symmetry are those in \mathcal{F}_p. We leave this for the enthusiastic reader.

Mirror Symmetry

Earlier, I deemed reflection symmetry in curves to be not so interesting. We find more interest here and encounter a family of groups worth knowing, the dihedral groups. Let us restrict attention to the simplest reflection, complex conjugation, to which we give a Greek-letter name, to emphasize its status as a transformation:

$$\sigma(z) = \bar{z}.$$

To create functions invariant under this reflection, we recall a routine from calculus (perhaps familiar from Exercise 9 in Chapter 4) for breaking a function of one variable into *even* and *odd* parts. An even function of $x \in \mathbb{R}$ satisfies $f(-x) = f(x)$ for all x, while an odd function has $f(-x) = -f(x)$. Graphs of even functions have mirror symmetry about the y-axis, while graphs of odd functions have point symmetry about the origin. If we have any function at all, we can define two new functions

$$f_e(x) = \frac{f(x) + f(-x)}{2} \text{ and } f_o(x) = \frac{f(x) - f(-x)}{2}.$$

Check that f_e is even, f_o is odd, and the two functions sum to $f(x)$. In fancy language, we could say that we start with a representation of the cyclic group of order two (generated by multiplication by -1 on \mathbb{R}). With that representation, the technique of *group averaging* gives us *projection operators* onto one space of functions invariant under the action (even functions) and another space of functions reversing under the action (odd functions). No need for such fancy language here unless you enjoy it.

We imitate this construction to find functions invariant under the reflection σ. If

$$f(z) = \sum a_{nm} z^n \bar{z}^m, \text{ then } f(\sigma(z)) = \sum a_{nm} \bar{z}^n z^m = \sum a_{mn} z^n \bar{z}^m,$$

by reindexing. The average $\left(f(z) + f(\sigma(z)) \right)/2$ will surely be σ-invariant, and the coefficient of the nm term in that sum is $(a_{nm} + a_{mn})/2$, which will agree with the coefficient of the mn term. In practice, all we have to do to create mirror symmetry in our sums is to require that

$$a_{nm} = a_{mn}.$$

This is what I call a *symmetry recipe*, an instruction for how to limit the coefficients in a superposition of symmetry building blocks that will force a desired symmetry. We test the recipe by trying to create a rosette with both 5-fold and mirror symmetry; if a and b are complex numbers to be chosen for artistic effect, we could find the desired symmetry in

$$f(z) = z^5 \bar{z}^0 + z^0 \bar{z}^5 + a(z^6 \bar{z}^1 + z^1 \bar{z}^6) + b(z^4 \bar{z}^{-6} + z^{-6} \bar{z}^4).$$

Figure 7.1. A rosette function with both mirror and 5-fold symmetry, along with the rhododendron that supplied its colors.

The result is shown in Figure 7.1, where the color wheel is an image of a rhododendron blossom. We have created the desired mirror symmetry very nicely and also found a diagram to illustrate all the other symmetries that arise when we create this one. Notice all the new mirror axes in addition to the horizontal one we introduced by forcing $a_{nm} = a_{mn}$ in the sum!

The group of symmetries of the function Figure 7.1 includes ρ_5, σ, and all the symmetries that devolve from these by composition. If you count carefully, you can see that there are 10 symmetries in all. (At first you may see 10 mirror reflections, but the reflection line with angle $\pi/5$ is the same as the one with angle at $3 \cdot 2\pi/5$, and so on. We concretize this in a coming exercise.)

To study the algebra of this group, we consider some of the necessary compositions it must contain. Can you visualize what happens when you first rotate the plane counterclockwise through $72°$ and then flip about the x-axis? Computation will confirm (as in the coming exercise) that this is the same transformation as first flipping about the x-axis and then rotating *clockwise* through $72°$. In symbols, this is

$$\sigma_x \circ \rho_5 = \rho_5^{-1} \circ \sigma_x,$$

a relation that, along with the orders of these two elements, is enough to characterize all the compositions of elements in this group, which we now consider in the abstract.

The *dihedral group* on p elements is the abstract group, called \mathbf{D}_p, generated by two elements a and b, which are bound by the relations $a^p = e$, $b^2 = e$, and $ba = a^{-1}b$. In shorthand notation, we write

$$\mathbf{D}_p = \langle a, b \mid a^p = e, b^2 = e, ba = a^{-1}b \rangle.$$

Such a group can be shown to contain $2p$ elements. The symmetry group of Figure 7.1 is, of course, \mathbf{D}_5. (Again, for greater precision, we would say that this is an isomorphic representation of \mathbf{D}_5.)

As we continue our study of symmetry, we will want to lump together all patterns that have, in some sense, the same group of symmetries. There is some subtlety to this idea, but we postpone the discussion until the next chapter. For now, we use the name of the symmetry group to name the *pattern type* of an image. Now that you know the cyclic and dihedral groups, you will no doubt see patterns of types \mathbf{C}_n and \mathbf{D}_n everywhere.

OTHER ROSETTE DEFINITIONS. Other authors define a rosette as a pattern with symmetry group \mathbf{C}_p or \mathbf{D}_p, sometimes being cagey about the exact definition of a pattern. The narrowest definition I know holds that a pattern is a set of points in the plane—a set of black dots that draw a monochrome image. To some extent, the entirety of my work in symmetry constitutes a reaction to that definition. It is also possible to define a rosette as being constructed by decorating a sector of the plane and then stamping out that decoration by transformations in the desired symmetry group. I hope that the beauty of the rosettes in this chapter convinces you that my definition—rosette as function—is at least worth trying out.

A Pause for Art

When we were selecting curves, hoping to find one more beautiful than others, we did literally have infinitely many choices. And yet the pictures had a certain sameness, because we were always depicting curves as drawn in black with a given line width. One can vary those display choices, of course, but even so the potential for something of timeless value is limited. Our rosette functions offer us a similar infinitude of choice of parameters, but using photographs as color wheels provides a delightful expansion of our palette.

When I begin to create a rosette (using C++ code described in Chapter 26) I have a particular symmetry in mind. My goals for an image are that it depict the symmetry clearly and that it be beautiful, though I still consider myself a beginner in appreciating the scope of that word. I choose images to please my own eye and hope that others enjoy the work.

Suppose we were creating a piece together. With a symmetry type in mind, we have an infinite-dimensional space of functions to search, so we should get started. As with curve selection, where including large amounts of high-frequency terms makes a curve too jangly, let's avoid powers of z that are too high. Suppose we settle on simple 5-fold symmetry, so we set our software to include the 4 terms in the expression (7.2). This will give us the desired symmetry, and we accept that the presence of the \bar{z}-terms will break the conformal property.

The next step is to choose a color wheel. On the day I made the rosette in Figure 7.2, I had carried my lunch up a stream in the Sierra Nevada and

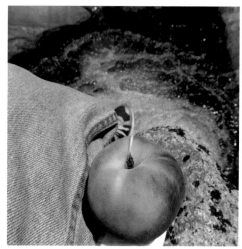

Figure 7.2. A 5-fold rosette with colors from a peach by a stream.

photographed the peach I had for dessert, using the granite, the stream, and my denim-clad leg as background. Suppose, in our joint process of creation, we assign this photograph as the color wheel, select some coefficients, and ask for the domain coloring. Usually, this leads to a boring or confusing image, so we begin varying the parameters, and varying them again. Will we work for hours to get something amazing, or run out of patience? To some extent, it is a random activity. All the images in this book were chosen as the best possible in the time allowed. Perhaps you will make better ones.

What tells me that the image I chose is a finished one? Let me answer by telling some of the things I like about this rosette: You can see the peach and yet its orange doesn't take over the whole image; I like the way the stream frames the outside of the rosette and the blue swirling patterns that evoke water, even though they're made from my shoe, which was just a tiny swatch of the original photograph—an occurrence I find funny. Notice the pixellation in the swirling region; this is caused by the function changing extremely slowly in that area—you have to move quite a lot in the domain before the value of the function moves to locate the pixel next door. Of course, if you had been there, you might have chosen differently.

For the example shown in Figure 7.3, I chose a function of the form shown in (7.3), heading for 6-fold symmetry. This is a formula without any \bar{z}s, creating

Figure 7.3. A conformal rosette with 6-fold symmetry, depicted by a Mariposa lily, one of my favorite Sierra flowers.

*** EXERCISE 15**

What is the symmetry group of the rosette in Figure 7.3? To find out, study the inversion $v(z)$ enough to realize that it actually has two fixed points, not just one. This means that the 12 centers of inversive rotation arise from only 6 symmetries. Compute the composition $v \circ \rho_6$. The result will tell you that this group is just a different representation of one we have seen before.

a conformal function. I thought this would preserve something of the beautiful shape of the Mariposa lily I had chosen for the color wheel.

I had another agenda in this image. I made some of the coefficients in (7.3) equal in pairs:

$$a_{6,0} = a_{-6,0} \text{ and } a_{12,0} = a_{-12,0}.$$

This makes the function invariant under the reciprocal transformation, $v(z) = 1/z$, which appears to be a sort of rotation about the fixed point 1, although it takes some imagination to see it that way: this map exchanges the inside and outside of the unit circle, one for the other, while leaving 1 fixed. If you have studied geometric circle inversion, you might see this transformation as geometric circle inversion followed by reflection in the x-axis. In any case, writing the formula $1/z$ in more familiar coordinates could be a starting point to study this further. As we proceed, I will call $1/z$ *reciprocal inversion* to distinguish it from geometric inversion.

The desire to talk about this type of symmetry motivated the decision not to restrict our symmetries, at this point, to be isometries. There are actually 12 different centers of this inversive rotation in the image. By our theorem, the set of symmetries form a group, so it is natural to ask which group this is. An answer will come in Chapter 23 or perhaps in Exercise 15.

One thing that made me choose this image was the way it makes the center of the lily, a small but fascinating part of the photograph, into the star of the show. As in the actual photograph, the white space around the floral center provides relief for the eye in the rosette and sets off the excitement of the flower's inner parts.

ON TO FRIEZES. There is much more to say about additional symmetries in rosette functions. Surprisingly, the discussion leads us to the next principal category of plane symmetry, the *friezes*. You may wish to experiment for yourself before moving on, with Exercise 15 as a starting point.

ANSWER FOR EXERCISE 15

The symmetry group is an unusual representation of D_6, generated by the rotation and a single inversion.

Chapter 8
Frieze Functions (from Rosettes!)

Question: How do you make functions invariant under a given frieze group, and how many of these groups are there? Every symmetry of a rosette pattern necessarily fixes the origin of our plane—rather a stern limitation on a pattern. Friezes—patterns invariant under translations in a single direction—provide a next natural category of symmetry groups, where the origin is allowed to echo through a pattern in a limited way.

Named for an architectural feature—a band of decor below a roofline—friezes are seen in many other places than building exteriors. Look for them in wallpaper bands along the tops and bottoms of rooms, around the edges of carpets, and anywhere a small band of decoration has been added. Unlike those you see in the world, our mathematical friezes repeat indefinitely—an idealization.

If a symmetry group contains any translations at all, then the set of all its translations necessarily forms a group, which we call the *translational subgroup*. A *frieze group* is any group of isometries of the plane whose translational subgroup is generated by a single translation. Without loss of generality, we limit our discussion to frieze groups whose translations are horizontal. And we may as well standardize as the length of the shortest horizontal translation as 2π. (As with rosettes, where we decided to place the origin of our coordinate system at the center of the pattern, our specifications declare an intention to represent a class of groups in a conventional way.) These choices simplify our next task: creating frieze symmetry.

For us, a *frieze function* is a complex-valued function f on \mathbb{C} that satisfies

$$f(z + 2\pi) = f(z), \text{ for all } z \in \mathbb{C}.$$

Note: My definition of frieze function asks that f be defined on the whole plane. If you prefer, you may work only with functions defined on a strip $|\operatorname{Im}(z)| < h$, for some height h. This might fit better with our mental image of friezes as bands of decor; more on this later.

If my choice of 2π as the length of the translation unit surprises you, rest assured that you can make a different choice, but only at the expense of having that pesky factor turn up elsewhere. The first interesting question about friezes is: What are the various possible frieze groups?

In this chapter, we develop the answer, based on assumptions that will be cleaned up much later (in Chapter 23), and go on to construct frieze functions. These functions arise from a surprisingly easy connection to rosettes: Our rosette constructions can be modified to give us friezes, as if we are unwinding a pattern that cycles around the origin and laying it out flat on the plane.

The Seven Frieze Groups

By our definition, a frieze group G contains all the translations $\tau_n(z) = z + 2\pi n$, for $n \in \mathbb{Z}$, and no other translations. These translations fix the x-axis, as well as all lines parallel to it. For now, let us restrict attention further to groups in which all the transformations map the x-axis to itself. (For instance, we will not allow a mirror reflection across the line $y = 1$, even though this is consistent with the translations; the only horizontal mirror we permit under our restriction is across the line $y = 0$.) In this chapter, we make various restrictive assumptions like this one, which we will justify when we return to friezes in Chapter 23, after developing more tools of algebra.

The easiest group to study is the one with no other symmetries than the translations required to make a frieze group. Postponing a discussion of notation for just a bit, we call this group p111:

$$p111 = \langle \tau_1 \rangle.$$

To create a frieze with this symmetry, we could use an infinite string of asymmetrical letters:

$$\ldots L\,L\,L\,L\,L\,\ldots.$$

The row can be slid up or down without changing the symmetry, so there is no particular way to specify where it sits with respect to the invariant line. If you see a pattern that repeats (potentially infinitely) along one directional axis, with no additional symmetries, its symmetry group is p111.

POSSIBLE FRIEZE TRANSFORMATIONS. What other symmetries might we include in a frieze group? If there were rotations other than half turns, they would work with the translation to generate a translation in a nonhorizontal direction (as we see in an exercise), so our highest-order rotations in frieze groups are half turns.

As for reflections, our conventions allow us to consider only mirrors about the x- and y-axes, which we call σ_x and σ_y, and whatever compositions arise from these in various ways. Finally, we will need to consider *glide reflections*, which are compositions of reflection with translation. The only one relevant for frieze groups, with our conventional horizontal orientation, is $\gamma_x(z) = \bar{z} + \pi$, which flips the plane across the x-axis and slides it half a frieze unit to the left.

Our count of frieze groups is simple: For each of these possibilities, we expand p111 by introducing the given symmetry and no others. Then we consider whether we can include two or more. It is a short list.

NAMING THE GROUPS. There are many possible notations for symmetry groups. We adopt that of the International Union of Crystallographers, which uses mnemonic letters to give clues about what symmetries we can expect to see in patterns. The notation begins with a p, which carries no particular information, except to indicate a primitive cell, which here refers to a chunk of the pattern one unit (of length 2π) wide. The p is followed by symbols of the form rvh—mnemonics for **r**otational behavior, **v**ertical behavior, and **h**orizontal behavior. If the symmetry is not present, we write a 1, and this is why our first group was called p111: none of the additional rotational or mirror symmetries are present.

As a first example, suppose that we wish to introduce ρ_2 (and as little else as possible) as an additional symmetry of a frieze pattern. We name the symmetry group

$$\text{p211} = \langle \tau_1, \rho_2 \rangle,$$

recalling that the angled brackets indicate the smallest group containing the given transformations, in other words, the group generated by them. This symmetry type could be realized by a row of letters

$$\dots S\,S\,S\,S\,S\,\dots\,.$$

Of course ρ_2 is not the only rotational symmetry; others are picked up through group composition. Your eye might be first drawn to the center of 2-fold rotational symmetry, called a 2-center, in the middle of each S. Pick one of these to serve as 0, and then notice the additional 2-centers *in between* adjacent letters. I say that these 2-centers are not *translationally related* to the ones I first mentioned. Later we will have occasion to use the mouthful *nontranslationally related* 2-centers to draw attention to this phenomenon.

We learn in Exercise 16 that including any 2-centers at all in a pattern produces additional 2-centers at the points $n\pi$ for $n \in \mathbb{Z}$. The ones with n odd are not translationally related to the ones with n even.

Similarly, introducing one reflection at a time leads to

$$\text{p1m1} = \langle \tau_1, \sigma_y \rangle \text{ and } \text{p11m} = \langle \tau_1, \sigma_x \rangle,$$

realized by

$$\dots T\,T\,T\,T\,T\,\dots\,\text{ and }\,\dots D\,D\,D\,D\,D\,\dots\,.$$

In the p1m1 pattern, notice the reflection symmetry of each T. Then find the necessary mirror axes between each pair of Ts, the nontranslationally related ones.

You may have less experience with glides than with reflections and half turns. They are tough to realize with letters, especially since fonts are so rarely perfectly symmetric. I can come close with

$$\dots L\Gamma\,L\Gamma\,L\Gamma\,L\Gamma\,L\Gamma\,\dots\,.$$

The pattern does *not* have mirror symmetry. Instead, to move the right-side-up Ls to the upside-down ones, we must flip the row and slide it half a unit to the right: a flip-and-slide motion. When we include this glide in a frieze group and no additional symmetries, we arrive at

$$\text{p11g} = \langle \tau_1, \gamma_x \rangle.$$

Since $\gamma_x^2 = \tau_1$, we could also say that p11g $= \langle \gamma_x \rangle$, with this last declaration providing a *minimal* set of generators for the group.

This completes the list of groups we can get by introducing a single additional symmetry to the required translations. We proceed to consider pairs of transformations.

Since $\rho_2 = \sigma_x \sigma_y$, if we introduce any two of these, we get the third for free, by group composition. There is only one group here:

$$\text{p2mm} = \langle \tau_1, \rho_2, \sigma_x \rangle = \langle \tau_1, \rho_2, \sigma_y \rangle = \langle \tau_1, \sigma_x, \sigma_y \rangle.$$

(These three different presentations might be useful for studying color-reversing frieze patterns later.) Many letters work to illustrate a pattern invariant under this group. Here is one:

$$\ldots \text{H H H H H H H} \ldots.$$

The last composition to analyze, $\gamma_x \rho_2$, produces a vertical mirror with axis $\text{Re}(z) = \pi/2$—a strange fact that you may wish to check. This is my favorite frieze group

$$\text{p2mg} = \langle \tau_1, \rho_2, \gamma_x \rangle,$$

realized, not quite perfectly, by

$$\ldots \text{V} \Lambda \text{V} \Lambda \text{V} \Lambda \text{V} \Lambda \text{V} \Lambda \ldots.$$

That's 7 groups. To prove that we have covered all possibilities (modulo the assumptions we made), just check that composing γ_x with either σ_x or σ_y leads to a translation shorter than G was assumed to have. We are done.

Figure 8.1 shows one example of each pattern type. In the next section, I'll explain how these functions were constructed. As usual, the function is depicted using the domain-coloring algorithm and artistic choice guides the process of selecting parameters within a large space of possible functions.

A TECHNICAL ASIDE ABOUT PATTERN TYPE. The group p11g is a good example for showing the subtlety of the concept of pattern type, mentioned near the end of the previous chapter. We want to say that patterns are equivalent if they have the "same" group of symmetries, and in group theory the same usually means *isomorphic*, as described in Chapter 4. However, each of p11g and p111 is an infinite cyclic group and the map that sends γ_x to τ_1 is indeed an isomorphism from the first to the second. Even so, the patterns are visually quite different, so there must be some mathematical way to distinguish them.

For another example of this subtle problem, consider the difference between a string of letters spaced one unit apart and the same string spaced at two units. Obviously, … OOOOO … is just … O O O O O … spaced differently; each should have pattern type p2mm. In this easy case, we just say that in the second example, the abstract group p2mm is represented on a scale that is twice as large in the horizontal direction. In other words, there is a nice, scale-changing deformation of the plane that carries the one representation to the other: translation by one unit is converted into translation by two units. Same type.

The p11g example requires more difficult language, which we revisit in Chapter 23. Intuitively, we say that there is no nice deformation of the plane that

ANSWER FOR EXERCISE 16

For the first part, compute, for instance, that $\tau(\rho_2(z)) = -z + 2\pi$. Analyze this last transformation to find that it has $z = \pi$ as its unique fixed point. Repeating the computation for $\tau^n(z) = z + n2\pi$ produces the desired rotations. The second part works the same way. For example, the composition $\tau(\sigma_y(z)) = -\bar{z} + 2\pi$, a reflection that fixes the vertical line $\text{Re}(z) = \pi$.

Figure 8.1. Examples of the seven frieze pattern types.

converts the glide, which turns the plane over, into a translation, which leaves the plane right side up: not the same type. Formally, we would say that the p2mm example shows two representations that are conjugate in the affine group [18], which is a large set of plane transformations that preserve lines and parallels but not shapes or distances. The groups p11g and p111 are not conjugate in the affine group. Different types. (We will learn much more about conjugation in later chapters; if this idea intrigues you but you don't know the term *conjugate*, plan to return later.)

Frieze Functions

Frieze functions came late in my study of symmetry. I did not think they would be interesting. This is seldom a correct attitude about any mathematical situation; somehow, there is always a right way to look at something that makes it interesting.

I had studied frieze *curves*—parametric curves with frieze symmetries—but not frieze functions. A Norwegian signal-processing engineer named Nils Kristian Rossing contacted me about a paper I had written for *Mathematics Magazine*, which explained the rosette curves of Chapter 3 [5]. Rossing sent pictures of elaborate rosettes he had woven from rope—an old sailors' craft—and proposed that we might collaborate. We worked out how to make curves with frieze symmetries and Rossing wove some of them [9]. It was fun but seemed unrelated to the new work on domain colorings of functions with various symmetries.

Also, I reasoned that if I wanted a frieze function, I could cut a strip out of wallpaper pattern. This can actually be a deceptive thing to do. To make Figure 8.2, I cut a strip from a pattern made from a peach and its negative. (In Chapter 15, we will learn to call this p4g, with the 4 indicating 4-fold rotational symmetry and the g referring to the glides.) If I indicate that the pattern extends infinitely *to the left and the right*, meaning that I intend it to be interpreted as a frieze, what is the symmetry group?

If we avoid being distracted by the mirror symmetries of fragments of the image, which are *not* symmetries of the strip, and the ghosts of 4-fold rotational symmetry from the original wallpaper, we see that the only actual symmetries of this frieze are the translations and a horizontal glide. The group is p11g. That said, it would be unkind to offer this, with its distracting partial symmetries, as an example to illustrate p11g symmetry.

Rather than be unkind, let us find a way to construct frieze functions. For me, the idea crept up when I was making rosettes, noticing that it is easy to make

Figure 8.2. A frieze pattern made from a strip of wallpaper can be deceiving.

a rosette function invariant under reciprocal inversion of the complex plane, $z \to 1/z$, as in Figure 7.3. I realized that the rosette functions I was making were actually frieze functions wound around the unit circle, with the part above the base line inside the unit circle and the part below outside. Let us formalize this idea.

A Frieze-to-Rosette Homomorphism

By now, I hope that you have become quite accustomed to the Euler formula for e^{it}, which winds the real axis around and around the unit circle in the complex plane. It has a natural generalization. For $z = x + iy$, define

$$\Phi(z) = e^{iz} = e^{i(x+iy)} = e^{-y}\left(\cos(x) + i\sin(x)\right). \tag{8.1}$$

Since $|e^{iz}| = e^{-y}$, the part of the plane with $y > 0$ ends up inside the unit circle. If we start with $y = 0$, we end up on the unit circle, confirming that Φ winds the real axis around and around the circle. Verify that

$$\Phi(z_1 + z_2) = \Phi(z_1)\Phi(z_2),$$

so that Φ is a homomorphism from \mathbb{C}, considered as a group under addition of complex numbers, to \mathbb{C}^*, the set of nonzero complex numbers considered as a group under multiplication. The *kernel* of this homomorphism—the set of elements that map to the identity of the target group—is the set of numbers $2\pi n$ for $n \in \mathbb{Z}$, exactly the periods of our frieze functions. What can we make of this remarkable object?

First, we compute that

$$\Phi(-z) = e^{i(-z)} = 1/\Phi(z).$$

(If it is too soon for you to trust that this exponential function obeys rules of exponents, you should verify this from the trigonometric functions in (8.1).) So a half turn in a frieze group corresponds to reciprocal inversion in \mathbb{C}.

Similarly, we find out how various transformations relevant to frieze patterns interact with the homomorphism:

$$\Phi(\sigma_x(z)) = e^{i(\bar{z})} = 1/\overline{\Phi(z)} \text{ and } \Phi(\sigma_y(z)) = e^{i(-\bar{z})} = \overline{\Phi(z)}.$$

(Again, these can be checked from (8.1) with algebra.) The first shows that σ_x, reflection across the x-axis in the domain, transfers over to geometric circle inversion, which is $z \to 1/\bar{z}$ in complex notation. The second says that σ_y in the horizontally oriented plane—what I might call *frieze space*—corresponds to reflection across the x-axis in our round space, \mathbb{C}^*.

Finally, check that

$$\Phi(\gamma_x) = -1/\overline{\Phi(z)},$$

which is geometric circle inversion followed by a half turn. Use your imagination to relate this to the flip and slide interpretation of glide reflections. The flip

exchanges inside and outside of the unit circle, while the slide simply turns the circle halfway around.

The point is: We know how to make functions invariant under all these symmetries of \mathbb{C}^* using just the techniques in Chapter 7. Let us review how we did this. Our idea of a function is a (possibly infinite) series

$$f(z) = \sum a_{n,m} z^n \bar{z}^m.$$

If n or m are negative, f will be undefined at 0, which we agreed to accept in our rosette functions. As an example to recall how we can create symmetry in rosette functions, observe that the rosette function will have horizontal mirror symmetry when it stays the same if we conjugate in the domain. In equations, this becomes a *symmetry recipe*:

$$f(z) = f(\bar{z}) \text{ if and only if } a_{n,m} = a_{m,n} \text{ for all } n, m \in \mathbb{Z}.$$

If we want our rosette function to show mirror symmetry across the x-axis, we lock together $z^n \bar{z}^m$ with $z^m \bar{z}^n$ by using the same coefficient for each on in the series.

Transferring Rosettes to Friezes

How do rosette functions become frieze functions? We use Φ: Since Φ goes from \mathbb{C} to \mathbb{C}^*, a function f on \mathbb{C}^* transfers over to a function on \mathbb{C} upon composition with Φ:

$$f(z) \text{ for } z \in \mathbb{C}^* \text{ becomes } f(\Phi(z)) \text{ for } z \in \mathbb{C}.$$

No matter which function f we use, the new function enjoys frieze periodicity:

$$f(\Phi(z + 2\pi)) = f(\Phi(z)), \text{ because } \Phi(z + 2\pi) = \Phi(z).$$

There is a fancy name for this method of transferring a rosette to a frieze: We call $f(\Phi(z))$ the *pullback* of f on \mathbb{C}^* to a function on \mathbb{C} using the map $\Phi : \mathbb{C} \to \mathbb{C}^*$.

If f has any of the symmetries we have mentioned on \mathbb{C}^*, such as invariance under $1/z$ or $1/\bar{z}$ for instance, then $f \circ \Phi$ will have the symmetry that corresponds to it: invariance under ρ_2 or σ_x in the instances we mentioned. In general, suppose that we have

$$f(z) = \sum a_{n,m} z^n \bar{z}^m.$$

The pullback of f under Φ is

$$f(\Phi(z)) = \sum a_{n,m} e^{inz} e^{-im\bar{z}}. \tag{8.2}$$

Creating frieze functions amounts to choosing coefficients that create the right symmetries. From a computational (and artistic) point of view, it might help to

use definitions to show that

$$f(\Phi(z)) = \sum a_{n,m} e^{-(n+m)y} e^{i(n-m)x}. \qquad (8.3)$$

EXERCISE 18

Suppose we wish to construct frieze functions with a different translation distance; say we want $f(z + 1) = f(z)$ instead of $f(z + 2\pi) = f(z)$. Show that the homomorphism $\Phi_{2\pi}(z) = e^{2\pi i z}$ will pull back rosette functions to frieze functions invariant under unit translations. No matter what we do, it seems that there will be a 2π in one place or another.

A few things relevant for frieze creators can be seen from the behavior of this product: If $n + m > 0$, that term decays in absolute value as we increase y in the positive direction and grows exponentially as we move y down below the x-axis. If $n + m = 0$, the function is constant in the vertical direction; if $n - m = 0$, the function is constant in the x direction. You can see something of this in the figures; for instance, in the p1m1 pattern, all the terms have $n + m < 0$. This explains the black band at the bottom: The function grows rapidly in absolute value as we go down and those pixels are colored black to indicate this. In some of the other images, I replaced the black by a different color, simply for artistic effect.

FRIEZE RECIPES. So what are the recipes that create the various symmetries? The horizontal mirror symmetry we created in rosettes transfers over immediately: Choosing $a_{n,m} = a_{m,n}$ created a rosette function with horizontal mirror symmetry; making the same choice in (8.3) creates a p1m1 function! We check this with

$$f(\Phi(-\bar{z})) = f(\overline{\Phi(z)}) = f(\Phi(z)),$$

meaning that the composite function on frieze space is invariant under σ_y.

Similarly, ρ_2, the half turn about the origin of frieze space, sends the term $a_{n,m} z^n \bar{z}^m$ to $a_{n,m} z^{-n} \bar{z}^{-m}$. If we choose coefficients in (8.3) with $a_{n,m} = a_{-n,-m}$, we "turn on" that half-turn symmetry, as well as all symmetries that devolve from it by composition.

* EXERCISE 19

For some of the frieze patterns in Figure 8.1, I modified the recipe in (8.3) to create friezes defined only in the strip $-1 < y < 1$. I did this by defining a coordinate

$$Y = \tanh(y) = \frac{e^y - e^{-y}}{e^y + e^{-y}}.$$

Show that, with this definition,

$$y = \frac{1}{2} \ln \frac{1 + Y}{1 - Y},$$

so that the recipe for frieze functions becomes

$$f(\Phi(z)) = \sum a_{n,m} \left(\frac{1 - Y}{1 + Y}\right)^{(n+m)/2} e^{i(n-m)x}. \qquad (8.4)$$

TABLE 8.1: A table of recipes to create frieze functions, where the complex numbers $a_{n,m}$ are coefficients of the series in (8.2).

GROUP NAME	SYMMETRY ENGAGED	RECIPE
p111	none	$a_{n,m}$ arbitrary
p211	ρ_2	$a_{n,m} = a_{-n,-m}$
p1m1	σ_y	$a_{n,m} = a_{m,n}$
p11m	σ_x	$a_{n,m} = a_{-m,-n}$
p11g	γ_x	$a_{n,m} = (-1)^{n+m} a_{-m,-n}$
p2mm	ρ_2, σ_y	$a_{n,m} = a_{-n,-m} = a_{m,n} = a_{-m,-n}$
p2mg	γ_x, ρ_2	$a_{n,m} = (-1)^{n+m} a_{-m,-n} = a_{-n,-m} = (-1)^{n+m} a_{m,n}$

Rather than draw the discussion out, I list the seven recipes in Table 8.1, inviting you to check for exercise. The recipes involving γ_x are especially interesting.

Looking Back to Rosettes

All the recipes in Table 8.1 can be used to create rosettes, with one small alteration: To create a rosette with p-fold symmetry, replace n and m by np and mp.

This makes it appear that there are seven different types of rosette functions for each value of p. Any book will tell you that for each p, the only possible rosette symmetry groups are \mathbf{C}_p and \mathbf{D}_p, meaning simple p-fold rotational symmetry and possibly reflection symmetry as well. The books are correct if only *isometries* are allowed to serve as symmetries. If we welcome our various inversions to the mix, then seven types are indeed possible for each p.

Indeed, if you look with new frieze-trained eyes at Figure 7.1 in Chapter 7, you might see that it is a pattern of type p1m1, wound around the unit circle with five pattern repeats in each revolution. Similarly, if we unwind Figure 7.3, we will find a p211 pattern.

Chapter 9

Making Waves

Question: How do you make plane waves and how do they want to move? When we last spoke of "everything" being a superposition of waves, I suggested that the word *wave* was used metaphorically—waves on the ocean are periodic, these functions are periodic, why not call them both waves? In this chapter, we make a more literal connection, even to surfaces moving up and down, modeling the swells in the ocean— not the waves crashing on the shore. Analyzing physical situations (heat and water waves, initially) led mathematicians to develop Fourier series. To indicate some of the heritage of our wave method for creating symmetry, we overview these situations.

To enjoy the subsequent chapters, you need not understand the details of solving the linear wave equation, so please feel free to skip them, perhaps after perusing the definition of *plane waves* in (9.4) near the end of the chapter. To enjoy all the intricacies that lead up to that definition, read on.

One Space Dimension

If we view a wave in the open ocean in cross section, we can sketch its height as a function of one space variable, say x, and, at a particular instant, see something like Figure 9.1. The height varies with time, so let us name $u(x, t)$ as the height of the wave at position x and time t. A sketch of a typical cross section at a particular time appears in Figure 9.1. Waves looking just like this can be seen in the transparent wall of a laboratory wave tank.

A rigorous study would have us analyze the mechanics of a small bit of the surface, balancing forces according to Newton's laws. Here, we take a shortcut by observing that two different things ought to be proportional to one another, and this gives us the *linear wave equation*. We don't mean to diminish the value of an actual derivation of the equation. It highlights the physical assumptions that must be made for the equation to hold; namely, the wave is assumed to move only up and down by amounts judged to be "sufficiently small." Here we confine the discussion to a quick heuristic, as follows.

We know that the second derivative of u with respect to x gives us the concavity of the wave; this tells us whether the wave is bending up or down and measures the extent of either. On the other hand, the second derivative of u with respect to t is the acceleration of the height—measuring how its velocity changes in an upward or downward direction. If you are unfamiliar with partial derivatives, know that differentiating twice with respect to t while holding x constant is written $\partial^2 u/\partial t^2$. For each fixed x, this is the vertical acceleration of the wave at that point, upward if the second derivative if positive, downward if negative. Similarly, $\partial^2 u/\partial x^2$ indicates the second x-derivative, which is the concavity.

Figure 9.1 is meant to convince us that these two derivatives ought to be proportional to one another: When the wave height is bending upward, it ought to accelerate upward; when it is bending downward, it ought to accelerate downward. This is the linear wave equation: the assumption that these two things are proportional.

$$\frac{\partial^2 u}{\partial t^2} = c^2 \frac{\partial^2 u}{\partial x^2}. \tag{9.1}$$

Figure 9.1. A wave in cross section. The heuristic: When the wave bends upward, it wants to accelerate the same way.

The constant of proportionality is written c^2, partly because the constant is known to be positive and partly because we will soon learn to interpret c as the *wave speed*.

Why is it called the *linear* wave equation? Observe that if you had two functions u_1 and u_2 that solve (9.1), any superposition of the two solutions, $au_1 + bu_2$, also solves the equation. This is because differentiation is a linear operation and we have not done anything—squaring, cubing, multiplying two derivatives together—to mess up the linearity. The observation is simple, but the impact is great: once we have some solutions to the wave equation, we can create a whole space of solutions by superposition.

In particular, we can superimpose a left-traveling wave from the d'Alembert solution (Exercise 20) with a right-traveling one and create many complicated motions. But how can we know how a given wave breaks down into left and right parts? This difficulty leads us to consider a different technique for solving (9.1).

Separation of Variables

We know that we can superimpose solutions once we find some, and this frees us to look for some very special solutions: products of functions of t and x alone. Suppose that

$$u(x,t) = X(x) \cdot T(t).$$

This assumption limits our search to waves that retain the same shape as they progress in time, being scaled by the number $T(t)$ at time t. Plugging into the wave equation (9.1) and rearranging gives

$$\frac{T''}{c^2 T} = \frac{X''}{X},$$

where we use primes to indicate taking the derivative with respect to the relevant variable, t for T and x for X. In this equation, the left-hand side depends on t alone, while the right-hand side is a function of x alone. Fix t and vary x. If the right-hand side moves with x, then the left-hand side must also, but we fixed t so it cannot. This is a long way of saying that the two sides must be constant. Taking advantage of prior knowledge, we name the constant $-\lambda^2$ and try to solve two separate ordinary differential equations

$$\frac{X''}{X} = -\lambda^2 \text{ and } \frac{T''}{T} = -c^2 \lambda^2.$$

* EXERCISE 20
The d'Alembert Solution

Test your skills with differentiation (the chain rule!) by showing that, if f is any twice-differentiable function, the composite functions

$$u_1(x,t) = f(x - ct) \text{ and}$$
$$u_2(x,t) = f(x + ct)$$

indeed solve the linear wave equation. Sketch any wave you like and pick an x-value to label x_0; it might be easiest to follow if $f(x_0)$ is a high point of the wave. Sketch the point $x_0 + ct$ on the x-axis, for some positive t, and observe that this is where you would end up if you traveled to the right for t units of time at speed c. The solution u_1 would compute the height of the wave at position $x_0 + ct$ and time t as $f(x_0 + ct - ct) = f(x_0)$. The wave peak is traveling to the right at speed c. Use software to make an animation of this solution and the left-traveling one for various shapes $f(x)$.

The best way to solve an ordinary differential equation is to guess (or know) the solution. Here, we could say that $X = \sin(\lambda x)$ or $X = \cos(\lambda x)$ are particular solutions, and they would work, but let us connect to our complex notation and write

$$X = e^{i\lambda x} \text{ and } T = e^{ic\lambda t}.$$

The products of functions like these give us quite a large set of functions that solve the wave equation. The Xs are just the periodic functions we have spent so much time with in earlier chapters, though they will not have period 2π unless λ is an integer. The important thing is the way this formula tells us the time function $T(t)$ that goes with any particular shape function $X(x)$. If we have a particular λ in mind, we know how that exponential wave moves into the future.

If the complex form bothers you, know that we can simply take the real parts of any complex u to describe a physical wave. Many prefer the complex form, as it facilitates an operation that is otherwise cumbersome, the trick of the *phase factor*. We give one simple example, while also reinforcing notation and the connection to physics.

Suppose your situation calls for the superposition of waves

$$f(x) = 3\sin(x) + 4\cos(x),$$

two waves with the same period, 2π, but different amplitudes, 3 and 4. If we use our complex imaginations, we can write

$$f(x) = \text{Re}\left(-3ie^{ix} + 4e^{ix}\right) = \text{Re}\left((4 - 3i)e^{ix}\right).$$

A little more imagination leads us to name the angle $\phi = \tan^{-1}(\frac{3}{4})$ (so convenient that the example involves a Pythagorean triple), so that

$$f(x) = \text{Re}\left(5e^{-i\phi}e^{ix}\right) = \text{Re}\left(5e^{i(x-\phi)}\right) = 5\cos(x - \phi).$$

Instead of a messy sum of sine and cosine functions, we have a single cosine wave, with an adjusted phase angle ϕ. If we think of $e^{i\lambda x}$ as the primary player, knowing that we will take real parts for physical applications, our computations gain elegance. The same trick works in the time domain to transform a particular time solution, which might come to us as a sum of a sine and a cosine term, into a single cosine function.

Boundary Conditions and the Vibrating String

What considerations determine the possible values of λ? If we knew, for some reason, that all of our waves should be periodic with period 2π, then the only relevant solutions $X(x)$ would have $\lambda = 0, \pm 1, \pm 2, \ldots$. If there is no particular reason to make that assumption, *boundary conditions* determine the possibilities for λ. Let us overview one classical example, the vibrating string.

A string is exactly π units long (in a mathematician's ideal world) and is *fixed* at both ends, meaning that they cannot move up or down. In the interior of the string, we assume the string moves only up and down and that, at a point x

along the string, its vertical displacement from equilibrium at time t is $u(x, t)$. This function is seen to satisfy the linear wave equation, either from rigorous analysis of forces on an element of the string or the simple heuristic in Figure 9.1. In addition, because the ends of the string are fixed, we know that

$$u(0, t) = u(\pi, t) = 0 \text{ for all } t.$$

When we separate variables, this means that

$$X'' = -\lambda^2 X \text{ and } X(0) = X(\pi) = 0.$$

The most general solution to the ordinary differential equation is

$$X(x) = ae^{i\lambda x} + be^{-i\lambda x}.$$

Plugging in the first boundary condition and doing some algebra leads to $X(x) = k\sin(\lambda x)$. The second boundary condition says that $\sin(\lambda \pi) = 0$, which tells us that λ is an integer.

The most general vibrating string is a superposition of special solutions, which are the waves $\sin(nx)$. These special solutions are called the *standing waves* of the problem.

A classical problem asks us to deform the string into a particular shape $f(x)$ and predict its future when we release it from rest. The solution can be shown to be

$$\sum_{n=1}^{\infty} a_n \sin(nx) \cos(nt), \text{ where } f(x) = \sum_{n=1}^{\infty} a_n \sin(nx).$$

The series for f is called the *Fourier sine series*, and the coefficients are defined by

$$a_n = \frac{2}{\pi} \int_0^{\pi} f(x) \sin(nx) \, dx.$$

These are, in fact, the Fourier coefficients of f, or rather, the *odd extension* of f to the interval $[-\pi, \pi]$, meaning that the solution we constructed to converge to the starting shape $f(x)$ on the *half interval* $[0, \pi]$ converges to $-f(-x)$ on the other half. An interested reader can learn about many interesting variations on this problem. All we intend here is to show that the functions we used to create symmetry in curves are literally physical waves.

If you play a string instrument or know someone who does, you can hear the frequencies of the waves in a succession of tones called the *harmonic series*. The special solution with $n = 1$ will sound as the fundamental tone of the string, the basic note we hear when the string is bowed. The solution with $n = 2$ corresponds to the player putting a finger lightly at the center of the string, causing a sound that is an octave higher. The $n = 3$ solution sounds like a fifth above that, followed by the second octave, and so on, up the harmonic series.

Plane Waves

We analyzed ocean waves in cross section and found the mathematical reason why they look like graphs of sine and cosine functions. Surprisingly, analyzing whole waves, not just cross sections, as displacements over a two-dimensional plane is not too much more complicated. We define the *Laplace operator*,

$$\Delta = \frac{\partial^2}{\partial x^2} + \frac{\partial^2}{\partial y^2}, \text{ so that } \Delta u(x, y) = \frac{\partial^2 u}{\partial x^2} + \frac{\partial^2 u}{\partial y^2}.$$

This last expression is called the *Laplacian* of u, which, roughly, measures unresolved tension in a surface deformed with (small) height $u(x, y)$ over the point (x, y) in the plane. The *linear two-dimensional wave equation* sets the Laplacian proportional to the acceleration, again asserting that a surface bending downward will accelerate downward, and so on:

$$\frac{\partial^2 u}{\partial t^2} = c^2 \Delta u. \tag{9.2}$$

(A more detailed analysis would show why we need only include the pure spatial partials of u, relying on the assumption that the height displacement is everywhere small.)

When we try to solve (9.2) by separation of variables, looking for product solutions of the form $u(x, y, t) = f(x, y)T(t)$, a little work leads us to a search for functions f so that

$$\Delta f = -\lambda f. \tag{9.3}$$

(Plug the product form into the wave equation (9.2) to see this.) Again, we have presciently named the constant of proportionality arising in the separation of variables routine as $-\lambda$.

A function that satisfies (9.3) is called an *eigenfunction* of the Laplacian with eigenvalue $-\lambda$. In German, *eigen* means "*self*," reflecting the idea that these functions are referred to themselves by the Laplacian. The set of eigenvalues of the Laplace operator is called its *spectrum*. In more advanced treatments, mathematicians absorb the minus sign into the definition of the Laplacian so that it may have a positive spectrum.

To vindicate our choice of notation for the eigenvalues, $-\lambda$, we exhibit the set of eigenfunctions of the Laplacian that are periodic with respect to unit translations in the horizontal and vertical directions in the Cartesian plane. If we seek $f(x, y)$ such that

$$f(x + 1, y) = f(x, y + 1) \text{ for all } (x, y) \in \mathbb{R} \text{ and } \Delta f = -\lambda f,$$

a further application of the separation of variables routine will inevitably lead us to

$$f_{n,m}(x, y) = e^{2\pi i(nx+my)}, \text{ where } n, m \in \mathbb{Z}.$$

I hope that you are sufficiently accustomed to the complex notation to see that this is nothing more than a package of various sine and cosine functions. Check, using (9.3), that the eigenvalue for $f_{n,m}$ is $-4\pi^2(n^2 + m^2)$. This gives us a family of special solutions to (9.2):

$$u_{n,m} = e^{2\pi i \sqrt{n^2+m^2}\,ct}\, e^{2\pi i(nx+my)}.$$

This looks like a mess until we think, Yes, differentiating u twice with respect to t pulls down $-4\pi^2(n^2 + m^2)c^2$, and this is c^2 times the Laplacian of u.

These special solutions of the wave equation are the *standing waves* of the two-dimensional problem, under the strong periodicity assumption. Rather than superimpose solutions to solve a particular problem, as we did with the vibrating string, we isolate the bit that becomes crucial to our efforts to create wallpaper, the *plane waves*. There are several possible choices of notation. We will later see the need to carry a few of these in our minds, but first we present standard real notation.

If we use vector notations, $\mathbf{x} = (x, y)$ and $\mathbf{n} = (n, m)$, then we can use the dot product to write our eigenfunction as

$$f_{\mathbf{n}}(\mathbf{x}) = e^{2\pi i \mathbf{x} \cdot \mathbf{n}}.$$

To admit that we may later want waves with a different periodicity than our examples, we relax the condition that \mathbf{n} be a vector of integers and define the *plane wave* with *frequency vector* \mathbf{v} to be

$$f_{\mathbf{v}}(\mathbf{x}) = e^{2\pi i \mathbf{x} \cdot \mathbf{v}}. \tag{9.4}$$

We will depict this wave in the next chapter, but perhaps I can make it live in your imagination—at least its real or imaginary part. The details are left for an exercise, but this is the iconic rolling wave in the open ocean. When \mathbf{v} is large, the crests are close together, justifying the name *frequency vector*. If at any point we look perpendicular to \mathbf{v}, the wave has the same height, so our wave is rolling along \mathbf{v} and is constant in the direction perpendicular to \mathbf{v}.

> *** EXERCISE 21**
>
> Check using (9.3) that $f_{\mathbf{v}}$ is an eigenfunction of the Laplacian with eigenvalue $-4\pi^2|\mathbf{v}|^2$, that $f_{\mathbf{v}}$ is constant in directions perpendicular to \mathbf{v}, and that $f_{\mathbf{v}}(\mathbf{x} + \mathbf{v}/|\mathbf{v}|^2) = f_{\mathbf{v}}(\mathbf{x})$. This last step is almost all you need to show that $\mathbf{v}/|\mathbf{v}|^2$ is the shortest period of $f_{\mathbf{v}}$.

> *** EXERCISE 22**
>
> We have seen several cases so far where complex notation greatly simplifies matters. Show that this is also true for planes waves, in two steps.
>
> 1. Show that if $z = x + iy$ and $v = n + im$, the dot product $(x, y) \cdot (n, m)$ is the same as $\text{Re}(z\bar{v}) = (z\bar{v} + \bar{z}v)/2$.
> 2. Define partial differentiations $\partial/\partial z$ and $\partial/\partial \bar{z}$ by
>
> $$\frac{\partial}{\partial z} = \frac{1}{2}\left(\frac{\partial}{\partial x} - i\frac{\partial}{\partial y}\right) \text{ and } \frac{\partial}{\partial \bar{z}} = \frac{1}{2}\left(\frac{\partial}{\partial x} + i\frac{\partial}{\partial y}\right).$$
>
> After checking such things as $\partial \bar{z}/\partial z = 0$, show that the Laplacian operator, in complex notation, becomes
>
> $$\Delta f = 4\frac{\partial^2 f}{\partial z \partial \bar{z}} \text{ so that } \Delta e^{2\pi i \text{Re}(z\bar{v})} = -4\pi^2 v\bar{v}e^{2\pi i \text{Re}(z\bar{v})}.$$
>
> (Advice: Write $\text{Re}(z\bar{v}) = (z\bar{v} + \bar{z}v)/2$ before you differentiate.)
>
> Comment: This may make things seem simpler than they actually are, since here we use *orthogonal* coordinates, where the x- and y-axes are perpendicular. Things become spicier when other coordinates become more convenient.

Chapter 10

Plane Wave Packets for 3-Fold Symmetry

Question: How do you combine plane waves to make periodic functions with 3-fold symmetry? We know how to create rotational symmetry in rosettes and unwind them to make friezes. We know how to create translational symmetry in plane waves. In this chapter, we find out what happens when we put the two ideas together, creating functions that have both translational and rotational symmetry.

It is conceivable that some readers could decide to begin the book with this chapter. I offer a brief summary of what you need to know, whether deeply or by acquaintance, in order to enjoy this material. Even if you have read every page faithfully, you might enjoy this summary of what we have learned so far.

We need to be able to imagine various spaces of functions (complex-valued functions on the plane) as infinite-dimensional vector spaces from which we can select, and superimpose, functions that have various desired symmetries, such as reflections and rotations. Another ingredient is the idea that any such function can become a potential work of art by the technique of domain coloring with a chosen color wheel. This involves taking $z = x + iy$ as a single complex coordinate on the plane, which simplifies computations enormously. Finally, we need the fundamental algebraic idea about symmetry: that patterns can be classified by their symmetry groups. We see these groups acting as transformations (usually taken to be isometries) on the domain of the functions we choose in order to create symmetry.

With this background, we now explore a carefully chosen experiment: averaging a single plane wave over a very small group generated by a single 3-fold rotation. Our experiment leads to new concepts: algebraic structures called *lattices*, with specially adapted coordinates and resident wave functions, appear quite naturally. These waves become our first examples of *wallpaper functions*. The climax of the chapter is the unveiling of *wave packets*, superpositions of particular waves that dance together to create symmetry.

Later chapters will reveal why the case of 3-fold symmetry is so special. For now, let's enjoy the specificity of 3.

Turning a Wave Three Ways

A simple choice of a plane wave from the previous chapter is

$$f(z) = f(x + iy) = e^{2\pi i y},$$

cycling upward along the y-axis with wave fronts parallel to the x-axis. Later, we'll see that this wave is not scaled conveniently; but this is a conceptually simple place to start.

It's easy to imagine the domain coloring diagram for the chosen wave: Since the absolute value of this exponential function is 1, we should see only the pure hues on the unit circle of the color wheel. This assumes a choice of traditional color wheel; I used one with only six pure hues around the unit circle. The result appears on the top in Figure 10.1.

To create 3-fold symmetry using this plane wave, we recall the technique of *group averaging*. We showed examples before; it is time for a formal definition.

Definition 3. Suppose that \mathcal{G} is a finite group of transformations of the complex plane with n elements and $f(z)$ is a function defined on (some domain in) the complex plane. The *average of f over \mathcal{G}* is

$$\hat{f}(z) = \frac{1}{n} \sum_{g \in \mathcal{G}} f(g(z)).$$

An exercise takes the interested reader through a formal proof that the new function \hat{f} is indeed invariant under every transformation in \mathcal{G}.

To create 3-fold symmetry, we enlist our $120°$ rotation, $\rho_3(z) = \omega_3 z = e^{2\pi i/3}z$, and average over the group

$$\mathbf{C}_3 = \{\iota, \rho_3, \rho_3^2\},$$

where I hope that you have become accustomed to the way I identify this particular set of transformations of \mathbb{C} with the abstract cyclic group of order 3.

To average the simple wave shown in Figure 10.1 over \mathbf{C}_3, we need to compute the y-values of $\rho_3(z)$ and $\rho_3^2(z)$. Working out the complex multiplications, we find that the average is

$$\hat{f}(z) = \frac{1}{3}\left(e^{2\pi i y} + e^{2\pi i(\sqrt{3}x - y)/2} + e^{2\pi i(-\sqrt{3}x - y)/2} \right). \tag{10.1}$$

The domain coloring for \hat{f} is shown on the bottom in Figure 10.1, with the origin marked by a black dot in the center left of the image. I hope this image surprises you at least a little: In addition to the 3-fold symmetry we forced on f by group averaging, we seem to have retained the translational symmetry of the original plane wave. Focusing only on the red dots may fool you into seeing 6-fold symmetry. To break the illusion, look at the cycle of 3 green dots surrounding the origin: no 6-fold symmetry there.

Explaining the symmetry of this figure will take some work. We introduce new coordinates and learn a great deal that is special about this first example.

Figure 10.1. Top: The simplest plane wave cycles around the color wheel. Bottom: When we average the wave over 3-fold rotation, we get more than 3-fold rotational symmetry. The black dot indicates the origin of the coordinate system.

Lattices and Lattice Coordinates

The image of the 3-fold averaged wave, \hat{f}, in Figure 10.1 suggests that this new function is invariant under various translations. One apparent translation, sliding to the right, must have the form $\tau(z) = z + r$ for some *real* number r. It looks like there is also a translational symmetry of the form $\tau'(z) = z + r\omega_3$. The condition

that

$$\hat{f}(z + r) = \hat{f}(z) \text{ for some } r \in \mathbb{R}$$

(and the useful fact $e^{2\pi i/3} = -1/2 + i\sqrt{3}/2$) leads us to

$$e^{2\pi i \sqrt{3}r/2} = 1, \text{ which means } \frac{\sqrt{3}r}{2} \in \mathbb{Z}.$$

Taking the smallest choice of r (and doing the algebra to verify invariance under τ', using the same r), we find that \hat{f} is invariant under translations by any complex numbers

$$a\frac{2}{\sqrt{3}} + b\frac{2}{\sqrt{3}}\omega_3 \text{ where } a, b \in \mathbb{Z}.$$

These complex numbers are called the *periods* of \hat{f}. You might be accustomed to *period* referring to a scalar quantity representing how long between repeats of a pattern; the way I use the term here is a generalization, because now the period contains information about the *direction* of repeating, as well as the distance. For instance, saying that 1 is a period of a function includes the information that the repeat is in the real, or horizonal, direction

The set of periods we found for \hat{f} is called a *lattice*, which, here, simply means the set of integer multiples of two different complex numbers. This is a rather awkward lattice, with the funny factor of $2/\sqrt{3}$. If we had scaled our original wave differently, we would be looking at the lovely lattice

$$\mathcal{E} = \{a + b\,\omega_3 \mid a, b \in \mathbb{Z}\},$$

called the *Eisenstein integers*, for reasons to be explained much later.

Would it not be nicer to create a wave with these elegant periods, since all we have to do is rescale the y-axis? Let us define

$$Y = \frac{2y}{\sqrt{3}} \text{ and rename } f(z) = e^{2\pi i Y}.$$

Let us further imagine that the bottom part of Figure 10.1 has been rescaled so that the horizontal distance between those red dots is 1 unit. Distances along the ω_3 direction, 120° counterclockwise from the horizontal, are now measured by the variable Y: increasing Y from 0 to 1 moves us up 1 unit of ω_3. This suggests the definition

$$z = X + Y\omega_3, \text{ where we check that } X = z - Y\omega_3 = x + \frac{y}{\sqrt{3}}$$

is real.

We can now indicate a point in \mathbb{C} in three ways: the complex number z, the Cartesian coordinates (x, y), and the coordinates $[X, Y]$, which we call *lattice coordinates*. The name evokes the idea that X indicates the number of steps, integral or fractional, along the 1, or horizontal, direction of the lattice to get

to our point, while Y counts the steps in the ω_3 direction. We will consider lattice coordinates in generality—but only after becoming much more familiar with this example.

To continue our analysis of the particular 3-fold average in Figure 10.1, we compute \hat{f}, where $f(z) = e^{2\pi i Y}$. As before, for the averaging recipe, we need to sort out the Y-coordinate of $\omega_3 z$ and $\omega_3^2 z$. This is facilitated by the almost magical formula

$$\rho_3(X + Y\omega_3) = \omega_3 X + \omega_3^2 Y = -Y + (X - Y)\omega_3,$$

where we used the easily verified formula $\omega_3^2 = -1 - \omega_3$. (It is fun to draw a picture to show this.) If the X- and Y-coordinates of a point are integers, then so are the coordinates of the rotation of that point. Nice coordinates!

We use the nice coordinates to compute

$$\hat{f}(z) = \frac{1}{3}\left(e^{2\pi i Y} + e^{2\pi i(X-Y)} + e^{2\pi i(-X)}\right).$$

The waves in this sum do indeed have 1 and ω_3 as periods, explaining the translation invariance in Figure 10.1.

We summarize the example, leaving generality for the next section. For one special wave, cycling once for every unit in the Y-direction, we averaged over 3-fold rotation and found a new function \hat{f}, which is invariant under three transformations:

$$\tau_1(z) = z + 1, \tau_{\omega_3}(z) = z + \omega_3, \text{ and } \rho_3(z) = \omega_3 z.$$

The last is hardly surprising, since we engineered \hat{f} to behave this way. The surprise is that the translation invariance of the original wave has spawned invariance under a whole lattice of translations. How were we so lucky?

Lattice Waves

The special lattice coordinates, $[X, Y]$ with $z = X + Y\omega_3$, quickly lead to waves with any integer frequency in each of the X- and Y-directions:

$$e^{2\pi i n X}, \ e^{2\pi i m Y}, \ \text{ and, indeed, } E_{n,m} = e^{2\pi i(nX+mY)}.$$

Do check that this last expression is invariant under τ_1 and τ_{ω_3}. (Hint: In $[X, Y]$ coordinates, τ_{ω_3} is just

$$\tau_{\omega_3}([X, Y]) = [X, Y + 1].)$$

Each function $E_{n,m}$ is called a *lattice wave*, as its periods include all the complex numbers in the lattice \mathcal{E}. Some of these waves have smaller periods. For instance, you may enjoy checking the strange fact that $E_{1,2}$ has $(3 + 2\omega_3)/7$ as a period. The magnitude of this translation vector is $1/\sqrt{7}$. This is another example of the phenomenon we called "accidental" symmetry. But let us return to our main point: that all our lattice waves have 1 and ω_3 as common periods.

The chapter on Fourier series gives us significant clues about where to go next. Since the symmetry conditions are linear, we can superimpose multiples of functions that satisfy them and find more invariant functions. In fact, a whole function space of translation-invariant functions is found in

$$\mathcal{F}_{1,\omega_3} = \left\{ f(z) = \sum_{n,m \in \mathbb{Z}} a_{n,m} e^{2\pi i(nX + mY)} \mid z = X + Y\omega_3, a_{n,m} \in \mathbb{C} \right\},$$

where, yet again, we find it convenient to be a little vague about exactly which rules we care to impose on these sums. For some purposes, finite sums will be quite enough; in other situations, various types of convergence of infinite sums may be required. Let us accept without proof a result from Fourier theory analogous to the one we proved in Chapter 5: Any continuously differentiable function that is periodic with respect to the lattice can be expressed as a point-wise convergent sum of functions from \mathcal{F}_{1,ω_3}.

At this point, what matters is that every function in \mathcal{F}_{1,ω_3} has both τ_1 and τ_{ω_3}, and hence all compositions of these, as symmetries.

A *wallpaper function* is one that is invariant with respect to a lattice, so \mathcal{F}_{1,ω_3} is our first space of wallpaper functions. The individual waveforms from which we build wallpaper functions are called *wallpaper waves*.

3-Fold Symmetry

We began this chapter seeking functions with 3-fold symmetry and have found instead a space of functions with a common translational invariance. Function averaging now comes to the rescue to complete our search. We use our earlier computation, that $\rho_3([X, Y]) = [-Y, X - Y]$, to learn how rotation affects the lattice waves:

$$E_{n,m}(\omega_3 z) = e^{2\pi i(n(-Y) + m(X-Y))} = e^{2\pi i(mX - (n+m)Y)} = E_{m,-(n+m)}(z).$$

Applying this formula again, we find a marvelous result: The (n, m) wave rotates to become the $(m, -(n + m))$ one, which in turn rotates to become the one with frequency pair $(-(n + m), n)$. Check that applying the transformation to this last pair takes us back to (n, m).

We are all set to apply the technique of group averaging. The *wave packet*

$$W_{n,m}(z) = \frac{1}{3} \left(E_{n,m}(z) + E_{m,-(n+m)}(z) + E_{-(n+m),n}(z) \right),$$

as the average of the function $E_{n,m}$ over the group we called \mathbf{C}_3, is invariant under 3-fold rotation. We will use such packets as fundamental building blocks for creating symmetry, because any superposition of these wave packets maintains the same invariance.

We now identify a second space of wallpaper functions:

$$\mathcal{F}_{p3} = \left\{ f(z) = \sum_{n,m \in \mathbb{Z}} a_{n,m} W_{n,m}(z) \mid a_{n,m} \in \mathbb{C} \right\}.$$

Figure 10.2. A wallpaper function with 3-fold rotational symmetry, depicted with a salad. The white shapes surround the Eisenstein integers, $a + b\omega_3$, $a, b \in \mathbb{Z}$.

You might guess correctly, based on the names of frieze groups, that the subscript p3 names the group of symmetries of these functions, with the p as something of a placeholder and the 3 indicating 3-fold symmetry. In Chapter 12 we explain the nomenclature of this and other groups. Here, we mention how functions in \mathcal{F}_{p3} might be constructed in practice: When superimposing waves to create symmetry, simply implement the *recipe*

$$a_{n,m} = a_{m,-(n+m)} = a_{-(n+m),n}.$$

Figure 10.2 shows the domain coloring of a function I chose from \mathcal{F}_{p3}, using a photograph of a salad as color wheel. The Eisenstein integers appear in the centers of white shapes that come from the rim of the plate. Let us use the term *3-centers* as an abbreviation for a center of 3-fold rotational symmetry. Spend time wandering through the image, which has some interesting features that we have not yet mentioned, as they will be best treated by the algebraic approach two chapters hence.

Another Accidental Symmetry

We close this chapter with one more thought about Figure 10.1. Practice with our new $[X, Y]$-coordinates by locating, relative to the black dot at 0, the points $[2, 1]$, $[4/3, 2/3]$, and $[2/3, 1/3]$. The pattern is quite similar at each of these points, differing only in color. In fact, as you progress from 0 along this line of points, the colors rotate from red to green to blue and back to red. In fact, you can check that

this function satisfies a *color-turning* condition:

$$f\left(z + \frac{2 + \omega_3}{3}\right) = \omega_3 f(z) \text{ for all } z \in \mathbb{C}.$$

This wave packet was not constructed to have this symmetry, but there it is, another example of accidental symmetry. We return to color-turning symmetry in Chapter 20.

EXERCISE 23

Use complex notation to investigate how certain symmetries interact, as follows: Suppose a function f belongs to \mathcal{F}_{p3}. In other words, suppose that f has the rotational and translational symmetries

$$f(z + 1) = f(z + \omega_3) = f(\omega_3 z) = f(z), \text{ for all } z.$$

By combining these formulas, show that $f(\omega_3 z + 1) = f(z)$ and $f(z) = f(\omega_3 z + 1 + \omega_3)$. Investigate the two transformations of the plane

$$T_1(z) = \omega_3 z + 1 \text{ and } T_2(z) = \omega_3 z + 1 + \omega_3,$$

which are evidently symmetries of f. Do this by finding fixed points (in each case, set $T(z_0) = z_0$ and solve) and drawing the image of a few points. You will need to use some handy formulas like $1/(1 - \omega_3) = (1 - \bar{\omega}_3)/3$, which you should justify. Identify the fixed points you found in Figure 10.2, and explain what you see there.

*** EXERCISE 24**

Continue the discussion of color-turning symmetry: Fix $j \in \{0, 1, 2\}$ and suppose that f is defined by a finite sum,

$$f(z) = \sum_{n,m \in \mathbb{Z}} a_{n,m} W_{n,m}(z),$$

where we also have

$$a_{n,m} = 0 \text{ except when } n - m \equiv j \pmod{3}.$$

Prove that, under these conditions, f satisfies

$$f\left(z + \frac{2 + \omega_3}{3}\right) = \omega_3^j f(z) \text{ for all } z \in \mathbb{C}.$$

(Using $[X, Y]$-coordinates will help a lot.) The equation says that f is periodic with respect to a smaller lattice when $j = 0$, color-turning through 120° when $j = 1$ and color-turning through 240° when $j = 2$. If we accidentally select frequency pairs whose sums share the same congruence modulo 3, we create accidental symmetry.

* EXERCISE 25

To prove that an averaged function \hat{f} is invariant under every transformation in \mathcal{G} seems to take longer to write out than to understand: Examine the definition of $\hat{f}(h(z))$ for any $h \in \mathcal{G}$ and see that the sum over $g \in \mathcal{G}$ can be reindexed. Justify the steps in the following computation.

$$\hat{f}(h(z)) = \frac{1}{n} \sum_{g \in \mathcal{G}} f(g(h(z))) = \frac{1}{n} \sum_{g \circ h \in \mathcal{G}} f(g \circ h(z)) = \frac{1}{n} \sum_{g \in \mathcal{G}} f(g(z)).$$

ANSWER FOR EXERCISE 23

To find fixed points for each transformation, we need to solve

$$\omega_3 z + 1 = z \text{ and } \omega_3 z + 1 + \omega_3 = z.$$

In the first case,

$$z = \frac{1}{1 - \omega_3} = \frac{1}{1 - \omega_3} \frac{1 - \bar{\omega}_3}{1 - \bar{\omega}_3} = \frac{1 - \bar{\omega}_3}{3} = \frac{2 + \omega_3}{3}.$$

In the second,

$$z = \frac{1 + \omega_3}{1 - \omega_3} = \frac{1 + \omega_3}{1 - \omega_3} \frac{1 - \bar{\omega}_3}{1 - \bar{\omega}_3} = \frac{\omega_3 - \bar{\omega}_3}{3} = \frac{\sqrt{3}}{3} i.$$

These transformations are $120°$ rotations about the midpoints of the triangle with sides 1 and $1 + \omega_3$ and the one with sides ω_3 and $1 + \omega_3$. In Figure 10.2, the fixed point of the first transformation appears as a 3-center surrounded by three red fish. The other point we have found looks like a rotor with avocado-colored blades. Every pattern assumed to the given translational and rotational symmetries must necessarily have these other symmetries.

Chapter 11

Waves, Mirrors, and 3-Fold Symmetry

Question: What other symmetries are possible in wallpaper functions with 3-fold symmetry? There are now two natural questions to ask about wallpaper functions with 3-fold symmetry: What additional symmetries can they have? And how can we be sure we have found all possible additional symmetries? We spend this chapter discovering additional symmetries and finding the recipes for functions that enjoy those symmetries. We postpone to the next chapter the question of whether we have covered every possible case. In other words, we are going to have dessert first.

Recall that a symmetry of a function $f(z)$ is a transformation of the plane $\alpha(z)$ so that $f(\alpha(z)) = f(z)$. For the rest of this chapter, let us assume that f is a function with symmetries $\tau_1(z) = z + 1$, $\tau_{\omega_3}(z) = z + \omega_3$, and $\rho_3(z) = \omega_3 z$. In other words, f is invariant with respect to translations by the Eisenstein integers and with respect to rotation through $120°$.

To preview the work of the next chapter, we remark that a function invariant with respect to τ_1 and ρ_3 must also be invariant with respect to τ_{ω_3}. This continues the theme: If a pattern has certain symmetries, it has all other symmetries that arise from those as compositions. You may wish to pause to show that τ_{ω_3} arises as a composition of τ_1 and ρ_3, but we proceed with the fun.

Having believed the main result of Fourier series for functions with lattice symmetry, we know that any (sufficiently smooth) wallpaper function with τ_1, τ_{ω_3}, and ρ_3 as symmetries can be written as a superposition of wallpaper waves:

$$f(z) = \sum_{n,m \in \mathbb{Z}} a_{n,m} W_{n,m}(z) \text{ where } W_{n,m} = \frac{E_{n,m} + E_{m,-(n+m)} + E_{-(n+m),n}}{3} \quad (11.1)$$

and $E_{n,m}(z) = e^{2\pi i(nX + mY)}$.

To gain intuition about what additional symmetries f may have, we realize that any symmetry of f must preserve the Eisenstein lattice. (This might be violated if f had accidental symmetries. For instance, if f were constant, any transformation in the world would leave it unchanged. In this discussion, we consider a general f.) Let us specialize to the case of transformations that leave the point 0 fixed. As it turns out, we will find everything we need among these transformations.

Three Special Symmetries

Figure 11.1 shows vectors that point to the vertices of a hexagon, each belonging to our lattice: ± 1, $\pm \omega_3$, $\pm(1 + \omega_3)$. We give special names to *some* of the symmetries that fix 0

and map the Eisenstein lattice to itself: We call σ_x and σ_y the reflections about the x- and y-axes; ρ_6 is rotation through $60°$. (What symmetries have we left out? An exercise will suggest a complete answer.)

The figure establishes a convention we will carry throughout: double lines indicate mirror axes.

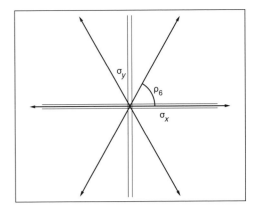

Reflecting across the Horizontal

The formula for reflection across the x-axis is easy to write down: $\sigma_x(z) = \bar{z}$. However, we will not be able to see what this does to a particular wave without writing it in $[X, Y]$-coordinates, where $z = X + Y\omega_3$. Again, the fine fact that $\overline{\omega_3} = -1 - \omega_3$ comes to the rescue, leading to the formula:

$$\sigma_x([X, Y]) = [X - Y, -Y].$$

After a bit of algebra, which I hope you will write down, this leads to

$$E_{n,m}(\sigma_x(z)) = E_{n,-(n+m)}(z).$$

Reflecting the (n, m) wave gives us the wave with frequency pair $(n, -(n + m))$. Curious. Imagine m and n switching roles and look back at (11.1); this is the middle wave in the packet that is $W_{m,n}$. This clue suggests something that we can check: Each of the waves in $W_{n,m}$ reflects to one of the waves in $W_{m,n}$. In symbols,

$$W_{n,m}(\sigma_x(z)) = W_{m,n}(z).$$

It is instructive to write this out with a particular wave packet. For instance, try writing out the three waves in $W_{2,3}$, reflecting each one, and seeing that these reflections are exactly the three wave components of $W_{3,2}$.

We can use this to create symmetry: By choosing $a_{n,m} = a_{m,n}$ in (11.1), we create a function with reflection symmetry across the x-axis. We formalize this recipe by naming a space of functions all having this same reflection symmetry:

$$\mathcal{F}_{\text{p31m}} = \left\{ \sum_{n,m \in Z} a_{n,m} W_{n,m}(z) \mid a_{n,m} = a_{m,n} \right\}.$$

Figure 11.2 shows an example, superimposing waves whose frequency pairs are $(1, 0)$, $(1, -2)$, $(1, 3)$, $(2, 4)$, and their reflective swaps. The beauty of the resulting image depends crucially on the choice of color wheel as well as the exact values of the coefficients; the process is entirely experimental. Here, the color wheel is a simple photograph of a spring bouquet—a bright daffodil with a blue hyacinth and white freesia.

As in our p3 example in the last chapter, this image displays many other symmetries than the ones we meant to force. By designing an image with reflection symmetry across the horizontal, we have created mirror symmetry across numerous other axes. The exact mechanism that causes the extra symmetries is group theory, the coming attraction of the next chapter. The group of symmetries of this pattern is called p31m, a somewhat unfortunate name, as I will explain when we learn more about it.

Figure 11.2. A wallpaper function with 3-fold rotational symmetry as well as mirror symmetry across the *x*-axis, created by the recipe $a_{n,m} = a_{m,n}$.

For me, the most interesting feature of Figure 11.2 is the contrast between mirror symmetry and lack of mirror symmetry: Strong mirror symmetry appears about axes through the points decorated by the yellow of the daffodil, but there are no mirror axes through the undulating blue rotors.

I count this as a mathematical success because the image illustrates the symmetry very clearly, but the aesthetics also delight me: The texture of the hyacinth petals gives motion to the blue rotors, and the white of the wall in the background provides relief from the strong yellow. The dark red of the subtle borders that outline the blue shapes comes from the pot of the green houseplant peeking out from behind the flowers, which gives a touch of green to the dominant yellow shapes. If I wanted to ask for more, I'd see if the white shapes between blue rotors could look more like angels or birds.

Reflecting across the Vertical

Leaving the details as an exercise, we simply report that the formula for reflecting wave packets across the vertical axis is just as simple and surprising as for the horizontal. We find that $\sigma_y([X, Y]) = [Y - X, Y]$, which leads to

$$W_{n,m}(\sigma_y(z)) = W_{-m,-n}(z).$$

This quickly gives a recipe and a new space of functions. To create functions invariant under this vertical reflection, we require $a_{n,m} = a_{-m,-n}$ and (again asking

Figure 11.3. A wallpaper function with 3-fold rotational symmetry as well as mirror symmetry across the y-axis, created by the recipe $a_{n,m} = a_{-m,-n}$.

the reader's patience with the notation p3m1) name a function space

$$\mathcal{F}_{\text{p3m1}} = \left\{ \sum_{n,m \in Z} a_{n,m} W_{n,m}(z) \mid a_{n,m} = a_{-m,-n} \right\}.$$

Figure 11.3 shows the domain coloring of a function I chose from $\mathcal{F}_{\text{p3m1}}$. Instead of a simple photograph, the color wheel is a collage of photographs: Sierra gooseberries, a peach, and their negatives, set against a background of granite. What a lot of mirror symmetry! In the next section, we will see how these mirrors multiply. For now, we enjoy their presence. Between p31m and p3m1, which pattern type do you find more appealing?

Rotation through 60°

Our whole setup of the Eisenstein lattice was geared toward creating 3-fold symmetry, but it turns out to be ideally suited to study 6-fold symmetry as well. We develop a recipe for functions invariant under 6-fold rotation by a technique that might seem a bit like cheating. We ask, What if a function has 2-fold *and* 3-fold rotational symmetry? We will see that 2 and 3 make 6 in this case. We first observe that rotation through 180° is

$$\rho_2(z) = -z$$

Figure 11.4. A wallpaper function with 6-fold rotational symmetry but no mirror symmetry, created by the recipe $a_{n,m} = a_{-n,-m}$.

and then compose this rotation with *the inverse* of ρ_3:

$$\rho_2(\rho_3^{-1}(z)) = -e^{-2\pi/3}z = e^{\pi i}e^{-2\pi/3}z = e^{2\pi/6}z = \rho_6(z).$$

The astute reader may see us sneaking up on the group theory of the next chapter: We are using the fact that the composition of two symmetries of a function must also be a symmetry of that function. Therefore, if we require that f be invariant under 2-fold rotation and if we already know that f is a superposition of 3-fold symmetric waves, then f will indeed have 6-fold symmetry. We name another function space to encode the recipe:

$$\mathcal{F}_{p6} = \left\{ \sum_{n,m\in Z} a_{n,m}W_{n,m}(z) \mid a_{n,m} = a_{-n,-m} \right\}.$$

An illustrative function from \mathcal{F}_{p6} (Figure 11.4) is depicted with a photograph of an heirloom tomato and an avocado, along with the knife that cut them. The orange of the knife handle did not make it into the image—the function I chose never called for that complex value.

Look ahead to the next chapter by asking, What additional symmetries seem to have been forced on this function by the recipe? Do you see the 3-fold *and* 2-fold rotational symmetries? Do these symmetries necessarily follow from the imposition of 6-fold rotational symmetry, or do they fall into the category of accidental symmetry?

EXERCISE 26

Prove the formula $\rho_6([X,Y]) = [X-Y, X]$ by multiplying $X + Y\omega_3$ by $e^{2\pi i/6} = -\bar{\omega}_3$. Use this formula for another proof that

$$W_{n,m}(\rho_6(z)) = W_{-n,-m}(z).$$

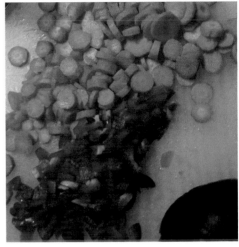

Figure 11.5. A wallpaper function with 6-fold rotational symmetry as well as mirror symmetry across additional axes, created by the recipe $a_{n,m} = a_{-n,-m} = a_{m,n}$.

Combinations of σ_x, σ_y, and ρ_6

In the category of patterns with 3-fold rotational symmetry, we have identified three different additional symmetries that we can "turn on" with specific recipes. It might seem that we could pick any two of them and find a new pattern type. Since choosing any two from a group of three can be done in three different ways, we might think that there are three more types to consider. If you think this chapter has already gone on long enough, you will be happy to hear that this is not the case.

We easily check that the conditions

$$a_{n,m} = a_{m,n} \text{ and } a_{n,m} = a_{-m,-n} \text{ together imply } a_{n,m} = a_{-n,-m}.$$

Similarly, you can check that any two of the recipes imply the third. Once we have turned on two of our additional symmetries, all three must be present. We name the function space whose waves are tuned together in exactly the right way to impose all of the symmetries in Figure 11.1 at once:

$$\mathcal{F}_{\text{p6m}} = \left\{ \sum_{n,m \in Z} a_{n,m} W_{n,m}(z) \mid a_{n,m} = a_{-n,-m} = a_{m,n} \right\}.$$

The way we wrote this, \mathcal{F}_{p6m} appears to be $\mathcal{F}_{\text{p6}} \cap \mathcal{F}_{\text{p31m}}$, but it is also $\mathcal{F}_{\text{p3m1}} \cap \mathcal{F}_{\text{p31m}}$ and $\mathcal{F}_{\text{p3m1}} \cap \mathcal{F}_{\text{p6}}$.

Continuing the food theme, I used a photograph of carrots and peppers on a cutting board, along with the recipe for p6m functions, to create Figure 11.5,

which rather goes overboard in mirror symmetry. I like the way the function makes carrot cross sections at the 6-centers: making carrots out of carrots. Again, we ask whether all the symmetries present in this image follow necessarily from the recipe; might some be accidental? We answer this question in the next chapter, first offering some exercises to set up the work ahead.

A WORD ABOUT RECIPES. I trust that you have caught on to my use of the word *recipe* as a set of instructions to choose coefficients in a particular type of Fourier series to create symmetries of a desired type. Five recipes for functions with various symmetry types are scattered through this chapter. For convenience, I have gathered all the recipes in Appendix B.

EXERCISE 27

In Figure 11.1 we seemed to prefer reflections across the coordinate axes. In this exercise, we investigate other mirror axes. As before, let σ_x denote the reflection of the plane about the x-axis, let σ_y be reflection about the y-axis, and let ρ_2, ρ_3, and ρ_6 be rotations about the origin through $180°$, $120°$, and $60°$, respectively. This means that, for instance, $\rho_6(z) = e^{2\pi i/6}z$. Use complex algebra to show that $\sigma_c = \rho_3\sigma_x$ is a reflection that exchanges 1 and ω. Compare σ_c with $\sigma_x\rho_3$. What can you say about $\sigma_y\rho_3$? Compare it with $\rho_3\sigma_y$. Which transformation that we saw in this chapter is the same as the composition $\sigma_x\sigma_y$? Show that the group generated by σ_x and ρ_3 is (an isomorphic representation of) the dihedral group \mathbf{D}_6.

* EXERCISE 28
Distant Mirrors, Distant Translations

In the previous problem, we studied only transformations that fix the origin. It turns out that when you have translations, you can create rotations and reflections about distant points. For instance, do the computations to find the fixed points of the transformation $\sigma(z) = 2d - \bar{z}$, where d is real. Explain what σ does to the plane. Explain why the formula

$$\rho_v(z) = \omega_3(z - v) + v$$

gives a rotation of $120°$ counterclockwise about the point v. You might not recognize the rotation if it were given to you as $\omega_3 z + v(1 - \omega_3)$. Apply this to compute the rotation of $120°$ counterclockwise about the point $(2 + \omega_3)/3$ and find this symmetry in all the images in this chapter. (Don't forget to simplify with $\omega_3^2 = -1 - \omega_3$.)

Chapter 12

Wallpaper Groups and 3-Fold Symmetry

Question: What algebraic structures describe the symmetries of functions with 3- or 6-fold rotations? If a pattern has certain symmetries, then it has all other symmetries that arise as compositions of those. This sounds like a weak principle; in this chapter, we show just how strong it is. As we have pointed out before, the composition law is the heart of the proof that the symmetries of a pattern form a group, called the symmetry group of the pattern. For us, patterns are complex-valued functions on (some subset of) the plane, and we have exhibited many spaces of functions guaranteed to be invariant under certain symmetries.

It is now time to justify the names given to the five function spaces in the last chapter. We will be able to see why these are the only spaces of functions needed to create the various types of symmetry that involve 3-fold rotation.

The Group p3

The functions in \mathcal{F}_{p3} were constructed to have symmetry with respect to the Eisenstein lattice, as well as 3-fold rotational symmetry. What other symmetries devolve from those? How can we specify the totality of symmetries with the minimal number of generators?

First, let us notice, through a simple computation, that

$$\tau_{\omega_3} \circ \rho_3(z) = (\omega_3 z) + \omega_3 = \omega_3(z + 1) = \rho_3 \circ \tau_1(z).$$

Let us dispense with the \circ for function composition. This allows us to rewrite

$$\tau_{\omega_3}\rho_3 = \rho_3\tau_1 \text{ as } \tau_{\omega_3} = \rho_3\tau_1\rho_3^{-1}.$$

This shows that τ_{ω_3} can be generated from τ_1, ρ_3, and ρ_3^{-1}, which, in turn, shows that any group containing τ_1 and ρ_3 must also contain τ_{ω_3}, since it must also have the inverse of every element.

We pause to point out that the expression $\rho_3\tau_1\rho_3^{-1}$ is called the *conjugate* of τ_1 by ρ_3. Conjugation is an important tool in group theory and we will use it many times. (In fact, it provided the main idea for Exercise 17 in Chapter 8.)

Let us use p3 to denote the smallest group of transformations of the plane that contains τ_1 and ρ_3. This is the International Crystallographers Union's notation for the group, or more specifically, the abstract group of which our particular transformation group is a representation. (That again.) The crystallographic

notation for these groups is not nearly as easy to explain as the frieze notation, where each letter in the name stood for something specific. A strength of the notation, and probably the reason it is used by scientists outside of mathematics, is that it tells us what to look for in patterns: the 3 signals 3-fold rotation and appears after a sort of initial placeholder p, which you might imagine means *plane* but, in fact, refers to *primitive*, a concept best explained much later when we can contrast it with to *centered*, which puts a letter c in that initial position. (I told you it was not easy to explain.) Alternative notations (for instance, from Conway, who calls this group 333) emphasize other aspects of the groups. To be an expert, one should probably learn all the notations, but for us, one will suffice.

We write our definition for this group as p3 = $\langle \tau_1, \rho_3 \rangle$, meaning that these two transformations *generate* p3, in the sense that every element of p3 can be written as a composition that uses only powers of these two and their inverses. Our computation shows that p3 contains τ_{ω_3} as well. It is permitted to write p3 = $\langle \tau_1, \tau_{\omega_3}, \rho_3 \rangle$, but that would not exhibit a *minimal* set of generators.

We use the notation p3 with the usual caveat that this is actually an isomorphic representation of p3. If someone wanted to generate a group from $\tau_{\sqrt{2}}$ and ρ_3, they would get an isomorphic copy of our group, and their images would be scaled by $\sqrt{2}$. The group $\langle \tau_{i\sqrt{2}}, \rho_3 \rangle$ is the same group but scaled and rotated by $90°$. We ask the indulgence of using the notation p3, even though this is but one manifestation of the abstract group p3. As we continue, we will not belabor this point.

If we think only about the translations in p3, we find the translational subgroup of p3. In contrast with frieze groups, the translational subgroup here has two independent translations, and we can write it as

$$\{ \tau_1^n \tau_{\omega_3}^m \mid n, m \in \mathbb{Z} \}.$$

We can check that the multiplication in the group is commutative and so satisfies

$$\tau_1^{n_1} \tau_{\omega_3}^{m_1} \tau_1^{n_2} \tau_{\omega_3}^{m_2} = \tau_1^{n_1+n_2} \tau_{\omega_3}^{m_1+m_2}.$$

In this operation of composing translations, the *n*s and *m*s behave independently, as if there were one operation for the *n*s and another for the *m*s. This is an example of what we call a *direct product* of two groups. Here, we say that the translational subgroup is isomorphic to a direct product two copies of \mathbb{Z}, one for the *n*s and another for the *m*s, which we write as $\mathbb{Z} \oplus \mathbb{Z}$. Each group—the translational subgroup and the product group—is really just a set of ordered pairs of integers that are added componentwise.

We use the term *wallpaper group* for any group of isometries of the plane whose translational subgroup is isomorphic to $\mathbb{Z} \oplus \mathbb{Z}$. If this sounds too technical, simply think of a wallpaper group as one whose set of translations is generated by two translations in different directions. So p3 is our first wallpaper group!

Evidently, every function in \mathcal{F}_{p3} is invariant under the group p3—hence the name. Are there other symmetries enjoyed by these functions?

As an earlier exercise, I asked you to analyze the composition

$$\hat{\rho}_3 = \tau_1 \circ \rho_3(z) = \omega_3 z + 1. \tag{12.1}$$

Let us confirm, as I hope you found, that this is a rotation through $120°$ counterclockwise about the point $(2 + \omega_3)/3$: We do this by constructing a transformation with that description and finding that the formula agrees with (12.1). We use the technique of the last exercise in the previous chapter, which we first review.

In order to rotate the plane about the point $(2 + \omega_3)/3$, we first translate the point to the origin, rotate about the origin, and then move that point back where it was. Try acting this out with your hand on a piece of paper to see that the composition does indeed give the desired rotation. In symbols, the stages of the transformation are

$$z \to z - \frac{2 + \omega_3}{3} \to \omega_3 \left(z - \frac{2 + \omega_3}{3} \right) \to \omega_3 \left(z - \frac{2 + \omega_3}{3} \right) + \frac{2 + \omega_3}{3}.$$

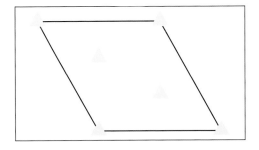

Figure 12.1. The cell diagram for the group p3.

The last expression simplifies to $\hat{\rho}_3(z) = \omega_3 z + 1$, justifying our claim.

What does this mean? Since τ_1 and ρ_3 are symmetries of every function in the space \mathcal{F}_{p3}, every such function also has the composition as a symmetry. Look back to Figure 10.2 and see that it does indeed have 3-fold rotational symmetry about the point $(2 + \omega_3)/3$. I see that point as having three red Dr. Seuss fish swimming clockwise about it. Since the pattern has 3-fold rotational symmetry about this point but the point is not related to the origin by a translational symmetry, I call it a *nontranslationally related* 3-*center* of the pattern, in relation to the origin. This is a mouthful, but it will be useful as we proceed.

A similar analysis shows that having τ_1 and ρ_3 as symmetries is enough to guarantee 3-fold rotational symmetry about the point $(1 + 2\omega_3)/3$. Look back and find this point in Figure 10.2—a three-way avocado airplane propeller?

These two nontranslationally related 3-centers are the tip of an infinite iceberg of such 3-centers. When we translate either of these by any Eisenstein integer, we get still more 3-centers. The symmetries of this pattern are so numerous that we cannot hope to name them all.

There is a happy way to summarize the features of the group p3. We diagram a *fundamental cell*, which is a parallelogram whose sides are lattice generators. We decorate the diagram with conventional notations that show additional symmetries that belong to the group. We make an additional rule that centers of rotation, if present, must be shown at corners of the cell.

For p3, the parallelogram has sides 1 and ω_3. We indicate the 3-centers by drawing triangles at the corners of the cell. We also draw triangles to show the two nontranslationally related 3-centers in the interior. The result appears in Figure 12.1. Note that if you and your friend choose different 3-centers as corners of the cell, your diagrams will, nonetheless, be exactly the same.

Groups p31m and p3m1

In the last chapter, we found that when we introduced one single mirror condition, using one of our wave recipes, the pattern formed seemed to inherit numerous other mirrors. Now we show how the group condition is responsible for this propagation of symmetries. Let us name two groups, recalling that σ_x and σ_y are the reflections about the x- and y-axes:

$$\text{p31m} = \langle \tau_1, \rho_3, \sigma_x \rangle \text{ and p3m1} = \langle \tau_1, \rho_3, \sigma_y \rangle.$$

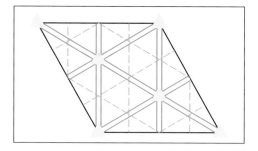

Figure 12.2. The cell diagrams for the groups p31m (top) and p3m1 (bottom).

We will see that these similar definitions lead to rather different groups. One clue to follow is that σ_x is a reflection parallel to a translation direction, while the axis of σ_y is perpendicular.

In an exercise in the last chapter, we established some facts, which I invite you to check now or simply accept. In the new notation, we summarize the facts as follows: The group p31m contains three reflections with axes at angles 0°, 60°, and 120° relative to the horizontal, while p3m1 has reflections with axes at 30°, 90°, and 150°. We will show these with a diagram presently, but a look back at Figure 11.1 may help.

How do we know that these two groups are really different? Could they be two different isomorphic representations of the same abstract group? A superficial analysis might say, Three generators, one translation, one 120° rotation, and one mirror—must be the same group. We critique this by observing a difference in the relations among the generators of the two groups. Some easy algebra leads to the formulas

$$\sigma_x \tau_1 \sigma_x = \tau_1 \text{ while } \sigma_y \tau_1 \sigma_y = \tau_1^{-1}.$$

Again, acting this out by flipping and sliding your hand on a table can replace the algebra, at some risk to your shoulder. (Best to start with the palm down to test the right-hand formula.)

These relations are evidence that the groups are different, but perhaps they are only *presented* differently. The business of proving that no evil genius could devise a clever isomorphism between the two is best done by advanced techniques— *group cohomology* is the name of the most powerful hammer for this purpose. There is, however, something more practical that we can observe to see that the two groups are different.

Recall that the composition $\hat{\rho}_3 = \tau_1 \rho_3$ is a rotation that fixes the point $(2+\omega_3)/3$. Let us consider the set of all the transformations in p31m that fix this same point, which is called the *stabilizer* of $(2 + \omega_3)/3$, and this is a *subgroup* of p31m. A quick look at Figure 11.2 confirms that there are no reflections in this subgroup; the stabilizer there is isomorphic to the cyclic group \mathbf{C}_3. On the other hand, the stabilizer of $(2 + \omega_3)/3$ in p3m1 does indeed contain a mirror reflection. As it contains the rotation $\hat{\rho}_3$, it is isomorphic to the dihedral group \mathbf{D}_3. We take this as enough to convince us that the groups are not isomorphic.

The understanding that we indeed have two different groups is confirmed when we produce their cell diagrams. Figure 12.2 shows the two diagrams. This may be the place to apologize, on behalf of the International Union of Crystallographers, for the nomenclature. Rest assured that this is the worst example of nonintuitive naming. We could see the first slot after the 3 in p31m as representing the vertical mirror, where the 1 indicates that it is not present. I remember them by telling myself that the m being close to the 3 means "more mirrors," meaning that every 3-center in a p3m1 pattern has a mirror axis through it.

We have not explained the presence of dashed lines in Figure 12.2. Before I tell you what they are, you may enjoy examining the axes indicated by these dashed lines in Figures 11.2 and 11.3. In each case, they are parallel to mirror axes, which is an important clue.

In cell diagram notation, a dashed line indicates a *glide reflection*, which is the composition of a mirror reflection and a translation in the direction of the mirror axis. These flip and slide transformations should be familiar from our

work with frieze patterns. In Figure 12.2, reflecting across any of the dashed lines does violence to the figure, until you slide half a unit (in $[X, Y]$-coordinates) along the line, at which point the triangles indicating 3-fold rotation line up again. See that these symmetries are also present in Figures 11.2 and 11.3.

You might imagine, What if I wanted to create a pattern with 3-fold symmetry, but *only* those glide reflections and none of the mirror symmetries?. Perhaps there are other groups waiting to be discovered. Let us study this idea with one specific glide and take it as a token for all the rest.

Consider the transformation, in $[X, Y]$-coordinates, $\gamma([X, Y]) = [Y + 1, X]$. First, let us see why this is a glide reflection: A search for fixed points of the transformation leads us to the condition $Y = Y + 1$; there are none. With a little creativity, touching back on the idea of parametrization from Chapter 1, we see that points on the the the line $L(t) = [t, t - \frac{1}{2}]$ are moved by γ to $[t + \frac{1}{2}, t] = L(t + \frac{1}{2})$—other points on the same line. This shows that the line $Y = X - \frac{1}{2}$ is an *invariant line* of the transformation. Second, we notice that $\gamma^2 = \tau_1 \tau_{\omega_3}$, so doing the transformation twice is the same as sliding the plane up the diagonal of the fundamental cell. These two facts together show that γ is a glide reflection, the one whose axis is the dashed line in the lower-right corner of the p31m cell.

If we love glides but not mirrors, could we create a wallpaper group that includes ρ_3 and γ, but no reflections? A little computation confirms that

$$\tau_1^{-1} \gamma([X, Y]) = [Y, X].$$

This is the coordinate version of the transformation we called σ_c in the last chapter—reflection across the line that divides the cell into two equal triangles. (Recall that $\sigma_c = \rho_3 \sigma_x$.) Thanks to our understanding of groups, we see that you cannot have γ and τ_1 without having a reflection as well. And we know that once you have σ_c, you must have σ_x, and so on. Another way to rearrange the same information: Write $\gamma = \tau^{-1} \sigma_c$ to see that γ must belong to any group that has τ_1 and σ_c.

It is also interesting to return to the wave approach of the last chapter and ask: What recipe creates wallpaper functions that have γ as a symmetry? We find out by computing

$$E_{n,m}(\gamma(z)) = e^{2\pi i(n(Y+1)+mX)} = E_{m,n}(z).$$

To turn on γ symmetry, we would require that $a_{n,m} = a_{m,n}$—the same recipe as for turning on the σ_x mirror.

Though we never intended to create glide reflections, they come along as a bonus from the mirrors and translations we selected. Our example treated a single glide reflection that appears in p31m. The others in p31m and all the many glides in p3m1 submit to the same treatment: they are compositions of the given generators.

Groups p6 and p6m

In the discussion of Figure 11.4, we wondered whether the appearance of 2-fold and 3-fold rotational symmetries was a necessary consequence of the 6-fold and

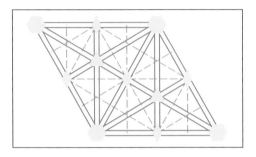

Figure 12.3. The cell diagrams for the groups p6 (top) and p6m (bottom).

EXERCISE 32

EXERCISE 32
Lengths in [X,Y]-Coordinates

I intended for the previous exercise to create just a bit of cognitive dissonance as you sketched the line $Y = 2X - \frac{1}{2}$ and found it to be the vertical line through the center of the cell. Working in skew coordinate systems is probably unfamiliar. Continue the investigation by finding the correct formula for the distance from the point $[X, Y]$ to the origin. Advice: Write $z = X + Y\omega_3$ and compute $z\bar{z}$ as the square of this length. Draw the point $[1, 1]$ and confirm that it lies on the unit circle.

translational symmetries we imposed on the pattern. You can probably guess by now that the answer is yes. We define the group

$$p6 = \langle \tau_1, \rho_6 \rangle$$

and investigate what other transformations must follow along from having these two. Since $\rho_6^2 = \rho_3$, we already get all the transformations in p3; this means that we will certainly see the same non-translationally-related 3-centers that we see in p3 patterns.

For 2-fold symmetry consider the transformation

$$\rho_6^3 \tau^{-1} : [X, Y] \rightarrow [1 - X, -Y].$$

Since it has a single fixed point at $[\frac{1}{2}, 0]$ and its square is the identity, this must be a rotation through $180°$ about that fixed point—what we call a 2-center. This was a coordinate-dependent computation; the same reasoning goes through to show that between any two translationally related 6-centers, we must find a 2-center. Look back at Figure 11.4 to confirm this. The locations of the various required rotational centers are shown on the top in Figure 12.3. Cell-drawing conventions hold that 6-centers are represented by hexagons, while 2-centers appear as diamonds.

When we include either of σ_x or σ_y in p6 to expand our group, we get the same result, which we call p6m. Formally,

$$p6m = \langle \tau_1, \rho_6, \sigma_x \rangle = \langle \tau_1, \rho_6, \sigma_y \rangle.$$

To see why these are the same, verify the formula

$$\rho_6^3 \sigma_x = \sigma_y.$$

Once we include one, and hence both, of these mirrors in our group, we pick up all the glides that they entail. This leads to a very complicated cell diagram, as you can see from the bottom part of Figure 12.3.

We leave as an exercise some checking to show that the 5 groups whose cell diagrams we have shown are the only ones anyone can find. This is a good time to preview the result that there are only 17 different (isomorphism classes of) wallpaper groups altogether! With all the choices available, no one can make a pattern with symmetry that repeats in two directions unless it falls into one of the 17 categories. We will not prove this as a single theorem, instead spreading out the proof through the next several chapters.

The knowledge that the wallpaper groups have such a limited number, 17, has broad impact. Crowe and Washburn's excellent book, *Symmetries of Culture* [19] highlights how this result has affected the cultural analysis of folk art. Doris Schattschneider documented a fascinating story about how Pôlya's version of this theorem informed the work of Dutch artist M. C. Escher [17]. Later in this book, we open the discussion to color-reversing and color-turning symmetries, which give ways to refine classifications into more than 17 pattern types. Even so, the 17 wallpaper groups, for me, figure as prominently as the 5 Platonic solids in my feeling that these things were there waiting for us to discover them, rather than human creations. So call me a Platonist.

EXERCISE 33
*Why There Are Only 5 Wallpaper Groups with 3-Fold Rotational Symmetry

Suppose G is a wallpaper group with 3-fold rotational symmetry. Without loss of generality, we scale and rotate G so that the specific translation τ_1 is in G and is as short as any translation in G. We translate if necessary so that the specific rotation ρ_3, which fixes the origin, is in G. This means that G contains p3 as a subgroup, and that all the translations in G are translations by Eisenstein integers, $a + b\omega$.

For now, we will work under the assumption—to be justified later—that any transformation in G always takes a lattice point to another lattice point. Having to assume this weakens our rigor a bit, but the exercise is more fun under this assumption.

Suppose that G contains some element g that is *not* in p3. We offer a sequence of steps to show that g belongs to one of the groups we have already met. Please draw pictures of the various possibilities as you go along.

Our assumption tells us that $g(0) = a + b\omega$ for $a, b, \in \mathbb{Z}$. Define a new isometry, which also belongs to G, by $h = \tau_1^{-a}\tau_{\omega_3}^{-b} g$ and show that $h(0) = 0$. Use the isometry condition to show that $h(1) = e^{i\theta}$. Our assumption about lattice points now says that $\theta \in \{0, \pm 2\pi/6, \pm 2\pi/3, \pi\}$. Define another new isometry $\alpha = \rho_{-\theta}(h(z)) = e^{-i\theta}h(z)$. (We are rotating to move $h(1)$ to 1.) Now we have $\alpha(0) = 0$ and $\alpha(1) = 1$. Use the isometry condition again to show that $\alpha(\omega_3)$ is ω_3 or $\bar{\omega}_3$, since these are the only two points on the unit circle that have the right distance from 1.

If $\alpha(\omega_3) = \omega_3$, then α fixes three points and must be the identity transformation ι. (My favorite reference for this theorem is Sibley's text [18].) In this case, show that $g = \tau_1^a\tau_{\omega_3}^b\rho_\theta$. Depending on the angle θ, we find that $g \in$ p3 or p6.

If $\alpha(\omega_3) = \bar{\omega}_3$, then show that $\sigma_x\alpha = \iota$. In this case, trace back through the definitions to show that $g = \tau_1^a\tau_{\omega_3}^b\rho_\theta\sigma_x$. Now $g \in$ p31m or p3m1, depending on the angle θ. You may wonder why p6m did not show up: We considered only a single element $g \in G$. Since p6m = p6 \cap p31m, and so on, we would need to examine two different elements to learn that G = p6m.

Chapter 13

Forbidden Wallpaper Symmetry: 5-Fold Rotation

Question: Why is it impossible to make wallpaper with 5-fold symmetry? This chapter proves that no one can make wallpaper—meaning a pattern with symmetry that repeats in two independent directions—that also has 5-fold rotational symmetry. Of course, being told that something is impossible might make you want to try, so I will show you what it looks like to modify our method that made periodic functions with 3-fold symmetry, in the hope of changing 3 to 5. We will see exactly what goes wrong.

In the spirit of experimentation, I offer Figure 13.1. I made it by taking a simple, real-valued sine wave (colored so that blue means +1 and red means −1) and averaging it over the cyclic group generated by rotation through 72°. Back in Figure 10.1, doing almost the same thing with 120° led to a periodic pattern, so why not try that here?

In Figure 13.1, the origin is the white spot near the lower left. There is actual 5-fold symmetry about that point, though you will have to trust me that this is so, since you cannot see to the lower left of the origin. The reason I don't expand the view to show more beyond the lower left is that later you will need to be able to look at the upper right.

Wander through the image to see if you find any repeats. I find myself fooled into thinking that there is indeed translational symmetry in two different directions. In this chapter, I explain why the image is an amusing cheat and then proceed to some more useful information about wallpaper in general. First, let us prove that Figure 13.1 cannot really be a wallpaper pattern with 5-fold symmetry.

The Crystallographic Restriction

A central part of the proof that there are exactly 17 wallpaper groups is a geometric fact known as *the crystallographic restriction*. To state it, we need to recall that the *order* of an element of a group is the smallest power to which we can raise the element and arrive at the identity of the group, in other words, the lowest n such that $g^n = \iota$. Using this language, the crystallographic restriction is:

> If G is a wallpaper group and ρ is a rotation in G, then the order of ρ is one of 2, 3, 4, or 6.

In particular, there cannot be a rotation of order 5. We will prove the general statement later, but let us analyze the possibility of 5-fold rotation; it takes us on a curious journey.

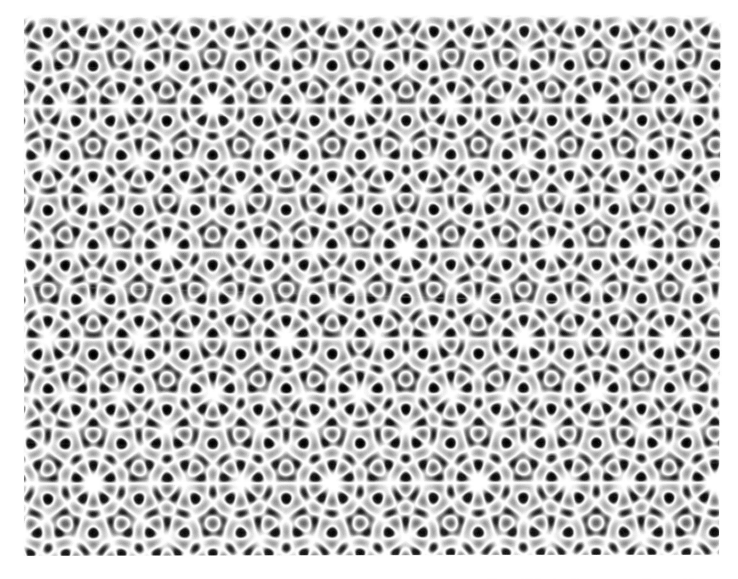

Figure 13.1. An effort to create wallpaper with 5-fold symmetry.

Suppose G is a wallpaper group, meaning that its translational subgroup is generated by two linearly independent translations, and suppose that G contains the transformation $\rho_5(z) = e^{2\pi i/5}z$. Perhaps by rotating and scaling, assume that the translation $\tau_1(z) = z + 1$ is a shortest translation, meaning that it is as short as any translation in G.

As we analyzed 3-fold rotational symmetry, the operation of conjugation gave us a way to generate a second independent translation from one translation and one rotation. Let us review the idea with Figure 13.2, where the origin is O and A has coordinates $(1, 1)$, so that τ_1 is a translation along \overrightarrow{OA}. We form two different conjugates of τ_1, by ρ_5 and its inverse:

$$\alpha_1 = \rho_5\tau_1\rho_5^{-1} \quad \text{and} \quad \alpha_2 = \rho_5^{-1}\tau_1\rho_5.$$

A quick computation shows that these are translations in directions $72°$ above and below the horizontal with translation vectors labeled \overrightarrow{OC} and \overrightarrow{OB}.

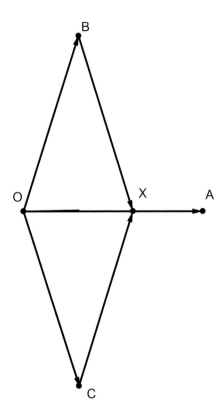

Figure 13.2. Conjugation by rotations produces a shorter translation than the one presumed to be shortest.

The sum of these vectors is labeled \overrightarrow{OX}, a translation vector in G that is evidently shorter than 1, contrary to hypothesis. This is the problem with 5-fold rotation: Given a translation claimed to be the shortest one in G, 5-fold rotation produces a new translation that is shorter.

The situation becomes more intriguing when we compute the ratio

$$\frac{1}{|OX|} = \frac{1 + \sqrt{5}}{2},$$

the golden ratio! (An exercise will outline details to help you prove this.) Refer back to Figure 13.1 and find any vector that appears to you to be a symmetry of the image. Shrink that vector by a factor of the golden ratio (about $1/1.618 \approx 0.618$) and critique the quality of that translation as a symmetry of the pattern. If the pattern really had translational symmetry, this shorter translation would also have to be a symmetry, as well as the translation that's about 62% shorter than that, and so on, forever. For a large initial translation, the shorter translation may look reasonably like a symmetry, but the sameness of the pattern seems to degrade as we repeat the process. In fact, there are no translational symmetries in this pattern, only translations that are close to being symmetries.

For a bit more detail, let me draw your attention to the white point at the far right edge of Figure 13. The coordinates of that seeming center of 5-fold rotational symmetry are close to $(13, 0)$. Shrink the vector from $(0, 0)$ to $(13, 0)$ by the golden ratio to find a point near $(8, 0)$; shrink again to find $(5, 0)$, or thereabouts. When we shrink again to $(3, 0)$ the breakdown in symmetry is almost complete. The appearance of the Fibonacci numbers in this example might not be too surprising, once the golden ratio has shown up.

The function obtained by averaging the sine wave over 5-fold rotation is called a *quasiperiodic function*. They are a 2-dimensional version of the *almost-periodic functions* discovered by Harald Bohr around 1905. For the full details of this story, including details about the role of the Fibonacci numbers, you may wish to read my article in the *Notices* [3].

EXERCISE 34

Call $(1+\sqrt{5})/2 = \phi$ and $e^{2\pi i/5} = \omega_5$. Drawing a quick diagram might be enough to convince you that

$$\sum_{k=0}^{4} \omega_5^k = 0.$$

If the diagram is not enough, prove this using algebra by dividing $z^5 - 1$ by $z - 1$ and use the fact that ω_5 is a zero of that fifth-degree polynomial. Use the summation identity to prove that, in Figure 13.2,

$$\frac{1}{|OX|} = \phi.$$

Limited Lattices

We tried and failed to make a wallpaper group containing the translation τ_1 and the rotation ρ_5. Here, we investigate the possibilities for groups with τ_1 and the rotation ρ_p, where $p > 2$ (and evidently not 5).

Once we have τ_1 and ρ_p, the usual conjugation trick gives us a translation along a vector of length 1,

$$\tau_{\omega_p}(z) = z + e^{2\pi i/p}.$$

If these are to be shortest translations, the set of translates of the origin must consist only of points in the lattice

$$\Lambda_{1, \omega_p} = \{a + b\omega_p \mid a, b \in \mathbb{Z}\}.$$

(Check that if 0 translates to any point not belonging to this lattice, we can use composition to find a translation shorter than τ_1. After all, every point in the plane can be written as $s + t\omega_p$ for real numbers s and t, and if this point is a translation image of 0, we can translate back using integer parts of s and t to find a translation with fractional multiples of 1 and ω_p, which is shorter.)

We can translate 0 to 1 and then rotate it to ω_p. If we rotate again, we have moved 0 to ω_p^2 and conclude that this must also be a lattice point. Therefore, we must have integers a and b so that

$$\omega_p^2 = a + b\omega_p. \tag{13.1}$$

In an exercise, we walk through the proof that this condition can only hold when $p = 3, 4$, or 6. This completes the proof of the crystallographic restriction. (We did not need to consider any special lattice for 2-fold rotation; we will see that 2-fold rotation occurs as a symmetry of every lattice.)

EXERCISE 35
Confirming the Crystallographic Restriction

We use algebra to analyze (13.1); it is also possible to use a purely geometric approach, which we leave to the reader. Rewrite (13.1) using the Euler formula (2.1). Take the imaginary part of each side and cancel to show that

$$\cos\left(\frac{2\pi}{p}\right) = \frac{b}{2}.$$

Explain why we reject any possibilities except $b = 0, \pm 1$, and show that these lead to $p = 3, 4$, and 6. Check back with the real part of each side of (13.1). Find the a's that go with the possible choices of b's and interpret geometrically. This short list of possibilities for rotational symmetry will inform our work in the next few chapters.

**** EXERCISE 36**
A Strange Group

(This exercise assumes some linear algebra. Nothing in the rest of the book depends on this exercise, so feel free to move on.)

Let $\omega_5 = e^{2\pi i/5}$ and write $z = X + Y\omega_5$, where you should verify that $X = x - y\cot(2\pi/5)$ and $Y = \csc(2\pi/5)y$. Verify the rotation formula in these coordinates,

$$\omega_5 z = -Y + \left(X + \frac{Y}{\phi}\right)\omega_5,$$

where $\phi = (1 + \sqrt{5})/2$ is the golden ratio. It is interesting to write this rotation in matrix form:

$$R_5 = \begin{pmatrix} 0 & -1 \\ 1 & \frac{1}{\phi} \end{pmatrix}.$$

(continued)

(We will write $[X, Y]$ as a column vector and multiply it on the left by R_5 to get a column vector with the coordinates of the rotated point.) Confirm the possibly counterintuitive fact that $R_5^5 = I$, the identity matrix. (Hint: You will make repeated use of identities like $\phi^2 = \phi + 1$.)

Next, we use a trick to write transformations of the 2-dimensional $[X, Y]$ plane with 3×3 matrices. If we write the point $[X, Y]$ as

$$\mathbf{X} = \begin{pmatrix} X \\ Y \\ 1 \end{pmatrix},$$

using the 1 at the bottom as a placeholder, then matrices of the form

$$M_{k,a,b} = \begin{pmatrix} R_5^k & \begin{matrix} a \\ b \end{matrix} \\ 0 \quad 0 & 1 \end{pmatrix}$$

leave the placeholder in place. This means that they map the $[X, Y]$-plane—really the plane $z = 1$ in some 3-space—to itself. You can read more about this way to write transformations in Sibley [18].

As a rather large project, use these transformation matrices to study the group G generated by τ_1 and ρ_5. When written as matrices, these are just

$$R = \begin{pmatrix} R_5 & \begin{matrix} 0 \\ 0 \end{matrix} \\ 0 \quad 0 & 1 \end{pmatrix} \text{ and } T = \begin{pmatrix} I & \begin{matrix} 1 \\ 0 \end{matrix} \\ 0 \quad 0 & 1 \end{pmatrix}.$$

With a great deal of work, we can show that every matrix representation of an element in G has the form $M_{k,a,b}$, where a and b belong to the set

$$\mathcal{R} = \left\{ \frac{n + \sqrt{5}m}{2} \text{ for } n, m \in \mathbb{Z}, \text{ where } n - m \text{ is even} \right\}.$$

If you have studied number theory, you may recognize the set of these numbers as the ring of integers in the quadratic number field $\mathbb{Q}[\sqrt{5}]$. If not, this example might intrigue you enough to inspire further investigation. Check that \mathcal{R} is indeed a ring. The fact that it contains real numbers that are arbitrarily close to 0 does not stop number theorists from calling them (generalized) integers. Don't blame me.

The group G is not a wallpaper group because it contains arbitrarily short translations. You can prove that the only continuous functions invariant under G are constant functions. Still, here is something you may wish to investigate as a project: For the function we used to introduce the chapter, you can measure how close a given element of G is to being a symmetry of the function by the size of the pair (a, b).

Chapter 14

Beyond 3-Fold Symmetry:
Lattices, Dual Lattices, and Waves

Question: How do you make plane waves invariant with respect to a given lattice? Suppose we have in mind two vectors k_1 and k_2 (written as complex numbers) and generate a lattice from them. Our goal in this chapter is to construct all (sufficiently nice) complex-valued functions on the plane such that

$$f(z + k_1) = f(z + k_2) = f(z) \text{ for all } z \in \mathbb{C}. \tag{14.1}$$

Once we know how to do this, we highlight some special cases to guide our further analysis of functions with wallpaper symmetry. As we work, we will discover why we require that k_1 and k_2 cannot point in the same direction.

We work in more generality than we need: Every example after this chapter assumes that one of the lattice generators is 1. We use general periods because the work gives us a nice chance to see how complex algebra can make computations elegant. If you do not care to join the party, you may skim the last section of this chapter and proceed to the next.

Review of Waves and a Complex Form
for the Dot Product

When we first looked at plane waves, they were expressed with exponential functions and dot products. The wave with *frequency vector* \mathbf{n} was defined to be

$$f_{\mathbf{n}}(\mathbf{x}) = e^{2\pi i \mathbf{x} \cdot \mathbf{n}},$$

where $\mathbf{x} = (x, y)$ and $\mathbf{n} = (n, m)$. This wave is constant in directions perpendicular to \mathbf{n} and has $\mathbf{n}/|\mathbf{n}|^2$ as a shortest period.

To write the same wave in complex notation, first examine the dot product in the exponent. Let us turn the real vector \mathbf{n} into a complex number v by writing $v = n + im$. We also write $z = x + iy$, as usual, and experiment a bit to find that

$$\mathbf{x} \cdot \mathbf{n} = xn + ym = \operatorname{Re}(z\bar{v}).$$

Check that $\operatorname{Re}(z\bar{v}) = \operatorname{Re}(v\bar{z})$, confirming that the dot product is symmetric.

In complex notation, we write a plane wave with frequency vector v as

$$f_v(z) = e^{2\pi i \operatorname{Re}(z\bar{v})}.$$

Check that this wave is constant in directions perpendicular to v and has $v/|v|^2$ as a fundamental period vector, meaning that no shorter translation leaves the wave unchanged. (This last claim is justified by noticing that $\operatorname{Re}(v\,\overline{v/|v|^2}) = 1$ and that 1 is the smallest positive number we can put in place of $\operatorname{Re}(z\bar{v})$ to leave the wave unchanged.)

Now we proceed to ask how to make waves with given numbers k_1 and k_2 as periods.

The Dual Lattice

In the wave formula

$$E_v(z) = e^{2\pi i \operatorname{Re}(z\bar{v})},$$

we need to choose two vectors v_1 and v_2 so that the periodicity condition (14.1) is satisfied, taking care to pick the smallest possible ones. One way to do this is to ask v_1 to stay out of the way of k_2, while v_2 keeps away from k_1. In symbols, this would mean that

$$\operatorname{Re}(k_1\overline{v_1}) = 1, \quad \operatorname{Re}(k_1\overline{v_2}) = 0,$$

$$\operatorname{Re}(k_2\overline{v_1}) = 0, \quad \operatorname{Re}(k_2\overline{v_2}) = 1. \tag{14.2}$$

A careful reader might notice that we could have used -1 in place of 1 in either position, so the vectors v_j are determined only up to a factor of ± 1. With the given choice, it turns out that the ordered basis $\{v_1, v_2\}$ has the same orientation as $\{k_1, k_2\}$, which might be useful in pictures.

Some complex-algebraic manipulations on this system (whose details are outlined in an exercise) leads to

$$v_1 = \frac{ik_2}{\operatorname{Im}(k_1\overline{k_2})},$$

$$v_2 = \frac{ik_1}{\operatorname{Im}(k_2\overline{k_1})}. \tag{14.3}$$

We say that v_1 and v_2 generate the *dual lattice* of our original one. The multiplication by i might make it appear that the vs are always counterclockwise rotations of the opposite ks, but this is not always the case, since the denominator is not necessarily positive.

This is a good time to mention that we had better assume that the denominator in (14.3) is not zero. Just as the real part of $z\bar{v}$ is the dot product of the vectors represented by these complex numbers, so the imaginary part corresponds to the cross product. Requiring that it not be zero is equivalent to assuming that our two translation vectors are linearly independent, which in this context simply means that they do not point along the same line.

Figure 14.1 shows how these might look in an example. Here, k_1 and k_2 have lengths greater than 1, and the lengths of the dual vectors are less than 1. For an intuitive understanding of this reciprocity, consider the simple case of perpendicular translation vectors, where

$$k_1 = K, k_2 = Li, \text{ so that } v_1 = \frac{1}{K}, v_2 = \frac{i}{L}.$$

The figure also illustrates our next concept: *lattice coordinates*. These are new coordinates $[X, Y]$ for the plane obtained by setting

$$z = Xk_1 + Yk_2.$$

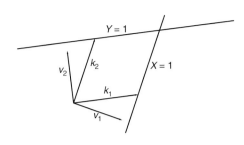

Figure 14.1. Lattice generators k_1 and k_2, along with generators v_1 and v_2 of the dual lattice.

(Square brackets will help us avoid confusion with rectangular coordinates.) We find nice formulas for the coordinates by dotting the vector z with v_1 and v_2, and applying (14.2): $X = \text{Re}(z\bar{v}_1)$ and $Y = \text{Re}(z\bar{v}_2)$.

In the diagram, notice two properties of the line $X = 1$: (1) it is parallel to the k_2 direction (what I called staying out of the way of k_2) and (2) it contains k_1. Exponential waves using v_1 will have k_1 as fundamental periods and will be constant with respect to translation by k_2. Similar statements apply to waves constructed from v_2, which are periodic in the k_2 direction and constant along k_1.

In terms of these lattice coordinates, every wave periodic with respect to k_1 and k_2 has the form

$$E_{n,m} = e^{2\pi i(nX+mY)}.$$

The most general (suitably nice) function f with the desired translational symmetry is a superposition of multiples of these basic waves, which we call *lattice waves*:

$$f(z) = \sum a_{n,m} e^{2\pi i(nX+mY)}.$$

This looks comfortably like our Fourier series for waves periodic with respect to the Eisenstein lattice, but now we know that it works in generality for any lattice we please.

EXERCISE 37

Use complex algebra to solve the system in (14.2), as follows: The first column of the system, using the algebraic expansion $\text{Re}(z) = 2(z + \bar{z})$, becomes

$$k_1\overline{v_1} + \overline{k_1}v_1 = 2,$$
$$k_2\overline{v_1} + \overline{k_2}v_1 = 0.$$

Multiply the first equation by k_2 and the second by k_1, and subtract the equations to find the first formula in (14.3). Work similarly to confirm the second formula. You may enjoy digesting Figure 14.1 with the concrete example $k_1 = 2$ and $k_2 = \frac{1}{2} + i\sqrt{\frac{3}{2}}$.

Special Lattices

We have already studied the lattice of Eisenstein integers, also called the *hexagonal*, or *hex*, lattice, which we chose for its 3-fold symmetry but which also served to create 6-fold symmetry. A quick check using $k_1 = 1$ and $k_2 = \omega_3 = e^{2\pi i/3}$ leads to our previous lattice coordinates, $X = x + y/\sqrt{3}$ and $Y = 2y/\sqrt{3}$. Our general method works in this special case.

To study 4-fold rotation, choose the simplest vectors that are 90° apart: $k_1 = 1$, $k_2 = i$. The lattice coordinates are obviously $X = x$ and $Y = y$, but it is nice to confirm that these follow from the preceding definitions. We pause to note that one could prefer to work with larger or smaller squares; an obvious modification can achieve this—multiply your *k*s by a scaling factor.

As we have mentioned, every lattice admits 2-fold rotation. The transformation $[X, Y] \rightarrow [-X, -Y]$ represents rotation through 180°, so there is no need for a special lattice to study this situation, unless additional symmetries require it. We will see that sometimes they do.

The lattices adapted for 3-fold and 4-fold rotation use a basis of two translation vectors that are equal in length. To capture the essence of this condition without requiring any special angle, we use what is called the *rhombic lattice*:

$$k_1 = a + bi, k_2 = a - bi.$$

Computing the relevant v's (or just working it out from scratch, starting at $z = Xk_1 + Yk_2$), we find lattice coordinates to be

$$X = \frac{1}{2}\left(\frac{x}{a} + \frac{y}{b}\right), Y = \frac{1}{2}\left(\frac{x}{a} - \frac{y}{b}\right).$$

Notice that these vectors are symmetric across the x-axis, which will make later analysis simpler.

The last special case is the *rectangular lattice*, already described. (Some simple theorems show that including certain symmetries in addition to two independent translations forces translational symmetry in two perpendicular directions.) Lattice coordinates in this case are simply

$$X = \frac{x}{K} \text{ and } Y = \frac{y}{L}.$$

Over the course of the next chapters, we will investigate each of these lattices in turn, always asking what additional symmetries we can introduce and using algebra to check whether we have indeed discovered all possibilities. With each step, we get closer to proving the celebrated result that there are exactly 17 wallpaper groups.

Chapter 15
Wallpaper with a Square Lattice

Question: Using the square lattice, how many symmetry types are possible? As we move to create 4-fold symmetry, we might think of pinwheels, Greek and Maltese crosses, certain flowers (the family *cruciferea*), and, alas, the swastika. The swastika served as a lovely element of Hindu and Native American art for centuries until it was spoiled in the 1900s. If the reader experiments with the recipes in this chapter, this culturally offensive symbol is likely to appear; you can make it go away by changing the parameters. Strange that a warning label is necessary on one of our recipes.

The Group p4

Applying the group theory we developed for 3-fold symmetry, we consider possibilities for 4-fold rotational symmetry in wallpaper. We start with a group that contains the basics: one translation and one rotation through 90°. Define

$$p4 = \langle \tau_1, \rho_4 \rangle, \quad \text{where } \tau_1(z) = z + 1 \text{ and } \rho_4(z) = iz.$$

Either a computation or a quick check with your hand on the table shows that we necessarily pick up a translation perpendicular to the first: We have

$$\tau_i(z) = z + i \text{ as } \rho_4 \tau_1 \rho_4^{-1}.$$

If we can implement a recipe to construct functions invariant under τ_1 and ρ_4, the group property will ensure that our functions are invariant with respect to a whole checkerboard's worth of translations. The formal term for such a set of translation vectors is, of course, a *lattice*, and this one is *the square lattice*, which we also met in Chapter 2 as the Gaussian integers,

$$\mathcal{G} = \{a + bi \mid a, b \in \mathbb{Z}\}.$$

In the last chapter, we learned that the correct lattice coordinates for this situation are $X = x$ and $Y = y$. Easy! The lattice waves are

$$E_{n,m}(z) = e^{2\pi i(nX + mY)},$$

as usual. Rotation through 90° is simply multiplication by i, and in lattice coordinates this becomes

$$\rho_4([X, Y]) = [-Y, X], \text{ so } E_{n,m}(\rho_4(z)) = E_{m,-n}(z),$$

a formula you can check for yourself.

Figure 15.1. A wallpaper function with 4-fold rotational symmetry, depicted with a collage of a jellyfish and its negative.

Wave packets with 4-fold rotational symmetry have 4 terms, representing the average of a single wave over the cyclic group generated by ρ_4:

$$S_{n,m} = (E_{n,m} + E_{m,-n} + E_{-n,-m} + E_{-m,n})/4.$$

The third is the $180°$ rotation of the first, which makes sense. The natural function space to consider is the set of superpositions of these wave packets with complex coefficients:

$$\mathcal{F}_{p4} = \left\{ \sum a_{n,m} S_{n,m} \right\}.$$

Experimenting with functions from \mathcal{F}_{p4}, I chose the one in Figure 15.1. With what we have learned about group theory, it should be no surprise that this image has a great many more symmetries than the two we forced with our selection of waves. Of course, there are distant rotations, through not just $90°$, but $180°$ and $270°$ as well, about every Gaussian integer—the centers of the stylized white flowers.

Perhaps unexpected is a center of 4-fold rotation not translationally related to the Gaussian integers, for instance, about the point $(1 + i)/2$. (Find this point as a pink dot in the center of the open blue area.) This is the fixed point of the composition $\tau_1 \rho_4$. Notice also the centers of 2-fold rotational symmetry at midpoints of segments joining adjacent flowers. One example of 2-fold rotational symmetry is the composition $\tau_1 \rho_4^2$, whose fixed point is $z = \frac{1}{2}$.

Perhaps this brief discussion is enough to convince you that Figure 15.1 shows all the symmetries required by group composition laws and no more. We close this section with Figure 15.2, the cell diagram for the group p4, wishing you happy experimentation with p4 functions.

Additional Symmetries of the Square Lattice

As the example of p4 shows, the rotation ρ_4 is a powerful ingredient when it comes to generating additional symmetries. We continue this theme as we cautiously attempt to introduce a single mirror symmetry: reflection across the main diagonal of the square cell. We clarify which reflection we mean, and then develop a recipe for p4 functions that have this additional symmetry. When we see a domain coloring of a function based on this recipe, what additional symmetries will we find?

Reflection across the diagonal of the square cell simply swaps the X- and Y-coordinates. We define

$$\sigma_c\left([X, Y]\right) = [Y, X],$$

(using c for *central mirror*), from which it is a short trip to

$$S_{n,m}\left(\sigma_c(z)\right) = S_{m,n}(z).$$

Our recipe is simply the familiar $a_{n,m} = a_{m,n}$. We define a new function space

$$\mathcal{F}_{\text{p4m}} = \left\{\sum a_{n,m} S_{n,m} \mid a_{n,m} = a_{m,n}\right\}$$

and a group

$$\text{p4m} = \langle \tau_1, \rho_4, \sigma_c \rangle.$$

Our memory of the strange distinction between p31m and p3m1 might suggest that we are being cavalier by using a single m in this name. What follows will vindicate the choice. In the meantime, let us examine an image based on a p4m function, in Figure 15.3.

Such a proliferation of mirrors! It is a little bit of a joke to use a photograph with 4-fold symmetry as the color wheel for this function: The symmetry of the table certainly does not survive the kaleidoscope treatment it receives from the function from p4m. Still, it can act as a diagram to illustrate the additional mirror symmetries. Let the center of the table be 0, and see how three other reflections about lines through 0, in addition to σ_c, preserve the square lattice. Since

$$\rho_4 \sigma_c = \sigma_y \text{ and } \sigma_c \rho_4 = \sigma_x,$$

reflections about vertical and horizontal axes belong to p4m and so are necessarily symmetries of any p4m function. Observe also that $\rho_4^2 \sigma_c$ is the reflection across $y = -x$, the fourth reflection axis we mentioned earlier.

Like a late-night TV hawker of goods, we say, But that's not all! Did you notice the glide reflections about the line $y = x - \frac{1}{2}$ in the p4m image in Figure 15.3? This glide and its rotational counterparts abound in the image and are quite prominent, once you see them. We will present the cell diagram for p4m in Figure 15.5 (see page 102), but try drawing it for yourself first. Don't forget the required mirrors $\tau_1 \sigma_y$, reflection about $x = \frac{1}{2}$, and a similar reflection about $y = \frac{1}{2}$.

Figure 15.2. The fundamental cell diagram for the group p4, showing five centers of 4-fold rotation and four 2-centers.

Figure 15.3. A p4m wallpaper function, depicted with a photograph of a tiled table, made by my father decades ago.

EXERCISE 38

First show that the definition of γ_c on p. 101 leads to a formula $\gamma_c(z) = i\bar{z} + (1 + i)/2$ and show by computation that $\tau_{(1+i)/2}\sigma_c = \sigma_c\tau_{(1+i)/2}$, so we could have composed the transformations in either order. Then express the action of γ_c in $[X, Y]$-coordinates and find a recipe for waves invariant under γ_c. (Hint: You should find the same recipe we discovered for σ_s-invariance.)

It seems that we turned on every possible mirror in the square lattice, but there is one more: The glide axis we just noticed in the p4m axis, the line $y = x - \frac{1}{2}$, though not an axis of symmetry of the square cell, is worth investigating. We use a now-familiar technique of conjugation to compute the formula for this reflection, which we call σ_s for *slant mirror*:

$$\sigma_s(z) = \tau_{1/2}\sigma_c\tau_{-1/2}(z) = i\bar{z} + \frac{1-i}{2}.$$

This is hardly promising, as the formula involves translation by halves of a Gaussian integer.

All will come right if we compute a recipe for functions invariant under σ_s. First, we find that σ_s looks more friendly in $[X, Y]$-coordinates:

$$\sigma_s([X, Y]) = \left[Y + \tfrac{1}{2}, X - \tfrac{1}{2}\right].$$

(In this coordinate system, we keep all the real numbers in the first slot and all the imaginary ones in the second.) The coordinate formula leads us to

$$E_{n,m}(\sigma_s(z)) = e^{2\pi i(n(Y+1/2)+m(X-1/2))} = (-1)^{n+m}E_{m,n}(z),$$

where I prefer to write the symmetrical $(-1)^{n+m}$ rather than the $(-1)^{n-m}$ that comes directly from the formula. They are, of course, the same.

The computation tells us to lock waves together with an extra minus sign that depends on the parity (even/odd) of the sum $n + m$. We pause to recall that we are

Figure 15.4. A p4g wallpaper function, using the limited color palette of a mountain gentian.

not combining simple waves, $E_{n,m}$, but wave packets, each containing four waves. Fortunately, the parity of $n + m$ is the same for all four pairs, (n, m), $(-m, n)$, $(-n, -m)$, and $(m, -n)$. We are all set to define a new function space

$$\mathcal{F}_{p4g} = \left\{ \sum a_{n,m} S_{n,m} \mid a_{n,m} = (-1)^{n+m} a_{m,n} \right\},$$

which encodes the soon-to-be-explained name of our new group

$$\text{p4g} = \langle \tau_1, \rho_4, \sigma_s \rangle.$$

The reason for the name is that introducing the single reflection σ_s into a group that already has τ_1 and ρ_4 produces a prominent glide refection, whose axis is the main diagonal of the cell. The proof is outlined in an exercise. For now, we record that the new glide is

$$\gamma_c = \tau_{(1+i)/2} \sigma_c,$$

visualized as flipping across the main diagonal and sliding up half a unit along the mirror axis.

Examine the p4g function in Figure 15.4 colored with the blossom on a mountain gentian. More subtle than most images I have produced, this illustrates the symmetry well, despite the limited color palette. Locate the corners of a square cell at translationally related 4-centers, which appear as green dots amid yellowish pinwheels. Then, observe the rhythm of the glide reflections: Imagine flipping the cell across a main diagonal and track the barbell shapes; they do not match up, until you slide them up or down along the diagonal axis. Find the slant mirror axis, σ_s, and observe that this reflection changes the handedness of the pinwheel

EXERCISE 39

Locate the composition $\tau_1 \rho_4 \gamma_c$, which must belong to p4g, in the cell diagram, perhaps by computing what it does to the $[X, Y]$-coordinates of a point. Modify this formula to show that the upward glide reflection along the line $x = \frac{1}{4}$ must belong to the group. Continue to show that all the other symmetries indicated in the cell diagram must follow from the generators.

EXERCISE 40

Suppose G is a wallpaper group containing the group p4 and having no translations shorter than 1, but G includes both σ_s and σ_x. Show that this leads to a contradiction by finding a shorter translation in G.

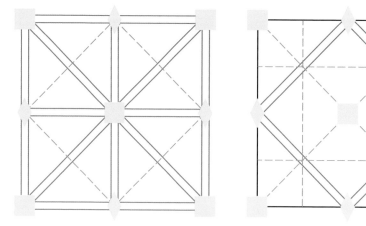

Figure 15.5. Fundamental cell diagrams for p4m and p4g, the only ways to introduce additional symmetries to p4.

*** EXERCISE 41**

Suppose that G is a wallpaper group containing the group p4 and having no translations shorter than 1. This means that every translation in G is by a Gaussian integer. Show that any mirror symmetry included in G must lead to the presence in G of either σ_x or σ_s. Since G cannot contain both, this shows that G can only be p4m or p4g.

shapes. These undulating changes in direction and the mixture of mirror rigidity with free waviness make p4g one of my favorite pattern types.

As usual, once we introduce some symmetries, many others follow along. In an exercise, I guide you through the steps to confirm that all the many glides shown in the p4g cell diagram in Figure 15.5 are indeed necessary elements of the group.

What happens if we try to adopt both σ_s and σ_c as generators of a group containing p4? We did this to great effect with the two reflections generating p31m and p3m1: That is how p6m was born. In an exercise, we outline the proof that this would create 4-fold rotational symmetry about the points where p4 has 2-fold rotational symmetry, which leads to a translation of length $\frac{1}{2}$, violating our assumption that τ_1 is shortest. Our chapter is complete with only three new groups.

ANSWER FOR EXERCISE 41

First we need a fact about the coordinate form of reflections. We show by computation that the transformation $\sigma(z) = e^{2\alpha i}\bar{z} + c$ is a reflection if and only if $c = ire^{\alpha i}$ for some real number r, possibly 0. Just as in Exercise 14, σ is a reflection if and only if it has a line of fixed points; searching for fixed points leads us to the condition $\mathrm{Re}(ce^{\alpha i}) = 0$. We recycle a trick:

$$z - \bar{z}e^{2i\alpha} = c \text{ can be rewritten as } ze^{-i\alpha} - \bar{z}e^{i\alpha} = ce^{-i\alpha},$$

so the right-hand side is purely imaginary.

Next, use translations and rotations to show that we can assume c lies in the square with vertices $0, 1, i,$ and $1 + i$.

Since $\sigma = \sigma^{-1}$, the conjugation of τ_1 by σ is $\sigma\tau_1\sigma$. Show that this composition is

$$\sigma\tau_1\sigma(z) = z + 2r\sin(\alpha) + e^{2\alpha i},$$

which is a translation in G. Since every such translation is by a Gaussian integer, we have

$$2r\sin(\alpha) + e^{2\alpha i} = a + bi, \quad \text{for } a, b \in \mathbb{Z}.$$

Show that this limits α to be $k\pi$ or $k\pi + \pi/4$, for $k \in \mathbb{Z}$. If $\alpha = k\pi$, show that $\sigma = \pm\bar{z} \pm i$, generating all the transformations in p4m. If $\alpha = k\pi + \pi/4$, which leads to $r\sqrt{2} \in \mathbb{Z}$, show that we either have $\sigma(z) = \pm i\bar{z}$, so that $\sigma \in$ p4m, or

$$\sigma(z) = \pm i\bar{z} \pm \frac{-1+i}{2}, \quad \text{so that } \sigma \in \text{p4g}.$$

Chapter 16

Wallpaper with a Rhombic Lattice

Question: Using the rhombic lattice, how many symmetry types are possible? Having exhausted the possibilities in *specific* lattices, the square and hexagonal ones where all the angles and relative dimensions are determined exactly, we turn to cases where there is a little more freedom. In the next few chapters, we are allowed to vary the aspect ratio of an image without destroying the symmetry. Still, there are significant limitations, and a brief discussion of these will motivate our focus on the rhombic lattice, where the cell is shaped like a rhombus. Here, the translational subgroup is generated by two translations that are mirror images of one another across a central axis. This leads people to refer sometimes to these patterns as *centered* or *diamond* patterns.

To arrive at this lattice, we suppose we wish to concentrate on wallpaper groups with at least some mirror symmetry. Work through Exercise 42 to learn the details of the divide at which we find ourselves: If a wallpaper group has mirror symmetry, then either there are translation vectors of equal length that are symmetric across the mirror axis or the generating translations are perpendicular to one another.

Having perpendicular generating translations means that our cell is rectangular. This case is the most complicated, and I will save it for last. In this chapter, let us enjoy the distinctive appearance of mirror symmetries in rhombic cells that have central mirrors—hence the name *centered cell* patterns. For a dull example of a centered cell pattern, observe the symmetry of a brick wall laid with each row offset exactly half a brick above another. For more variety, find samples of French wallpaper. The classical French decorative style—with vertical mirrors instead of the horizontal ones we draw in our diagrams—seems to favor the rhombic lattice.

Groups Consistent with the Centered Cell

In light of the preceding discussion, we assume that G is a group containing one mirror reflection, which might as well be reflection across the x-axis, as well as one translation neither along nor perpendicular to the mirror axis. This means that G contains τ_ω and σ_x, where, for convenience, we have scaled so that $\operatorname{Re} \omega = \frac{1}{2}$. These choices force $\tau_{\bar\omega}$ and τ_1 to belong to our group G.

First, let us make images with as little symmetry as possible, consistent with our setup. We write $\omega = \frac{1}{2} + bi$, for b real. (We *could* pick $b = \sqrt{3}/2$ or $b = \frac{1}{2}$ to make a hexagonal or square lattice, but study the structure of this cell without either of

those special restrictions.) Refer to Chapter 14 to find the lattice coordinates for this rhombic cell. These are

$$X = x + \frac{y}{2b}, \quad Y = x - \frac{y}{2b}, \text{ with the nice property that } \sigma_x\left([X, Y]\right) = [Y, X].$$

The lattice waves, as usual, are $E_{n,m} = e^{2\pi i(nX + mY)}$. In order to create the desired mirror symmetry, we lock waves in pairs:

$$C_{n,m} = \frac{E_{n,m} + E_{m,n}}{2},$$

and define a space of functions

$$\mathcal{F}_{\text{cm}} = \left\{ \sum a_{n,m} C_{n,m} \mid n \geq m, a_{n,m} \in \mathbb{C} \right\}.$$

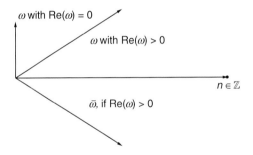

Figure 16.1. The rhombic/rectangular alternative when σ_x is present in a wallpaper group.

Consistent with this definition, we name the group $\text{cm} = \langle \tau_\omega, \sigma_x \rangle$. (We could not have generated a wallpaper group with only τ_1 and σ_x, because we could not produce two independent translations using just these two.)

By design, we know that every function in this space will be periodic with respect to our rhombic lattice and also have mirror symmetry across the x-axis. If we desire symmetry across the y-axis instead, we can either change the lattice coordinates or simply rotate the picture by $90°$. It was this latter trick I used when a function choice led to an image that I thought would look more interesting turned on its side. The result is shown in Figure 16.2.

During my experiments with cm functions, it was the appearance of Medusa heads that led me to save this one and to set the heads upright. Take time to become accustomed to the distinctive rhythm of the rhombic cell: Rows of symmetric heads are offset by half a unit and placed above one another. The late-summer goldenrod gives its colors to areas shaped like blank faces, and the tree

Figure 16.2. A function invariant under cm, turned sideways, with colors from a late summer day in the University of Minnesota arboretum.

becomes a dramatic snake headdress. The blue of the sky delineates the figure, giving us definite shapes to draw our attention to the symmetry this image is meant to help us study.

By now, we expect to see repetitions of the single mirror symmetry our recipe forces on the image, so this is no surprise. Can you see a different type of symmetry in this diagram—one that we have not mentioned in this chapter? Draw a vertical line halfway between mirror axes—two nearest ones, so that they are not related by horizontal translation. When we flip about that line and slide half a unit up, the pattern falls into coincidence with itself. This pattern has glide symmetry.

As usual, we ask: Is this a necessary feature of cm patterns, or did my choices introduce it as an accidental symmetry? Even though the image has vertical mirrors, we persist with our horizontal notation. A computation left as an exercise shows that

$$\gamma_h = \tau_w \sigma_x \in G$$

is indeed a glide reflection with axis $Y = X - 1/2$, or $y = b/2$, halfway between mirror axes, just as we observed in the diagram. The glide symmetry is indeed a necessary feature of a cm pattern.

This equation can be rewritten as $\tau_w^{-1}\gamma_h = \sigma_x$. This means that if we tried to create a group with only the glide symmetry, we would end up with the mirror symmetry as well. We want to be able to conclude that we have found all types consistent with the rhombic lattice, and this little computation is one step in that direction.

EXERCISE 43

Write all the symmetries shown in the cell diagrams for cm and cmm as compositions of the group generators. Check the claim that $\tau_w \sigma_x$ is a glide reflection by computing the formula for the composition in $[X, Y]$-coordinates.

Figure 16.3. A cmm pattern with angels or spacemen created from a kitchen shot and a cmm function.

An Additional Mirror

To find another possible group consistent with the centered cell, we notice that the cell itself is symmetric about two perpendicular axes. What happens if we introduce reflection across the y-axis into our group? A quick check shows that

$$\sigma_x(\sigma_y(z)) = -z,$$

which is ρ_2, the rotation about 0 through $180°$. Having perpendicular mirror axes necessitates 2-fold rotational symmetry. Computationally, it is slightly more convenient to generate a group by including ρ_2 into cm, so let us define

$$\text{cmm} = \langle \tau_\omega, \sigma_x, \rho_2 \rangle$$

and, since $E_{n,m}(\rho_2(z)) = E_{-n,-m}$,

$$\mathcal{F}_{\text{cmm}} = \left\{ \sum a_{n,m} C_{n,m} \mid n \geq m, a_{n,m} = a_{-n,-m} \right\}.$$

Waves in this function space are, up to scaling, 4-fold sums that look like $E_{n,m} + E_{m,n} + E_{-n,-m} + E_{-m,-n}$. Figure 16.3 shows one experiment with a cmm function. We have picked up vertical and horizontal glide reflections as well as vertical mirrors just by requiring our periodic function to have one horizontal

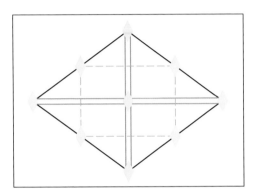

Figure 16.4. The fundamental cell diagrams for groups cm and cmm.

reflection and 1 center of 2-fold rotation. The proof that supports this is almost identical to the one that justified the additional glide in cm.

Cell diagrams for cm and cmm are provided in Figure 16.4. Observe the 9 centers of 2-fold rotation in cmm, all generated from a single one, together with the translations. Why are these the only possibilities? We find it plausible to suggest that there is nothing else one could add to either of these groups without messing up the claim that we have identified the shortest translations. If we introduce a mirror at some acute angle to the horizontal, that forces a rotation whose order we know to be 3, 4, or 6 (not 2 if the angle is acute), and we have already covered those cases. Introducing a mirror parallel to one of the others, but closer than in the cell diagram, would lead to a shorter translation. A similar argument can be made with glides. Perhaps this is not completely rigorous, but I find it convincing.

EXERCISE 44

Recall that a *subgroup* of a group G is a subset of G that is itself a group (using the same operation). Show that cmm has two different groups that are each isomorphic to cm. (Hint: Name the vertical and horizontal mirrors that you see in Figure 16.4.)

Chapter 17
Wallpaper with a Generic Lattice

Question: Using the generic lattice, how many symmetry types are possible? We repeat the mantra that group theory dictates: If you have some symmetries, you must have all others that follow along as compositions of the given ones. What are the minimal symmetries a pattern can have without leaving the category of wallpaper altogether? In this chapter, we find out by investigating wallpaper functions periodic with respect to the *generic cell*, meaning a parallelogram with no special proportions between the sides and no restriction on the angles.

The base group for this cell is generated by two independent translations, which we may as well call τ_1 and τ_ω. We require that the imaginary part of ω be nonzero, so that it points in a different direction from 1, but nothing else is specified. Let us call this group p1, so that

$$\text{p1} = \langle \tau_1, \tau_\omega \rangle.$$

Since, as we pointed out before, translations commute with one another, the elements of p1 are exactly $\tau_1^n \tau_\omega^m$ for $n, m \in \mathbb{Z}$.

I thought I would not especially enjoy making p1 patterns, since they have so little symmetry. Figure 17.1 surprised me when that blindfolded figure with a cuboid heart showed up.

What transformations could we introduce to expand p1 to a larger group without changing the translation lattice? We saw in the last chapter that introducing *any* mirror symmetry requires either the rectangular or rhombic lattice. We have already exhausted the possibilities of 3-fold, 4-fold, and 6-fold rotation and know that special lattices are required for these. This leaves 2-fold rotation and glides.

We can eliminate any thought of introducing a glide reflection to p1: A computation outlined in an exercise shows that the presence of a single glide in a wallpaper group implies that the translation lattice is rhombic or rectangular. Happily, we are not quite out of ideas for the generic cell; we now consider 2-fold rotational symmetry in the generic cell

The Group p2

The presence of a single 2-fold rotation is enough to propagate infinitely many, thanks to the group property. We start with the simplest such rotation, $\rho_2 = -z$, and define

$$\text{p2} = \langle \tau_1, \tau_\omega, \rho_2(z) \rangle.$$

Figure 17.1. A wallpaper function with symmetry group p1, colored with a red-handed beet cutter, me.

EXERCISE 45

Suppose a wallpaper group G contains a glide reflection γ. Rotate and translate so that the axis of γ is the x-axis. This means that

$$\gamma(z) = \bar{z} + c, \quad \text{where } c \in \mathbb{R}.$$

Prove that $\tau_{2c} \in G$. Since G must have a translation in a different direction, name another generating translation τ_ω, with $\text{Im}(\omega) \neq 0$. If $\text{Re}(\omega) = 0$, we have a rectangular lattice; if not, prove, using the conjugation $\gamma\tau_1\gamma^{-1}$, that $\tau_{\bar{\omega}} \in G$, meaning that our lattice is rhombic.

Figure 17.2. Fundamental cell diagrams for p1 and p2, the only groups that use the generic cell.

What other rotations follow along? Conjugating ρ_2 by translations turns every lattice point into a 2-center! In addition, between any two 2-centers related by translation is another 2-center, which is not translationally related to the others if that translation is a shortest one. (Prove this by investigating the

Figure 17.3. A wallpaper function with symmetry group p2. An amaryllis and historical newspaper serve as color wheel.

composition $\tau_1\rho_2$. In your computations, you can recognize a transformation α as a rotation through $180°$ by two properties: It has a unique fixed point and $\alpha^2 = \iota$, the identity. Also, notice that $\tau_2\rho_2$ is a 2-fold rotation about 1, which is translationally related to 0.)

This makes those diamonds that indicate 2-centers proliferate through the cell diagram: There are a total of 9 of them, including the 4 corners, the 4 midpoints of the sides, and the midpoint of the diagonals. Figure 17.2 shows cell diagrams for p1 and p2.

To make functions invariant under the action of p2, we use the same lattice waves but lock them together into rotational pairs using the recipe

$$a_{n,m} = a_{-n,-m}.$$

This is probably familiar, since it is exactly the recipe we used to introduce the 2-fold rotational symmetry that turned p3 into p6. For some reason, this pattern type is a challenge for me. I have rejected quite a few p2 images before deciding that Figure 17.3 is good enough.

Chapter 18

Wallpaper with a Rectangular Lattice

Question: Using the rectangular lattice, how many symmetry types are possible? If you have been counting, you know that we have so far enumerated 12 wallpaper groups. Given that there are 17 in all, there must be 5 yet to have their turn. We begin our search for the last of the 17 wallpaper groups by assuming that any group not yet found must have the rectangular lattice acting as its translational subgroup. We suppose that G is such a group.

Recall the lattice discussion from Chapter 14, where we discussed a $K \times L$ rectangular lattice, and make things a bit simpler by scaling so that $K = 1$. This means that every translation in G has the form

$$\tau_{a+bLi}(z) = z + a + bLi, \text{ where } a, b \in \mathbb{Z} \text{ and } L > 0. \tag{18.1}$$

What other transformations can belong to G without violating this assumption about translations?

First, we dispense with the idea that there can be any mirrors or glide reflections whose axes are not parallel to one of the coordinate directions. As you can work out in the following exercise, the presence in G of a glide or mirror with axis at angle $0 < \alpha < \pi/2$ with the horizontal forces $\alpha = \pi/4$ and $L = 1$; this implies that the lattice is square and the group is one of cm, cmm, p4g, or p4m. (Recall something I mentioned in Chapter 16: We are allowed—though not required—to represent cm and cmm in a rhombic cell where the angle between the mirror-reflected translations happens to be 90°.)

We proceed with our search, knowing that all reflections and glides must have axes parallel to one of the coordinate axes. No matter what additional symmetries we seek, we will use the same lattice waves

$$E_{n,m}(z) = e^{2\pi i (nX + mY)} \quad \text{where } X = x, \ Y = \frac{y}{L}$$

and form functions as linear combinations of these waves in sums of the form

$$f(z) = \sum a_{n,m} E_{n,m}(z).$$

Our recipes will look very much like ones we have found before. Before we proceed, you might wish to guess the ways we can create symmetry by locking waves together in packets. Some of our past tricks are available; others are impossible when $L \neq 1$, a condition we adopt from now on. All this means is that we really are dealing with a rectangle, not a square.

Figure 18.1. Waves with symmetry group pm make an image with colors from a Sierra vista and its negative.

Groups without Rotation

Having eliminated all mirrors but ones with axes parallel to the coordinate axes, it is now natural to ask, What happens when we introduce one of the coordinate reflections? Let us call

$$\mathrm{pm} = \langle \tau_1, \tau_{Li}, \sigma_y \rangle,$$

where I chose reflection about the vertical axis only because I found a pretty image with vertical mirror symmetry. An isomorphic representation of pm occurs if you replace σ_y by σ_x in the generating set. With pm as I defined it, the group property shows that the composition

$$\tau_1 \sigma_y(z) = -\bar{z} + 1$$

belongs to pm. Determine that every point of the form $\frac{1}{2} + yi$ is fixed by this transformation, so it is a reflection with axis $x = \frac{1}{2}$. (This can be generalized to show that between any two reflection axes that are related by translation, there is another reflection axis.) We might call this a *half-mirror*, as its axis is halfway through the cell.

This is the rhythm of pm: We will see an alternating sequence of parallel mirror axes, unrelated by translation and then related by translation. Have a look at Figure 18.1 where symmetric Buddhas hover below temple arches. This image was made from a Sierra landscape using lattice waves and a recipe that is our next order of business.

EXERCISE 46

Suppose G is a wallpaper group in which every translation has the form in (18.1). Suppose also that G contains a mirror reflection σ or a glide γ whose axis is not parallel to the coordinate axes. Prove that $L = 1$, so the lattice is square.

The computation

$$E_{n,m}(\sigma_y z) = e^{2\pi i(-nX+mY)} = E_{-n,m}(z)$$

shows that we should lock the waves with frequency vectors (n, m) and $(-n, m)$ together in pairs to activate the σ_y mirror. Our space of functions with pm symmetry is thus

$$\mathcal{F}_{pm} = \left\{ \sum a_{n,m} E_{n,m}(z) \mid a_{n,m} = a_{-n,m} \right\}.$$

Glides Instead of Mirrors

We get a different group when we repeat our steps but replace σ_y with the glide γ_y, where

$$\gamma_y(z) = -\bar{z} + \frac{Li}{2}, \quad \text{which means that} \quad \gamma_y([X, Y]) = \left[-X, Y + \frac{1}{2} \right].$$

(Take a moment to enjoy how the lattice coordinate $Y = y/L$ allows us the simplicity of adding $1/2$ instead of $L/2$.) Since $\gamma_y^2(z) = z + Li$, this is the shortest glide we can introduce without violating our agreement about the lattice.

To learn how to create functions invariant under γ_y, we evaluate

$$E_{n,m}(\gamma_y z) = e^{2\pi i(-nX+mY+m/2)} = (-1)^m E_{-n,m}(z).$$

This gives a recipe similar to the one we found for p4g. Define

$$\mathcal{F}_{pg} = \left\{ \sum a_{n,m} E_{n,m}(z) \mid a_{n,m} = (-1)^m a_{-n,m} \right\}$$

and

$$pg = \langle \tau_1, \tau_{Li}, \gamma_y \rangle = \langle \tau_1, \gamma_y \rangle.$$

As before, repeating these steps with $\gamma_x(z) = \bar{z} + 1/2$ quickly leads to another group (with a related function recipe) that is isomorphic to this representation of pg.

We leave the details for the reader, but it is easy to produce, from this single glide and the translation τ_1, a glide in pg whose axis is $x = 1/2$. This leads to an alternating succession of glide axes in any pg image. One such image is shown in Figure 18.2.

Our observations about additional symmetries in pm and pg are summarized in their cell diagrams (Figure 18.3), where we adhere to a convention that cell corners must be shown on mirror or glide axes, if any are present. Why are the two groups not isomorphic? In pm, there is an element of order 2, something not present in pg. Also, since $\gamma_y^2 = \tau_{Li}$, in pg some translations have square roots, unlike those in pm.

Why are these all the groups we can find without introducing any rotational symmetry? Two facts, which are left as exercises, come to our aid: (1) The

Figure 18.2. A tree on White Bark Vista colors a wallpaper function with symmetry group pg.

composition of any two glides or reflections (or one of each) whose axes are perpendicular produces a rotation through 180°; (2) if a wallpaper group has a reflection and a glide with parallel axes, then the lattice is rhombic, not rectangular. We have done all we can with axes parallel to a single direction, so we proceed to investigate groups with 2-fold rotations.

Groups with Rotations

We start our search for the last of the wallpaper groups by assuming that our group contains, in addition to translations by elements of the rectangular lattice, a 180° rotation about the origin, ρ_2. To distinguish this group from p2, which we have already crossed off our list, we assume that the group contains at least one reflection or one glide.

First, let us lock together waves to create 2-fold rotational symmetry. Our recipes become more elegant if we write

$$T_{n,m} = \frac{E_{n,m} + E_{-n,-m}}{2}$$

and express our functions as

$$f(z) = \sum a_{n,m} T_{n,m}.$$

Figure 18.3. Fundamental cell diagrams for pm and pg, groups with minimal symmetry.

Figure 18.4. Waves with symmetry group pmm colored with a buttercup collage.

The simplest place to start is to introduce reflection symmetry across the y-axis, defining the group pmm by :

$$\text{pmm} = \langle \tau_1, \tau_{Li}, \rho_2, \sigma_y \rangle.$$

Recall that the presence of ρ_2 causes us to lock waves with frequency vectors (n, m) and $(-n, -m)$ together in pairs. Any additional symmetries must be consistent with this locking. To see what I mean, observe that σ_y moves $E_{n,m}$ (which is locked with $E_{-n,-m}$) to $E_{-n,m}$ (locked with $E_{n,-m}$); it is simpler to say that σ_y moves $T_{n,m}$ to $T_{-n,m}$ and be done with it.

Recalling that now the coefficients $a_{n,m}$ refer to multiples of the Ts, our recipe for pmm is

$$a_{n,m} = a_{-n,m}.$$

We define \mathcal{F}_{pmm} to be the set of superpositions of waves locked together by this condition. Searching through \mathcal{F}_{pmm}, I found the image in Figure 18.4. Although this is not one of my favorite symmetry groups—too little freedom here, I think— the pattern turned out well, as if the green and yellow columns are hanging in front of a blue background. Something not too far from this pattern might have been seen hanging as paper on a Victorian wall.

Figure 18.4 allows us to see the additional symmetries that follow from the invariance of the function under the group generators: It should be no surprise that we see the vertical half-mirror, because our work on pm showed that the half-mirrors follow just from including σ_y. (Recall that "half-mirror" is just

my term for a mirror halfway through the cell, parallel to another mirror.) Simple computation shows that $\rho_2 \sigma_y = \sigma_x$, so we have horizontal mirrors and the half-mirrors that follow from those. The grid of nontranslationally related 2-centers appears for the same reason it did for the group p2. All these symmetries are shown in the cell diagram for pmm, Figure 18.5.

Do you think we can do the same thing with glides? Imagine Figure 18.5 with the parallel lines that indicate mirrors replaced with the dashed lines that indicate glides. Let us investigate by including ρ_2 and $\gamma_x(z) = \bar{z} + 1/2$ in a group with the rectangular translations. The surprise is that

$$\gamma_x \rho_2(z) = -\bar{z} + \frac{1}{2}$$

Figure 18.5. Fundamental cell diagram for pmm.

is a mirror reflection about the line $x = 1/4$! I call this a *quarter-mirror*, since is appears one-quarter of the way across the cell. A similar computation justifies the presence of a quarter-mirror at $x = 3/4$ as well. Since there is a mirror as well as a glide, we use the name pmg for this group:

$$\text{pmg} = \langle \tau_1, \tau_{Li}, \rho_2, \gamma_x \rangle.$$

The name, which I remind you comes from the International Union of Crystallographers, writes the m first, even though it is the glide whose axis passes through the 2-center. For a *minimal* set of generators, we could leave out τ_1, since $\gamma_x^2 = \tau_1$.

The recipe for pg quickly leads to one for pmg, though that recipe was computed using γ_y and here I switched to γ_x. After a quick check that the locked packets cooperate, it is easy to see that the relevant function space is

$$\mathcal{F}_{\text{pmg}} = \left\{ \sum a_{n,m} T_{n,m} \mid a_{n,m} = (-1)^n a_{n,-m} \right\}. \tag{18.2}$$

Keeping the same buttercup collage as color wheel, I searched for a nice pmg function. This is one of my favorite symmetry groups, and it was hard to choose the one in Figure 18.6 from so many pmg patterns I have made. I enjoy the contrast between the vertical mirror symmetry and the waving horizontal glides. Don't stop looking until you have identified two different-looking vertical axes of reflection and two different-looking horizontal glide axes.

In case you are wondering why I favored γ_x in this discussion, there was really no reason other than to match the orientation of a cell diagram I had already drawn. You can define a different isomorphic representation of pmg that includes γ_y. It does not count as a different wallpaper group, just one more way to represent pmg.

We will see the cell diagram for pmg presently. First, look at the pattern on the right in Figure 18.6, which is labeled pgg. Yes, it is possible to have a rectangular-cell, 2-fold symmetric pattern with no mirrors, just glides. The trick is that the glide axes cannot pass through the 2-center. One easy way to define the group pgg uses what I'll call a *vertical quarter-glide*:

$$\gamma_q(z) = -\bar{z} + \frac{1 + Li}{2}, \quad \text{which means} \quad \gamma_q([X, Y]) = \left[\frac{1}{2} - X, Y + \frac{1}{2}\right].$$

Figure 18.6. Patterns with groups pmg and pgg, using the same buttercup color wheel shown in Figure 18.4.

This last expression should make it clear that γ_q flips about $X = \frac{1}{4}$ and slides up by half a vertical lattice unit; check that starting with $X = 1/4$ leads us back to $X = 1/4$ after applying γ_q.

Our last wallpaper group is

$$\text{pgg} = \langle \tau_1, \tau_{Li}, \rho_2, \gamma_q \rangle.$$

A computation will confirm that this single vertical quarter-glide generates three more quarter-glides with axes inside the fundamental cell, as drawn in Figure 18.7. Find them all in Figure 18.6.

You might guess the recipe for pgg functions from seeing the halves in each component of the $[X, Y]$-coordinate formula for the quarter glide γ_q. Without making any more of it than that, we present the space of functions

$$\mathcal{F}_{\text{pmg}} = \left\{ \sum a_{n,m} T_{n,m} \mid a_{n,m} = (-1)^{n+m} a_{n,-m} \right\}.$$

Thus pairs of waves are locked together with other pairs, where the pair corresponding to (n, m) (along with $(-n, -m)$) is locked with $(n, -m)$ (paired with $(-n, m)$) if $n + m$ is even; each is locked with the negative of its partner if $n + m$ is odd.

As a major project, you might wish to reduce all our wallpaper recipes, but most especially these for the rectangular cell, into formulas involving sine and cosine functions rather than our complex exponentials. Recipes using those functions were my first wallpaper recipes [6, 7], and whether you look them up or find them for yourself, I hope you will agree that the complex notation is more elegant.

So, these are the last of the 17 wallpaper groups. Our various discussions can be added up to a rigorous proof that we have really found them all, but surely there are better ways to think about such a fundamental question—why are there 17?—than to wander around tinkering with transformations that can and cannot be

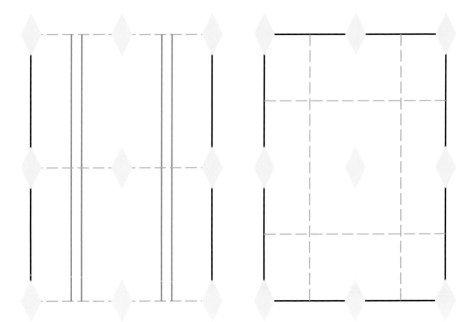

Figure 18.7. Fundamental cell diagrams for pmg and pgg, the last of the 17 wallpaper groups.

included while maintaining consistency with various translational lattices. A few chapters hence, we offer a more satisfying approach. It still requires some case-by-case analysis, but the techniques involved are more general and—perhaps you will think—more beautiful. We build to the more abstract material by first moving to color-reversing and color-turning symmetries, which provide a natural way to learn some abstract algebra.

Chapter 19

Color-Reversing Wallpaper Functions

Question: How can we make functions with color-reversing symmetries, and how many types are there? Some years ago, I was creating wallpaper functions invariant under the group pmg and found a pattern, similar in appearance to the one in Figure 19.1, that gave me pause. You might recall from the previous chapter that pmg has two versions; this is the one with horizontal mirrors and vertical glide reflections. Take time to notice the horizontal mirror axes through the egg shapes and the vertical glide that flip and slide the vertical purple and green strips. What else do you see?

What I noticed back then was an unanticipated feature: When you reflect the image across a vertical axis through those egg shapes, the colors appear to swap— purple changes to green and green to purple. We call this *color-reversing* symmetry or *antisymmetry* for short. Depicting color-reversing symmetries requires a special color wheel, as we will see.

Let's look for the general principles of color-reversing symmetry by examining this example in detail.

The Case of pmg

The recipe for constructing functions invariant under pmg is one of the more surprising ones. First we lock waves together into packets called $T_{n,m}$ to create 2-fold rotational symmetry. We then take functions that look like

$$f(z) = \sum a_{n,m} T_{n,m}(z)$$

and lock Ts together in pairs, according to the recipe

$$a_{n,m} = (-1)^m a_{-n,m}.$$

(This is the version of pmg with horizontal mirrors; comparing it with (18.2) shows that n and m are swapped. This was done to match the picture.)

This is a strange recipe, which perhaps you did not have enough time to digest in the previous chapter. It means that if we wish to include the wave packet $T_{1,2}$, we must include an equal multiple of the packet $T_{-1,2}$; to use $T_{2,1}$, we must also use the same amount of $-T_{-2,1}$, because here m is odd. Notice that any amount of $T_{0,2k+1}$ requires an equal amount of $-T_{0,2k+1}$, so the frequency pair $(0, 2k + 1)$ never contributes to a pmg function.

Figure 19.1. Waves with symmetry group pmg make an image that has more symmetry than planned. (The color wheel has a special property, to be examined in this chapter.)

In the long-ago example that led me to stumble across color-reversing symmetry, I implemented this recipe but accidentally chose frequencies so that $n+m$ was odd. To illustrate how odd frequencies sometimes lead to strange behavior, let us see what happens to a simple 1-dimensional wave with frequency $2k+1$ when we translate through half a period

$$f(x) = e^{2\pi i(2k+1)x} \text{ has } f\left(x + \tfrac{1}{2}\right) = e^{2\pi i(2k+1)x} e^{2\pi ik} e^{\pi i} = -f(x).$$

The wave reverses its value whenever we translate halfway. If its height is far above 0 at one point, it will be equally far below 0 at a point that is half a unit away.

This is like what we see in Figure 19.1. First let us do the algebra. For any wave packet $T_{n,m}$, let us compute what happens when we translate diagonally a distance halfway across the cell, which I call a *diagonal half-translation*. In other words, let's compose the translation

$$\tau_d(z) = z + \frac{1 + Li}{2}, \text{ which is } \tau_d\left([X, Y]\right) = \left[X + \frac{1}{2}, Y + \frac{1}{2}\right],$$

with the waves in $T_{n,m}$. Starting simply with the term $E_{n,m}$, we find

$$E_{n,m}\left(\tau_d(z)\right) = e^{2\pi i(n(X+1/2)+m(Y+1/2))} = E_{n,m}(z) \cdot e^{2\pi i(n+m)/2}.$$

If $n+m$ is odd, that last factor will be -1, as if the wave has reversed itself. The same is true of all the waves in the locked sum $T_{n,m} + (-1)^m T_{-n,m}$. No matter

what function we choose from \mathcal{F}_{pmg}, if we cross out all the terms except those with $n + m$ odd, we will have a function f that satisfies

$$f\left(\tau_d(z)\right) = -f(z),$$

which we will take as a definition of τ_d being a color-reversing symmetry.

This gives a clue about the color wheel used in the opening example: We want to see the relationship between the color assigned to a particular complex number z and the one attached to its negative $-z$. In Figure 19.1, I started with a photograph of a green mountain gentian and pasted the negative of the original, rotated $180°$, in the right place to ensure that z and $-z$ have opposite colors.

You might see the exception to this principle: The dark strip down the middle is meant to indicate a neutral color that serves as its own negative. Reducing the size of this strip to zero might make the image more precisely color-reversing in appearance. However, I find that a small white or dark strip enhances the visual beauty of the images, while slightly damaging the mathematical perfection.

Having observed color-reversing symmetry in one example, let us see how widespread this phenomenon is in the world of wallpaper functions.

The Algebra of Color-Reversing Symmetry

Definition 4 (Color-reversing symmetry). If β is an isometry of the complex plane and $f(z)$ is any function, we say β is a *color-reversing symmetry* of f to mean that

$$f\left(\beta(z)\right) = -f(z).$$

When thinking about how Figure 19.1 was made, we computed why τ_d is a color-reversing symmetry of any function composed of wave packets where $n + m$ was odd. But when we first spoke of this image, I drew your attention to the color-reversing vertical mirror. Obeying the rule that the origin of our coordinate system must be a 2-center, the formula for one of these vertical mirror transformations is

$$\sigma_q\left([X, Y]\right) = \left[\tfrac{1}{2} - X, Y\right],$$

which we called a quarter-mirror in earlier discussions. Is it possible for a pmg function to have τ_d but *not* σ_q as a color-reversing symmetry?

A quick computation shows that if γ_y is the glide reflection upward along the side of the cell, we have

$$\tau_d \gamma_y^{-1} = \sigma_q.$$

If f is any pmg function with τ_d as a color-reversing symmetry, then

$$f(\sigma_q(z)) = f\left(\tau_d(\gamma_y^{-1}(z))\right) = -f\left(\gamma_y^{-1}(z)\right) = -f(z),$$

so σ_q is necessarily color reversing.

This computation and one extremely like it are all we need to prove the following proposition, which is more powerful than it might appear at first.

Proposition 1. *If β is any color-reversing symmetry of a function f, then β^2 is a symmetry of f. If α is any symmetry of f, then the compositions $\alpha\beta$ and $\beta\alpha$ are color-reversing symmetries. Moreover, if β is a single color-reversing symmetry of a function f whose symmetry group is G, then every color-reversing symmetry of f has the form $\beta\alpha$ for some $\alpha \in G$.*

Proof. The first part follows from

$$f\left(\beta^2(z)\right) = -f\left(\beta(z)\right) = f(z).$$

Proving the middle claim uses the same steps we followed with specific transformations. For the last part of the proposition, first observe that β^{-1} is a color-reversing symmetry whenever β is. Then notice that for any color-reversing symmetry β', the composition $\beta^{-1}\beta'$ is an actual symmetry α in G, meaning that $\beta' = \beta\alpha$. ∎

The proposition goes far to limit the possibilities for color-reversing symmetries: If we start with a class of functions invariant under G and find a way to introduce a single antisymmetry, we necessarily will see all the antisymmetries that arise as composition with elements of G. If you have some color-reversing symmetries, you must necessarily have others. This sounds familiar.

A first effort to bring group theory into the picture might be to ask: Do the color-reversing symmetries form a group? Well, no, since the square of any color-reversing symmetry is an honest symmetry. Here is a trick to help us use what we already know about symmetry groups: We analyze the symmetries of a new function obtained from f by taking absolute values. If β is an antisymmetry of f, then

$$|f(\beta(z))| = |-f(z)| = |f(z)|,$$

so the function $|f(z)|$ is invariant under β as well as all the actual symmetries of f. This means that the set of symmetries and antisymmetries together form one big group, which we call the *color group* of f, or perhaps the *2-color group* of f, looking ahead to the next chapter, where we may wish to do more things to colors than simply reverse them.

Let us ground ourselves in an example, referring back to Figure 19.1. There the symmetry group is pmg. What group do we get when we annex the element τ_d to pmg? This upward diagonal half-translation that generates all the color-reversing symmetries can be combined with elements of pmg to make a downward diagonal half translation, and those two directions together outline the border of a centered cell. The color group is (an isomorphic representation of) cmm.

Since the color group, containing all symmetries and color-reversing symmetries, is cmm and the actual symmetry group is pmg, we say that this pattern has *type* cmm/pmg. How many pattern types are there? We do not analyze this question completely, but we do report an answer. In order to do so, we need one more result from algebra.

Conjugation and Normal Subgroups

Intuitively, it makes sense that reversing colors, submitting a pattern to a symmetry, and reversing the colors again will leave a pattern back where it was: unchanged. In algebraic notation, this amounts to

$$f\left(\beta\alpha\beta^{-1}(z)\right) = -f\left(\alpha\beta^{-1}(z)\right) = -f\left(\beta^{-1}(z)\right) = f(z).$$

The transformation $\beta\alpha\beta^{-1}$ is what we learned to call the *conjugate* of α by β. So whenever you conjugate a symmetry by an antisymmetry, you get back to a symmetry. The symmetries of a pattern are, of course, a subgroup of the color group, since they form a group using the same operation of composition. This condition, that every conjugate of elements of the subgroup by any element of the larger group lands back in the subgroup, is the defining property of a special kind of subgroup, namely, a *normal subgroup*.

We summarize with a definition.

Definition 5. We say that H is a normal subgroup of a group G to mean that H is a subgroup of G with the additional property that

$$ghg^{-1} \in H, \text{ whenever } h \in H \text{ and } g \in G.$$

Putting this all together, we have a theorem, which states all the information in a concise, but abstract, form.

Theorem 6. *The symmetry group of a function f is a normal subgroup of the color group of f.*

We will later have need of an important consequence of this normality condition: When H is normal in G, we can define a new group called a *quotient group*, G/H. Rather than define the concept here, we preview it conceptually. Symmetries and antisymmetries provide a great example. Conceive of all the symmetries of a pattern lumped together as a single object, with the antisymmetries lumped together as another. Make a mental multiplication table with entries like symmetry times symmetry equals symmetry, antisymmetry times antisymmetry equals symmetry, and antisymmetry times symmetry equals antisymmetry, where "times" really means function composition. What group is this? It is really the same as the group whose elements are 1 and -1, with the operation of multiplication. This is the same as (isomorphic to) the cyclic group with two elements C_2. When you meet other quotient groups, this is a good example to keep in mind.

Since the quotient group has only two elements, we say that the symmetry group has *index* 2 in the color group.

Our search for pattern types amounts to an investigation of which wallpaper groups can be normal subgroups of index 2 in which others. That is a mouthful. Before we leave the pmg example, let us see what other spaces we can find of color-reversing functions with symmetry group pmg.

Patterns of Type G_c/pmg

We will not offer a formal proof here, but it stands to reason that the only ways to create antisymmetries in pmg functions involve finding recipes consistent with the pmg recipe, which, we recall, was

$$a_{n,m} = (-1)^m a_{-n,m}.$$

Our condition for cmm/pmg was that $n + m$ should be odd. What if $n + m$ were even? In that case, τ_d would be a symmetry, not an antisymmetry, so our functions would have symmetry group cmm. If we agree to stick with pmg, we cannot do that. Similarly, we cannot require that n or m be even without forcing a larger translational lattice (meaning a larger group of shorter translations). This leaves us with two options: Let n be odd; let m be odd.

If m is odd, $f([X, Y + \frac{1}{2}]) = -f([X,Y])$. We have picked up a negating vertical half-translation, which we might call $\tau_{Li/2}$. One particular composition will make it clear what the color group must be: Observe that

$$\tau_{Li/2}^{-1}\gamma_y([X,Y]) = [-X, Y],$$

which is just reflection about the y-axis. We have not picked up a diagonal half-translation in the color group, so the fundamental cell of the color group is a rectangle half as large as the pmg one. We have a wallpaper group with a rectangular cell and half turns and mirror axes that meet a right angles. Which one is this? It's pmm.

If n is odd, we pick up $\tau_{1/2}$, a horizontal half translation. We leave proving that the color group is pmg as an exercise. This version of pmg again has a rectangular cell half the size of the original pmg cell. Here, instead of splitting off the top half, we have split off the right half.

Compare the rhythms of the two patterns in Figure 19.2. In the pmm/pmg pattern on the left, we see stripes of the neutral color (here, black) that necessarily occur on a negating mirror axis. Try to imagine that all the colors have been leached from the design; then try to see the pmm pattern on the left and the pmg pattern on the right. This is a little simpler on the right, where there are alternating patterns of positive and negative stamps of a figure that, if you tilt your head, might look like a leering clown.

How to Search for Pattern Types

For us, a pattern type consists of a pair of wallpaper groups, G_c and G—color group and symmetry group—where G is a normal subgroup of G_c. The group G consists of actual symmetries of the pattern, while G_c is the larger group, containing all antisymmetries and symmetries together. We call the pattern type G_c/G.

We mention the usual caveat that we are not too fussy about the distinction between an abstract group and a particular representation of one. For instance, when we used the name pmg/pmg in the previous section, we were content to label two different instantiations of the abstract group pmg as "pmg," even though one had half the fundamental cell of the other—different as sets of transformations, but isomorphic as groups. I hope this does not cause confusion.

Figure 19.2. Patterns of types pmm/pmg and pmg/pmg. On the left, the pmm/pmg pattern has negating repeats in the vertical direction. The negating repeats in the pmg/pmg pattern on the right are horizontal. We recycle the buttercup color wheel from Figure 18.4, which works to depict color-reversing symmetry.

One more bit of abstraction will help with a systematic discovery of all the possibilities. Suppose we have a function whose pattern type is G_c/G, and suppose β is a particular color-reversing symmetry. Define a function

$$\phi : G_c \to \{1, -1\} \text{ by } \phi(\beta) = -1, \phi(\alpha) = 1 \text{ whenever } \alpha \in G,$$

and extend ϕ by the homomorphism condition

$$\phi(ab) = \phi(a)\phi(b) \text{ for all } a, b \in G_c.$$

In particular, since every color-reversing symmetry β' is a product $\beta\alpha$, the homomorphism condition says

$$\phi(\beta') = \phi(\beta)\phi(\alpha) = -1 \cdot 1 = -1.$$

The map ϕ takes the color-reversing symmetries in G_c to -1 and the actual symmetries to 1. This offers an elegant way to express both the symmetries and antisymmetries of a function f in a single equation:

$$f(g(z)) = \phi(g)f(z) \text{ for every } g \in G_c. \tag{19.1}$$

I intend for this to remind you of the symmetry conditions from our early chapters about curves. We had a group acting on the domain of a function and a map from that group to another group acting on the range of the function. The condition on f in (19.1) could be called an *intertwining* condition.

We use the name *group character* for a homomorphism from a group to the set of complex numbers. Our investigation of color-reversing symmetry has led us to a place where group characters arise naturally. Any character ϕ suitable for use

in (19.1) is a special case, where the range of ϕ is just the set $\{1, -1\}$. We will find roles for other characters in the next chapter.

What has this to do with counting pattern types? We know that the color group G_c is limited to be one of the 17 wallpaper groups. We know that the symmetry group G is another on that same list of groups. The entire behavior of a homomorphism ϕ can be deduced from knowledge of a single element $\beta \in G_c$ to generate all the color-reversing symmetries, and we know that $\beta^2 \in G$. Here is the program: Walk through the 17 wallpaper groups, letting each play the role of G_c in turn, and consider each generator as a possibility to play the role of β, a generating color-reversing symmetry. Extend ϕ to a homomorphism by sending all the other generators to 1.

In some cases, we will find an obstruction. In other cases, two different choices of β will lead to equivalent pattern types. We suggest the full-blown investigation as a substantial project for the reader. Here, we content ourselves with a few examples and some warnings about obstructions.

The condition that the square of β must belong to G does limit our choices. Suppose I was thinking about the group p3 and hoped to make one of its generators, ρ_3 (rotation about the origin through $120°$), into a negating symmetry. Then ρ_3^2 would be a positive symmetry, but that means that ρ_3^3 would be a negating symmetry. So the identity map is a color-reversing symmetry? Never. After all, this would lead to $f(z) = -f(z)$ for all z, so the only possibility is $f \equiv 0$.

Recall that the *order* of an element g of a group is the smallest positive integer k so that the kth power of g is the identity. The general principle behind the discussion of ρ_3 is the following proposition, whose proof is left to the reader.

Proposition 2. *An element β in a color group cannot be a color-reversing symmetry if its order is odd.*

Lest you start counting by identifying generators of wallpaper groups with even or infinite order, here is a short example to show what we are up against: The group p1 has two generators, say, τ_1 and τ_ω. The three homomorphisms defined by

$$\phi_1(\tau_1) = -1, \ \phi_2(\tau_\omega) = -1, \text{ and } \phi_3(\tau_1 + \tau_\omega) = -1,$$

extended by sending other generators to 1, all define equivalent pattern types. These are all called p1/p1. Here is why: Define an isomorphism of p1 to itself by

$$\psi(\tau_1) = \tau_\omega \text{ and } \psi(\tau_\omega) = \tau_1,$$

swapping the generators. For every $g \in$ p1, we have

$$\phi_1(\psi(g)) = \phi_2(g).$$

Since we have agreed that all isomorphic representations of p1 are interchangeable, there is no difference between the patterns that arise from ϕ_1 and ϕ_2. You should be able to define ψ' to show why ϕ_1 and ϕ_3 are equivalent. This is the closest I plan to come to a formal definition of pattern equivalence. I intend this only as a cautionary tale that geometry as well as simple counting of generators is important in our study of pattern types. The moral of this story is that τ_1 and τ_ω play interchangeable roles in p1, so we count only one homomorphism, not two, let alone three.

This is not to say that we must treat all translational generators the same. The example of pmg shows that marking τ_1 as a color-reversing symmetry leads to a different pattern type from the one where τ_{Li} is color reversing.

Let us touch back with that pmg example. Recall that a minimal set of generators for pmg is

$$\text{pmg} = \langle \tau_1, \rho_2, \gamma_y \rangle.$$

(This is the version of pmg with horizontal quarter-mirrors that arise from a composition of ρ_2 with γ_y.) It turns out that there are *five* pattern types with color group pmg. Here is an outline of a proof:

We have already seen the pmg/pmg type that, in our new notation, arises from $\phi(\tau_1) = -1$.

For a second type, check that ρ_2 does indeed have even order, and consider a homomorphism with $\phi(\rho_2) = -1$. This forces negating quarter mirrors and an actual symmetry group of only pg, for type pmg/pg.

If we send γ_y to -1, those quarter mirrors again are color reversing, for a symmetry group of just p2; this type is pmg/p2.

We have considered one homomorphism for each generator, but we must not forget the possibility $\phi(\gamma_y \rho_2) = -1$. Here the generating antisymmetry is that quarter mirror. With that symmetry negated, we are left with positive 2-centers and a positive glide, which means symmetry group pgg. This fourth type is pmg/pgg.

Where is the fifth? We presented one *particular* set of generators for pmg and this one-at-a-time technique for defining ϕ led us to overlook something: the group pmg can also be generated as $\langle \tau_1, \rho_2, \sigma_q = \gamma_x \rho_2(z) \rangle$. The last pattern type uses ρ_2 as the generating antisymmetry but extends the homomorphism by $\phi(\sigma_q) = 1$, which means γ_x is negating. (Another way to view this is to define ϕ to send two different generators of pmg to -1, but I prefer the clarity of finding a single generating antisymmetry.) Here the actual symmetry group is pm, for type pmg/pm.

To prove rigorously that we have found all the pattern types of the form pmg/G, we would need to say something about all possible ways anyone could generate this group. An alternative comes from an analysis that is even more abstract, coming two chapters hence.

An Unpleasant Truth. Though I very much like the notation G_c/G, there is one, lone situation where it fails us. Consider the group

$$\text{pm} = \langle \tau_1, \tau_{Li}, \sigma_x \rangle.$$

Whichever of the two translations we choose as a negating translation, the actual symmetry group of the pattern remains pm. There are two ways for pm to sit inside itself as a normal subgroup, and these do indeed lead to two visually different pattern types: When τ_{Li} (perpendicular to the mirror axis) is negating, the composition $\tau_{Li}\sigma_x$, the "half-mirror," is a color-reversing mirror symmetry; when τ_1 is negating, there are no color-reversing mirrors. For some reason, taking the negating translation to be perpendicular to the mirror axis has been declared the first among the two [1]. So $(\text{pm/pm})_1$ has τ_{Li} as a negating translation and $(\text{pm/pm})_2$ goes the other way, with the negating translation in the same direction

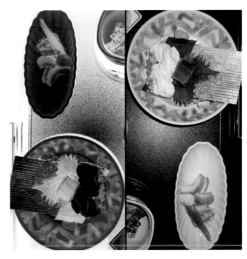

Figure 19.3. A pattern with symmetry group cmm and color group p4g, for pattern type p4g/cmm. The color wheel is based on a photograph of a Japanese dinner.

as the mirror. I do not find these to be particularly interesting patterns. You may see examples in the appendix. (The images there are turned 90° relative to this discussion.)

The happy news is that the pm/pm example is unique: In all other cases, we uniquely specify the pattern type (up to isomorphism, as usual) by naming the color group and the symmetry group.

We close the chapter with one more example, which highlights my favorite pattern type. We start with

$$\text{p4g} = \langle \tau_1, \rho_4, \sigma_s \rangle,$$

where σ_s was that *side mirror*, with axis inclined at 45° across a bottom corner of the square.

The rotation ρ_4 does indeed have even order, so we may consider it for generating color-reversing symmetries. If we do this, we will pick up ρ_4^2 as a positive symmetry of the pattern. Look for it in Figure 19.3, where I have implemented a ρ_4-reversing recipe. The details are spelled out in an exercise, as there are several things to check, but the conclusions are these: τ_1, τ_i, and σ_s remain positive; if we picture the translation vectors as having their tails at the positive 2-centers from p4g, we find a centered cell with mirrors across both axes. Turning our view 45°, we see the cell of a cmm function. The pattern type here, my all-time favorite, is p4g/cmm.

After our hypothetical trip through all 17 groups, finding nonequivalent ways to pick out a single color-reversing symmetry to generate all others, we will have identified 46 pattern types. An appendix shows the recipe for each type with a representative example, but I highly recommend that you generate the list for yourself, as it is quite an adventure.

It appears that the first person to complete the exhaustive search was H. J. Woods, publishing his findings in *The Journal of the Textile Institute* (Manchester) in 1936 [24]. The Textile Institute? The jacquard loom, which used punch cards to instruct a weaving machine, had already been in use for two centuries and surely people had been using them to make color-reversing symmetries long before 1936. I speculate that it was the 1924 article by Pôlya, mentioned earlier in the context of M. C. Escher [17], that led Woods to publish his article, which contains one example of each of the 46 color-reversing types.

All the ideas in this section can be applied to create rosettes and friezes with color-reversing symmetries. Rather than pursue this, we turn our attention to ρ_3, the 3-fold rotation that was not permitted to serve as a color-reversing symmetry. It should not feel neglected, as it becomes the star of the next chapter.

Chapter 20
Color-Turning Wallpaper Functions

Question: What construction methods create color-turning symmetry? Keep your eyes open and you will see exotic types of color symmetry in decorative art, though it is not nearly so prevalent as symmetry and color-reversing symmetry. The reigning expert in constructing images with color symmetry is, of course, M. C. Escher, whose figurative 3- and 4-color images are stunning: How did he do that? A quick Internet search will lead you to dozens of wonderful pictures, some of which are posted legally. You may enjoy coming back to those after you learn a little more about color symmetry in this chapter.

We met color-turning symmetry in Chapter 6, where we extended the mystery curve to a function on the plane, to find that it satisfied the equation

$$f(\omega_5 z) = \omega_5 f(z), \text{ where } \omega_5 = e^{2\pi i/5}.$$

You may wish to go back and examine Figure 6.2 to see how this looked for 5-fold color-turning symmetry: Pick any point A, locate in the image its rotation by 72° about 0, and call that point B; the color at B is obtained by rotating the color you saw at A by 72°—by *turning* the color wheel. See why I call it color-turning symmetry?

Fresh from our discussion of color-reversing symmetries, we might realize that those antisymmetries could be called 2-fold color-turning symmetries: The new color after performing a negating transformation is 180° around the color wheel from the old one. In this chapter, we sample the possibilities for replacing 2, by 3, 4, and higher numbers, maintaining our focus on wallpaper functions rather than rosettes or friezes.

The possibilities for color symmetry in wallpaper are so many that we will not develop a comprehensive list, except in the case of one type of 3-fold color-turning symmetry. The neglect suffered by the transformation ρ_3 in the last chapter makes this 3-fold rotation a good place to begin.

3-Fold Color-Turning Symmetry in Wallpaper

Let us say that α is a p-fold *color-turning* symmetry (of type k) of a function $f(z)$ on the plane to mean that

$$f(\alpha(z)) = \omega_p^k f(z), \text{ for all } z \in \mathbb{C}, \text{ where } \omega_p = e^{2\pi i/p}.$$

To understand the role of k, verify that $f(\alpha(z)) = \omega_p f(z)$ implies $f(\alpha^2(z)) = \omega_p^2 f(z)$, so if one color-turning symmetry uses $k = 1$, then another will use $k = 2$, and so on.

This might remind you of Chapter 4. There, we saw how to construct such things as curves with 7-fold symmetry of type 3, where the curve, at time $2\pi/7$, started to repeat what it was doing at time 0, only rotated $3 \cdot 2\pi/7$ around.

Taking absolute values, we see that α is an actual symmetry of $|f|$.

The first thing we can say about any such α, by applying the condition p times, is that $f\left(\alpha^p(z)\right) = f(z)$, which means that α^p is a symmetry of f. One way this can happen is if α is an element of order p in the symmetry group of f. When it comes to a candidate for a 3-fold color-turning symmetry in a wallpaper group, the rotation ρ_3 was born to play this role. How can we construct functions that have ρ_3 as a color-turning symmetry?

We modify the concept of group-averaging to project a generic function from p3 (the ones with basic 3-fold rotational and translational symmetry) to a space of functions that are all color-turning with respect to $\rho_3(z) = \omega_3 z$. It may be a good idea to review the chapters on p3 and its subgroups before moving on.

We start with

$$f(z) = \sum a_{n,m} E_{n,m}(z), \text{ where } E_{n,m}(z) = e^{2\pi i(nX+mY)}$$
$$\text{and } X = x + \frac{y}{\sqrt{3}}, \ Y = \frac{2y}{\sqrt{3}}.$$

One way to create color-turning symmetry from f is to define a new function

$$\hat{f}(z) = \frac{f(z) + \omega_3^{-1} f(\omega_3 z) + \omega_3^{-2} f(\omega_3^2 z)}{3}.$$

Does the power -1 surprise you? We justify it by computing

$$\hat{f}\left(\rho_3(z)\right) = \frac{f(\omega_3 z) + \omega_3^{-1} f(\omega_3^2 z) + \omega_3^{-2} f(\omega_3^3 z)}{3}$$

and comparing this with

$$\omega_3 \hat{f}(z) = \frac{\omega_3 f(z) + f(\omega_3 z) + \omega_3^{-1} f(\omega_3^2 z)}{3}.$$

The terms are a different order, but they do match up. Our process does produce a color-turning function.

We make this more useful by seeing how \hat{f} is formed from wave packets. We recall how rotation moves the lattice waves and compute the color-turning version of a typical wave:

$$\hat{E}_{n,m}(z) = \frac{E_{n,m}(z) + \omega_3^{-1} E_{m,-(n+m)}(z) + \omega_3^{-2} E_{-(n+m),n}(z)}{3}.$$

We leave the details as an exercise, but it is easy to show, assuming that we can compute \hat{f} wave by wave, that

$$\hat{f} = \sum \left(a_{n,m} + \omega_3 a_{m,-(n+m)} + \omega_3^2 a_{-(n+m),n}\right) \hat{E}_{n,m}.$$

Figure 20.1. A 3-fold color-turning function, illustrated with a color wheel made from dinner.

If the positive powers of the ω_3's in front of the *a*s seems confusing when they were negative in the preceding line, leave that detail for future inquiry. (It does work out!) Observe that we now have a technique for computing a function with 3-fold color-turning symmetry: build it by adding multiples of the turning waves $\hat{E}_{n,m}$.

If you hope to *see* the color-turning symmetry, you must use a color wheel where the relationship between points $120°$ apart on the wheel is readily apparent. I cobbled up such a wheel from a third of a plate from a memorable dinner in Perth, Scotland—a steak with a smear of yams. I rotated my favorite portion of the plate and used software to alter the hue by $120°$.

As you can see in Figure 20.1, the result is not pretty. I would hate to live with a print of this image on my wall, but confess that I cannot stop looking at the cartoonish effect.

The image, as usual, has more color-turning symmetry than we forced upon it by construction. This is due to the following simple computation: Suppose that ρ_3 is a color-turning symmetry of f, whose symmetry group is G, and that α is any element of G related to ρ_3 by translation, meaning that $\alpha = \rho_3\tau$ for $\tau \in G$; then

$$f\left(\alpha(z)\right) = f\left(\rho_3\tau(z)\right) = \omega_3 f\left(\tau(z)\right) = \omega_3 f(z).$$

This means that α is also color-turning. Remember the nontranslationally related 3-centers in any p3 pattern? Those symmetries are compositions of ρ_3 with translations, so they must be centers of color-turning symmetry. Locate the origin in Figure 20.1 (several choices are possible), and find the other centers of color-turning symmetry.

Color-Turning Pattern Types

If you enjoy risking some abstraction in order to see the big picture, this section is for you. It may safely be skipped. Our goal is to develop vocabulary we would need if we wanted to attempt a thorough classification of color-turning symmetries.

First let us examine the algebraic landscape: If we have a wallpaper group G_c (c for color) that contains a generator α of order 3 ($\alpha^3(z) = z$), we can define a homomorphism ϕ from G_c to $\mathbf{C}_3 = \{1, \omega_3, \omega_3^2\}$ by

$$\phi(\alpha) = \omega_3, \phi(\beta) = 1 \text{ for other generators } \beta \text{ of } G_c.$$

Any function f for which α is a color-turning symmetry will satisfy

$$f(\alpha(z)) = \phi(\alpha)f(z).$$

For any such f, any element of G_c is an actual symmetry of $|f|$ because $|\phi(\alpha)f(z)| = |f(z)|$.

There is something special about the *kernel* of any homomorphism, which is the set of elements mapped to the identity: It is *normal* in G. The kernel of a homomorphism is always a normal subgroup of the domain group. Proof of this in the abstract is almost identical to the following quick check: if $\phi(\gamma) = 1$, then by the homomorphism property,

$$\phi(\alpha\gamma\alpha^{-1}) = \phi(\alpha)\phi(\gamma)\phi(\alpha^{-1}) = \omega_3 1 \omega_3^{-1} = 1,$$

so $\alpha\gamma\alpha^{-1}$ is in the kernel.

Now suppose β is any transformation not in the kernel. Since ϕ takes β to ω_3 or ω_{3j}^2, β^3 must be in the kernel. Since the cube of any element in G lands in the kernel of ϕ, we say that the kernel of ϕ has *index* 3 in G.

Why is this relevant? If we hope to find all possible ways to create 3-fold color-turning symmetry, we must make, for *each* wallpaper group, a list of its normal subgroups of index 3. For 4-fold color-turning symmetry, we need subgroups of index 4, and so on. Some of the ways to find subgroups are obvious, but, even with 3-fold symmetry, the situation gets a little crazy.

The main point of this algebraic discussion is to define the *color-turning pattern type* of a function, like the one shown in Figure 20.1. Building on the previous discussion, we call G_c the *color group* of f when G_c contains all symmetries and color-turning symmetries of f together. As usual, we call G the symmetry group of f.

Definition 6. Suppose f is a function with 3-fold color-turning symmetry. If the symmetry group is G and the color group is G_c, we say that f has *pattern type* $G_c/_3G$. (The subscript 3 reminds us that G is normal with index 3 in G_c.)

Next, we summarize the analysis we have accomplished in our first example: We have constructed a projection from the space of p3-invariant functions, \mathcal{F}_{p3}, to a new space of functions with pattern type $p3/_3p1$:

$$\mathcal{F}_{p3/_3p1} = \left\{\sum b_{n,m}\hat{E}_{n,m}(z)\right\}.$$

Remembering the projection operators in Chapter 5, we can define

$$\coprod_{\rho_3} : \mathcal{F}_{p3} \to \mathcal{F}_{p3/_3p1} \text{ by } \coprod_{\rho_3}(f) = \hat{f}.$$

There is a similar projection $\coprod_{\rho_3^2}$, which produces functions where the colors turn by 240°, but enough is enough.

Other Types That Use Color-Turning Waves

Our first success was to create patterns of type p3/₃p1—meaning that the actual symmetry group is only p1 and the group of color-turning and ordinary symmetries together is p3. These patterns were made by superimposing color-turning wave packets $\hat{E}_{n,m}$—each being a bundle of three waves locked together. Our functions all have the form

$$f(z) = \sum b_{n,m} \hat{E}_{n,m}(z), \text{ for some chosen } b_{n,m} \in \mathbb{C}.$$

With a little care, we can lock these packets together in pairs to create additional symmetries.

One attractive possibility is to introduce 2-fold rotation as a symmetry. Since

$$\hat{E}_{n,m}(\rho_2(z)) = \hat{E}_{-n,-m}(z),$$

(just carry the minus sign through each of the constituent waves), we simply require that

$$b_{n,m} = b_{-n,-m}.$$

Functions with this additional symmetry will have pattern type p6/₃p2 (since $\rho_3^2 \rho_2 = \rho_6$).

An example appears in Figure 20.2, colored by a mountain heather and its differently hued companions. If you look closely, you can see the stamens of the flower adding fine detail to the image.

Didn't that look easy? Alas, we have now used up the only two easy examples. The difficulty is that reflection is not compatible with our color-turning waves: When you reflect them, they turn the other way. The remedy is to introduce a new type of function symmetry, one that we have not met before: conjugation symmetry.

A transformation α of order 2 is a *conjugation symmetry* of a function $f(z)$ when

$$f(\alpha(z)) = \overline{f(z)}.$$

If we wish to display conjugation symmetry, we require a color wheel that allows us to see the relationship between a number and its conjugate clearly. To construct a suitable wheel, I took a cue from the bible of plane symmetry by Grünbaum and Shepherd [12]. Their examples illustrating the 3-color groups—all composed from tiny triangles—are literally printed in three colors, actually

Figure 20.2. A function of type p6/₃p2, which has actual 2-fold symmetry and color-turning 3-fold symmetry.

gray, black, and white, since they wrote in the days when math books were not printed in color. One can see three types of conjugating mirrors, each of which keeps one color fixed while swapping the other two.

Figure 20.3 shows my interpretation, starting with the jellyfish from Chapter 6. Notice how restrictive it is to ask a wheel to show us both color-turning and conjugation symmetry: There must be color-swapping mirrors across lines at $120°$ and $240°$ as well as the x-axis.

To create functions with α as a conjugation symmetry, we use a projection

$$\check{f}(z) = \frac{f(z) + \overline{f(\alpha(z))}}{2},$$

checking that $\check{f}(\alpha(z)) = \overline{\check{f}(z)}$.

EXERCISE 49
No Antisymmetries!

If we limit our discussion to 3-fold color-turning symmetry, we are mercifully exempt from considering the color-reversing symmetries that made Chapter 19 so complicated. Prove that if ρ and α are *any* elements of a group, where

$$f(\rho(z)) = \omega_3 f(z) \text{ and } f(\alpha(z)) = -f(z), \text{ for all } z \in \mathbb{C},$$

then f must have 6-fold color-turning symmetry. (Hint: Compute $f(\rho\alpha\rho(z)) = \omega_6 f(z)$.)

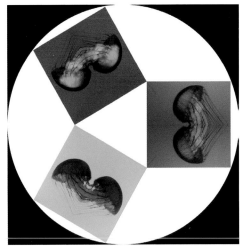

Figure 20.3. A function of type p31m/₃p1.

It requires some checking, but the waves $\hat{E}_{n,m}$ are compatible with this recipe. For instance, using the reflection across the x-axis, σ_x, gives us

$$\overline{\hat{E}_{n,m}(\sigma_x(z))} = \hat{E}_{-m,-n}(z).$$

The conjugation carries over to the coefficients, so the recipe

$$b_{n,m} = \overline{b_{-n,-m}}$$

used in sums of \hat{E}s will create functions with 3-fold color-turning *and* reflection symmetry. The color group is p31m and the actual symmetries are limited to p1, so the type is p31m/₃p1. Figure 20.3 shows an example, which has the same symmetry type as certain Escher prints. The jellyfish turns into a manta ray, in a sort of Monterey Bay Aquarium miracle.

Similar recipes cause the transformations σ_y and ρ_2 to be conjugate symmetries (types p3m1/₃p1 and p6/₃p3). Combining any two of the recipes that cause σ_x, σ_y, and ρ_2 to be conjugation mirrors, we obtain a pattern of type p6m/₃p2.

Such a pattern is shown in Figure 20.4 using the same color wheel. I find it difficult to make anything truly beautiful with symmetry types like these: Requirements of the color wheel are too strict. That said, I like how the jellyfish turned into flowers. The image might fool you into thinking it has mirror symmetry, especially when you focus on a vertical mirror through a flower: The red shapes are exactly symmetrical. Reflection across that mirror is not a symmetry of the pattern, as it swaps all the blues with greens. The other mirror axes of the flower have similar properties.

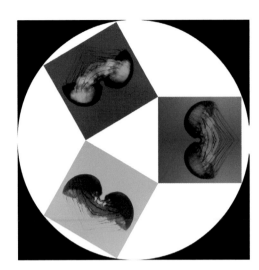

Figure 20.4. Floral shapes with color-swapping mirror axes appear in the domain coloring of a function of type p6m/$_3$p2.

In an exercise, we walk through count of all the possible pattern types with 3-fold color-turning symmetries, at least those with some kinds of 3-fold *rotational* symmetry. First, we consider something we have until now overlooked: 3-fold *translational* color-turning symmetry.

3-Fold Color-Turning Translations

Way back in Chapter 10, we saw a color-turning pattern. The simplest lattice wave, in Figure 10.1, was observed to have an accidental symmetry, a color-turning translation by the unusual amount of $(2 + \omega_3)/3$. It turns out that this is prototypical of a color-turning translation: It is as short as any translation τ so that τ^3 is a lattice translation. (Refer back to Exercise 32, about computing lengths in the skew $[X, Y]$-coordinates, to confirm that the length of this translation is $1/\sqrt{3}$.)

It is quite simple to make functions where the lattice of the color group contains our special point $(2+\omega_3)/3$, and the lattice of the symmetry group is the Eisenstein integers. If you diligently did the exercises in Chapter 10, what follows will be familiar. We investigate how the wallpaper waves for the Eisenstein lattice behave with respect to this shorter translation:

$$E_{n,m}\left(z + \frac{2 + \omega_3}{3}\right) = E_{n,m}e^{2\pi i(2n+m)/3}.$$

If $2n+m$ is a multiple of 3, the (n, m)-wave is unchanged. If we choose such waves consistently, the whole pattern will be invariant under the shorter translation

Figure 20.5. Left: Pattern type p3/₃p3. Right: Type p31m/₃p3m1. On the right, try focusing on the white area near a color-turning 3-center; that should help you see a pinwheel where three differently colored congruent shapes dance around.

lattice. For color-turning symmetry, we should choose

$$2n + m \equiv 1 \quad (\text{mod } 3) \text{ or, equivalently } m - n \equiv 1 \quad (\text{mod } 3). \quad (20.1)$$

The accidental symmetry of Chapter 10 is now a desired color-turning symmetry!

If we implement this recipe, forming a function from waves whose frequencies all satisfy (20.1), we can create a variety of patterns, all sharing this color-turning translational symmetry. Of course, if you choose $m - n \equiv -1 \pmod 3$, the colors will turn the other way; the type is the same.

If we do nothing special, superimposing enough generic waves to prevent accidental symmetry, we will find a function of pattern type p3/₃p3. Figure 10.1 does display this symmetry, but has additional ones—a conjugating mirror, in fact. A typical pattern of our new type is shown on the left in Figure 20.5.

Among the symmetry recipes for functions with 3-fold rotational symmetry ($a_{n,m} = a_{m,n}$ turns on σ_x, $a_{n,m} = a_{-m,-n}$ gives us σ_y symmetry, and $a_{n,m} = a_{-n,-m}$ produces half turns), the only one compatible with the congruence condition in (20.1) is the one producing σ_y symmetry. We are not using the color-turning waves \hat{E}, so there is nothing more to check: The recipe

$$a_{n,m} = a_{-m,-n}, \text{ where } m - n \equiv 1 \quad (\text{mod } 3)$$

produces functions with symmetry group p3m1 and an additional color-turning translational symmetry. In this and future recipes, it should go without saying that we mean for all coefficients to be zero for pairs where $m - n$ is not congruent to 1 (mod 3).

If we implement this recipe, as I did to produce the image on the right in Figure 20.5, what is the color group? The points 0 and $(2 + \omega_3)/3$ are now translationally related 3-centers in the group, so there must be two different nontranslationally related 3-centers in between them. We created no mirrors through these new 3-centers, so the color group is p31m.

Enough! I hope this gives you enough of a taste to inspire you to work through the exercise and determine that there are exactly 10 pattern types of 3-fold

* EXERCISE 50

Work through the recipes to show that Table 20.1 exhausts all possibilities for 3-fold color-turning symmetry, at least if we require *some* 3-fold rotational symmetry in the color group. (Advice: For each generator of each group, consider whether it can be a color-turning generator.)

* EXERCISE 51

Imitate the construction in this chapter, but use square waves, to find the color-turning wave packets you would use to create 4-fold color-turning symmetry. If you did *not* use those color-turning packets, how could you use congruence modulo 4 to create 4-fold color-turning symmetry?

As a major project: Investigate which of these efforts are compatible with other symmetries in groups that contain p4. Create a color wheel with the right symmetry to depict your functions. The number of 4-color pattern types is large [23]. How many of these actually involve 4-fold rotation rather than repeated stamps of the same pattern colored 4 different ways?

TABLE 20.1: A table of recipes for the 10 pattern types with 3-fold color-turning symmetry and 3-fold rotational symmetry in color group. All but the first 3 types require the special color-turning wave packets, $\hat{E}_{n,m}$.

USE WAVES $E_{n,m}$ WITH 3-FOLD SYMMETRY	
$m - n \equiv 1 \pmod{3}$	type p3/$_3$p3
$m - n \equiv 1 \pmod 3$ and $a_{n,m} = a_{-m,-n}$	type p31m/$_3$p3m1
$m - n \equiv 1 \pmod 3$ and $a_{n,m} = \overline{a_{-m,-n}}$	type p31m/$_3$p3

USE COLOR-TURNING WAVES $\hat{E}_{n,m}$	
generic frequencies	type p3/$_3$p1
$a_{n,m} = a_{-n,-m}$	type p6/$_3$p2
$a_{n,m} = \overline{a_{-m,-n}}$	type p31m/$_3$p1
$a_{n,m} = \overline{a_{m,n}}$	type p3m1/$_3$p1
$a_{n,m} = a_{-n,-m}$ and $a_{n,m}$ real	type p6/$_3$p3
$a_{n,m} = \overline{a_{-m,-n}} = \overline{a_{m,n}}$	type p6m/$_3$p2
$a_{n,m} = a_{-m,-n}$, $a_{n,m}$ real, and $m - n \equiv 1 \pmod 3$	type p6m/$_3$p3m1

color-turning symmetry, if we limit ourselves to the case where the color group contains ρ_3. Without that limitation, there are 23 types. I find them boring: For instance, in the pmm recipe, if you consistently choose $n \equiv 1 \pmod 3$, your pattern will look like it has been stamped out from the same potato stamp with three different colors of ink as you move across.

I have included images with 4-fold color-turning symmetry in art exhibitions. I find them lovely, but having spent so much time on 3-fold turning, we should move on and leave something to be investigated in the exercises.

Chapter 21
The Point Group and Counting the 17

Question: How do point groups help us know we have found all possible wallpaper groups? In this chapter we focus on mathematical rather than visual beauty. I find the vistas remarkable but have to acknowledge that they may not be to everyone's taste. A deceptively named object called the *point group* gives us just what we need to verify that our search for all possible wallpaper groups is indeed limited to the 17 we have found. To clean up a detail we left hanging in Chapter 12, we use complex algebra to write formulas for all the possible plane isometries. This, along with some lovely abstract algebra, helps us know that the 17 wallpaper groups cannot be joined by some new discovery.

Once again, we pause to reflect that this is remarkable: If anyone tries to create a pattern with translational symmetries—supposing that these are exact symmetries—the symmetry group of that pattern will be one those on our interestingly short list.

The goal of this section is to explain what I mean by the following enigmatic statement, where the first part summarizes what we already know and the second part describes role of the the point group:

> A wallpaper group acts on the plane as isometries, which may be symmetries of a particular pattern; such a pattern is, for us, a function whose domain is the plane, the place where the wallpaper group acts. The point group of the wallpaper group acts on a function by acting on *frequency space*, in the sense that it acts on the Fourier coefficients of a periodic plane function. The number of distinct wallpaper groups can be counted by counting, for each lattice type, possible actions in frequency space.

Let's begin with a motivating example, interpreting this statement in the context of the Eisenstein lattice, where we have passed so much time, starting in Chapter 10. Recall that this lattice is

$$\mathcal{E} = \{a + b\omega_3 \mid a, b \in \mathbb{Z}\}, \text{ where } \omega_3 = e^{2\pi i/3}.$$

Recall too that all the functions shown in Chapter 11 were periodic with respect to translation by any element of \mathcal{E}.

The Point Groups of the p3 Series

Our focus in creating symmetry has been fixed on the recipes that lock waves together in packets. In Chapter 11, we studied superpositions of wave triples

$$f(z) = \sum a_{n,m} W_{n,m}(z),$$

where

$$W_{n,m}(z) = \left(e^{2\pi i(nX+mY)} + e^{2\pi i(mX-(n+m)Y)} + e^{2\pi i(-(n+m)X+nY)} \right)/3$$

and $z = X + \omega_3 Y$. We learned that any such function enjoys 3-fold rotational symmetry about the origin, as well as the translational symmetry present in each of the individual component waves. The symmetry group of any such function is at least as large as p3. Although we did nothing to force additional rotations, any such function f also enjoys 3-fold rotational symmetry about three different infinite grids of points: the Eisenstein integers \mathcal{E}, as well as what I called the nontranslationally related 3-centers, which lie at centers of triangles whose vertices are a nearest triple of Eisenstein integers.

The proliferation of extra rotations is explained entirely by the group concept; examining it will carry us to a definition of the point group. If the original 3-fold rotation, the one about the origin, is called $\rho_3(z) = \omega_3 z$, then it turns out that *every one* of those other 120° rotations in a p3 pattern can be expressed in the form $\tau\rho_3$, where τ is some translation by an element of \mathcal{E}. If this conflicts with your memory that distant rotations are created by a recipe $\tau\rho_3\tau^{-1}$, you are right to be concerned. An algebraic trick rescues us.

Computation shows that $\rho_3\tau_{a+b\omega_3}\rho_3^{-1}(z) = \tau_{\omega_3(a+b\omega_3)}(z)$, which means that $\rho_3\tau_{a+b\omega_3} = \tau_{\omega_3(a+b\omega_3)}\rho_3$. We cannot commute τ's and ρ's, but we can slip a rotation past a translation if we are willing to swap for a different translation. Thus, if you call my attention to a rotation through 120° about the point $a + b\omega_3$ and want to express it as

$$\tau_{a+b\omega_3} \, \rho_3 \, \tau_{a+b\omega_3}^{-1},$$

I can use my trick to express this as

$$\tau_{a+b\omega_3} \, \tau_{\omega_3(a+b\omega_3)}^{-1} \, \rho_3,$$

which has the right form, as $\tau\rho_3$.

For wallpaper functions with group p3, all the many 120° rotational symmetries can be generated from the original one, ρ_3. Even those rotations about nontranslationally related 3-centers are, in a compositional sense, related by translation to ρ_3. For instance, our first example of a nontranslationally related 3-center in Chapter 12 was the fixed point of the composition $\tau_1\rho_3$, which has the desired form. We want to be able to say that ρ_3 and $\tau_1\rho_3$ *differ by a translation*. The word *difference* is sometimes reserved for subtraction, but here we use it to indicate that one group element is obtained from the other by composing with a translation. Thanks to the algebraic trick, we don't need to be fussy about which order we specify.

In Chapter 19, we previewed just the language that best captures this idea of one master rotation and all the subsequent rotations that devolve from it through composition with translations: That was the language of normal groups and quotient groups, and it bears fruit for us here.

Let us define the *equivalence class* of ρ_3 to be the set of all transformations that differ from ρ_3 by a translation in p3:

$$[\rho_3] = \left\{ \tau_{a+b\omega_3}\rho_3 \mid a, b \in \mathbb{Z} \right\}.$$

The classes $\left[\rho_3^2\right]$ and $[\tau_0 = \iota]$ are defined similarly: Two transformations are considered equivalent if one is a translation times the other.

A little work, which we leave as an exercise, shows that the set

$$\left\{ [\tau_0 = \iota], [\rho_3], \left[\rho_3^2\right] \right\}$$

is a group isomorphic to \mathbf{C}_3, the cyclic group on three elements. The heart of the proof is this algebraic trick of shuffling translations past rotations by trading them for different translations.

This group of three elements is, in fact, the point group of p3. It is suspiciously similar to the group that fixes the origin, which we called the *stabilizer* of the point 0, consisting of the three elements ρ_3, ρ_3^2, and ι, the identity transformation. Do not be fooled. In general the point group is not the stabilizer of any point, which is why the name is deceptive.

Let's look at another example: p31m. Recall that σ_x denotes reflection across the x-axis and that two different reflections with axes through the origin are spawned by combining σ_x with ρ_3. This may help you guess that the point group of p31m has 6 classes:

$$\left\{ [\tau_0 = \iota], [\rho_3], \left[\rho_3^2\right], [\sigma_x], [\sigma_x\rho_3], \left[\sigma_x\rho_3^2\right] \right\}.$$

This group with 6 elements is isomorphic to the dihedral group \mathbf{D}_3.

Again, the point group happens in this case to be isomorphic to the group of transformations in p31m that fix 0. Trust me: It's an accident. We really should think of $[\sigma_x]$ as the *class* of transformations related to σ_x by translation.

To gain a feeling for why the point group concept helps us limit the possibilities for wallpaper groups, recall how σ_x—and any translation multiple of it, in the group sense—acts on one of our wave packets. If τ is any translation by an Eisenstein integer,

$$W_{n,m}\left(\tau\sigma_x(z)\right) = W_{n,m}\left(\sigma_x(z)\right) = W_{m,n}(z).$$

Every transformation in the class swaps the wave with frequency pair (n, m) for the one with frequency pair (m, n). This element of the point group, being an entire class of transformations, acts on the space of (n, m) pairs because the translation part of any element in the class is invisible from the point of view of the waves. This is what I mean by the point group acting on frequency space.

EIGENVALUES AGAIN! When we think about possible ways to shuffle the (n, m) pairs to create different symmetries, we face an additional limitation: Since an isometry preserves the entire geometry of the wave—size and shape,

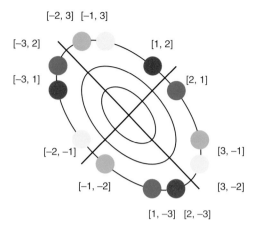

Figure 21.1. Twelve frequency pairs (n, m) satisfy $n^2 + nm + m^2 = 7$. Colors show how they are locked together to create 3-fold symmetry. Other symmetries are created by further lockings.

though perhaps not direction—submitting a wave to an isometry produces a new wave with the same eigenvalue. Recall from Chapter 9 that our plane waves are eigenfunctions of the Laplace operator and that the eigenvalues are, in vague terms, a measure of their energy; waves with larger eigenvalues will vibrate more rapidly.

In Chapter 9, we had not met the Eisenstein lattice, so I could not assign the marvelous exercise of computing the eigenvalues of the fundamental waves periodic with respect to this unusually symmetric lattice:

$$\Delta E_{n,m} = -\tfrac{16}{3}\pi^2(n^2 + nm + m^2)E_{n,m}. \tag{21.1}$$

We neglect the constant in front and define the *quadratic form*

$$Q(n, m) = n^2 + nm + m^2$$

as capturing the essence of the eigenvalues. The remark about isometries preserving the shape of waves suggests that symmetry can only be created if we lock together waves with the same eigenvalue. Fortunately, as computation will confirm,

$$Q(n, m) = Q(m, -(n + m)) = Q(-(n + m), n),$$

so locking the Es together into Ws groups together waves with the same eigenvalue. Likewise, $Q(n, m) = Q(m, n)$ is rather a no-brainer, so σ_x behaves nicely with respect to eigenvalues.

We summarize this circle of ideas in Figure 21.1, which shows a colored dot for each of the frequency pairs (n, m) with $Q(n, m) = 7$. The triples that make up a single W-packet share the same color.

The black lines are meant to help you see at a glance the entirety of ways we can possibly lock waves together to create symmetry. They suggest all the possible ways a point group could act. Locking waves across the line $n = m$ produces p31m functions; locking them across $n = -m$ takes us to p3m1. Functions invariant under p6 are created by locking (n, m) with $(-n, -m)$, and engaging any two of these lockings at once takes us to p6m.

Does the diagram convince you that these are the only possibilities? A more rigorous proof later in the chapter uses some rather ad hoc methods to finish the details. An alternative approach could come from computing the group of transformations of the (n, m) plane that leave the quadratic form Q fixed, which we leave as a rather substantial exercise. With our example complete, we are ready for greater abstraction.

The Point Group of a Wallpaper Group

We create symmetry in two steps: We create translational symmetry with respect to a lattice, by constructing a family of lattice waves, and then combine lattice waves in specific ways that yield additional symmetries. The point group involves the second of these steps, and this means we have an interest in lumping together all the symmetries in a given group whose only difference is a translation. This motivates a definition, which requires just a bit of backstory.

Suppose G is a wallpaper group with translational subgroup T, meaning that every translation in G belongs to T. It turns out, as an exercise will confirm, that T is always normal in G. Recall that this means that the conjugation $g\tau g^{-1}$ is always a translation whenever τ is a translation and g is any element of G. Before thinking about a formal proof, convince yourself of a few examples: Flip, translate, and flip back; yes, that is a translation. Examples are fun to try with dynamic geometry software, such as the open-source *Geogebra*.

A consequence of this normalcy is that we can slip translations past other group elements, as long as we are willing to trade one translation for another. It is as if we want to identify all the translations in the group and find out what is left over. To shine the light on one particular group element g, we define the *class of g* to be

$$[g] = \{\tau g \mid \tau \in T\},$$

which, by the normal property, is the same as $\{g\tau \mid \tau \in T\}$. As an easy exercise, show that $[g] = [h]$ if and only if hg^{-1} is a translation. In the language we used earlier, this means that g and h are equivalent if they differ by a translation.

By another application of the same property, if g and h are any elements of G,

$$\{\tau gh \mid \tau \in T\} = \{(\tau_1 g)(\tau_2 h) \mid \tau_1, \tau_2 \in T\},$$

so we can think of the class $[gh]$ as the product of classes $[g]$ and $[h]$. This is the main step in proving that the set of classes forms a group, called the *quotient group* of G by T, written G/T.

Definition 7. Suppose G is a wallpaper group with translational subgroup T, meaning that every translation in G belongs to T. The *point group* of G is the quotient G/T, which is the set of equivalence classes of G where two elements are considered equivalent if they differ by an element of T.

Here is an example to show why the name *point group* is potentially confusing. In Chapter 18, we studied the group pg, which is generated by two perpendicular translations and a glide reflection γ whose axis is parallel to one of the translation directions. The only element of pg that fixes a point is the identify transformation, which fixes all points. And yet the point group of pg has a nonzero element, $[\gamma]$, because γ is not equivalent to a translation—it flips the plane over.

The point group of pg is

$$\mathrm{pg}/T = \{[\iota], [\gamma]\},$$

a group isomorphic to the two-element cyclic group \mathbf{C}_2. In contrast, the stabilizer of any point is the trivial group with one element, the identify transformation ι.

We close this section with one more point: Two nonisomorphic groups may have isomorphic point groups. If this were not the case, we could classify wallpaper groups by the isomorphism classes of their point groups. Alas, both pg, which we have just reviewed, and pm both have point groups isomorphic to \mathbf{C}_2, which is also the point group of groups cm and p2. We will see that the difference between these nonisomorphic groups is best detected by the way they act on the waves that make up periodic functions. First we enjoy an algebraic interlude, which you are welcome to skip.

We introduce some unnecessary vocabulary, on the off chance that you will enjoy it if you have seen it before or benefit later from seeing it now. The concept of an *exact sequence of groups* is the start of the group cohomology we mentioned earlier as the power tool for analyzing wallpaper groups, which remains beyond the scope of this book. Personally, I have little taste for *homological algebra*, of which this subsection gives a small sample. See if you like it more than I do.

Suppose that A, B, and C are groups and that when I write an arrow between them, I mean to indicate a specific homomorphism from one to the other in the direction of the arrow. Sequences of homomorphisms occur frequently in practice, and it turns out that having a symbol, say 1, for the trivial group with a single element makes things particularly elegant. So, in the diagram

$$1 \to A \to B \to C \to 1,$$

I mean that there is a homomorphism that includes the trivial group in A, where, of course, the single element must land on the identity of A. I also mean that every element of C must be squashed down onto the single element of the group 1.

I say that the sequence is *exact at B* to mean that the image of A in B is the same as the kernel of the homomorphism of the map leaving B for C. (Recall that the kernel of a homomorphism is the set of elements that map to the identity in the target group.) We call the whole sequence exact when it is exact at each of its groups. A sequence with three groups sandwiched between trivial groups is called a *short exact sequence*.

We practice with the concept of exactness by observing that the sequence is exact at A if and only if the map from A to B is one-to-one: There can be only one element in the kernel of the map leaving B, the identity of A. Similarly, the sequence is exact at C if and only if the map from B to C is onto: The image of that map from B must contain all of C, since that is what gets mapped to the identity in the map leaving C. Yes, the price we pay for not giving names to these maps is the complexity of these sentences. My choice may be justified presently.

We apply this vocabulary to our new concept of a wallpaper group's point group. If a wallpaper group G has translation group T, we form a sequence of homomorphisms

$$1 \to T \to G \to G/T \to 1.$$

The map from T to G is just inclusion, so there is no need to give it a name. The map from G to G/T is just $g \to [g]$, assigning to g the equivalence class of g. Again, no need for cumbersome extra notation. The key to checking exactness is to notice that the map from G to the quotient group G/T causes all the translations in T to end up in the same equivalence class, which is the identity of G/T.

For one more example of a short exact sequence, we recall the color-reversing and color-turning patterns of Chapters 19 and 20. For instance, enjoyment of the image in Figure 19.3, of type p4g/cmm, might be enriched by admiring the short exact sequence

$$1 \to \mathrm{cmm} \to \mathrm{p4g} \to \mathbf{C}_2 \to 1.$$

Similarly, in Figure 20.1, you can see evidence of the short exact sequence

$$1 \to \mathrm{p1} \to \mathrm{p3} \to \mathbf{C}_3 \to 1.$$

Complex Algebra and Isometries

We need two useful propositions before we can move on to study the action of the point group in frequency space. First we state them both, with proofs to be completed in exercises. Recall that a plane isometry is a map from \mathbb{C} to itself that preserves distances (and hence angles).

Proposition 3. *Every plane isometry α has one of two forms*

$$\alpha(z) = sz + t \text{ or } \alpha(z) = s\bar{z} + t.$$

In either case, $|s| = 1$.

In the first case, we call α a *direct isometry*; in the second α is called an *indirect isometry*. Intuitively, direct isometries leave the plane right-side up, while indirect ones turn it over. Every indirect isometry is either a reflection, with a line of fixed points, or a glide, with no fixed points at all. Every direct isometry is either a translation or a rotation. (These comments are justified in an exercise, which outlines a proof of Proposition 3.)

The next proposition is a bit cumbersome, due to several caveats that are necessary to standardize the way we talk about groups. For instance, it is not productive to talk about a group that is essentially p3 but moved a bit so that the random point $0.6 + i0.8$ is a 3-center. If someone offered us that group, we could change coordinates, adjusting the plane so that the origin of the new coordinate system is the 3-center. It is essentially the same group. You are welcome to skip this fine point on a first reading, but we begin the discussion with a definition.

Definition 8. Suppose that G is a wallpaper group with translational subgroup T, meaning that T contains *all* of the translations in G. We say that G is *conventionally represented* when the following adjustments have been made as necessary:

1. The plane has been rotated and scaled, if necessary, so that T is generated by translations by the complex numbers 1 and $\omega = \xi + i\eta$. Name the lattice $\Lambda = \{a + b\omega \mid a, b \in Z\}$.
2. If G contains any rotation, then the origin is a fixed point of a rotation of highest degree.
3. If G contains any indirect isometry and does not contain ρ_3, then it also contains an indirect isometry whose axis is the x-axis.
4. If Λ is the rhombic lattice, a mirror axis passes through the origin.
5. If G contains ρ_3, the rotation about the origin by $120°$, as well as some reflection, then G has been translated as necessary so that there is a reflection in G that fixes 0.

A rigorous proof that every wallpaper group can be represented conventionally is tedious, so we hope that you get the idea and proceed with the useful part.

Proposition 4. *Suppose G is a conventionally represented wallpaper group with lattice Λ.*

1. *If $\alpha \in G$ is a direct isometry, thus having the form $\alpha(z) = sz + t$, then $t \in \Lambda$ and the lattice Λ is invariant under multiplication by s. This means that $\alpha(0) = t$ is always a lattice point.*

2. *If $\alpha \in G$, with $\alpha(z) = s\bar{z} + t$, is an indirect isometry, then the lattice Λ is invariant under complex conjugation and under multiplication by s. Furthermore, $t \in \Lambda$, with some possible exceptions:*

- *If $s = i$, meaning that we are in the square lattice with $\omega = i$, then we may have $t = (a + bi)/(i - 1)$.*
- *If $s = \pm 1$, then we may have $t = (a + b\omega)/2$, unless the cell is rhombic.*

In these exceptional cases, $\alpha(0)$ may not be a lattice point.

Let's prove the easy part of this here and relegate the difficult part—the part about indirect isometries—to an exercise. The techniques are similar for both, but the second case requires some cumbersome cases. We do pause, however, to think back through the groups we have known and comment on how they measure up to the proposition. The exceptional cases for indirect isometries might remind you of the discussion around pg. One of the generators of this group is $\gamma(z) = \bar{z} + \frac{1}{2}$, so the group does indeed contain an element that maps 0 to a point that does not belong to the translation lattice.

Similarly, what I called the slant mirror in p4g,

$$\sigma(s) = i\bar{z} + \frac{1 - i}{2} = i\bar{z} + \frac{i}{i - 1},$$

takes the origin to the point $(1 - i)/2$. Find the slant mirror in Figure 15.4 and confirm that the 4-center you chose as the origin flips to an opposite-sensed 4-center when we reflect.

Proof (partial). Suppose $\alpha(z) = sz + t$ is a direct isometry in G, as before. Since $|s| = 1$, we can write $s^{-1} = \bar{s}$. This means that

$$\alpha^{-1}(z) = \frac{z - t}{s} = \bar{s}z - \bar{s}t.$$

Conjugate the general translation by $a + b\omega$ by α to find that

$$\alpha \tau_{a+b\omega} \alpha^{-1} = z + s(a + b\omega).$$

This is a translation and so must belong to T, meaning that Λ is invariant under multiplication by s. Reversing the roles of α and α^{-1} shows that Λ is also invariant under multiplication by \bar{s}.

Assume that $s \neq 1$, so that α is not a translation. (If it is, $t \in \Lambda$ is already required by hypothesis.) Rearranging α as

$$\alpha(z) = s\left(z - \frac{t}{1 - s}\right) + \frac{t}{1 - s}$$

shows that α is a rotation of some sort about the point $t/(1 - s)$. By the crystallographic restriction, $s = \omega_p$, where $p = 2, 3, 4,$ or 6. But we promised that

the highest order of rotation in G occurs at the origin, so, in any case, $\rho_p(z) = \omega_p z$ belongs to G. The composition

$$\alpha\left(\rho^{-1}(z)\right) = \omega_p \omega_p^{-1} z + t$$

shows that $t \in \Lambda$, as desired.

For the easy part of the proof for an indirect isometry α, verify that $\alpha^{-1} = s\bar{z} - s\bar{t}$, so conjugation gives

$$\alpha \tau_{a+b\omega} \alpha^{-1} = z + s\,\overline{a + b\omega}.$$

We proved in Chapter 16 that the lattice of any group containing indirect isometries is invariant under conjugation, so this shows that it is also invariant under multiplication by s. ∎

The Action of the Point Group

Admitting to the usual minor vagueness, we think of functions and Fourier series as being the same things. One *can* clarify exactly which functions have convergent Fourier series and exactly which Fourier series converge to exactly which type of function, but we leave that for further study. The point is: A function and its Fourier series are sufficiently close to being the same object that we lose little by treating them as one object.

With this in mind, we notice that when two elements of a wallpaper group G differ by a translation, their action on plane waves is identical: If g and \hat{g} belong to the same class in the point group of G, so that $g = \tau\hat{g}$, where τ is a translation, then

$$E_{n,m}(\hat{g}(z)) = E_{n,m}(\tau g(z)) = E_{n,m}(g(z)).$$

Thanks to our work on the structure of isometries in G, we can say a great deal about just how one of these classes in the point group treats waves: An element of the point group always takes waves to other waves, possibly multiplying by a unit complex number. We illuminate this in two stages, for direct and indirect isometries.

Although our initial example of groups that contain p3 used ordered pairs (n, m) to index waves, it turns out to be simpler to use complex vectors, as developed in Chapter 14. We review the concept and then show how easy it makes our lives.

If Λ is generated by 1 and ω (where ω need not be a unit number—we subscript with p if necessary when we wish to show a pth root of unity), we can compute the dual lattice to be

$$v_1 = -\frac{i}{\text{Im}(\omega)}\omega, \ v_2 = \frac{i}{\text{Im}(\omega)}.$$

These provide a nice basis for the frequency vectors, and we reconcile the two notations by checking that

$$v_{n,m} = \frac{i}{\text{Im}(\omega)}(-n\omega + m) \text{ gives } \text{Re}(z\bar{v}_{n,m}) = nX + mY,$$

where $z = X + \omega Y$.

ACTION OF DIRECT ISOMETRIES. Let's first investigate how direct isometries treat our wave functions. Suppose $g \in G$ is a direct isometry, so that $g(z) = sz + t$, with $t \in \Lambda$, the lattice of G. Knowing that t belongs to the translation lattice simplifies things greatly: This means that g is equivalent to multiplication by s, a rotation.

To compute the action of $[g]$ on waves, we use a simple v as a shorthand for $v_{n,m}$, understanding that a sum over all possible v will mean all the possible vectors $v_{n,m}$. We compute

$$E_v(g(z)) = e^{2\pi i \text{Re}(g(z)\bar{v})} = e^{2\pi i \text{Re}((sz+t)\bar{v})} = e^{2\pi i \text{Re}(z\overline{\bar{s}v})}.$$

This last expression is simply $E_{\bar{s}v}(z)$. Our direct isometry g, like all other elements of G in its equivalence class, moves the wave indexed by v to the one indexed by $\bar{s}v$. Can we be sure that this is one of our lattice waves?

We know that Λ is \bar{s}-invariant, and the dual lattice is really just Λ turned and scaled a bit, so the dual lattice is also \bar{s}-invariant. Yes, $\bar{s}v$ is one of our lattice waves.

For instance,

$$\bar{\omega}_3 v_{n,m} = \bar{\omega}_3 \frac{2i}{\sqrt{3}}(-n\omega_3 + m) = \frac{2i}{\sqrt{3}}(-m\omega_3 - (n+m)) = v_{m,-(n+m)},$$

consistent with our earlier recipe.

Let us see what this means for Fourier series. If

$$f(z) = \sum_v a_v E_v(z), \text{ then } f(g(z)) = \sum_v a_v E_{\bar{s}v}(z) = \sum_v a_{sv} E_v(z).$$

The missing bar on the s in the subscript of a is not a typo: If we index waves by $w = \bar{s}v$, then the subscript on a is $v = sw$, and then we relabel each w as a v.

Instead of indicating a function by $f(z)$, let's describe it as $a : \{v_{n,m}\} \rightarrow \mathbb{C}$, a function that tells us, for each possible frequency vector $v_{n,m}$, how much of the corresponding wave is included in the Fourier series of f. To avoid having subscripts on subscripts, let's write $a(v)$ instead of a_v, feeling free to suppress the dependence of v on (n, m) when clarity permits. Using this new notation, we can write for a direct isometry g,

$$[g] : a(v) \rightarrow a(sv), \text{ or, if we wish, } [g]a(v) = a(sv),$$

Every element of the equivalence class of g in G moves the frequency vector v to sv, so the function $a(v)$ is moved to $a(sv)$. If a is the Fourier-coefficient function of f, then f is invariant under $[g]$ if and only if a is invariant under $[g]$. This is just a rearticulation of the "recipe" concept of earlier chapters: If we want to create

a function periodic with respect to Λ and invariant under g, we should choose the Fourier coefficients a so that $a(v) = a(sv)$.

If g has order 2, then creating such a function is as simple as averaging *any* arbitrarily chosen coefficients, producing

$$\frac{a(v) + a(sv)}{2} \text{ from the coefficient function } a(v).$$

If g has higher order, we can average over more terms. For instance, the wave packets W from our introductory example in this chapter are really just a way to set

$$a(v) = a(\omega_3 \, v) = a(\omega_3^2 v),$$

resulting in the 3-fold symmetry we created so many chapters back.

To summarize, rotations act on functions by a simple swap of the waves in their Fourier series. When we reindex the waves, the action of the rotation appears as an action on frequency vectors, which are the domain of the coefficient function a. The coefficient function a of a function f that has the rotation as a symmetry in the space domain will be invariant under this action in the frequency domain. The situation is slightly more complicated for indirect isometries in the point group.

THE ACTION OF INDIRECT ISOMETRIES. We study the action of a particular indirect isometry $g(z) = s\bar{z} + t$ on waves periodic with respect to our lattice Λ. Our computations go through almost as before, with a twist:

$$E_v(g(z)) = e^{2\pi i \operatorname{Re}((s\bar{z}+t)\bar{v})} = e^{2\pi i \operatorname{Re}(z\overline{s\bar{v}})} e^{2\pi i \operatorname{Re}(t\bar{v})} = E_{s\bar{v}}(z) e^{2\pi i \operatorname{Re}(t\bar{v})}.$$

In the middle step, to put the wave in a recognizable form, with z in the exponent, I used the fact that $\operatorname{Re}(w) = \operatorname{Re}(\bar{w})$ for any complex number w.

Repeating the wave-by-wave analysis of a Fourier series under this action, using that trick of reindexing, we can express the action of $[g]$ on the Fourier coefficient function a as

$$[g]a(v) = a(\bar{s}\bar{v}) e^{2\pi i \operatorname{Re}(t\bar{v})}.$$

There are two things to notice: We need to use what we learned about indirect isometries in wallpaper groups to know that the new frequency vector $\bar{s}\bar{v}$ belongs to Λ. Fortunately, we showed that any lattice of a group with indirect isometries is invariant both under conjugation and multiplication by \bar{s}. Second, the unit factor that appears when we submit a to this action means that we are not simply swapping one wave for another; we are possibly turning it. If $t \in \Lambda$ that factor is simply 1: By design of the dual lattice, the dot product with v is always an integer when we plug in a lattice point as t. Any unusual behavior occurs in those exceptional cases, where t may not belong to Λ. We turn out attention to these.

Suppose we have indirect isometries where $s = \pm 1$ and hence the possibility of $t = (a + b\omega)/2$. Now is a time to restore the subscript (n, m) to the frequency vector v to compute that that

$$e^{2\pi i \operatorname{Re}(t\bar{v}_{n,m})} = e^{\pi i \operatorname{Re}((a+b\omega)\bar{v}_{n,m})} = (-1)^{an+bm}.$$

If a is odd and b is even, this reduces to $(-1)^n$. In other cases, it could look like $(-1)^m$ or perhaps $(-1)^{n+m}$. I hope that these remind you of recipes for groups like pg, pmg, and so on.

Similarly, in the square lattice, suppose we have an indirect isometry with $s = i$. This opens the door to the possibility that

$$t = (a + bi)/(i - 1), \text{ which we rewrite as } t = (b - a - i(a + b))\,/2.$$

Plugging into the formula for that exponential factor gives, in this case,

$$e^{2\pi i \operatorname{Re}(t\bar{v}_{n,m})} = e^{\pi i \operatorname{Re}((b-a-i(a+b))\bar{v}_{n,m})} = (-1)^{(b-a)n-(a+b)m}.$$

That might look scary. It is not. If a and b are both even or both odd, then $b-a$ and $a+b$ are both even, so the complicated expression collapses to 1. If a and b have opposite parities, one even and one odd, the expression becomes the innocuous $(-1)^{n+m}$, perhaps familiar from the p4g recipe.

There is something all these factors have in common: Each is a homomorphism from the lattice Λ to the group $\mathbf{C}_2 = \{1, -1\}$. You can convince yourself that, no matter what the lattice is, there are only four of these: the trivial homomorphism that sends everything to 1 and the three we have mentioned, $(-1)^n$, $(-1)^m$, and $(-1)^{n+m}$. (Although the homomorphism is literally from the dual lattice to \mathbf{C}_2, the two lattices are isomorphic to one another and to the direct product $\mathbb{Z} \times \mathbb{Z}$, so we sweep that detail under the rug.)

Note that the homomorphism depends on the *equivalence class* of t, so we might label it $\phi_{[t]}$, but we choose the simpler ϕ_t instead, understanding that we can trade t for $t+a+b\omega$ if convenient. In fact, we may as well assume that $t = c+d\omega$, where $0 \le c < 1$ and $0 \le d < 1$. Geometrically, this would mean trading an indirect isometry that moves 0 far from the origin to one that moves 0 into the fundamental cell or perhaps onto one of its lower-left edges.

Putting this all together, if $[g]$ is the class of any indirect isometry in a wallpaper group, the action of $[g]$ on a Fourier coefficient function always has the form

$$[g]a(v) = \phi_t(v)a(\bar{s}v), \text{ where } \phi_t : \Lambda \to \mathbf{C}_2$$

is a homomorphism. Wow! The paucity of homomorphisms to play the role of ϕ, along with the limitation that the lattice be s-invariant, is really what limits us our list of wallpaper groups to the celebrated 17.

Before we say any more about how this leads to a proof that there are indeed only 17 different wallpaper groups, let us look at a few examples.

If the direct isometry is the easy glide, $\gamma(z) = \bar{z} + \frac{1}{2}$, one of the generators of the group pg, check that the fancy formula simplifies to the quite tractable

$$[\gamma]a(v_{n,m}) = a(\bar{v}_{n,m})(-1)^n,$$

differing from our pg recipe only in appearance.

Similarly, if we simplify that exponential factor for $\sigma_s(z) = i\bar{z} + (1 - i)/2$, one of the generators of p4g, we find that

$$[\sigma_s]a(v_{n,m}) = a(-i\bar{v}_{n,m})(-1)^{n+m},$$

which checks with the p4g recipe.

The 17 Wallpaper Groups

Why are there 17 wallpaper groups? By this we mean, of course, why are there 17 different isomorphism classes of wallpaper groups? We are now in a position to see why this is so.

We have shown that if G, a wallpaper group with lattice Λ, is conventionally represented, then the point group of G acts on Fourier coefficient functions a in a very limited way. If $g = sz + t$ is a direct isometry in G, then

$$[g]a(v) = a(sv), \tag{21.2}$$

meaning that this isometry simply shuffles the vectors in frequency space. If $g = s\bar{z} + t$, then there is a homomorphism $\phi_t : \Lambda \to C_2$ that allows us to express the action as

$$[g]a(v) = \phi_t(v)a(\bar{s}\bar{v}). \tag{21.3}$$

This theoretical setup is all about the action of a *single* element of the point group. To count wallpaper groups, we need to take into account the possible interactions of multiple elements of the point group, a task we now begin.

My unveiling of the various groups progressed, roughly, from more complicated to less complicated groups. Here, we reverse the journey. Throughout, we assume that G is a conventionally represented wallpaper group with lattice Λ. Let us also assume that, if G is not using the symmetry of Λ, then we tilt G just a bit so that the tilted lattice is not symmetric. For example, you are free to make p1 wallpaper in the hexagonal lattice, but you might as well be making that pattern in a lattice that has been skewed just a bit. We want to be able to count groups by their lattice types, so let us agree not to waste a perfectly symmetric lattice on a group that is indifferent to the symmetry.

Suppose Λ has no mirror symmetry, so that the point group contains no indirect isometries. What rotational symmetries could Λ have? A quick look at the square and hexagonal lattices show that they do have mirror symmetry, so the only rotational symmetry left is 2-fold rotation. In this case, the point group of G either has $[\rho_2]$ or it doesn't. Only two cases are possible; G is either p1 or p2.

Suppose Λ is the rhombic lattice. By convention, we have assumed that G uses the symmetry of this lattice, and therefore a mirror axis passes through 0. We need not consider any homomorphisms ϕ_t, and the only possible values of s in (21.3) are ± 1. The two possibilities are reflections σ_x and σ_y. If the point group has only one element other than the identity, $s = 1$ turns on σ_x, producing the horizontal version of cm, as presented in Chapter 16, while $s = -1$ gives an isomorphic copy: cm generated by translation and σ_y; cm turned on its side.

Continuing with the rhombic case, notice that the presence of $[\rho_2]$ and $[\sigma_x]$ forces their composition, $[\sigma_y]$, to belong to the point group. If the point group of G contains two nonidentity elements, then it must contain four. In this case, G is cmm. There are no other possibilities for this lattice.

The rectangular lattice is the most complicated case. By convention, we know that there must be indirect isometries present. (Otherwise, we would not be using this wonderfully symmetric lattice.) Therefore, suppose the point group of G contains $[g]$, where $g(z) = s\bar{z} + t$. From (21.3), we see that, again in this case, $s = \pm 1$, for horizontal and vertical reflections.

Suppose first that $[g]$ is the only nonidentity class in the point group. We may as well take $s = 1$, because the single-class case with $s = -1$ leads to the same groups turned on their sides. Among the possibilities with $s = 1$, the easy cases are $t = 0$ and $t = 1/2$. If $t = 0$, G contains the reflection σ_x and is therefore isomorphic to pm. If $t = 1/2$, we have a horizontal glide along the x-axis: pg.

Now for a messy point. Our algebraic work did not eliminate the possibilities $t = Li/2$ or $t = (1 + Li)/2$, where L is the height of the rectangle. These would lead to actions

$$[g]a(v) = (-1)^m a(\bar{v}) \text{ and } [g]a(v) = (-1)^{n+m} a(\bar{v}),$$

respectively. These are not bad recipes, but it turns out they come from actions of groups we have already counted, but a bit in disguise. If $g = \bar{z} + Li/2$ belongs to G, then σ_x does not, or we would have a shorter translation by $Li/2$ in G. The fixed points of g constitute the line $\text{Im}(z) = L/4$, a horizontal line a quarter of the way up the cell; this is what I called a *quarter mirror* in Chapter 18. The group must also have horizontal mirrors at all "quarter lines." If we simply move G up or down by a quarter unit, it will be identical with pm; so G is just a slightly shifted copy of pm, not a new entry on our list.

Similarly, the possibility $g = \bar{z} + 1 + Li/2$ works out to be a quarter glide. If this represents the only nonidentity element of the point group of G, we simply have a shifted-up copy of pg. I wish this were more elegant, but even the most well-kept garden requires some weeding.

To complete the case of the rectangular lattice, assume that the point group of G contains two different nonidentity classes. First, we eliminate the possibility that they both arise from isometries where $s = 1$ (or $s = -1$ for both). Having σ_x in one class and $\bar{z} + t$ in another leads to a too-short translation by t. A little more work leads to the same conclusion for any two of the four possibilities, the most interesting of which is this: If $g_1(z) = \bar{z} + 1/2$ and $g_2(z) = \bar{z} + Li/2$ belong to G, the composition $g_2 g_1^{-1} = z + (1 + Li)/2$; the lattice is rhombic and if we move the x-axis up to the horizontal quarter-line of the rectangular cell, we'll be looking at cm.

So, we have one class in the point group where $s = 1$ and another where $s = -1$. If both are indirect, composing them gives a direct isometry with $s = -1$: a rotation through $180°$. Our conventions force the origin to be a 2-center, so we know that $\rho_2(z) = -z$ belongs to G. Without loss of generality, we may assume that our two nonidentity classes consist of $[\rho_2]$ and $[g]$, where $g(z) = \bar{z} + t$. We investigate the four possibilities: $t = 0$, $t = 1/2$, $t = Li/2$, and $t = (1 + Li)/2$.

If $t = 0$, we have σ_x, and hence σ_y in G, which must be pmm. If $t = 1/2$, we also have the composition $-\bar{z} + 1/2$, a vertical quarter mirror: Look! It's pmg. The possibility $t = Li/2$ leads to a second copy of pmg, this one with a vertical glide and horizontal quarter mirror. Finally, $t = (1 + Li)/2$ gives us pgg. Check your understanding by confirming that this last case leads to the requirement on Fourier coefficient functions,

$$a(v) = a(-v) = (-1)^{n+m} a(\bar{v}),$$

matching our recipe for pgg functions.

Here is another way to view what we have done for the rectangular cell: Assuming that G contains a half turn, we considered the four possible homomorphisms that could arise in the action of the point group of G on Fourier functions; two led to the same group; the two others are different groups. There are three groups with half turns in the rectangular cell. So that's five groups for the rectangular cell.

In the square cell, we assume that the point group has $[\rho_4]$, relying on our convention that we would not be talking about the square cell if we did not want to see 4-fold rotations. (If we wish to expand the search to include color symmetries, that is a different story. Here we continue with symmetries.) Having $[\rho_4]$ in the point groups requires the presence of its powers, the fourth of which is the identity. If these are the only classes in the point group, our group is p4, with point group isomorphic to \mathbf{C}_4. If there is another nonidentity class, we take a moment to eliminate the possibility that it contains a different rotation. (As an exercise, show that all 4-fold rotations in G are $\tau\rho_4$, unless G has a shorter translation than it ought.) We are left to study the case where G has the class

$$g(z) = s\bar{z} + t, \text{ where } s = \pm i \text{ and } t = \frac{a + bi}{2},$$

with a and b either both even, in which case they may as well be zero, or both odd, which can be traded for $t = (1 + i)/2$.

We can compose g with some power of ρ_4 to reduce to the case where $s = 1$. If $t = 0$, we have σ_x in G and our group is p4m. If $t = (1 + i)/2$, we are looking at p4g. Interesting how the algebra reduces the possibilities so quickly.

To study the hexagonal cell would be to repeat the long discussion from earlier in our chapter. We summarize by saying that the point group has either $[\rho_3]$ or $[\rho_6]$. If G has no indirect isometries, then it is p3 in the first case, p6 in the second. In the first case, we can reduce any indirect isometry to the case where $s = \pm 1$ with $t = 0$. These quickly lead to p31m and p3m1. If $[\rho_6]$ is in G, we can always reduce to $s = 1$, leading to p6m.

This completes the proof. How did we do it? We established conventions about turning and scaling a given group to make it sit nicely with respect to cases we have studied before. We went through all the possibilities, considered possible actions of the point group of G on Fourier coefficient functions, and sorted every case into one we have seen before.

To summarize the count, point group considerations have eliminated all possibilities except

1. p1 and p2 in the general lattice,
2. cm and cmm in the rhombic lattice,
3. pm, pg, pmm, pmg, and pgg in the rectangular lattice,
4. p4, p4g, and p4m in the square lattice, and
5. p3, p31m, p3m1, p6, and p6m in the hexagonal lattice.

These are our 17. The list is exhaustive.

EXERCISE 54
Where Can 0 End Up?

We proved much of the proposition in the body of the chapter. Let's clean up some details. First suppose that $\alpha(z) = s\bar{z} + t$ and G contains a nontrivial rotation about the origin, in other words, $\rho_p = \omega_p z$, for $p = 2, 3, 4$, or 6. Verify the formula

$$\alpha^{-1}\rho_p\alpha\rho_p(z) = z + s\bar{t}(\bar{\omega}_p - 1).$$

Using the fact that every translation belongs to Λ, which is conjugation invariant and invariant under multiplication by s, show that

$$\alpha(0) = t = \frac{a + b\omega}{\omega_p - 1}.$$

This is where things start to look bad for the hexagonal lattice. Check, for instance, that

$$\frac{1}{\omega_3 - 1} = \frac{-2 - \omega_3}{3},$$

which you might recognize as the translation vector of one of the color-turning translations from Chapter 20. It certainly does not belong to the lattice. Can a wallpaper group that contains p3 map the origin to this point? Well, it can if the group is p31m and we have accidentally put 0 at a point that is a center of rotational, but not mirror, symmetry. (Look back at the p31m cell diagram; you'll find such a point in the middle of a triangle.) To fix this, we require that, if a hexagonal-lattice group G has an indirect isometry, and hence a mirror, it should have a mirror through 0. Earlier discussion shows that this mirror might as well be σ_x or σ_y, so we know that $\sigma(z) = \pm\bar{z}$ belongs to our group. Compose with α to find $\alpha(\sigma(z)) = \pm sz + t$, a direct isometry. The part of the proof about direct isometries now assures us that $t \in \Lambda$.

This is what we're up against: several other cases like these. Complete the proof of the proposition by examining (21.3) for $p = 2, 4$, and 6. Use conventions to eliminate $t = (a + b\omega)/2$ for the rhombic cell.

Chapter 22
Local Symmetry in Wallpaper and Rings of Integers

Question: What causes the appearance of local symmetries in wallpaper? After I had studied wallpaper functions for several years, when I thought there could not possibly be anything to add to the story, at least from a mathematical point of view, an image like Figure 22.1 appeared on my screen. I call it a moment of happy accident, since a random choice of wallpaper coefficients led to something that I think makes a pretty good story. Spend a moment to see if you can recognize what caught my eye.

The symmetry group of the pattern is p6 and it contains no mirror symmetries. After all, symmetries are transformations that leave the entire pattern invariant, and there simply are no reflections that do so. And yet, if you restrict your gaze to a neighborhood of any 2-center (recalling that every p6 pattern has to have 2-centers halfway between nearest 6-centers), that piece of the pattern seems to have mirror symmetry across two perpendicular axes—some sort of "local symmetry." The light purple outlines around the 2-centers are not perfectly symmetric, but the dark purple Xs inside (human figures?) certainly seem to be.

I put the term local symmetry in quotes because it is not a precise term and is not one I intend to define. Instead, I will explain what causes the appearance of the phenomenon in *this* example and tell you how to make something like it happen in patterns you may construct.

The story is not very interesting from the point of view of pattern analysis. We will not uncover new categorizations of wallpaper according to local symmetries. After all, if you adopt the "potato stamp" model to create patterns, you can carve 5-pointed stars into your potato all day, creating perfect local 5-fold symmetry without creating any actual symmetry in the pattern.

The story is internal to the method of constructing wallpaper with wave functions. That said, it takes us over some unexpected ground. So far, the algebraic structures most important to us have been groups and vector spaces. This story takes us into the land of rings, specifically, the rings of integers of quadratic number fields. If you do not know these terms, read on to see how they arise rather naturally once we start analyzing the facts behind Figure 22.1.

Analyzing the Happy Accident

By now, you know that p6 patterns can be made by superimposing waves that are locked into packets that create the 6-fold rotation. Specifically, if $z = X + \omega_3 Y$,

Figure 22.1. A p6 wallpaper function with local symmetry, a term whose meaning has not been made precise.

where $\omega_3 = e^{2\pi i/3}$, we start with the waves

$$E_v(z) = e^{2\pi i \, \mathrm{Re}(z\bar{v})} \text{ where } v = v_{n,m} = \frac{2i}{\sqrt{3}}(-n\omega_3 + m).$$

To create 6-fold symmetry, we lock waves in two steps:

$$W_v = (E_v + E_{\omega_3 v} + E_{\omega_3^2 v})/3 \text{ and } S_v = (W_v + W_{-v})/2.$$

Any sum

$$f(z) = \sum a_v S_v(z)$$

will create a function with 6-fold symmetry about the origin, but more is true: Every such f is invariant under every element of p6.

My happy accident arose from a superposition of just two of those wave packets. The frequency vectors were

$$v_1 = \frac{2i}{\sqrt{3}}(-2\omega_3) \text{ and } v_2 = \frac{2i}{\sqrt{3}}(-3\omega_3 - 1),$$

or $(n,m) = (2,0)$ and $(n,m) = (3,-1)$, if you prefer to think in terms of (n,m) pairs. I thought my choices were sufficiently random not to create any accidental symmetries. But then I found myself staring at apparent local mirror symmetries near the 2-centers.

Figure 22.2. One line of local reflection connects 0 and $2 - \omega_3$. The fundamental cell is outlined in yellow.

To investigate, I found, among the many choices, a rather simple line along a particular mirror axis: the line through 0 and the point $2 - \omega_3$. Find it in Figure 22.2, where the origin is near the center of the left edge.

Initially, I worked this all out in real notation, where it is quite cumbersome. With fortunate hindsight, I can show you how simple the analysis becomes in complex notation.

Let's show that reflection about the line through 0 and $2 - \omega_3$ is given by the formula

$$\sigma_{2-\omega_3}(z) = \frac{2 - \omega_3}{2 - \bar{\omega}_3} \bar{z}.$$

The coefficient of \bar{z} is indeed a unit complex number, so this is an isometry. A quick check shows that $\sigma_{2-\omega_3}^2(z) = z$, so this must be a reflection. Finally, this formula evidently fixes both 0 and $2 - \omega_3$. It must be the desired reflection.

To study how this reflection treats wave functions, we recall a computation from Chapter 21 to learn what an indirect isometry $g(z) = s\bar{z}$ does to a wave function:

$$E_v(g(z)) = e^{2\pi i \, \mathrm{Re}(s\bar{z}\bar{v})} = e^{2\pi i \, \mathrm{Re}(z\overline{s\bar{v}})} = E_{s\bar{v}}(z).$$

We need to know what happens to waves with frequency vectors v_1 and v_2. Take a deep breath and compute

$$\frac{2 - \omega_3}{2 - \bar{\omega}_3} \overline{\frac{2i}{\sqrt{3}}(-2\omega_3)} = -\frac{2i}{\sqrt{3}}\left(\frac{16 + 6\omega_3}{7}\right).$$

The reflection pops this frequency vector right out of the lattice: The 7 in the denominator of this frequency vector means that the reflected wave is not one of our nicely periodic waves. The first term in the function of the happy accident is not invariant under this reflection. Perhaps we will have more luck with the second term.

Reflecting the frequency vector v_2, we find a surprising result:

$$\frac{2 - \omega_3}{2 - \bar{\omega}_3} \overline{\frac{2i}{\sqrt{3}}(-3\omega_3 - 1)} = -\frac{2i}{\sqrt{3}}\left(2\omega_3 + 3\right). \tag{22.1}$$

Decoding into (n, m) pairs, this means that the reflection across this line of the wave with frequency $(3, -1)$ is the wave with frequency $(2, -3)$, which you could conceivably recognize as $-(-(3 + (-1)), 3)$, meant to remind you of $(-(n + m), n)$, one of the other waves in the packet $S_{3,-1}$. If you do not recognize that, complex algebra can help:

$$\omega_3(-3\omega_3 - 1) = 3 + 3\omega_3 - \omega_3 = 2\omega_3 + 3.$$

The reflection of vector v_2 is just the negative of the rotation of v_2 by ω_3. This means the reflected vector does indeed belong to the wave packet S_{v_2}. This particular chanced-upon wave packet is reflection invariant.

To summarize the discussion so far, I created Figure 22.1 by superimposing two wave packets, only one of which is reflection invariant across the line through 0 and $2 - \omega_3$. How did the symmetry—or at least some of the symmetry—of one wave packet survive the superposition? The answer is in Figure 22.3, where I revert to a simple color wheel instead of a photograph, for clarity. On the top left, we see the higher-frequency wave packet S_{v_2}; the top right image shows the lower-frequency packet. It turns out that the shape of the lower-frequency part is very, very round at strategic points; this roundness allows the symmetry of the high-frequency part to emerge at those points, as if revealed by a gap in a mask.

Before we leave this example, we notice something about the low-frequency wave packet $S_{2,0}$, in (n, m) notation. Since both n and m are even, the wave is periodic with respect to translations along half the fundamental cell. In other words, there is a copy of the $[0, 0]$ 6-center at the point $[X, Y] = [\frac{1}{2}, \frac{1}{2}]$ and at every midpoint of a cell side. These are exactly the 2-centers of the overall p6 pattern. This particular wave packet is just as round at the 2-centers as it is at the 6-centers. This more-than-usual roundness is what allows the local symmetry to peek through. The calculus needed for a detailed analysis is outlined in the following exercise.

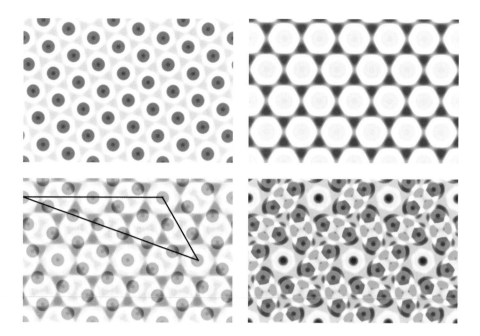

Figure 22.3. The apparent local symmetry is created by a superposition of waves: a high-frequency part with mirror symmetry across the desired axis and a low-frequency part that allows the mirror symmetry to peek through at strategic points.

* EXERCISE 55
Infinitesimal Roundness

We develop a concept of infinitesimal roundness and check that the masking wave of the example fits the definition. If you were able to compute the Laplacian in complex coordinates, you should be able to do this exercise, though I admit the computation is rather baroque. We start with some necessary background. First, let me hold up an icon of circular symmetry, the function $z\bar{z} = r^2$. I call this function *round* because it is invariant when you spin the complex plane.

We can measure the failure of a function to have rotational symmetry at a point, say $z = 0$ for convenience, from its derivatives at 0. For instance, if $\partial f / \partial z(0) = s \neq 0$, then the function can be approximated as $f(z) \approx f(0) + sz$, and, for instance, $f(z)$ will be very different from $f(-z)$ and $f(iz)$ near 0. We would not say this function displays any roundness at the origin. Similarly, if $\partial f^2 / \partial z^2(0) = s \neq 0$, there there is a sense in which f has a part that is like sz^2; a quick look back at Figure 6.3 shows that this function, though close to constant in a neighborhood very near 0, is not circularly symmetric.

On the other hand, $\Delta f(0) \neq 0$ does not speak against roundness. That condition says that f looks something like our very round function $z\bar{z}$ near 0.

Let us say f is *infinitesimally round to order p* to mean

$$\frac{\partial^j \partial^k}{\partial z^j \partial \bar{z}^k} f \bigg|_{z=0} = 0 \text{ when } j \neq k \text{ and } j + k \leq p.$$

This means that if $j + k$ is smaller than p, when we differentiate j times with respect to z and k times with respect to \bar{z}, the result is zero at the origin unless the differentiations are balanced, with the same number of zs and \bar{z}s.

(continued)

Generalizing the Example

Two properties of a special wave packet made the accident happy: All the waves in the packet, when reflected across the line through 0 and $2 - \omega_3$, were again lattice waves, and all the waves—original and reflected—belonged to the same 6-fold wave packet. To study the first of these phenomena, we change notation a bit.

A bit of shuffling will confirm that

$$\operatorname{Re}(z\bar{v}) = \operatorname{Re}\left(z\,\overline{\frac{2i}{\sqrt{3}}(-n\omega_3 + m)} \right) = \frac{1}{i\sqrt{3}}(z(\overline{-n\omega_3 + m}) - \bar{z}(-n\omega_3 + m)).$$

If we name $\alpha = \alpha_{n,m} = -n\omega_3 + m$, we can conveniently index waves by α's. Just define

$$E_\alpha(z) = \exp\left(2\pi i\,\frac{1}{i\sqrt{3}}(z(\overline{-n\omega_3 + m}) - \bar{z}(-n\omega_3 + m)) \right) = e^{2\pi(z\bar{\alpha} - \bar{z}\alpha)/\sqrt{3}}.$$

(22.2)

It will be convenient not to have to carry around a cumbersome factor of $2i/\sqrt{3}$ in frequency vectors but rather to think of a wave as being associated with a complex number $-n\omega + m$.

This definition emphasizes the role of the Eisenstein integers, which we recall to be

$$\mathcal{E} = \{a + b\omega_3 \mid a, b \in \mathbb{Z}\}.$$

We will see that they are not called integers lightly. They have more in common with \mathbb{Z} than one might think.

So, when I refer to an α wave, I mean the wave with frequency vector v built from that α. In our example, we had $\alpha = -3\omega_3 - 1 \in \mathcal{E}$. What condition on α will result in the α wave's reflection being periodic with respect to the lattice? Sorting through the reflection formula shows that we need to have

$$\frac{2 - \omega_3}{2 - \bar{\omega}_3}\bar{\alpha} = a + b\omega_3 \text{ for } a, b \in \mathbb{Z},$$

If you have some time, bravery, and skill, you can differentiate the wave packet $S_{2,0}$, the mask of my happy accident example, to find

$$\frac{\partial^j \partial^k}{\partial z^j \partial \bar{z}^k} S_{2,0}\Big|_{z=0} = \frac{1}{6}\left(\frac{4\pi}{\sqrt{3}} \right)^{j+k} \left((-1)^j + (-1)^k \right)\left(1 + \omega^{k-j} + \omega^{2(k-j)} \right).$$

Or you can just believe me. In either case, notice that the factor with -1s vanishes when j and k have different parities, while the sum of the powers of ω is 0 unless $j \equiv k \pmod 3$. Put these together to see that the derivative is 0 unless $j \equiv k \pmod 6$. Conclude that $S_{2,0}$ is infinitesimally round to 6th order at 0. The derivatives with $(j,k) = (1,7)$ and $(7,1)$ describe the first deviation from roundness as we examine higher and higher derivatives.

Comment: Some may recognize this business of using derivatives to make a comparison between a function f and various polynomial approximations. This is called Taylor theory. Most people encounter it first in the context of real-valued functions.

or, equivalently,

$$\frac{2 - \bar{\omega}_3}{2 - \omega_3}\alpha = a + b\bar{\omega}_3 = a - b - b\omega_3 \in \mathcal{E}.$$

It is as if the Eisenstein integer $2 - \omega_3$ has to divide evenly into α in \mathcal{E}.

A sufficient condition for invariance of the α wave is that $\alpha = (2 - \omega_3)(c + d\omega_3)$ for $c, d \in \mathbb{Z}$, which is to say that $\alpha = (2 - \omega_3)\gamma$ for $\gamma \in \mathcal{E}$. In simple terms, this means that α is an Eisenstein multiple of $2 - \omega_3$. We will see that this sufficient condition is necessary, but first let us increase the generality of our discussion.

Rings and Ideals

The integers are the prototypical *ring*, which is an algebraic structure with two operations, which we will call addition and multiplication. To qualify as a ring, a set with these two operations must form a group under addition but need be merely closed under multiplication. Finally, the operation of multiplication must distribute over addition. The integers fit this concept: The operation of addition always has an inverse in the integers, but multiplication need not. After all, there is no *integer m* that satisfies $3m = 4$; multiplication by 3 is not invertible.

We take a moment to check that the Eisenstein integers, \mathcal{E}, do form a ring: The additive inverse of $a + b\omega_3$ is just $-a - b\omega_3$ and any product of elements in \mathcal{E}, $(a + b\omega_3)(c + d\omega_3)$ belongs to \mathcal{E}, thanks to the formula $\omega_3^2 = -\omega_3 - 1$. The additive identity in \mathcal{E}, required to exist by the group laws for addition, is simply $0 + 0\omega_3$ and, though no multiplicative identity was required by our definitions, \mathcal{E} has one: 1.

The integers are included as a subring of \mathcal{E} as expressions of the form $a + 0\omega_3$. We have seen a different example of a ring that includes the integers: the Gaussian integers, which are numbers of the form $a + bi$ for $a, b \in \mathbb{Z}$. Keep these three rings in mind as we study this new structure.

In any ring, we can study divisibility. For instance, when we studied color-turning symmetries, the set of integers evenly divisible by 3 played a central role. In creating rosettes with p-fold symmetry, the key role was played by integers that are multiples of p.

Whenever you have a ring \mathcal{R} and an element $m \in \mathcal{R}$, you can define a set

$$m\mathcal{R} = \{ma \mid a \in \mathcal{R}\},$$

the set of multiples of m in \mathcal{R}. You can find a quick example in $2\mathbb{Z}$, the set of even numbers. It would be silly to use $m = 0$, the additive identity, and taking m to be 1, the multiplicative identity, if present, would generate the whole ring—not an interesting example.

The set $m\mathcal{R}$ is closed under addition and multiplication. In fact, if you multiply an element of $m\mathcal{R}$ by *any* element of the ring, the product stays in $m\mathcal{R}$—a sort of super-closure, as if $m\mathcal{R}$ absorbs products.

In the study of abstract rings, a set with this property of being closed under multiplication by any ring element is called an *ideal* of the ring, provided it is also an additive subgroup. In the special case where an ideal has the form $m\mathcal{R}$, the ideal is called *principal* to indicate that there is one star of the show, namely, m,

and the ideal consists exactly of multiples of *m*. We don't need any concept more general than principal ideals to continue our study of local symmetry. All we need is a name for the set of multiples of a given ring element.

Let us take up the discussion of the special wave that behaved nicely with respect to the strange reflection across the line connecting 0 and $2 - \omega_3$. The wave E_α reflects to a lattice wave if and only if

$$\frac{2 - \bar{\omega}_3}{2 - \omega_3}\alpha \in \mathcal{E}. \tag{22.3}$$

We would like to be able to conclude that this special occurrence is limited to the cases where $2 - \omega_3$ divides α, in others words, when α belongs to the ideal $(2 - \omega_3)\mathcal{E}$.

This is highly analogous to some imagined scenario where we know that $35x/12$ is an integer and want to conclude that x is a multiple of 12: Since 12 and 35 have no common factor greater than 1, all the prime powers that make up 12 have to divide evenly into x, so 12 divides x. If someone did not believe, at first, that 12 and 35 have no common factor, one "read 'em and weep" proof would be to pull from one's hat the equation

$$3 \cdot 12 - 1 \cdot 35 = 1.$$

If *d* were a common factor to 12 and 35, it would be a factor of 1.

An argument like this requires that we know how ring elements are built up of prime factors. The cases of interest here—the ordinary integers along with the Gaussian and Eisenstein ones—turn out to be *unique factorization domains*, meaning that every element has a unique factorization (up to units) as a product of powers of primes. (In the ordinary integers, the only units are ±1, while in the Eisenstein integers, we have ±1, ±ω_3, and ±ω_3^2 as units.) In a unique factorization domain, we can talk about a *greatest common divisor* of two elements. We say that the greatest common divisor of *a* and *b* is 1, written $\gcd(a, b) = 1$, to mean that the prime factorization of *a* has no factors other than units in common with the prime factorization of *b*. Let us temporarily limit our discussion to rings that enjoy this convenient property.

In a unique factorization domain \mathcal{R}, we can use the principle (suggested by the preceding example but not rigorously proved here) that if $cb/a \in \mathcal{R}$ and $\gcd(a, b) = 1$, then *a* divides *c*, meaning that $c = da$ for some $d \in \mathcal{R}$.

In the example of the reflection across the line through 0 and $2 - \omega_3$, we can verify with algebra that

$$-\omega_3(2 - \omega_3) - \bar{\omega}_3(2 - \bar{\omega}_3) = 1,$$

meaning that $\gcd(2 - \omega_3, 2 - \bar{\omega}_3) = 1$. The *only* waves invariant under the given reflection are ones whose αs belong to the ideal $(2 - \omega_3)\mathcal{E}$.

General Reflections

Let us solidify understanding by moving to a more abstract case: Let's reflect across the line through 0 and $p + q\omega_3$, where *p* and *q* are integers with

$\gcd(p, q) = 1$. The formula for the reflection is easily checked to be

$$\sigma_{p+q\omega_3}(z) = \frac{p + q\omega_3}{p + q\bar{\omega}_3}\bar{z}.$$

Again, we set $v = 2i\alpha/\sqrt{3}$, using Eisenstein integers α to index our waves. The only waves that reflect to lattice waves under $\sigma_{p+q\omega_3}$ are those whose indices α satisfy

$$\frac{p + q\omega_3}{p + q\bar{\omega}_3}\bar{\alpha} \in \mathcal{E}.$$

Taking conjugates and assuming also that $\gcd(p + q\omega_3, p + q\bar{\omega}_3) = 1$ (Exercise 56 shows that this can be complicated), we see that the good waves are exactly those with α in the ideal $(p + q\omega_3)\mathcal{E}$. Let's formalize this as a theorem and add on just a bit more, to be proved presently.

Theorem 7. *Suppose p and q are integers with $\gcd(p + q\omega_3, p + q\bar{\omega}_3) = 1$. The set of waves invariant as a set under the reflection $\sigma_{p+q\omega_3}$ is exactly*

$$W_{p,q} = \{E_v(z) \mid v = \frac{2i}{\sqrt{3}}\alpha, \text{ where } \alpha \in (p + q\omega_3)\mathcal{E}\}.$$

Furthermore, every wave function in $W_{p,q}$ is periodic with respect to translations by the vectors in the set (called a fractional ideal*)*

$$\frac{1}{p + q\bar{\omega}_3}\mathcal{E} = \left\{\frac{1}{p + q\bar{\omega}_3}\beta \mid \beta \in \mathcal{E}\right\}.$$

Proof. The first part was proved in the general discussion. For the second part, suppose that τ belongs to the fractional ideal, so that $\tau = (a + b\omega_3)/(p + q\bar{\omega}_3)$. We will show that τ is a period of the wave indexed by $\alpha = (p + q\omega_3)\beta$, where $\beta \in \mathcal{E}$. Referring back to (22.2) for the correct wave form, we write

$$E_\alpha(z + \tau) = E_\alpha(z)e^{2\pi(\tau\bar{\alpha} - \bar{\tau}\alpha)/\sqrt{3}}.$$

The wave is periodic if and only if the exponential factor is 1. But

$$\tau\bar{\alpha} - \bar{\tau}\alpha = (a + b\omega_3)\bar{\beta} - (a + b\bar{\omega}_3)\beta,$$

after the factors of $p + q\bar{\omega}_3$ cancel in numerator and denominator. It is as if we are evaluating the wave indexed by β at the lattice point $a + b\omega_3$. We know this gives 1, so the wave is periodic with respect to τ, as claimed. ∎

As an aid to intuition, notice that the ideal $(p + q\omega_3)\mathcal{E}$ is itself a lattice, generated by $p + q\omega_3$ and $\omega_3(p + q\omega_3)$. The theorem says that if we pick waves from this smaller lattice (with larger, higher-frequency generators), we get waves periodic with respect to the larger lattice (with smaller, shorter-frequency generators). This is highly analogous to something we could notice in Fourier series in a single variable: If you restrict attention to waves whose frequencies are all multiples of 2, those waves will all have period $\frac{1}{2}$.

Comment: If we do not care to check the condition $\gcd(p + q\omega_3, p + q\bar{\omega}_3) = 1$, we can still know that the waves with $\alpha \in (p + \omega_3)\mathcal{E}$ work the right way; it's just

*** EXERCISE 56**
When $\gcd(p + q\omega_3, p + q\bar{\omega}_3) \neq 1$

Consider the reflection $\sigma_{5+\omega_3}(z)$. Show that $5 + \omega_3$ factors as $(-1 - 3\omega_3)(\omega_3 - \bar{\omega}_3)$, so that $\gcd(5 + 1\omega_3, 5 + 1\bar{\omega}_3) \neq 1$. Use the factorization to exhibit waves that are invariant under the given reflection but do not belong to $(5 + \omega_3)\mathcal{E}$.

that there may be other waves that behave well with respect to the reflection. Exercise 56 might illuminate this point.

Closed Geodesics of Orbifolds and Some Geometric Fun

If you liked the quotient groups in Chapter 21, I have some more for you. If we have any lattice whatsoever in the complex plane, say, $\Lambda_{1,\omega}$, we can consider it as a subgroup of the additive group \mathbb{C}. This subgroup is evidently normal: Since \mathbb{C} is commutative, conjugation is always trivial, so conjugating an element of Λ by z returns us to Λ. This means we can define a quotient group

$$T_{1,\omega} = \mathbb{C}/\Lambda_{1,\omega}.$$

As before, we'll indicate the class of the complex number z in the quotient group as $[z]$, the set of all numbers equivalent to z by adding or subtracting a lattice element. All the elements of $\Lambda_{1,\omega}$ end up as a single element of $T_{1,\omega}$, namely, $[0]$.

As a concrete example, consider $\Lambda_{1,i}$. If, for a real number x, $\{x\}$ indicates the fractional part of x (as in $\{22/7\} = 1/7$ and $\{-22/7\} = 6/7$), we have

$$[z] = [x + iy] = [\{x\} + i\{y\}].$$

Just chop off any unnecessary integers from the real and imaginary parts of z to deliver a point in the fundamental 1×1 cell of the lattice. (You may wish to prove that $\{x_1\} + \{x_2\} = \{x_1 + x_2\}$ to check that the group operation is well defined.)

Some computer games actually use this quotient. If you are traveling in a virtual landscape and go too far to the right, you may end up reappearing on the screen at the left. I remember exercising on one of the first virtual bicycles in the 1990s; I would ride off the north edge of the map and see my avatar appear on the south edge.

**** EXERCISE 57**

This is more an open-ended project than an exercise: Show how the ideas in this section extend to the Gaussian integers. Then study other possible rings that are also lattices, $\Lambda_{1,\omega}$, where ω need not be one of the nice ones we have used so far. Show that several things go together:

- The lattice $\Lambda_{1,\omega}$ is a ring. (The thing to check is whether it is closed under multiplication.)
- The square-lengths of elements in the lattice are always integers. (Check how $(p + q\omega)(p + q\bar{\omega})$ turns out.)
- The eigenvalues of all lattice waves are always integers times some common factor that depends on $\mathrm{Im}(\omega)$.

Comment: These rings turn out to be the *rings of integers of quadratic number fields*. This is a long story, one that I will not tell here. Suffice it to say that beautiful discoveries await, should you be unfamiliar with these. These rings fit into two main categories; in each instance, d denotes an odd prime. The possibilities are

$$\omega = 1 + \sqrt{d}i, \text{ where } d \equiv 1 \pmod 4, \text{ and } \omega = \frac{1 + \sqrt{d}i}{2}, \text{ where } d \equiv 3 \pmod 4.$$

Strange, aren't they? The Gaussian integers exemplify the first type, though of course 1 is not an odd prime; the Eisenstein integers are first in a sequence of the second type. Most of them are not unique factorization domains, but you can still create local symmetries using any of these rings.

Use your imagination to deform a piece of the plane as if you were picking up that fundamental unit and identifying the pieces that are the same. The left and right edges have to be put together and so do the top and bottom edges. When this is done, all four corners end up in the same place. If you have done this correctly, the resulting shape is a *torus*, the surface of a donut.

It didn't matter that we started with a square. The quotient of the plane by *any* lattice is a torus. This quotient is an example of an *orbifold*, which is the name for any quotient of the plane by a wallpaper group. Here, let's stick with quotients of the plane by the group p1, a simple lattice, so all our orbifolds will be tori.

I mention this only because there is something lovely to say about our lines from 0 through $p + \omega q$, no matter which lattice we are in: These are *geodesics* on the orbifold, in the sense that they are *straightest paths* from 0 to $p + \omega q$. (If the line is straight on \mathbb{C}, then it is also straight on the quotient, which inherits the local geometry of the plane.)

Look back at Figure 22.2 and imagine starting at 0, in the middle left of the image, and traveling the black line down to the left. The fundamental cell is outlined in yellow, so you can see that you would leave the cell when you hit the purple X-shape at the right-hand edge. In the orbifold, you would jump from the X at the midpoint of the right of the cell to the one at the left and keep moving along a parallel line until you arrive at $1 - \omega_3$, which is equivalent to your starting point. This geodesic winds around the torus twice before returning to the starting point.

Figure 22.4 shows this geodesic, starting at D, along with the one through A that is turned by 60°. (This one corresponds to $3 + 2\omega_3$, as you can check.) Together they cut off a rhombus, whose area is a perfect one-seventh of the whole. I have titled this a "Proof Without Words," though a rigorous proof requires our lattice concepts.

We can play the same game in the square lattice. Perhaps you've seen a special case of the following as a Proof Without Words. Using Figure 22.5, you can show that the geodesic corresponding to $p + qi$ and its 90° rotational partner together cut off a square with area $(p - q)^2/(p^2 + q^2)$ of the whole.

There is much more to say about the orbifolds of groups other than p1. Indeed, Conway's notation [1] for the wallpaper groups emphasizes the shape of their orbifolds. Analyzing the topology of these quotient spaces produces an elegant proof that there are exactly 17 isomorphism classes of wallpaper groups. I take this as yet another illustration that any given mathematical topic can be viewed through many different lenses by each of us, at different times for different purposes.

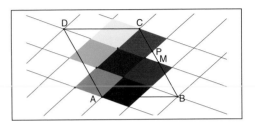

Figure 22.4. If point P lies a fraction $\frac{2}{3}$ up the side of the rhombus of the hexagonal lattice, the inner rhombus shown has area $\frac{1}{7}$ of the whole, as can be seen from the Proof Without Words.

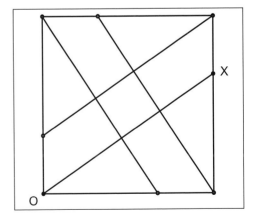

Figure 22.5. If point X lies a fraction q/p up the side of the square, the inner square shown has area $(p - q)^2/(p^2 + q^2)$ of the whole. (The famous example has $q/p = \frac{1}{2}$, for $\frac{1}{5}$ of the whole.)

Chapter 23

More about Friezes

Question: What color-reversing frieze patterns are there? In Chapter 8, we left dangling a few threads about the algebra of frieze groups. Now that we have studied point groups, it is easy to clean up those details. First, let's enjoy some more art, creating color-reversing frieze patterns.

Color-Reversing Friezes

As in Chapter 19, we develop color-reversing symmetries with a homomorphism ϕ from a group G, this time a frieze group, to $\{1, -1\}$. The elements mapped to -1 will become color-reversing ones, while the kernel of the homomorphism will be the symmetry group. We easily modify the recipes in Table 8.1 to make functions that satisfy

$$f(g(z)) = \phi(g)f(z) \text{ for } g \in G, z \in \mathbb{C}.$$

Let us concretize this with an example based on recipes and then proceed to abstraction. I made the image in Figure 23.1 by starting with ingredients to create p11g symmetry as in Table 8.1. Then I chose coefficients, making sure that

$$a_{n,m} = -a_{-n,-m},$$

which turns on a negating half turn in the pattern. Look for evidence of the negating vertical mirrors that group composition requires.

If we take the absolute value of the function, it is invariant under p2mg, which we again call the *color group* of the pattern. The actual symmetry group, where only the color-preserving transformations are allowed, is p11g, so we call the pattern type p2mg/p11g. (The photograph shows a hibiscus in front of the observatory on Nantucket where pioneering astronomer Maria Mitchell detected a comet in 1847.)

To create this example, I defined a homomorphism $\phi : \text{p2mg} \to \{1, -1\}$ by

$$\phi(\gamma_x) = 1 \text{ and } \phi(\rho_2) = -1,$$

recalling that p2mg has a minimal set of generators in $\{\gamma_x, \rho_2\}$. How many different such homomorphisms are there?

Swapping the minus signs in the preceding definition leads to a negating glide and positive half turn for pattern type p2mg/p211. Making both signs negative causes their composition, a vertical mirror to be positive, for p2mg/p1m1.

It turns out that these exhaust the possibilities. If we try to send $\tau_1 = \gamma_x^2$ to -1, thinking to create a pattern of type p2mg/p2mg, we get stuck. The homomorphism

condition would require $(\phi(\gamma_x))^2 = -1$, impossible when we know $\phi(\gamma_x) = \pm 1$. When I implement the recipe for p2mg but use $n + m$ odd, that turns on σ_x as a color-reversing mirror; this makes the color group p2mm, not p2mg. Figure 23.2 shows examples of these three additional types, two with color group p2mg and one with color group p2mm.

Analyzing possibilities for the other frieze groups is similar. I leave it to you as a project to find all the possible ways to create color-reversing symmetries in frieze patterns.

It is known [12] that there are 17 types of frieze patterns with color-reversing symmetry. This is the same as the number of ways that one frieze group can occur as a normal subgroup of another. As far as I know, it is a different 17.

Finally, we connect back to rosettes. For each p, each of these pattern types transfers over to a type of p-fold rosette, using the "winding-around" process mentioned in Chapter 8. If the frieze group G is wound around p times, the symmetry group of the resulting rosette would be the quotient group of G by the pth power of the generating translation of G: $G/\langle t_1^p \rangle$. For instance, the symmetry group of Figure 7.3 is $p211/\langle \tau_1^6 \rangle$. This group is isomorphic to the dihedral group of order 12, but the visual appearance is strikingly different from a pattern using the usual mirror representation of that group.

Figure 23.1. A color-reversing frieze with color group p2mg and symmetry group p11g: type p2mg/p11g.

Frieze Algebra

Let's clean up those details of frieze algebra. For earlier convenience, we declared that the translational subgroup of a frieze group G must be generated by $\tau_1(z) = z + 2\pi$. We choose to further favor the x-axis by declaring some conventions: Let us say that a frieze group G is *conventionally represented* when the following hold:

- If G contains an indirect isometry g, then the x-axis is an invariant line of g.
- If G contains any rotation, then the origin is a center of rotation.

We do not have to worry about there being two glide reflections in G that have different invariant lines: In the proof of the following proposition, outlined in an exercise, we show that this cannot happen.

p2mg/p211

p2mg/p1m1

p2mm/p2mg

Figure 23.2. Samples of three color-reversing frieze types that arose in the discussion of color group p2mg. The third actually has color group pmm.

Prove the proposition by following these steps. Suppose $g(z) = sz + t$ is a direct isometry in G that is not a translation. Conjugate to show that the translation $z + 2\pi n s$ belongs to G. Conclude that $s = \pm 1$. If $s = 1$, we contradict our assumption that g is not a translation. If $s = -1$, then g is a rotation. By convention, we must have $\rho_2(z) = -z$ in G, and this gives $t = 2\pi n$. In any case, g preserves the real axis.

If G has an indirect isometry, name it $g(z) = s\bar{z} + t$. Conjugation again leads to $s = \pm 1$. The square of g is either the identity or a translation; show that this leads to $t + s\bar{t} = 2\pi n$. If $s = -1$, this means t is real, so that g is reflection across a vertical line, which leaves the x-axis invariant. If $s = 1$, we have $\text{Re}(t) = \pi n$. Call $\text{Im}(t) = a$ and show that g is a glide reflection with axis $\text{Im}(z) = a/2$. By convention, we have $a = 0$.

Clean up one last detail: show that there cannot be two glide reflections with different axes parallel to the x-axis. (Hint: Compose to create a nonhorizontal translation.)

Proposition 5. *Suppose G is a frieze group, whose translations all have the form $\tau_n(z) = z + 2\pi n$, for $n \in \mathbb{Z}$. If G contains any isometries that are not translations, then all its elements leave invariant a unique horizontal line. The conventions assure that this line is the x-axis.*

In Chapter 8, we were necessarily a bit vague about the concept of *pattern type* for friezes. We saw that p111 and p11g are isomorphic as groups but lead to visually different pattern types. For another example, you can show that p211 and p11m are isomorphic as groups.

To define equivalence of pattern types, we require the language of *affine transformations*, which are compositions of nonsingular linear maps with translations. We say that frieze groups G_1 and G_2 have equivalent *pattern types* when they are conjugate in the affine group, meaning that there is an affine transformation $\alpha(z)$ such that

$$G_2 = \alpha G_1 \alpha^{-1} = \{\alpha g \alpha^{-1} \mid g \in G_1\}.$$

If you know some linear algebra, it is not too hard to show, using determinants, that it is impossible to conjugate a rotation by an affine transformation and turn it into a reflection. Thus, p211 and p11m are not conjugate in the affine group and the pattern types are different. Similarly, we cannot conjugate a glide and turn it into a translation, so p11g and p111 are different types.

Having created symmetry in rosettes, friezes, and wallpapers, we have completed the traditional categories of plane symmetry, meaning *Euclidean* plane symmetry. In the next chapters, we investigate what happens when we open our investigation to geometries other than Euclidean.

* EXERCISE 59
The Return of the Laplacian

Refer to Chapter 9 to recall the role of the Laplacian in our construction of waves, which are eigenfunctions of this operator; the higher the eigenvalue in magnitude, the more oscillatory the wave. In Exercise 22, we proved that two forms of the Laplacian are equivalent:

$$\Delta f = \frac{\partial^2 f}{\partial x^2} + \frac{\partial^2 f}{\partial y^2} = 4\frac{\partial^2 f}{\partial z \partial \bar{z}}.$$

Use both forms to show that each term in the series (8.2), in either form as

$$E_{n,m} = e^{inz}e^{-im\bar{z}} \text{ or } E_{n,m} = e^{-(n+m)y}e^{i(n-m)x},$$

is an eigenfunction of the Laplacian with eigenvalue $4nm$.

Recall that these terms come from composing the homomorphism Φ with functions $T_{n,m}(z) = z^n\bar{z}^m$. Use the complex form of Δ to compute that

$$z\bar{z}\Delta T_{n,m} = 4nmT_{n,m}.$$

Thus, the Ts are eigenfunctions of the strange operator

$$\tilde{\Delta} = z\bar{z}\Delta.$$

It turns out that this is the natural Laplacian (called the Laplace-Beltrami operator) on the space \mathbb{C}^* endowed with an altered concept of distance.

To investigate, let's define a new concept of distance on \mathbb{C}^* by declaring that the length of a curve $\gamma(t) = x(t) + iy(t)$ over the interval $[a, b]$ is

$$L(\gamma) = \int_a^b \frac{\sqrt{(x'(t))^2 + (y'(t))^2}}{\sqrt{(x(t))^2 + (y(t))^2}} \, dt.$$

This is very like the ordinary arc length formula for parametric curves, but the denominator says that a piece of the curve near the origin is actually longer than it looks, while a piece of the curve out in the distant realms is actually shorter than it appears. Use the formula to prove that every circle

$$\gamma(t) = Re^{it} \text{ for } 0 \le t \le 2\pi$$

has the same length: 2π.

If we use this altered concept of distances, we can show that the map Φ is an isometry! And the funny Laplacian $\tilde{\Delta}$ is what is called the *push-forward* under Φ of the ordinary Laplacian on the plane. So we come full circle: After thinking of our rosette functions as being made from power series, we find that they too are eigenfunctions of a sort of Laplacian.

Chapter 24
Polyhedral Symmetry (in the Plane?)

Question: How do you make functions with polyhedral symmetry? After such a long and (compulsively) detailed study of plane symmetry, you might be wondering when, if ever, we are going to make it to 3 dimensions. After all, literal wallpaper may be 2-dimensional, but literal crystals are not. And it was the study of physical crystal structures that led scientists to study groups of symmetries in the first place.

I offer the symmetries of regular polyhedra as a starting point to move us toward a study of symmetry in space. They are beautifully symmetric objects and something that most people know. I have several ways to create symmetry using the symmetry groups of the platonic solids: the tetrahedron, the cube, and the icosahedron. Strangely, my favorite method lands us right back in the plane, where I can once more exploit domain coloring and all the things we have learned about complex transformations.

Polyhedral symmetry highlights a new concept from abstract algebra: the idea of decomposing a group into *cosets* of a given subgroup. (This is really just another appearance of the pervasive idea of *equivalence class* in a new setting.) Our wallpaper recipes took great advantage of the fact that the translations form a normal subgroup of any wallpaper group. This meant that we could average a function over the action of its point group. The symmetry groups of polyhedra are short on normal subgroups, so we need a new technique for creating symmetry, and that takes us to cosets, whether we work in the plane or in space.

We will not continue to a general study of crystals; the 219 groups (or 230, depending on the concept of equivalence) won't fit here. Suffice it to say that you can apply all the ideas in this book to a study of 3-dimensional symmetry, though the complex numbers necessarily play less of a role. I have not personally worked much with symmetry in space. One reason is that I have never had access to technology that would allow me to depict functions periodic with respect to a lattice in space. Will 3D printers change this?

The Platonic Solids

I assume some familiarity with the five Platonic solids: the tetrahedon, cube, octahedron, dodecahedron, and icosahedron. For millennia now, humans have known that these five solids give the only ways to enclose space with a collection of congruent regular polygons, called the *faces*, with no gaps or overlaps. The definition of polyhedron requires that faces may meet only along full *edges* and that edges must meet only at *vertices*.

The Tetrahedron

Figure 24.1 can get us started, with both a tetrahedron—whose four faces are equilateral triangles—and a cube—with six square faces. Did you know that a tetrahedron can sit inside a cube this way? Just take two diagonals of opposite cube faces, making sure they point in different directions, and you'll be able to fill in the rest of a tetrahedron. Checking, for instance, that all the edges have the same length is an easy exercise.

The figure helps us talk about tetrahedral symmetry. Let's introduce coordinates (x, y, z) so that the corners of the cube are $(\pm 1, \pm 1, \pm 1)$. Imagine that the point nearest your eye in each figure is $(1, 1, 1)$. We can see the top edge of the tetrahedron: a line from $(1, 1, 1)$ to $(-1, -1, 1)$. Hidden behind in both views is the point $(-1, -1, -1)$, the other end of the long diagonal through $(1, 1, 1)$.

The bottom view of the tetrahedron makes it clear that rotating the tetrahedron (and the cube) $120°$ in either direction is a symmetry of the solid. Rotations in 3-dimensional space can be difficult to write down but this one is easy, because the figure helps us see that the x-axis moves to the y-axis, which moves to the z-axis: This is just the cyclic permutation of those variables,

$$P(x, y, z) = (z, x, y).$$

(If the x-axis is coming toward us along the lower left of the image, this formula will give counterclockwise rotation.) We could describe this as spinning the back, hidden face of the tetrahedron while keeping the front vertex fixed.

What other symmetries are apparent? We can spin the tetrahedron $180°$ about a vertical line through the midpoint of that top edge. This is a half turn

$$H_z(x, y, z) = (-x, -y, z),$$

leaving all heights unchanged. The picture is so symmetrical that we can also do this leaving each of the other axes fixed, with half turns

$$H_x(x, y, z) = (x, -y, -z) \text{ and } H_y(x, y, z) = (-x, y, -z).$$

Verify that the product of any two of those half turns is the third of the set. (Pause to think of all the other times we have come across groups with four elements, where each has order two and the product of any two is the third. For instance, the stabilizer of the origin in pmm comes to mind: $\{\sigma_x, \sigma_y, \rho_2, \iota\}$. This is called the *Klein 4-group*.))

It turns out that these fundamental motions—and the others that arise by group composition—complete the set of possible rigid motions of the tetrahedron. Let us agree—at least for now—not to allow reflections of the tetrahedron, which cannot be accomplished without deforming the solid. The *tetrahedral group*, which I denote \mathcal{T}, is generated by P and any one of the three half turns. (The other half turns are conjugates of any one we choose by P.)

How many elements belong to \mathcal{T}? Calling $I(x, y, z) = (x, y, z)$ the identify transformation, we first identify an easy 3-element subgroup, generated by the rotation: $S = \{I, P, P^2\}$. There is a nice way to count all of \mathcal{T} by organizing it into subsets, which I claim are disjoint and exhaust the group:

$$\{I, P, P^2\}, \{H_z, PH_z, P^2 H_z\}, \{H_x, PH_x, P^2 H_x\}, \text{ and } \{H_y, PH_y, P^2 H_y\}.$$

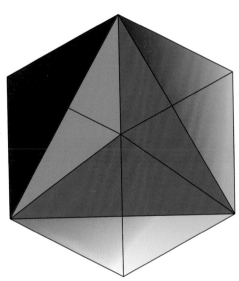

Figure 24.1. Two views of a tetradron sitting inside a transparent cube.

Using the given definitions for specific symmetries of the tetrahedron, prove the relationships

$$PH_x = H_y P,$$
$$PH_y = H_z P,$$
$$PH_z = H_x P.$$

Explain why these show that the given four subsets of \mathcal{T} are disjoint and that their union is all of \mathcal{T}.

These subsets exemplify the concept of (right) *cosets* of a subgroup in a group. Cosets are a special case of the general concept of *equivalence class*, which we met in Chapter 4. There we wanted to say that two numbers are equivalent if they differ by a multiple of an integer m. Here, we say that two group elements, g_1 and g_2, are equivalent if $g_1 = hg_2$, where $h \in S$. Rearranging to $g_1 g_2^{-1} \in S$ shows that this is another way to say that the elements "differ" by an element of S. The equivalence classes in a group relative to a subgroup S of the group are called (right) cosets of S.

I claim that the four subsets shown, which are obtained by multiplying the set S, element by element, by I, H_z, H_x, and H_y, partition the group \mathcal{T} into disjoint subsets, which we write as S, SH_z, SH_x, and SH_y. Every element of \mathcal{T} belongs to exactly one of them. This might seem to be a stretch, since the group property requires the group to include *all* compositions of Hs and powers of P. In an exercise I ask you to verify relationships such as $PH_x = H_y P$. These allow us to move P to the right through a product, however complicated, and sort any given group element into one of the four cosets.

A rigorous proof is nice, but we can also engage our intuition for a convincing argument: For each of the four faces of the tetrahedron, we can spin that face while leaving the opposite vertex fixed. No other rigid motions map the tetrahedron to itself. Each coset is a set of symmetries that map the front face to a given face and then rotate in one of three ways. There are four faces, so our group \mathcal{T} has $3 \times 4 = 12$ elements.

In my argument about the size of \mathcal{T}, I used a particular set of *coset representatives*, meaning that, when I chose I, H_x, H_y, and H_z for coset notation, I had to be sure that no two of these belong to the same coset and that making cosets with this list exhausts the group. It is just a coincidence that these four elements form a group on their own. (To learn more, find out what it means for \mathcal{T} to be the *semidirect product* of S and the Klein 4-group.) The important thing here is that I had one *representative* of each set in the partition.

The Cube and Other Solids

What about the symmetries of the cube? All the rigid motions we performed to move the tetrahedron to itself also preserve the cube that surrounds it. But there are additional ways to move the cube to itself while moving the tetrahedron to a different tetrahedron—the one whose edges are the other six face diagonals of the cube. A simple example is rotation through $90°$ about the z-axis. Let us name the rotation

$$R_4(x, y, z) = (-y, x, z).$$

Then $R_4^2 = H_z$ is a symmetry of the tetrahedron, which makes sense since rotating the cube by two quarter-turns returns the original tetrahedron back to itself. There are also rotational symmetries about the three other axes of the cube. Convince yourself that they can all be produced by composing R_4 with elements of \mathcal{T}.

One traditional name for the symmetries of the cube is \mathcal{O}. We'll get around to saying why. First, let me convince you that \mathcal{T} is a normal subgroup of \mathcal{O}. For instance, check what happens when we conjugate any element of \mathcal{T} by R_4: First we rotate, displacing the tetrahedron from its starting position; then we perform

any symmetry in \mathcal{T}, leaving the tetrahedron in its off-base position; then we rotate back, returning the tetrahedron to its original location (though possibly turned). The quotient group is isomorphic to \mathbf{C}_2, the cyclic group with two elements.

If we consider the cosets of \mathcal{T} in \mathcal{O}, we find only two: All elements of the coset that is \mathcal{T} itself move the tetrahedron onto itself; the coset $\mathcal{T}R_4 = \{gR_4 \mid g \in \mathcal{T}\}$ consists of symmetries of the cube that move the one tetrahedron to the other. This allows us to count: \mathcal{O} has 24 elements, because you can see that it is twice as big as \mathcal{T}, which has 12.

To understand the name \mathcal{O}, start with the cube (of side length 2, centered at the origin) and put a point in the center of each of its six faces. Each of these points has 4 neighbors exactly $\sqrt{2}$ units away. These form the vertices of 8 equilateral triangles, the faces of a regular octahedron. This process is called finding the *dual* of a given polyhedron: Put vertices in the centers of faces and fill in polygons. The octahedron is the dual of the cube. Any rigid motion that preserves the cube also preserves the octahedron, meaning that the cube and octahedron have the same symmetry group.

Similarly, the dual of the dodecahedron is the icosahedron. We write \mathcal{I} to name the group of rigid motions of either the icosahedron or dodecahedron (excluding reflections, which cannot be realized as rigid motions). I'll explain how to generate this group, but only after we learn how to create functions with tetrahedral and octahedral symmetry.

A useful fact to store away: Every element of each of these three polyhedral groups—\mathcal{T}, \mathcal{O}, and \mathcal{I}—could be viewed as a mapping of the sphere to itself; to see this, just imagine the given polyhedron inscribed in the unit sphere. Finally, I'll mention that these are, up to isomorphism, the only *finite* groups that act as rigid motions of the sphere with no axis fixed by the entire group. (You can act on the sphere with any finite cyclic group by rotating the equator and fixing the north pole; you can also act with a dihedral group that flips the poles. Neither case is a rich new ground for symmetry. These are essentially the rosettes from Chapter 7.)

Polyhedral Functions—Naive and Clever Group Averaging

Our notation for the tetrahedral group \mathcal{T} shows that it acts on \mathbb{R}^3, the space of (x, y, z) triples. Our search for \mathcal{T}-invariant functions might begin by applying the simplest tool in our kit: group averaging. Since \mathcal{T} has 12 elements, we can always form, for any given function $f(x, y, z)$, an averaged function

$$\hat{f}(\vec{x}) = \tfrac{1}{12} \sum_{g \in \mathcal{T}} f(g\vec{x}), \text{ where } \vec{x} = (x, y, z).$$

With only 12 terms, this sum is not too cumbersome to implement on a machine, but I would not want to write out an example by hand.

Here's a trick that saves a lot of work. Suppose we start with a function f that is already invariant under the action of P. For instance, we could choose $f(x, y, z) = \sin(x + y + z)$, which is certainly invariant under cyclic permutation

of variables. Simple observation shows that

$$f(H_x\vec{x}) = f(PH_x\vec{x}) = f(P^2H_x\vec{x}),$$

so those three terms in our sum—the three that correspond to the coset SH_x—are the same. The same happens with the other three cosets. *We need only include a set of coset representatives in our average.* For this example,

$$\hat{f}(\vec{x}) = \tfrac{1}{4}(f(\vec{x}) + f(H_x\vec{x}) + f(H_y\vec{x}) + f(H_z\vec{x}))$$

$$= \tfrac{1}{4}\left(\sin(x + y + z) + \sin(x - y - z)\right.$$

$$\left. + \sin(-x + y - z) + \sin(-x - y + z)\right).$$

(It doesn't really matter that this simplifies as $-\sin(x)\sin(y)\sin(z)$, unless you plan to work out a basis for the periodic functions with tetrahedral symmetry—a project for a 3D crystallographer.)

How shall we picture this function, now that we know it to be \mathcal{T}-invariant? One way to picture a function of three variables is by its *level sets*, sets in space where $f = c$, for various given c. Figure 24.2 (top) shows a portion of one level surface; I chose $f = \tfrac{1}{2}$. This makes a surface that falls apart into four pieces, like dice centered at the vertices of the tetrahedron. Look closely to see that the smooth surface is rendered in small triangular shapes. The file format that stores a surface as a set of small triangles is just what you need to address a 3D printer. Of course, if you print this example, you'll just get four dice.

We can use the same function in a different way to produce Figure 24.2 (bottom). We think of f as a function on the unit sphere $x^2 + y^2 + z^2 = 1$ and take it as expanding or contracting the radius of a spherical surface at that point, depending on whether f is positive or negative. Implementation is easiest in spherical coordinates, where we write $(x, y, z) = (\rho\cos(\theta)\sin(\phi), \rho\sin(\theta)\sin(\phi), \rho\cos(\phi))$. My conventions match the usual polar coordinates in the plane, where θ is the positive angle from the x-axis. The angle ϕ is measured down the z-axis.

We deform the radius of the sphere by adding an artistically chosen multiple of the symmetrized function to a base value of 2 that I happened to choose. The result is

$$\rho = \rho(x, y, z) = 2 + 4f(x, y, z) = 2 - 4\sin(x)\sin(y)\sin(z).$$

(Calculus aces may use Lagrange multipliers to show that ρ assumes a positive minimum value.) Then we ask a computer to plot the parametric surface

$$(\theta, \phi) \to (\rho(x, y, z)\cos(\theta)\sin(\phi), \rho(x, y, z)\sin(\theta)\sin(\phi), \rho(x, y, z)\cos(\phi)).$$

The result is the rounded tetrahedral shape in Figure 24.2 (right), rotated in order to make a visual connection to Figure 24.1. The formula shows that the deformed sphere should actually bulge inward in the octant where all three variables are positive; connect this to the correct orientation of the dice in Figure 24.2 (left).

Let's leave functions in space for another time, rich as the topic is. Instead, let's turn our attention back to the plane, where we have so many tools for

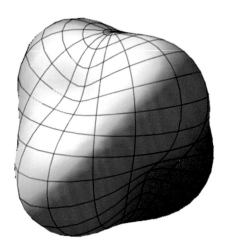

Figure 24.2. Two ways to picture a tetrahedral function: top, as a level set and bottom, as a function that deforms the sphere.

visualization. It will help that discussion to formalize the idea about averaging over a set of coset representatives, which facilitated the construction of the tetrahedral example. We leave the proof as an exercise.

Proposition 6 (Averaging over a set of coset representatives). *Suppose G is a finite group, acting as transformations on a set X. Suppose G has a subgroup S, which need not be normal. Finally, suppose we have a set of coset representatives $g_1, g_2, \ldots g_k$, so that $G = S \cup Sg_1 \cup Sg_2 \cup \cdots \cup Sg_k$ and the union is disjoint. If f is a function on X that is invariant under S, then the symmetrized function*

$$\hat{f}(x) = \frac{1}{k} \sum_{j=1}^{k} f(g_j x)$$

is invariant under G.

(Hint for proof: The main step is to show that, for any particular coset representative g_p, the set $\{g_j g_p\}$ is a different set of coset representatives for G. In other words, the map $g_j \to g_j g_p$ is always just a permutation of the coset representatives.)

Polyhedral Symmetry in the Plane

It was a happy day when I realized how nicely the formulas turn out when we move the polyhedral groups to act on the plane. A technique called *stereographic projection* maps points on the unit sphere—except for 1 point, which I take to be the north pole—to the plane. We imagine our eye at the north pole $(0, 0, 1)$ and look directly from there to a point on the sphere, (x, y, z) with $x^2 + y^2 + z^2 = 1$; our line of sight is found (by a nontrivial, but tractable, exercise) to intersect the xy-coordinate plane (where $z = 0$) in the point

$$\Pi(x, y, z) = \left(\frac{x}{1 - z}, \frac{y}{1 - z} \right).$$

(We left off the z-coordinate, since it's 0.) The inverse of this projection takes the point (x, y) to the point

$$\Pi^{-1}(x, y) = \left(\frac{2x}{r^2 + 1}, \frac{2y}{r^2 + 1}, \frac{r^2 - 1}{r^2 + 1} \right).$$

*** EXERCISE 61**

Verify the given formulas for the projection and its inverse. Find the analogous formula for the stereographic projection of the 1-sphere, S^1, which is the unit circle, to the line \mathbb{R}. Compute the inverse of this projection and observe that it is essentially the rational parametrization of the circle, (1.1), introduced in Chapter 1, differing only by a rotation.

TRANSFER TO THE PLANE. If g is any transformation that maps the sphere to itself, as all of our polyhedral symmetries do, we can transfer the action of g to the plane by conjugation:

$$\gamma_g(x, y) = \Pi g \Pi^{-1}(x, y).$$

We move from the plane up to the sphere by Π^{-1}, perform the transformation g, and come back down to the plane by Π.

This can be messy to compute, but I was surprised by the beauty of the results. For instance, if $g = H_z$, we find

$$\gamma_g(x, y) = (-x, -y),$$

which is rotation through $180°$ about the origin. Apologizing copiously for using z to mean two different things and trusting you to tell them apart, I return to complex notation and use $z = x + iy$ to write this as

$$\gamma_g(z) = -z.$$

This makes sense: Rotating the sphere about the axis through north and south poles should correspond to rotating the plane about 0, which corresponds to the south pole. We can even think of the north pole as corresponding to a "point at infinity," which is fixed by this rotation. Calling this point ∞ is not so frightening, once we see that it is just a different representation of the north pole of a sphere.

Similarly, we can work out that H_x transfers over to $z \to 1/z$, which we learned to see, in Chapter 8, as a sort of rotation that fixes points 1 and -1. Check that, under stereographic projection, these correspond to the poles $(\pm 1, 0, 0)$ and that H_x interchanges north and south poles, just the way $1/z$ exchanges 0 and ∞.

I was very surprised to learn that the cyclic permutation of variables, $P(x, y, z)$ transfers over to

$$\gamma_3(z) = \frac{z + i}{z - i}.$$

Proving this required such skills as, for example, factoring

$$1 + z\bar{z} + i(z - \bar{z}) = (z - i)(\bar{z} + i).$$

I recommend it as an exercise, along with the check that $\gamma_3^3(z) = z$. You may also enjoy computing that γ_3 has two fixed points,

$$(1 \pm \sqrt{3})\frac{1 + i}{2}.$$

Functions like γ_3 are called *fractional linear transformations*, formed from the quotient of two linear functions. It turns out that every rigid motion of the sphere transfers over to a fractional linear transformation of the plane, as you may wish to prove. The converse is not valid: If we use a reverse conjugation to transfer the simple fractional linear transformation $2z/1$, with the most trivial fractional part, we find a nonlinear transformation of space. Geometrically, this would be like grabbing the sphere and smooshing it upward from south pole to north pole—not a symmetry.

Table 24.1 shows the correspondences between polyhedral symmetries we have seen so far and their actions on the plane. The subscripts on the first three occurrences of ρ were chosen to indicate a fixed point of the rotation.

TABLE 24.1: How certain polyhedral symmetries correspond to fractional linear transformations in the plane. (Apologies: z has a different meaning in each column.)

SPACE SYMMETRY	SPACE FORMULA	CORRESPONDING PLANE SYMMETRY
Half turn about x-axis	$H_x(x,y,z) = (x,-y,-z)$	$\rho_1(z) = 1/z$
Half turn about y-axis	$H_y(x,y,z) = (-x,y,-z)$	$\rho_i(z) = -1/z$
Half turn about z-axis	$H_z(x,y,z) = (-x,-y,z)$	$\rho_0(z) = -z$
Cyclic permutation	$P(x,y,z) = (z,x,y)$	$\gamma(z) = (z+i)/(z-i)$
$90°$ rotation about z-axis	$R_4(x,y,z) = (-y,x,z)$	$\rho_4(z) = iz$

Plane Functions with Polyhedral Symmetry

Having laid the groundwork, it is easy to create functions invariant under \mathcal{T} and \mathcal{O}, as they act on the plane. We could average over whole groups, but the idea of averaging over a set of coset representatives makes things much simpler.

We begin with functions invariant under \mathcal{T}. Earlier in the chapter, I used the four cosets of the rotational subgroup of \mathcal{T} to count the group and to average a function of three variables. Here, it is more convenient to change the subgroup to

$$K = \{I, H_x, H_y, H_z\} \text{ with cosets } K, KP, \text{ and } KP^2.$$

This is because we know how to make functions invariant under all three ρ's: Just choose coefficients in

$$f(z) = \sum a_{n,m} z^n \bar{z}^m \text{ with } a_{n,m} = a_{-n,-m} \text{ and } n - m \equiv 0 \pmod{2}. \quad (24.1)$$

The first condition on the coefficients guarantees symmetry under the inversion ρ_1 and the second comes from the 2-fold symmetry recipe way back in Chapter 7.

Figure 24.3 shows an image I made from averaging a function of the form

$$c_1(z\bar{z}^{-1} + z^{-1}\bar{z}) + c_2(z^2 + z^{-2}).$$

There is a lot to see in this image. I mentioned that the fixed points of γ_3 are $(1 \pm \sqrt{3})(1+i)/2$; you can find them on the line $y = x$, with distances about 1.9 and 0.51 from the origin. The first appears in the image as a sort of triangle outlined by yellow peppers in the upper right; the second is in a much smaller triangle of orange peppers closer to the origin in the lower left. These are somehow centers of 3-fold rotational symmetry?

To see why this is so, observe that the yellow one corresponds to the point $(1,1,1)$ in space, a vertex of our tetrahedron. (You might prefer to think of it as $(1,1,1)/\sqrt{3}$, since we scale to put the tetrahedron inside the sphere.) The orange one is opposite that on the sphere, the center of the back face in Figure 24.1. To view these figures, it helps to recall how distances are distorted by stereographic projection (though angles are not, as stereographic projection is conformal). It's as if the figure is a polar projection map of the globe; this tells us how to interpret distances on the map. The point $(1,1,1)$ is near the north pole, so it is projected to a more distant part of the plane than the antipodal point $(-1,-1,-1)$. Distances near $(1,1,1)$ seem larger than they should on the plane, and distances

Figure 24.3. A plane function invariant under the tetrahedral group \mathcal{T}. One set of four 3-centers corresponds to the four vertices; the other to the four faces. Notice 2-fold rotational symmetry about the centers of edges, which are colored black.

near its antipodal point seem smaller. Seeing with adjusted eyes, you can convince yourself that in each of the four yellow and four orange triangular shapes, there really is a center of distance-preserving 3-fold rotation.

What about the black scalloped regions in Figure 24.3? Since our tetrahedral function contains negative powers of z, it will take on infinite values, colored black, at various points. These are the centers of edges of the tetrahedron, and the image, now that we now how to interpret distances, confirms that each is a 2-center. Later in this chapter, I explain an artistic choice we could make to fill in those black regions with color; for now, let's stick with the classic domain-coloring algorithm, where large values of a function are colored black.

In Whose Plane Are These Transformations Isometries?

Let's think about this distance concept, to help prevent dizziness when viewing these figures. When we think of various points as centers of rotational symmetry in Figure 24.3, it's as if we are assigning a new way to compute distances in the plane, one under which these rotations are actually isometries. A course in differential geometry would develop abstract tools for this. Here, I'll be very concrete by talking about curves. Please skip ahead if the calculus doesn't suit you.

In a manner similar to what we did in Exercise 59, let me define a new distance concept by declaring that the length of a plane curve $c(t) = x(t) + iy(t)$ over the time interval $[a, b]$ is

$$L_c = \int_a^b \frac{2\sqrt{(x')^2 + (y')^2}}{x^2 + y^2 + 1}\, dt.$$

Two examples might help you believe that this is the correct way to measure lengths, assuming that we want to interpret our plane diagrams as accurate maps of a spherical world. First, choose the curve $c_1(t) = t$ for $-\infty < t < \infty$—the whole real axis. Moving this up to the sphere by inverse stereographic projection, we find

$$\Pi^{-1} c_1(t) = \left(\frac{2t}{t^2 + 1}, 0, \frac{t^2 - 1}{t^2 + 1} \right).$$

Look back at Chapter 1 to see that this is the rational parametrization of the circle, the one that gives rise to Pythagorean triples. Of course, the length of this curve should be 2π, and we can compute, using the new distance formula, that

$$L_{c_1} = \int_{-\infty}^{\infty} \frac{2}{1 + t^2} dt = 2\pi.$$

That works pretty well!

For the second example, pick $c_2(t) = Re^{it}$, a circle whose radius in the plane seems to be R. (Appearances can be deceiving.) We compute

$$\Pi^{-1} c_2(t) = \left(\frac{2R\cos(t)}{R^2 + 1}, \frac{2R\sin(t)}{R^2 + 1}, \frac{R^2 - 1}{R^2 + 1} \right),$$

and see that the image of this circle up on the sphere (hanging at height $z = (R^2 - 1)/(R^2 + 1)$) is another circle, but with radius $2R/(R^2 + 1)$. Fortunately, our integral formula predicts the right answer for the length of c_2:

$$L_{c_2} = \int_0^{2\pi} \frac{2R}{R^2 + 1} dt = 2\pi \frac{2R}{R^2 + 1}.$$

Only with $R = 1$ is c_2 a unit circle.

All our polyhedral symmetries are isometries in terms of this unusual distance concept. This means that the plane we are studying through spherical projection is a model for spherical geometry. By finding functions invariant under the actions of \mathcal{T}, \mathcal{O}, and \mathcal{I}, whether on the plane or up on the sphere, we are making spherical wallpaper.

Octahedral Symmetry and Beyond

We again turn to the trick of coset averaging, this time to make functions with cube symmetry. If we take a function that already has \mathcal{T}-symmetry, there are just two cosets of \mathcal{T} in \mathcal{O} to average over. It's as simple as taking f invariant under \mathcal{T} and forming

$$g(z) = \tfrac{1}{2} \left(f(z) + f(iz) \right). \tag{24.2}$$

One example appears in Figure 24.4, colored with a photo of a lake in the Sierra Nevada. Find the centers of 2-, 3-, and 4-fold rotational symmetry and use your imagination to transfer the image back to the sphere.

Figure 24.4. A plane function invariant under the octahedral group \mathcal{O}. Centers of the 6 faces are colored black. The 8 vertices are gray dots, marking centers of 3-fold rotational symmetry. The centers of edges—centers of half turns—appear between two bits of cloud.

Astute readers might connect the formula in (24.2) to (24.1) and realize that it amounts to requiring that $n - m \equiv 0 \pmod 4$ for nonzero coefficients. This is actually how the image was created. Equation (24.2) gave us another chance to think about the technique of coset averaging.

THE ICOSAHEDRAL GROUP. Felix Klein wrote an entire book about \mathcal{I}. This group is a glorious but painful object. It can be obtained from the tetrahedral group by introducing a single 5-fold rotation with an obscure axis: the vector $(\phi, 1, 0)$, where $\phi = (1 + \sqrt{5})/2$ is the golden ratio. (Remember how this curious number popped up in our study of 5-fold symmetry in Chapter 13? It's back!) To get the full group, we must find all compositions of this rotation with elements of \mathcal{T}. There are 60 of them.

The details will be handled in an exercise. Here, I'll just report that this transfers to the plane as (drumroll, please)

$$\gamma_5(z) = \frac{\phi(1 - i\phi)z + 1 + 2i}{\sqrt{5}z + \phi(1 - i\phi)}.$$

I never would have guessed.

To make functions invariant under \mathcal{I}, we could simply average over all 60 elements. I did this to produce a surface in space, analogous to the one with tetrahedral symmetry in Figure 24.2 (bottom). Figure 24.5 shows how much fun this can be. But let's move on.

Let's use coset averaging to make icosahedral functions in the plane. We start with functions invariant under \mathcal{T} and average over the five cosets of the

Figure 24.5. A sphere deformed by a function with icosahedral symmetry.

Figure 24.6. Two views of a plane function invariant under the icosahedral group \mathcal{I}. The 12 vertices are colored a steely gray; the 20 face centers are beet-colored.

rotation γ_5. This amounts to picking a function f invariant under \mathcal{T} and forming

$$\hat{f}(z) = \tfrac{1}{5}(f(z) + f(\gamma_5(z)) + f(\gamma_5^2(z)) + f(\gamma_5^3(z)) + f(\gamma_5^4(z))).$$

I would never perform this averaging by hand, but Figure 24.6 shows how well a machine can do it. This image uses the photograph of the red-handed beet cutter from Figure 17.1. I offer two views, because we need to see both the big picture and some detail if we are to see all 20 triangular beet shapes and all 12 steel pentagons. Enjoy!

*** EXERCISE 62**
Linear Representations of the Polyhedral Groups

The details of the icosahedral group are best handled with linear algebra. To get the ball rolling, I'll write the generating rotations of \mathcal{T} in matrix form.

$$H_x = \begin{pmatrix} 1 & 0 & 0 \\ 0 & -1 & 0 \\ 0 & 0 & -1 \end{pmatrix}, H_y = \begin{pmatrix} -1 & 0 & 0 \\ 0 & 1 & 0 \\ 0 & 0 & -1 \end{pmatrix}, \text{ and } H_z = H_x H_y.$$

(continued)

Back to the Sphere

I enjoy the challenge of looking at images like Figure 24.6 and understanding them as functions on the sphere, but why not put them back on the sphere where they came from? Making a 2-dimensional view of the 3-dimensional sphere is not hard but is beyond the scope of this book. Suffice it to say that I did some very ordinary computer graphics to create Figure 24.7 from a function made from the icosahedral recipe.

There is one twist: The poles of the polyhedral functions—the places where the function values are undefined—make large black patches in the images. In a way, these are interesting because they mark the borders of the square image used as the color wheel. However, when I transferred functions back to the sphere and viewed only the front side, I was dissatisfied to lose so much area to a single color. To add visual interest to those areas, I adapted the domain-coloring algorithm to corral all the complex numbers output by the function f, even the extremely large ones, into the unit disk. Instead of putting the color of $f(z)$ at the point z, I used the color of the complex number

$$\frac{f(z)}{\sqrt{1 + f(z)\overline{f(z)}}}.$$

The destroys any possibility for conformality, but the functions with polyhedral symmetry will not be conformal anyway, except in very special cases. For the sake

These are easy matrices. The matrix for cyclic permutation isn't bad either:

$$P = \begin{pmatrix} 0 & 0 & 1 \\ 1 & 0 & 0 \\ 0 & 1 & 0 \end{pmatrix}.$$

Check that $P^3 = I$. While you are thinking about P, this would be a good time to verify the formula $\gamma_3(z) = (z + i)/(z - i)$ for the action of P transferred to the plane by stereographic projection.

The matrix for the 5-fold rotation with fixed vector $(\phi, 1, 0)$ is rather hairy to work with, though it doesn't look too bad:

$$R_5 = \tfrac{1}{2} \begin{pmatrix} \phi & \phi^{-1} & 1 \\ \phi^{-1} & 1 & -\phi \\ -1 & \phi & \phi^{-1} \end{pmatrix}.$$

Confirm that R_5 leaves the vector $(\phi, 1, 0)^t$ fixed. This and $R_5^5 = I$ confirm that R_5 is as claimed. If you can compute by hand that the fifth power of this matrix is the identity, I congratulate you; it's a heroic computation. It can be tough even if you use a machine. Computer algebra systems can be better or worse at applying such golden-ratio identities as $\phi^2 = \phi + 1$.

Now for the real challenge. Compute the composition $\Pi R_5 \Pi^{-1}$ to confirm the formula for the fractional linear transformation I offered as the element to introduce with \mathcal{T} to create the icosahedral group.

For more exercise, prove that \mathcal{T} is not normal in \mathcal{I}.

Figure 24.7. An icosahedral function depicted on the sphere, using an iris as the color wheel.

of art, I did something that I find less than mathematical. Judge for yourself in Figure 24.7. The interesting *S*-shapes, made from some greenery and the siding of my house, add much more to the design than the black patches that would have been there using unmodified domain coloring.

Polyhedral Color-Reversing and Mirror Symmetries

When I was writing about how \mathcal{T} is a normal subgroup of \mathcal{O}, I could not resist the opportunity to create color-reversing symmetry, where elements of \mathcal{T} act as symmetries and elements of \mathcal{O} outside of \mathcal{T} act as antisymmetries. The recipe method is just what was described in Chapter 19, if you'd like to try making them. (In this case, creating a color-reversing f is as simple as restricting the terms in its power series, before coset averaging, to satisfy $n - m = 2 \pmod 4$, as you may wish to prove.)

One example is shown in Figure 24.8, colored by a photograph of a granite cairn and its negative. Again, the six centers of faces are colored black, and the function enjoys a negating quarter turn about each one of those. The easiest ones to see are the $90°$ rotations about the origin (which is also a rotation about ∞, the center of the top face of the cube, which touches the north pole).

Figure 24.8. A function with a color-reversing quarter turn and tetrahedral symmetry, colored with a granite cairn.

The centers of 3-fold rotation are somewhat hidden in the centers of light and dark gray regions; if you focus on the upper-right quadrant of the pattern, you'll see three copies of the cairn, each stretching to touch a dot of blue sky. The symmetry type of this image might be called \mathcal{O}/\mathcal{T}, because the only actual symmetries belong to \mathcal{T}, but if you include both symmetries and color-reversing symmetries, the group is enlarged to \mathcal{O}.

Neglecting mirror symmetries would leave us with only this example of color-reversing symmetry, so it is time to study what happens when we introduce reflections into polyhedral groups. I'll mention some highlights and leave full classifications as projects.

The simplest mirror to study is

$$M_d(x, y, z) = (y, x, z),$$

reflection across the plane $x = y$, which we call the *diagonal mirror*, as the main diagonal of the cube lies on the mirror axis. The corresponding transformation of the plane is our old friend $\sigma_d(z) = i\bar{z}$. Computation leads us to the recipe, with coefficients as in (24.1),

$$a_{n,m} = i^{n-m} a_{m,n},$$

to engage this diagonal mirror. An example appears on the left in Figure 24.9.

The smallest group obtained by introducing M_d into \mathcal{T} is known as \mathcal{T}_d, in the Schoenflies notation used by crystallographers. Careful examination of the figure (or the formulas) shows that the "pinwheel" nature of the 3-centers was not disturbed by introducing this mirror. This is quite like the situation with the wallpaper group p31m, where there are 3-centers not on mirror axes. In the project outline, you can read about another way to expand \mathcal{T} with a mirror symmetry to find a group called \mathcal{T}_h. This is the tetrahedral analog of p3m1, where

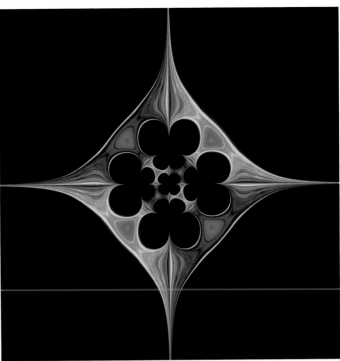

Figure 24.9. Left: A function with symmetry group \mathcal{T}_d. Right: A function with tetrahedral and mirror symmetry, with a color-reversing quarter turn.

there are mirror axes through every 3-center. Here, I'll just allude to Figure 24.9, where I turned on that mirror, but also introduced a negating quarter turn for symmetry type $\mathcal{O}_h/\mathcal{T}_h$. (The group \mathcal{O}_h; it contains *all* the symmetries of the cube, including M_d, which, working with the 90° rotation, forces the "horizontal" mirror behind the subscript h in the group name. More details are given in a project description.)

PROJECT. The group \mathcal{T}_h is obtained by introducing the horizontal mirror, $\sigma_{xy}(x, y, z) = (x, y, -z)$, into \mathcal{T}. Investigate the possibilities for introducing these mirrors to the other polyhedral groups; you should find that there are 4 groups. In Schoenflies notation, these are \mathcal{T}_d, \mathcal{T}_h, O_h, and \mathcal{I}_h. Each of these is called a *double cover* of the related polyhedral group, and it is curious that \mathcal{T} has two double covers, but the others do not. Study these groups and adapt the methods in this chapter to create plane functions invariant under these groups. Once you have recipes for invariant functions, it is easy to adapt them as recipes for color-reversing functions. This would naturally lead you to discover that there are 7 ways for one of the groups to be a normal subgroup of another.

PROJECT. When we use the distance concept that makes the plane isometric with the sphere under stereographic project—the one in terms of which I showed how to compute arc length—the Laplacian takes the form

$$\tilde{\Delta} f = (1 + z\bar{z})^2 \frac{\partial^2}{\partial z \partial \bar{z}} f.$$

Research spherical harmonics and use them to find eigenfunctions of $\tilde{\Delta}$. These can be used to create vibrating polyhedral wallpaper.

PROJECT. In our study of curves, we found symmetric ways to map the circle into the plane. Study an analog of those circle mappings, which I call *G-symmetric mappings of the sphere*, where G is one of the polyhedral groups. These are maps from the sphere into space, which we can construct to have symmetries reminiscent of the curves in Chapter 3. Specifically, f is a G-symmetric mapping of the sphere in \mathbb{R}^3 with group G when

$$f : S^2 \to \mathbb{R}^3 \text{ satisfies } f(g\vec{x}) = gf(\vec{x}), \text{ for } |\vec{x}| = 1.$$

Note the formal similarity to curve symmetry: A group acts on both the domain of the function, the sphere S^2, and the range, \mathbb{R}^3. Adopting ideas from our study of polyhedral functions, we can start with *any* function f that maps the sphere into space and symmetrize it with naive group averaging. Just use the formula

$$\hat{f}(\vec{x}) = \frac{1}{|G|} \sum_{g \in G} g^{-1} f(g\vec{x}),$$

where $|G|$ is the number of elements in G.

Figure 24.10 shows one example, where the group is \mathcal{I}. Use naive group averaging to create your own examples with the three polyhedral groups we have studied.

Figure 24.10. An \mathcal{I}-symmetric mapping of the sphere into space. When you apply $g \in \mathcal{I}$ in the domain, the output value of the mapping turns by g.

Chapter 25
Hyperbolic Wallpaper

Question: Can we make wallpaper for non-Euclidean geometry? In the previous chapter, on polyhedral symmetry, we learned to look at an image and tell ourselves, All these things are the same size, knowing that our eyes were showing us a distorted (but conformal) image of a perfectly symmetrical image on the sphere. I hope that the experience helped you adopt a flexible concept of distance in the plane, because yet another distance concept takes us into the realm of non-Euclidean geometry, specifically the hyperbolic geometry of the Poincaré upper halfplane.

I think of the Poincaré upper halfplane as a sort of toy universe, an imaginary 2-dimensional world where we can perform thought experiments about the properties of space. If you know Edwin Abbott Abbott's *Flatland*, this story has some similarities, but Euclidean geometry does not apply, in a very specific sense. There are two things to keep in mind about the universe of the Poincaré upper halfplane:

- The universe consists exactly of those Cartesian points (x, y) that have $y > 0$.
- All matter, including rulers, shrinks as y gets smaller and grows as y gets larger.

I speak of the points with $y = 0$ as the "edge of the universe." We, as outside Euclidean observers of this toy universe, can see them, but they are outside the world of the "Poincarites"—my name for the imaginary inhabitants of this space. The Poincarites might use the term *ideal point* to indicate one of these infinitely far points, created as a fiction for the missing point at the end of a line. Ideal points are quite analogous to a hypothetical nonexistent point in Euclidean geometry where two parallel lines meet at infinity.

Let's gain experience with this model universe by looking at some wallpaper I made for its inhabitants. Let the shrinking-ruler hypothesis guide your distance-interpreting vision: An object that looks small down near the edge of the universe can actually be quite large, because it takes many shrunken rulers to measure it across.

With this in mind, examine Figure 25.1 on the next page. Does your experience in Chapter 24 help you believe that the creamy circles (with three red ears) are centers of 3-fold rotational symmetry? Find the three blue shapes that stripe the image—they might look like birds flying downward with their beaks in the black fans. Can you accept that these are invariant under half turns centered at bluish ovals? That all the other blue shapes in the figure are congruent in every detail? Can you infer that there must be infinitely many of these congruent shapes—blue birds and creamy circles—all crammed together down near the edge of the universe? These experiences are the heart of hyperbolic geometry. The rest is working out the details.

Figure 25.1. Wallpaper for a hypothetical universe, the Poincaré upper halfplane. Experience how distance works in the universe by finding shapes that differ in apparent size—like the cream-colored circles—and believing that they are all the same size and shape in this universe.

Isometries of the Poincaré Upper Halfplane

We study hyperbolic geometry through the isometries that leave distances unchanged in our particular model. The Poincaré upper halfplane is only one model of hyperbolic geometry, but it will be enough for us. We study the transformations that leave Figure 25.1 unchanged and a few that don't. They give us insight into a particular episode in the history of mathematics: the discovery of this counterintuitive non-Euclidean geometry.

Perhaps the most obvious symmetry of the figure is translational symmetry: When you slide the pattern to the left or right by just the right amount, it falls into coincidence with itself. Let's call that special distance 1. Using complex notation, we say that $\tau_1(z) = z + 1$ is a symmetry of the pattern.

Since the shrinking of rulers occurs only when we alter y, it stands to reason that sliding side to side by any amount is an isometry of our space. Yes, $\tau_t(z) = z + t$ is an isometry for any $t \in \mathbb{R}$, but a *symmetry* of this pattern only when $t \in \mathbb{Z}$.

Next we consider the half-turn symmetry of the vertical blue bird figures. It is important to remark that this symmetry extends to the whole pattern, even though I used the blue birds to draw attention to it. The Euclidean distance from those 2-centers to the x-axis seems to match the translational distance (and I promise this is so), so we may as well choose one of them to be the point $i \in \mathbb{C}$.

A half turn about i is something we have seen before: It belongs to the tetrahedral group. In the context of polyhedra, I call this ρ_i, but here I'll drop the i and simply name this 2-fold rotation as

$$\rho(z) = -\frac{1}{z}.$$

Let's study the symmetries that follow by composition from only these two, ρ and τ_1. Perhaps later we will find a larger group that includes the 3-fold rotations that we see in the example. Even with only two symmetries to start with, there is a surprising amount of work to do. Contrast this with what happened in Euclidean geometry: With only a half turn and one translation, we'd get the easy-to-grasp frieze group p112. Why should hyperbolic geometry be different? We find out by imitating the conjugations that showed us why p112 is so easy to understand.

First the part that turns out the same: For any $n \in \mathbb{Z}$, conjugating ρ by τ_n gives

$$\tau_n \rho \tau_n^{-1}(z) = -\frac{1}{z-n} + n = \frac{nz - (n^2+1)}{z-n}.$$

This looks horrible until we remember what it means—translate to the left by n units, turn, and then translate back, reminiscent of the "distant rotations" we produced by conjugation. If we do the algebra, we find that the fixed points of this composition are $n \pm i$, of which only $n + i$ is a point in our universe. Another feat of algebra shows the square of the composition to be the identity! This is a half turn about the point $n + i$, a symmetry evident in the diagram.

Not so familiar is the other conjugation, $\rho \tau_n \rho^{-1}$. It is sufficiently surprising that I'll stick with $n = 1$ for this discussion. Working out the composition, we find

$$\rho \tau_1 \rho^{-1}(z) = \rho\left(-\frac{1}{z} + 1\right) = -\frac{z}{z-1}, \text{ with a unique fixed point } z = 0.$$

In Euclidean geometry, an isometry with a unique fixed point is a rotation, so let's check on the order of this composition by computing its nth power:

$$(\rho \tau_1 \rho^{-1})^n(z) = \rho \tau_n \rho^{-1}(z),$$

since all the internal factors $\rho^{-1}\rho$ in the product cancel. Again, the only fixed point of the nth power is 0, so we never arrive back at the identity transformation. This composition has infinite order, which makes it sound a lot like a translation, though it certainly does not have the form of the other translations, $z + n$.

Let's put that one on hold for a bit and see what happens when we conjugate ρ by this mystery transformation, $\rho \tau_1 \rho^{-1}$, which we know is a symmetry of Figure 25.1. Wanting a better name, I'll call it μ:

$$\mu(z) = (\rho \tau_1 \rho^{-1})\rho(\rho \tau_1 \rho^{-1})^{-1}(z) = \rho \tau_1 \rho \tau_{-1} \rho(z) = -\frac{z+1}{2z+1}.$$

A little algebra will show the fixed points of μ to be $(-1 \pm i)/2$ and that $\mu^2(z) = z$. This is a half turn about the point $(-1 + i)/2$ (the one with $y > 0$), which we can see in Figure 25.1, just down to the left of the half turn about i. Notice that μ swaps the ideal points 0 and -1. Since ρ swaps 0 and ∞, we see the need to declare that our set of ideal points ought to include one called ∞.

Pushing this a bit more, we repeat the process with τ_n to find

$$\mu_n(z) = (\rho \tau_n \rho^{-1})\rho(\rho \tau_n \rho^{-1})^{-1}(z) = -\frac{nz+1}{(n^2+1)z+n}.$$

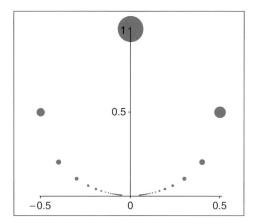

Figure 25.2. Algebra shows that each blue dot is a required center of rotation in any pattern that has a single rotation and translation, ρ and τ, as symmetries.

This time, we have a half turn about the point

$$C_n = \frac{-n + i}{n^2 + 1}.$$

Perhaps you notice this, but let me use Figure 25.2 to illustrate: These centers of rotation all lie on the circle of radius $1/2$ centered at the point $i/2$. (In the diagram, I took care so that the Poincarites might find all my blue dots to have the same size.) Can you find this succession of 2-centers in Figure 25.1?

Seeing these 2-centers allows us to say more about the compositions $\rho\tau_1\rho^{-1}$, which seemed to be some sort of translation, since it is a direct isometry of infinite order. This transformation shifts the row of 2-centers along the circle in Figure 25.2, moving i to $(-1 + i)/2$ and $(1 + i)/2$ to i—each one shifts one dot counterclockwise. If we think of the generating translation $z \rightarrow z + 1$ as shifting the plane while keeping ∞ fixed, $\rho\tau_1\rho^{-1}$ has the same quality, only fixing 0.

What other 2-fold rotational symmetries must occur in addition to those in Figure 25.2? By translational symmetry, there must be another circle of 2-centers falling toward each integer point on the ideal line. That is quite a lot of 2-centers. And yet, if you inspect Figure 25.1 carefully, you will find 2-centers that lie on none of these circles. Where do they come from? To find out, we turn away from conjugation and study simple compositions, something we might have considered in the first place.

The composition of ρ with τ_1 is computed to be

$$\rho\tau_1(z) = -\frac{1}{z + 1}.$$

This transformation has a unique fixed point (in the upper halfplane), the familiar number $\omega_3 = (-1 + \sqrt{3})/2$. If you locate this point in Figure 25.1, you can guess what algebra will confirm:

$$(\rho\tau_1)^3(z) = z.$$

This composition is a rotation of order 3 about the point ω_3. The 3-fold rotational symmetry of Figure 25.1 is required by group composition, provided we start with τ_1 and ρ as symmetries.

Look back at Figure 25.1 and find the images of ω_3 under our quasi translations, $\rho\tau_n\rho^{-1}$. Rotating about any of these additionally required 3-centers explains the proliferation of 2-centers. The overwhelming feeling for me as I look at these diagrams is how much space there is down near the edge of the universe. How capacious it must be to hold infinitely many 2- and 3-centers. This experience with hyperbolic geometry is reinforced by further study: It's a space with too much space in it, whatever that means.

The Modular Group

Let me summarize the symmetries of Figure 25.1 that we have met so far. (We'll get to the reflection symmetry across the y-axis later; it is not so interesting, from a group-theoretic point of view, I think.) Looking at the expressions for all the compositions we have studied, you might guess that the most general element of

the group generated by τ and ρ is the fractional linear transformation

$$\gamma(z) = \frac{az + b}{cz + d} \text{ with } a, b, c, d \in \mathbb{Z}.$$

This is close, but take a moment to check that, for our generators, we have $ad - bc = 1$. Check that this also holds for all the compositions. In fact, the property that $ad - bc = 1$ is invariant under group composition! To show these, we call on matrices; if you have skipped over all the matrices earlier in the book, this can provide a fine first experience. If you prefer to skip this, you will lose little by accepting that the group of direct symmetries of Figure 25.1 is called PSL(2, \mathbb{Z}) and proceeding to the next section.

A surprisingly effective shorthand for the transformation γ is the array

$$\begin{pmatrix} a & b \\ c & d \end{pmatrix}, \text{ and we write } \begin{pmatrix} a & b \\ c & d \end{pmatrix} z = \frac{az + b}{cz + d}.$$

What makes this powerful is the interface with a known apparatus of *matrix multiplication*, which I will illustrate with just one example, using the matrices corresponding to ρ and τ_n:

$$\begin{pmatrix} 0 & -1 \\ 1 & 0 \end{pmatrix} \begin{pmatrix} 1 & n \\ 0 & 1 \end{pmatrix} = \begin{pmatrix} 0 \cdot 1 - 1 \cdot 0 & 0 \cdot n - 1 \cdot 1 \\ 1 \cdot 1 + 0 \cdot 0 & 1 \cdot n + 0 \cdot 1 \end{pmatrix} = \begin{pmatrix} 0 & -1 \\ 1 & n \end{pmatrix}.$$

This amounts to taking the dot product of each row from the left-hand matrix with each column from the right. For instance, the first-row, second-column entry of the product is the dot product of the first row of ρ with the second column of τ; the result is -1.

The minor miracle here is that the product of matrices for ρ and τ is the matrix form of the composition $\rho\tau$. How useful! We can automate function composition (for these fractional linear transformations) as the mechanical multiplication of matrices. (If you doubt that this is so in general, I have an exercise for you.)

The quantity $ad - bc$ is called the *determinant* of the matrix, and it is known that the product of determinants is the determinant of the product, so if we multiply two matrices with $ad - bc = 1$, then that condition is true of the product.

We are almost ready to characterize the group of symmetries of Figure 25.1 as the set of integer matrices with determinant 1. There is a minor fly in the ointment. Even the lowly identity transformation $\iota(z) = z$ has *two* matrix representations,

$$\begin{pmatrix} 1 & 0 \\ 0 & 1 \end{pmatrix} \text{ and } \begin{pmatrix} -1 & 0 \\ 0 & -1 \end{pmatrix},$$

because the minus cancels in numerator and denominator. To be honest, we must say that our group is the quotient of the group of integer matrices with determinant 1 by its normal subgroup $\pm I$. At last, we can define the group of

$$\mathrm{PSL}(2, \mathbb{Z}) = \left\{ \begin{pmatrix} a & b \\ c & d \end{pmatrix} \mid a, b, c, d \in \mathbb{Z}, ad - bc = 1 \right\} / \{\pm I\}.$$

Phew!

What do these letters stand for? Groups of matrices like this one are called *linear* groups, hence the L. The S stands for *special*, meaning that the determinant of every element is 1. The P stands for *projective*, which is hard to explain without saying a whole lot more; here; it refers to our having identified the identity with its negative.

Reflection Symmetry and Hyperbolic Lines

Figure 25.1 has reflection symmetry across the y-axis: our friend $\sigma_y = -\bar{z}$. The nature of the shrinking ruler hypothesis, involving motions toward and away from the edge of the universe, shows that this side-to-side reflection is an isometry of the Poincaré upper halfplane. (This can also be confirmed by the integral formula in Exercise 64.)

This reflection gives strong evidence that this vertical line, the y-axis, would be considered a straight path by the Poincarites: If it were straighter to diverge from it to the right, then by reflection, it would also be straighter to veer off to the left. There should be only one way to proceed as straight as possible, so it must be along the y-axis.

We take the radical step of calling the y-axis, and indeed every vertical line, a *hyperbolic line*. Since we should be able to connect any two points with a straightest path, and the family of vertical lines can't accomplish this, we feel that there must be more lines. We seek them in the function composition

$$\rho \sigma_y(z) = -\frac{1}{-\bar{z}} = \frac{1}{\bar{z}},$$

Just compute

$$\mathrm{Im}\left(\frac{az + b}{cz + d} \right) = \frac{1}{2i} \left(\frac{az + b}{cz + d} - \frac{a\bar{z} + b}{c\bar{z} + d} \right)$$

$$= \frac{(ad - bc)y}{(cz + d)(c\bar{z} + d)}.$$

The left-hand side is the y-value of the transformed point. The fraction on the right will be positive, given that y is positive, if and only if the determinant $ad - bc$ is positive.

*** EXERCISE 64**
The Shrinking Ruler Hypothesis

We assumed that the half-turn symmetry of Figure 25.1 was an isometry of our hyperbolic model, using the image as a guide to teach us about the shrinking ruler hypothesis. In this exercise, we make that rigorous. Again, we define distance in terms of the lengths of curves. If $C(t)$ for $a \le t \le b$ is a curve in \mathbb{C} (this time using C to denote the location of the curve as a complex number), we define the length of C to be

$$L_C = \int_a^b \frac{|C'|}{\mathrm{Im}(C)} \, dt.$$

(To connect back with the possibly more familiar real notation for lengths, verify that the integrand is just $\sqrt{(x')^2 + (y')^2}/y$.) This is the essence of the shrinking ruler: When $\mathrm{Im}(C)$ is small, a unit velocity vector $|C'|$ counts as very large, and so on.

Show that ρ is an isometry, in that lengths of curves remain the same before and after performing the transformation. You may either reduce to real notation or take advantage of such tricks as $(-1/C)' = C'/C^2$—a complex version of the chain rule—to verify that the length of C remains the same after we submit it to the transformation ρ.

the geometric inversion across the unit circle. Since this isometry fixes the unit circle, that curve—or at least the part of it that belongs to our universe—must be a straightest path.

It's fun to see this in Figure 25.1: Start at the blue 2-center at i and circle left to ω_3. Yes, the image is symmetric across the path—at least when we see with hyperbolic eyes. Continue down past a creamy arrowhead and follow the black path all the way to -1. Repeat this with other mirror axes you find.

It turns out that geometric circle inversion is always an isometry of the Poincaré upper halfplane, as long as the circle has its center on the ideal line. Some elementary geometry then leads us to conclude that the collection of hyperbolic lines is exactly the *set of circles that meet the ideal line at right angles.*

Calling these obviously bent curves by the name lines is a bold move. It makes sense for a few reasons: The Poincarites use them as their straightest paths. Moreover, they satisfy a great number of the properties we expect of lines: Given two points in our universe, there is a unique way to join them with a circle that meets the ideal line at right angles. (Exercise: Prove this by construction.) In fact, all manner of things we know from Euclidean geometry can be proved, such as side-angle-side theorems for triangle congruence.

There is a deal-breaking difference with Euclidean geometry: Given a line l and a point P not on it, instead of finding one unique parallel to l through P, there are infinitely many lines through P that do not intersect l. (Exercise: Draw some hyperbolic lines and prove this.) This is too long a story to tell here; suffice it to say that parallelism goes all wrong for the Poincarites, leading to such unfamiliar outcomes as every triangle having an angle sum *less than* $180°$. In my opinion, this blew the collective mind of the ninteenth century and we are still recovering.

Here is one anecdote to illuminate the difference between Euclidean and hyperbolic geometry. In Euclidean geometry, start with a family of lines all parallel to one another and imagine a curve governed by a single rule: You must always travel exactly perpendicular to every line in the family. What locus do you get? Evidently, it's a line.

If we try this in hyperbolic geometry, we need a clearer picture of what is meant by a family of lines all parallel to one another. Fortunately, we were just talking about all the reflection axes in Figure 25.1; let's focus on the ones that pass through the ideal point 0. In other words, consider the family of hyperbolic lines (which are Euclidean circles with centers on $y = 0$) that pass through the ideal point 0. You can pick some of them out in Figure 25.1 as the reflection axes of the blue birds. Such a family of lines is called a *horopencil,* the analog in hyperbolic geometry of a family of mutually parallel lines. (In projective geometry, we call a family of mutually parallel Euclidean lines a *pencil* of lines and declare that they all share a common ideal point at infinity.)

Travel with your eye across the horopencil, trying to move along a path that stays perpendicular to every one. If you do this carefully, you will follow a curve that looks just like the one in Figure 25.2! This is a Euclidean circle that is tangent to the ideal line. In hyperbolic geometry, it is called by the marvelous name *horocycle.*

Now that we know the term, it makes sense to say that the translation-like symmetries $\rho\tau_n\rho$ were translating 2-centers along a horocycle, shifting one line in the horopencil through 0 to another. If we allow a horizontal line to count as a special horocycle, we could say that the translations $z + n$ are translating the 2-centers at $i + n$ along the horocycle $z = i$, shifting one line in the horopencil

** EXERCISE 65
**Proving That Horocycles
Are Euclidean Circles**

Start with the family of curves

$$(x - a)^2 + y^2 = a^2,$$

showing that these are all circles through 0 with their centers on the ideal line. These are the lines in a horopencil and we wish to cross them at right angles. Find a differential equation satisfied by *all* these circles by eliminating the parameter a. Use that slope field to pose an ordinary differential equation that all the crossing curves satisfy. Solve it to find the equation for horocycles.

Repeat to find curves that cross all the lines in a horopencil at $30°$ angles or at any specified angle. These are the hyperbolic analog of *loxodromes,* which are navigationally valuable lines on the sphere: A sailor follows a loxodrome by keeping a constant angle with the lines of longitude. Here we imagine a hyperbolic sailor keeping a constant angle with the lines in a horopencil.

through ∞ to another. From the point of view of the Poincarites, who do not distinguish among ideal points, these are all just translations.

The Wallpaper of the Poincarites

We now have so much experience creating functions invariant under the actions of groups, I can make this reasonably short. First, since the formula for naive group averaging (made explicit in Chapter 24) involves dividing by the size of the group, this is probably not a good idea: PSL(2, ℤ) is infinite. Even if this were not a problem, it turns out that there is little hope that the sum

$$\hat{f}(z) = \sum_{\gamma \in PSL(2, \mathbb{Z})} f(z)$$

will converge, except perhaps by choosing $f = 0$.

There is no lattice here, so lattice waves are not relevant. We might consider some generalization of that idea: The translational subgroup is normal in a wallpaper group, so perhaps we can find some nice normal subgroup of PSL(2, ℤ) and an analog of wave functions. Alas, our experience conjugating generators of PSL(2, ℤ) suggests that normal subgroups are in short supply.

This leaves us with the idea of averaging over a set of coset representatives of some nice subgroup. Recall that this means find a subgroup S where it's easy to find S-invariant functions, and then find coset representatives, so that the whole group is written as a disjoint union of the cosets, which are the multiples of S by these particular elements. We then average an S-invariant function over the action of the coset representatives.

To play the role of S, I offer the group of horizontal translations,

$$\Gamma = \{\tau_n(z) = z + n \mid n \in \mathbb{Z}\}.$$

Conjugating the group Γ by ρ gives us the set of translations along the horocycle through 0; it certainly doesn't return us to Γ as normalcy requires. Clearly Γ is not normal in PSL(2, ℤ), but it is easy to write down functions of z invariant under translations by integers—for instance, all the wallpaper functions from the major part of this book.

We need to look for a set of coset representatives. Something nice happens when we multiply an element of Γ by an element of PSL(2, ℤ):

$$\begin{pmatrix} 1 & n \\ 0 & 1 \end{pmatrix} \begin{pmatrix} a & b \\ c & d \end{pmatrix} = \begin{pmatrix} a + nc & b + nd \\ c & d \end{pmatrix}.$$

The bottom row stays the same. Each right coset of Γ in PSL(2, ℤ) is characterized by its bottom row. If we can make a list of the possible bottom rows and find a particular matrix in PSL(2, ℤ) with that bottom row, we can try averaging.

To learn what (c, d) pairs form possible bottom rows, we turn to the condition $ad - bc = 1$. Our brief discussion of divisibility in Chapter 22 can be applied here: The condition $ad - bc = 1$ is equivalent to saying that $\gcd(c, d) = 1$. the set of possible bottom rows consists exactly of pairs of relatively prime integers. So $(3, 8)$ is a bottom row, but $(36, 54)$ is not.

A classic routine to determine whether two integers are relatively prime comes to our aid: the Euclidean algorithm. If you have not learned this, I will invite you to read about it elsewhere, feeling that I have little to add to what others have said. It proceeds by trial division, dividing the smaller number into the larger and ending by reporting the greatest common divisor, which is either 1 or something greater. Furthermore, the algorithm can be induced to divulge numbers that *prove* that the greatest common divisor is 1, in the following sense: If we apply the algorithm to c and d and the Euclidean algorithm tells us that they are relatively prime, then we can also discover, as part of the process, two integers a and b so that $ad - bc = 1$.

This helps us organize our search for coset representatives. We let c and d range over nonzero integers and pick out the ones where $\gcd(c, d) = 1$, saving the corresponding top row (a, b) for each (c, d) pair. If we could do this forever, we would have an exhaustive set of coset representatives. Let's label them $\gamma_{c,d}$, with one for each pair of relatively prime integers.

We might become discouraged, knowing that there are infinitely many coset representatives to average over. Fortunately, the sum

$$\hat{f}(z) = \sum_{\gcd(c,d)=1} f(\gamma_{c,d}(z)),$$

though infinite, can be shown to converge, as least if we choose f nicely.

Let us consider which functions to use for f. Periodicity with respect to translation by positive integers is easy: Just use the familiar $e^{2\pi i n x}$. For y-dependence, we need to ensure sufficiently rapid decay as y approaches 0. Intuitively, the origin has so many translation equivalents close to it (the numbers $1/n$ are related to 0 in $\mathrm{PSL}(2, \mathbb{Z})$ by generalized translations) that the sum would have trouble converging without f decaying there.

For the images in this section, I superimposed one or two functions of the form

$$f(z) = y^s \cos(2\pi n x)$$

for integer values of n and various values of s with $\mathrm{Re}(s) > 1$. (If raising y to complex powers seems confusing, just take s to be real with $s > 1$.) Choosing only the cosine portion creates mirror symmetry across the y-axis for free. I have made other images lacking this symmetry; here, I stick with the mirror symmetry because the images tend to be visually simpler.

Knowing that the sum that creates \hat{f} is convergent is nice, but knowing how many terms to add to get a good approximation is another story. I worked empirically, adding about a thousand terms for each value of \hat{f} in an image.

Figure 25.3 shows a second example of how this averaging technique turns out. Images like these are computationally expensive and I have not made all that many.

I love the complexity of the image, but also the clear way it illustrates hyperbolic geometry. The red triangles marking 3-centers are aligned around horocycles. The crazy arms reaching for the origin are hyperbolic lines. The urge to look more closely near the edge is irresistable. I offer one blowup, this one above the interval $(0, 1/2)$ on the real axis. The detail especially highlights the hyperbolic lines, where the colors, the orange of the peach and the red of the plastic container I used to carry it to the top of a mountain, cycle until they fade to white, the color of

Figure 25.3. Another hyperbolic wallpaper, created by averaging over (only a finite number of) coset representatives, shown with its color wheel, made from a peach and its negative. Detail: a close-up above the interval [0, 1/2].

infinity in this rendering. Climbing Kaiser Peak in the Sierra Nevada is a favorite pilgrimage, and taking a peach to the top is a traditional way to make a peach taste especially wonderful. So I call this color wheel *Kaiser Peach*. It was used to produce Figure 1 in the preface, which shares the same title.

PROJECT. **Lest the Poincarites become bored: More hyperbolic wallpaper types.** The modular group is not the only group acting on the Poincaré upper halfplane that has wallpaper potential. There are at least two other sequences of groups that beg to be investigated: the Hecke groups and the congruence subgroups.

The Hecke groups are generated by the same half turn that belongs to $PSL(2, \mathbb{Z})$, $\rho(z) = -1/z$. Instead of the unit translation $z \rightarrow z + 1$ as a second generator, we generalize to $z \rightarrow z + 2\cos(2\pi/p)$ for $p \in \mathbb{Z}$. What? Well, when $p = 3$, this *is* the unit translation. The Hecke group \mathcal{H}_p is generated by ρ and $\tau_{2\cos(2\pi/p)}$. As a first step, show that \mathcal{H}_p contains a p-fold rotation.

The congruence subgroups, as the name suggests, are defined as subgroups of $PSL(2, \mathbb{Z})$ using the concept of modular congruence. For a given integer p, define the congruence subgroup of level p as

$$\Gamma[p] = \left\{ \begin{pmatrix} a & b \\ c & d \end{pmatrix} \in PSL(2, \mathbb{Z}) \mid a \equiv d \equiv \pm 1 \quad (\bmod \ p), b \equiv c \equiv 0 \ (\bmod \ p) \right\}.$$

(Remark: Since the elements of $PSL(2, \mathbb{Z})$ are equivalence classes of plus-or-minus matrices, we need to check that this definition respects equivalence classes. It does.)

Students at Carleton College have made wallpaper functions invariant under these groups; an academic paper based on their results has been proposed but not yet written. They produced starting images, some of them using an image of me, as if to show me my place in the land of the Poincarites. Don't let this stop you from investigating for yourself.

Chapter 26

Morphing Friezes and Mathematical Art

Question: How are "morphing friezes" an homage to M. C. Escher? Dutch artist M. C. Escher had an uncanny talent for realizing symmetry in drawings. As Doris Schattschneider tells us [17], it was Pólya's 1924 article about the 17 wallpaper groups that moved Escher to produce figurative patterns with wallpaper symmetry. Among the many expansive directions of his work, Escher created patterns that seemed to morph gradually from one pattern to another. Probably the most famous of these is the *Metamorphose* series, which is easily seen, though in low resolution, online.

In Escher's work, he emphasized the idea of *tesselation*, a process of dividing the plane into congruent polygons with no overlap and no gaps. This is also called *tiling*, and it is surprisingly difficult to enumerate all the ways to tile a space—obeying various constraints—even in simple situations. In a wonderful survey article, Schattschneider [16] summarized the known ways, as of 1978, to tile the plane by pentagons. (Of course, these cannot be regular pentagons, as you can prove.) Escher seems to have used his imagination to see how one tiling could gradually become another. The patterns are breathtaking.

Kaplan [13] has offered his own homage to Escher, explaining possibilities for automating the deformation of one tiling into another. By contrast, my method is rather a cheat, having nothing to do with tilings. (Indeed, though all my wallpaper images can be construed as being decorated tilings—using fundamental cells—tiling concepts have little to do with creating them. I get a little discouraged when my friends say they like all the tilings I have created. I smile and nod.)

In this chapter, I explain how an artless technique (related to linear interpolation) allows me to create images that morph one pattern to another. Figure 26.1 shows an example, where the morphing occurs as the eye travels down the image. At the top, we see one image of type p6; at the bottom, another. In between, we see shapes that change gradually, as if snow is falling to crystallize on the ground. I call this a *morphing frieze* because, technically, the image has only *one* direction of translational symmetry, the horizontal; mathematically, it is classified as a frieze pattern. (The type is p111, as there are no additional symmetries: Despite the strong visual impact of the stripes of pattern type p6 at top and bottom, there is actually no rotational symmetry of the pattern as a whole.)

There is almost no new mathematical content here, so I also take this chance (here and in Chapter 27) to describe some exhibitions of my mathematical art. For these, I printed the morphing frieze from Figure 1 in the preface as a large fabric banner 4 feet wide and 9 feet tall. (If you are curious, you can see fabrics at http://www.spoonflower.com/profiles/frankfarris.) Seeing these images move from my screen into the world has been a delight.

Figure 26.1. A vertically morphing frieze: Falling Snow from a winter tree in western Kansas.

The Simple Trick

The idea of linear interpolation is powerful in mathematics. Why not apply it to wallpaper functions? First let me explain what linear interpolation is.

Suppose you have two wallpaper functions on the plane $f_1(z)$ and $f_2(z)$. They need not even have the same symmetry type. Suppose you are computing an

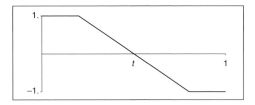

Figure 26.2. The function $\phi(t)$, used as an angle to turn the color wheel to create morphing.

image over a domain of width L; for convenience let's say we will create an image of a part of \mathbb{C} where $0 \leq x \leq L$, where, as always, $z = x + iy$. Consider the interpolation

$$g(z) = \frac{L - x}{L} f_1(z) + \frac{x}{L} f_2(z).$$

When x is near 0, g will consist mostly of f_1; when x arrives at L, we'll have one full unit of f_2 and none of f_1. The function gradually changes from the one to the other.

This example makes it easy to write down the formulas. In practice, you would want to expand the view to include some of the f_1 pattern to the left of 0 and some of the f_2 pattern to the right of L. If we did this, the eye would see the stable patterns on left and right and enjoy a gradual transition from one to the other over the middle strip. (Figure 26.1 was actually computed as a horizontal one; I turned it sideways when I saw the hexagonal snowflakes and wanted them to fall.)

I have made morphing friezes using linear interpolation, but here I offer a different technique. All the examples in this chapter use something even simpler: They morph from a pattern with wallpaper function $f(z)$ to its negative $-f(z)$ by a simple rotation of the color wheel. The first ingredient is the function $\phi(t)$ graphed in Figure 26.2—a relative of g. To morph with ϕ, choose a wallpaper function $f(z)$ and compute your image using

$$g(z) = e^{\pi i \phi(x/L)} f(z),$$

over a domain where $0 \leq x \leq L$. When x is in the left-hand 20% of the image, we see the positive wallpaper pattern $f(z)$; in the right-hand 20%, we get the negative, $-f(z)$, because $e^{-\pi i} = -1$. Does that feel like cheating?

To make Falling Snow (Figure 26.1), I used a simple photograph, a color wheel where the color of a complex number z bears no particular relation to the color of $-z$. The two patterns in the outer bands seem visually consonant—their waves have all the same frequencies—but the exact relationship is unclear. I suppose the strong horizon in the photograph of that tree—blue above and gray/white below—makes something of a negating effect.

To emphasize that the bands on the outer sides of a morphing frieze are related by a color-reversing symmetry, we need a color-reversing color wheel, as explained in Chapter 19. One type of color wheel is created from a collage of photographs, in an effort to create stronger shapes in the computed images. I made the one in Figure 26.3 after viewing some paintings by Mark Rothko, with their strong color fields. It uses bright sumac and other autumn colors from Iowa and Minnesota.

The mathematics is easy, but my experience is that few wallpaper functions look good when submitted to this treatment. It took me many rounds of experiments to find patterns with visual interest in all three parts of the morphing frieze: the stable patterns on both ends and the transition zone. If you wish to make these, all I can suggest is to expect a lot of trial and error.

There are any number of other ways to morph. For Figure 26.4, I used a p3 function with an old favorite color wheel, Kaiser Peach (Figure 25.3 left). Then I interpolated using the radius $|z|$ instead of the horizontal variable x. We see

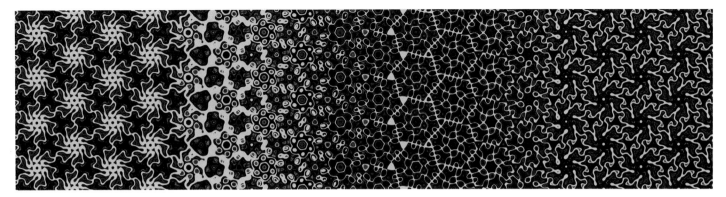

a stable pattern in the center, which morphs to its opposite as we move out. I located the origin in the lower-left corner, for artistic effect.

The Design Process—Joys and Sorrows

Every image of symmetry I offer in this book requires two ingredients: a function to depict and an image to play the role of color wheel. For each of these, there are infinitely many possibilities. Let me describe my process for wandering through the large spaces of possibility to choose an image that I make bold to call art.

Compared to the tools I used to see my first wallpaper functions, back in the late 1990s, the software I have today is fantastic. Compared to what is possible, my setup is antiquated. Images still take about 15 minutes to compute at a resolution of 6000 by 4800 pixels—the format I chose for the Carleton show and have generally adhered to. This file size will print to 20 inches by 16 inches at 300 dots per inch. I do remember a time—the 1980s—when I spent 24 hours of computer time to crunch a 200-by-200 square, so I should not complain.

I am told that either MATLAB or an Adobe product called PixelBender would cut down the computational time, making images even instantaneously. This would be wonderful for sorting through design possibilities to choose that image that you know others will want to see.

The image size that my machine and software can update instantaneously happens to be about 200 pixels on a side. What once took a day now takes an instant. In the context of today's screen resolutions, this is a rather small window, so I find myself peering at the screen, trying to discern the features that will make for a nice image.

Figure 26.5 shows two screen shots from the process of designing Figure 26.4. On the left, the pattern has hardly any features, but I had used a function very close to this one to good effect with a different color wheel, so I trusted that there was a nice p3 pattern in there somewhere.

This graphical interface was written, using a C++ development environment called QtCreator, by Santa Clara University student Cameron Wong, supported by my department as a summer project. I met with Cameron and showed him the code I had been cobbling together for about 10 years, explaining the features of a software package that would allow me to experiment. (Our students here in the Silicon Valley see a fine resume builder in the chance to design a whole software package.)

Figure 26.3. A morphing frieze for a scarf, using a single p6 function and a Rothko-inspired color wheel.

Figure 26.4. An outward-morphing pattern, this time using a p3 pattern. As we move out from the origin, in the lower-left corner, the color wheel rotates, creating interesting shapes as the pattern reverses itself.

Other than the long compute time, Cameron's package works perfectly. I have modified it for many other purposes: For example, the screen shots show a version where the ring-making interpolation is hard coded; all other design choices, including wallpaper type, are unrestricted. I can superimpose any number of wallpaper waves, with certain packets (like 3- and 6-fold rotational packets) already conveniently locked together. I can alter the image resolution and choose a rectangle in the complex plane, whether to preview or compute. Parameter sets that have led to great images can be saved and loaded back later. Compared to the Excel spreadsheets I was using in the 1990s, this is a luxury.

In the lower right appear fields where I can enter a complex number, in polar form, to scale or rotate the source image. In the first screen shot, the one with the very boring preview, the angle is 1 radian. Also, notice that the swatch of the

Figure 26.5. The graphic interface, designed by Cameron Wong, shown in the process of making Figure 26.4.

complex plane is 2 units square and offset a bit down to the left. This helped me focus on the unmorphed pattern.

Figure 26.4 came together when I starting increasing that angle, 1 radian, by increments of 0.1, watching as the image changed. When I got all the way around to 2.1 radians, I liked the result: The balance of orange and blue was nice, and I loved the gray snowflake pattern. The snowflake does not look truly symmetric in the preview, but I have learned to trust that a high-resolution image will indeed have the promised symmetry. I thought the blue rotors were a little prosaic but decided that the interesting shapes at the other two nontranslationally related 3-centers would carry the day.

As another step in the process, I reversed the sign of the scaling radius, to see how the image would look after the interpolation had turned the color wheel over. I really liked the dark green versions of the snowflake.

I previewed a larger rectangle in the complex plane to investigate how the shapes would change in the morphing, which is hard coded to occur between 2 and 4 units from the origin. I adjusted that window to give the image what I thought was a nice rhythm. The patterns that arose in the morphing seemed interesting. I decided it was time to stop fiddling with this one and press the button to save it.

After waiting for my machine to compute the image one pixel at a time—finding the value of the wallpaper function, identifying the correct color from the peach wheel, and writing that color to a file—I was pleased with the result. I liked the both positive and negative patterns and the transition zone is interesting, even when the orange and blue disappear entirely. That zone uses the orientation of the wheel that colored my first view of this function; what was boring as a static image provides visual contrast in the transition. I decided to keep it. Could there be a better example? I'm sure there could, but I have some mathematics that needs to be done.

Are stories like this one interesting? It's hard for me to tell, but there is one like this for every image in the book.

Chapter 27
Epilog

Whether you become an avid creator of symmetry or an enthusiastic consumer—that person who, like me, freezes movie frames to inspect the wallpaper patterns—I hope this book has changed you. I hope I have increased your sensitivity to a strange property of mathematics: that every part of it can find application in every other part. Whatever your next stop on your mathematical journey, I trust you will be stronger from learning the connections drawn here.

In hindsight, let's pause to appreciate some of those connections. Vector spaces need not be literal spaces of vectors, but rather spaces of functions from which an artist can choose patterns. Groups need not appear as abstract sets with generators and relations, but as symmetries of those patterns. Complex numbers are not just for doing contour integrals, but for moving the plane about and even controlling the symmetries of polyhedra. Fourier series are good for more than predicting the progress of heat in the legendary laterally insulated bar; they can help wallpaper patterns dance.

What does any of this matter? Our world faces difficult problems that many believe can be addressed only by a new generation well educated in mathematics. Educating to solve grim difficulties would be one approach, but would miss opportunities for fun and beauty. When we promote the inherently attractive nature of mathematics, we may be playing on a human need to be entertained, but we also strengthen those we amuse.

Seeing Symmetry—An Exhibition of Mathematical Art

So far, I have been pleased to offer four exhibitions of images of symmetry made by the processes described in this book. The shows have been academic ones, as opposed to museum shows or commercial gallery shows.

I am grateful to Carleton College for sponsoring the first one, which later traveled to the University of Minnesota (Twin Cities) and the University of St. Thomas. Indeed, it was thanks to an inquiry from Carleton's Victoria Morse that I even thought of offering images for an exhibition. She was part of Carleton's VIZ Initiative (Visualizing the Liberal Arts), a 3-year project funded by a Mellon Grant to study the role of visualization in the liberal arts. During my visit to Carleton in 2011, Morse had heard that I was teaching a visually intensive course—called Creating Symmetry, the course from which this book grew—and saw the connection to the VIZ intitiative.

Planning the exhibition required me to think beyond mathematics. My goal in teaching Creating Symmetry was mathematical: to show undergraduate mathematics majors how Fourier series, group theory, and eigenfunctions of the Laplacian all come together when we try to create symmetry. Morse's inquiry opened other opportunities.

I gave a public lecture called Seeing Mathematics, which generated enough interest to inspire me to broaden my goal. With Morse's encouragement, I submitted a proposal for an art exhibition to take place during the final year of the VIZ initiative in September 2012.

My proposal claimed that an art exhibition called Seeing Symmetry would use images of symmetry to introduce the general public to the mathematical concept of a group. Since some students would continue to work with the symmetry software for the remainder of the academic year, I offered to include some of their work. Saewon Eum, a junior in the Geometries course I taught at Carleton, would pursue an independent study in art and mathematics, hoping to create a catalog with a beautiful image representative of each of the 63 symmetry types. Two groups of seniors from the seminar group, continuing their senior comprehensive exercises, would research some types of hyperbolic wallpaper not treated in the course (mentioned in Chapter 25), under the guidance of Carleton professor Stephen Kennedy. I was deeply impressed by these students' mathematical work about functions invariant under the Hecke groups and the congruence subgroups of the modular group; still, the full artistic potential of their ideas remains to be explored. The images by Ms. Eum were actually the only student work included in the exhibition.

The exhibition included twenty-two framed prints—three by Saewon Eum—printed at 20 inches by 16 inches and two large fabric banners, which open and close the show. The show builds in complexity, starting with rosettes and building through color-turning symmetry. In many cases, the source photograph is displayed alongside the symmetric image from which it was computed.

Near the end of the show, a three-by-three grid of images serves as a final quiz to ask, What do you see in this image? One of the images is a collage of source photographs, inviting viewers to look for matches in the exhibition. Another is a humorous self-portrait: a photograph of myself turned into a rosette with both 5-fold and inversive symmetry. There are images with symmetry types previously unseen in the exhibition, some with color-reversing symmetry and some with 4-fold color-turning symmetry—an idea mentioned very briefly for 3-fold symmetry in the show. Answers to the quiz are provided, but nothing is done to record viewers' experience—a rather lax assessment plan.

Originally, I had no ambition that the interpretive text would include detailed information about how to interpret type names like pmg or cmm. Thanks to the advice of curator Margaret Pezalla-Granlund, the final interpretive signs include simple diagrams to explain necessary vocabulary, *translation, reflection, rotation,* and *glide reflection*. Enough information is provided to help visitors guess, for instance, that one of the images in the quiz has type pg, since the only symmetries, other than translations, are glides in one direction.

It was a pleasure to visit Carleton while the show was hanging. Carleton's new Weitz Center for Creativity offered a spacious venue where both the banners and the prints could be seen from a variety of vantage points. I accepted an invitation to participate in their Chalk Slam, an event planned to honor the classic slate chalkboards that had been preserved in the building's conversion from old middle school to new art building. It took me two hours, but I filled five chalkboards with the cell diagrams for all 17 wallpaper groups. When curious people would cycle through, I stopped to explain the connection between these diagrams and the art hanging nearby. Figure 27.1 shows me posing before the p4 series panel.

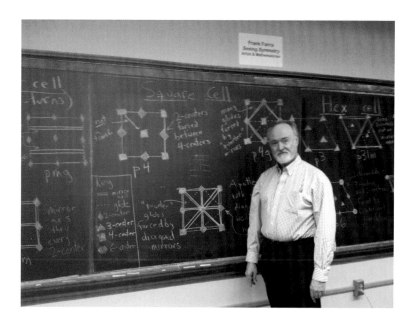

Figure 27.1. The Chalk Slam at Carleton College. Cell diagrams as performance art.

The Pomona College Show

Visitors from Pomona College, my alma mater, attended a conference at Carleton as another part of the VIZ initiative. I wondered whether Pomona might like to host an exhibition. Thanks to the efforts of Kathy Sheldon, math administrator extraordinaire, and Rick Elderkin, my mentor from undergraduate days, this came to be.

For the Pomona College version, I created a LaTeX poster template that allowed me to incorporate the descriptive text along with the images. The Pomona show had fourteen of these printed at 36 inches by 24 inches and framed, along with two fabric banners similar to the ones that worked so well at Carleton. Since this display was designed to hang in the wide corridor of Pomona's Millikan Hall, where the traffic consists mostly of mathematics students, I felt free to be a bit more technical in my explanations, with even a few equations—the Euler formula and a few other things. I tried to communicate how the images help us to see abstract mathematics: groups, rings, waves, and so on. It's as if I tried to put this whole book into fourteen posters—more like condensed poetry than prose.

I will never know the overall impact of hanging my images in these various exhibitions. It seems to me that whenever anyone has an experience to help them feel that mathematics is interesting or approachable or attractive, we all win.

Appendix A

Cell Diagrams for the 17 Wallpaper Groups

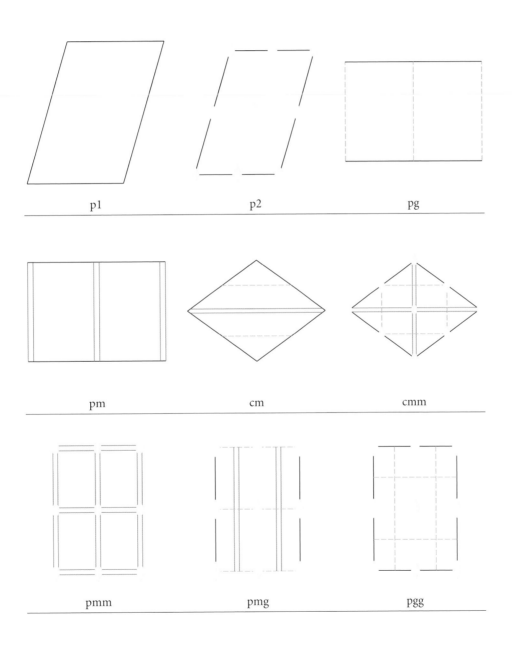

p1 p2 pg

pm cm cmm

pmm pmg pgg

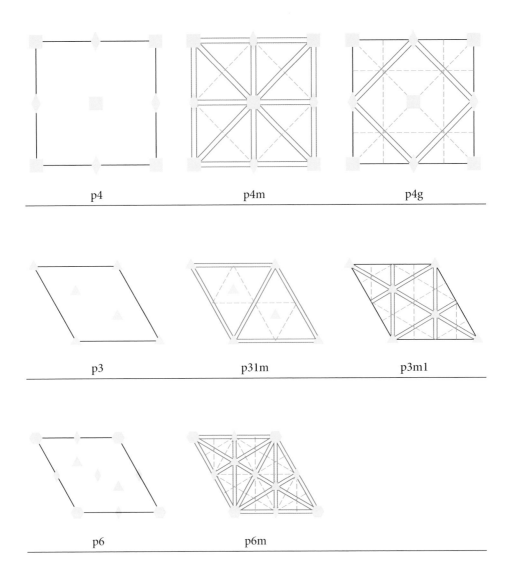

<div align="center">

p4　　　　　　　　　p4m　　　　　　　　　p4g

</div>

<div align="center">

p3　　　　　　　　　p31m　　　　　　　　　p3m1

</div>

<div align="center">

p6　　　　　　　　　p6m

</div>

KEY: Solid lines outline a fundamental cell, parallel lines mark mirror axes, dashed lines are glide axes. Diamonds are 2-centers and regular p-gons mark centers of p-fold rotational symmetry.

Appendix B
Recipes for Wallpaper Functions

Scattered through the book are formulas that identify the functions invariant under each of the 17 wallpaper groups. For convenience, we gather all the recipes here. For each lattice type, the lattice vectors and lattice coordinates are given, as well as the waves that we superimpose to create functions invariant under all the translations in the lattice. Tables list the conditions on the coefficients needed to engage the symmetries that (along with the 3-fold and 4-fold rotations for the groups that have them) generate the given group.

By convention, n and m always stand for integers, and the coefficients $a_{n,m}$ can be complex.

THE GENERAL LATTICE. Lattice vectors are $1, \omega = \xi + i\eta$, with $\eta \neq 0$. Waves are

$$E_{n,m} = e^{2\pi i(nX+mY)}, \text{ where } X = x - \frac{\xi y}{\eta}, \; Y = \frac{y}{\eta}.$$

Functions have the form

$$f(z) = \sum_{n,m \in \mathbb{Z}} a_{n,m} E_{n,m}(z).$$

TABLE B.1: Recipes for wallpaper functions invariant under groups that use the general lattice.

GROUP NAME	SYMMETRY ENGAGED	RECIPE
p1	none	$a_{n,m}$ arbitrary
p2	ρ_2	$a_{n,m} = a_{-n,-m}$

THE RHOMBIC (OR CENTERED) LATTICE. Lattice vectors are $\omega = \frac{1}{2} \pm bi$, with $b \neq 0$. Waves are

$$E_{n,m} = e^{2\pi i(nX+mY)}, \text{ where } X = x + \frac{y}{2b}, \; Y = x - \frac{y}{2b}.$$

Functions have the form

$$f(z) = \sum_{n,m \in \mathbb{Z}} a_{n,m} E_{n,m}(z).$$

TABLE B.2: Recipes for wallpaper functions invariant under groups that use the rhombic, or centered, lattice.

GROUP NAME	SYMMETRY ENGAGED	RECIPE
cm	σ_x	$a_{n,m} = a_{m,n}$
cmm	ρ_2, σ_x	$a_{n,m} = a_{-n,-m} = a_{m,n} = a_{-m,-n}$

THE RECTANGULAR LATTICE. Lattice vectors are $1, Li$, with $L \neq 0$. Waves are

$$E_{n,m}(z) = e^{2\pi i(nX+mY)} \text{ where } X = x, \ Y = \frac{y}{L}.$$

Functions have the form

$$f(z) = \sum_{n,m \in \mathbb{Z}} a_{n,m} E_{n,m}(z).$$

Note: In these recipes, the roles of n and m can often be swapped for functions invariant under a different representation of the same group.

TABLE B.3: Recipes for wallpaper functions invariant under groups that use the rectangular lattice. The axis of the generating glide reflection in pmg passes through a 2-center; the one that helps to generate pgg does not.

GROUP NAME	SYMMETRY ENGAGED	RECIPE
pm	σ_x	$a_{n,m} = a_{n,-m}$
pg	γ_x	$a_{n,m} = (-1)^n a_{n,-m}$
pmm	ρ_2, σ_x	$a_{n,m} = a_{-n,-m} = a_{-n,m} = a_{n,-m}$
pmg	ρ_2, γ_x	$a_{n,m} = a_{-n,-m} = (-1)^n a_{n,-m} = (-1)^n a_{-n,m}$
pgg	ρ_2, γ_q	$a_{n,m} = a_{-n,-m} = (-1)^{n+m} a_{n,-m} = (-1)^{n+m} a_{-n,m}$

THE SQUARE LATTICE. Lattice vectors are $1, i$. Waves are

$$E_{n,m}(z) = e^{2\pi i(nX+mY)}, \text{ where } X = x, Y = y.$$

Wave packets to create 4-fold symmetry are

$$S_{n,m} = (E_{n,m} + E_{m,-n} + E_{-n,-m} + E_{-m,n})/4$$

and functions have the form

$$f(z) = \sum_{n,m \in \mathbb{Z}} a_{n,m} S_{n,m}(z).$$

TABLE B.4: Recipes for wallpaper functions invariant under groups that use the square lattice. The symmetries σ_c and γ_c are the mirror and glide whose axes lie on the long diagonal of the square.

GROUP NAME	SYMMETRY ENGAGED	RECIPE
p4	none	$a_{n,m}$ arbitrary
p4m	σ_c	$a_{n,m} = a_{m,n}$
p4g	γ_c	$a_{n,m} = (-1)^{n+m} a_{m,n}$

THE HEXAGONAL LATTICE. Lattice vectors are $1, \omega_3 = (-1 + i\sqrt{3})/2$. Waves are

$$E_{n,m}(z) = e^{2\pi i(nX + mY)}, \text{ where } X = x + \frac{y}{\sqrt{3}}, Y = \frac{2y}{\sqrt{3}}.$$

Wave packets to create 3-fold symmetry are

$$W_{n,m} = (E_{n,m} + E_{m,-(n+m)} + E_{-(n+m),n})/3$$

and functions have the form

$$f(z) = \sum_{n,m \in \mathbb{Z}} a_{n,m} W_{n,m}(z).$$

TABLE B.5: Recipes for wallpaper functions invariant under groups that use the hexagonal lattice.

GROUP NAME	SYMMETRY ENGAGED	RECIPE
p3	none	$a_{n,m}$ arbitrary
p31m	σ_x	$a_{n,m} = a_{m,n}$
p3m1	σ_y	$a_{n,m} = a_{-m,-n}$
p6	ρ_6	$a_{n,m} = a_{-n,-m}$
p6m	ρ_6, σ_x	$a_{n,m} = a_{-n,-m} = a_{m,n} = a_{-m,-n}$

Appendix C
The 46 Color-Reversing Wallpaper Types

Surprise 1: Every pattern that repeats perfectly in two independent directions can be classified as one of 17 different types. Surprise 2: If such a pattern, in addition to the symmetries that preserve the pattern, has some transformations that *reverse* colors, then that pattern is limited to one of 46 different types. This catalog shows one example of each type.

I am aware of two other places where you can see one pattern for each of the 46 types [12, 24]. Neither catalog is especially easy to look at, one being prepared for a strictly mathematical audience and the other, in 1936, for textile designers. Here I use the technique of domain coloring, from Chapter 6, in an effort to make patterns that are beautiful as well as instructive.

A Quick Review of Pattern Type

To determine the pattern type of an image, first determine the symmetry group: Find a *fundamental cell*, a smallest parallelogram from which the entire pattern could be reproduced, taking care to put the corners of the cell at centers of rotational symmetry. Look for any mirror or glide symmetries and use the table in Appendix A to pick out the cell diagram that encodes the actual symmetries of the pattern.

Next determine the color group, which contains all the symmetries of the pattern as well as all color-reversing symmetries. One quick way to do this is to imagine all color and tones washed from the image, leaving only shapes to be analyzed. For this shapes-only version, find a fundamental cell and choose the correct symmetry group, which is the color group.

If the color group is G_c and the group is G, we call the pattern type G_c/G, with one exception, since there are two patterns of type pm/pm. (See Chapter 19 for an explanation or flip to that part of the catalog and look.)

The types are arranged by the type of cell required: general, rectangular, rhombic, square, and hexagonal. Hoping to proceed from less to more complicated patterns, I made one exception: the rhombic patterns fall between the rectangular patterns *without* positive half-turn symmetries and rectangular patterns with half turns. This is almost the opposite of the order of the book, where we dove directly into the rich pattern types that live in the hexagonal cell.

The Catalog as Mathematical Art

In some sense, these images are found objects: First I took a photograph, documenting views that came my way, with a focus on flowers, food, and landscapes. (Figurative photos make nice funhouse images, but those have been omitted from this book.) Then I used that photograph as the color wheel for a domain coloring of a superposition of complex waves, using waves that I knew would produce the desired pattern type. Among all the infinite possibilities of results, I chose the ones that I included here, one for each type.

Each image is shown with its source color wheel: a photograph (or photographic collage) juxtaposed with some variation of its negative, rotated 180°. If I take the responsibility to use the negative too literally, the resulting images can be very difficult to look at: An original photograph with balanced colors can produce a negative with shockingly hot, saturated tones. Sometimes the actual negative works perfectly, but more often I either reduced the saturation or rotated the hue wheel just a bit to produce a better color balance.

However you are actually viewing the images—printed on paper or displayed on a screen—you might imagine them the way I do: as fine digital prints at 20 inches by 16 inches. At this resolution, you can see fine details of the source photograph: stamens of flowers, scales on butterfly wings, leaves on trees. It is sweet to become lost in tracing how the textures and shapes of the photograph end up coloring the features of the patterns. I hope that you enjoy them.

The Recipes

The recipes in the table require some interpretation because they are simple abbreviations for information that appears elsewhere. You must look back to the chapter treating the given cell type or to Appendix B to learn which lattice waves are required to be locked together. The numbers $a_{n,m}$ are the coefficients of these locked-together wave packets. The recipes show how to restrict the choice of coefficients to guarantee that the pattern has the desired type. In most cases, some care is needed to prevent accidental symmetry; for instance, when it is not specified that the sum $n + m$ is odd, we must choose the frequencies n and m so that $n + m$ is sometimes odd and sometimes even.

The Generic Cell

Type	Recipe	Color wheel	Pattern
p1/p1	$m + n$ odd		
p2/p1	$a_{n,m} = -a_{-n,-m}$		
p2/p2	$a_{n,m} = a_{-n,-m}$ $m + n$ odd		

The Rectangular Cell, without Positive 2-Fold Rotational Symmetry

Type	Recipe	Color wheel	Pattern
pg/p1	$a_{n,m} = -(-1)^m a_{-n,m}$		
pm/p1	$a_{n,m} = -a_{-n,m}$		
pg/pg	$a_{n,m} = (-1)^m a_{-n,m},$ n odd		
pm/pg	$a_{n,m} = (-1)^m a_{-n,m},$ m odd		
cm/pg	$a_{n,m} = (-1)^m a_{-n,m},$ $n + m$ odd		

Type	Recipe	Color wheel	Pattern
pmg/pg	$a_{n,m} = (-1)^m a_{-n,m}$ $a_{n,m} = -a_{-n,-m}$		
pgg/pg	$a_{n,m} = (-1)^{n+m} a_{-n,m}$ $a_{n,m} = -a_{-n,-m}$		
$(pm/pm)_1$	$a_{n,m} = a_{-n,m},$ n odd		
$(pm/pm)_2$	$a_{n,m} = a_{-n,m},$ m odd		
cm/pm	$a_{n,m} = a_{-n,m},$ $n + m$ odd		

Type	Recipe	Color wheel	Pattern
pmm/pm	$a_{n,m} = a_{-n,m}$ $a_{n,m} = -a_{-n,-m}$		
pmg/pm	$a_{n,m} = -(-1)^m a_{-n,m}$ $a_{n,m} = -a_{-n,-m}$		

The Rhombic Cell

Type	Recipe	Color wheel	Pattern
cm/p1	$a_{n,m} = -a_{m,n}$		
cmm/p2	$a_{n,m} = -a_{m,n}$ $a_{n,m} = a_{-n,-m}$		

Type	Recipe	Color wheel	Pattern
pm/cm	$a_{n,m} = a_{m,n}$ $n + m$ odd		
cmm/cm	$a_{n,m} = -a_{m,n}$ $a_{n,m} = -a_{-n,-m}$		
pmm/cmm	$a_{n,m} = a_{m,n}$ $a_{n,m} = a_{-n,-m}$ $n + m$ odd		

The Rectangular Cell with Positive Half Turns

Type	Recipe	Color wheel	Pattern
pmm/p2	$a_{n,m} = -a_{-n,m}$ $a_{n,m} = a_{-n,-m}$		

Type	Recipe	Color wheel	Pattern

pmg/p2

$a_{n,m} = -(-1)^m a_{m,n}$

$a_{n,m} = a_{-n,-m}$

pgg/p2

$a_{n,m} = -(-1)^{n+m} a_{m,n}$

$a_{n,m} = a_{-n,-m}$

pmm/pmm

$a_{n,m} = a_{-n,m}$

$a_{n,m} = a_{-n,-m}$

n odd

cmm/pmm

$a_{n,m} = a_{-n,m}$

$a_{n,m} = a_{-n,-m}$

$n + m$ odd

pmm/pmg

$a_{n,m} = (-1)^m a_{-n,m}$

$a_{n,m} = a_{-n,-m}$

m odd

Type	Recipe	Color wheel	Pattern

pmg/pmg

$a_{n,m} = (-1)^m a_{-n,m}$

$a_{n,m} = a_{-n,-m}$

n odd

cmm/pmg

$a_{n,m} = (-1)^m a_{-n,m}$

$a_{n,m} = a_{-n,-m}$

$n + m$ odd

pmg/pgg

$a_{n,m} = (-1)^{n+m} a_{-n,m}$

$a_{n,m} = a_{-n,-m}$

n odd

cmm/pgg

$a_{n,m} = (-1)^{n+m} a_{-n,m}$

$a_{n,m} = a_{-n,-m}$

$n + m$ odd

Square Cell with Negating 4-Centers

Type	Recipe	Color wheel	Pattern
p4/p2	$a_{n,m} = -a_{-m,n}$		
p4m/pmm	$a_{n,m} = -a_{-m,n}$ $a_{n,m} = -a_{m,n}$		
p4g/pgg	$a_{n,m} = -a_{-m,n}$ $a_{n,m} = -(-1)^{n+m}a_{m,n}$		
p4m/cmm	$a_{n,m} = -a_{-m,n}$ $a_{n,m} = a_{m,n}$		
p4g/cmm	$a_{n,m} = -a_{-m,n}$ $a_{n,m} = (-1)^{n+m}a_{m,n}$		

Square Cell with Positive 4-Centers

Type	Recipe	Color wheel	Pattern
p4/p4	$a_{n,m} = a_{-m,n}$, $n + m$ odd		
p4m/p4	$a_{n,m} = a_{-m,n}$ $a_{n,m} = -a_{m,n}$		
p4g/p4	$a_{n,m} = a_{-m,n}$ $a_{n,m} = -(-1)^{n+m} a_{m,n}$		
p4m/p4m	$a_{n,m} = a_{-m,n}$ $a_{n,m} = a_{m,n}$ $n + m$ odd		
p4m/p4g	$a_{n,m} = a_{-m,n}$ $a_{n,m} = (-1)^{n+m} a_{m,n}$ $n + m$ odd		

Hexagonal Cell, Symmetry Group p3

Type	Recipe	Color wheel	Pattern

$$a_{n,m} = a_{m,-(n+m)}$$
$$= a_{-(n+m),n}$$

p31m/p3 $\quad a_{n,m} = -a_{m,n}$

$$a_{n,m} = a_{m,-(n+m)}$$
$$= a_{-(n+m),n}$$

p3m1/p3 $\quad a_{n,m} = -a_{-m,-n}$

$$a_{n,m} = a_{m,-(n+m)}$$
$$= a_{-(n+m),n}$$

p6/p3 $\quad a_{n,m} = -a_{-n,-m}$

Hexagonal Cell, Color Group p6m

Type	Recipe	Color wheel	Pattern

p6m/p31m

$$a_{n,m} = a_{m,-(n+m)}$$
$$= a_{-(n+m),n}$$
$$a_{n,m} = a_{m,n}$$
$$a_{n,m} = -a_{-n,-m}$$

p6m/p3m1

$$a_{n,m} = a_{m,-(n+m)}$$
$$= a_{-(n+m),n}$$
$$a_{n,m} = a_{-m,-n}$$
$$a_{n,m} = -a_{-n,-m}$$

p6m/p6

$$a_{n,m} = a_{m,-(n+m)}$$
$$= a_{-(n+m),n}$$
$$a_{n,m} = a_{-n,-m}$$
$$a_{n,m} = -a_{m,n}$$

Bibliography

[1] J. H. Conway, H. Burgiel, and C. Goodman-Struass, *The Symmetries of Things*, A. K. Peters, Wellesley, MA, 2008.

[2] F. Farris, *The Edge of the Universe—Noneuclidean Wallpaper,* Math Horizons, 8 (September, 2001), pp. 16–23. (Reprinted in *The Edge of the Universe*, S. Kennedy and D. Haunsperger, eds., MAA, Washington, DC, 2006.)

[3] F. Farris, *Forbidden Symmetry*, Notices Amer. Math. Soc., 59:10 (2012), pp. 2–6.

[4] F. Farris, *Review of Visual Complex Analysis, by Tristan Needham*, Amer. Math. Monthly, 105:6 (1998), pp. 570–76. (Supplementary materials, including color versions of the published images, appear at http://www.maa.org/pubs/amm_complements/complex.html.)

[5] F. Farris, *Wheels on Wheels on Wheels—Surprising Symmetry*, Math. Mag., 69:33 (1996), pp. 185–89.

[6] F. Farris, *Vibrating Wallpaper*, Communications in Visual Mathematics (now vol. 0 of online journal JOMA).

[7] F. Farris, *Wallpaper Functions*, Expositiones Math., 20:3 (2002), pp. 1–22.

[8] F. Farris, *A Window on the Fifth Dimension*, MAA Focus (Nov. 2008), pp. 1–4.

[9] F. Farris and N. K. Rossing, *Woven Rope Friezes*, Math. Mag., 72:1 (1999), pp. 32–38.

[10] M. Field and M. Golubitsky, *Symmetry in Chaos*, Oxford University Press, Oxford, UK, 1992.

[11] F. Greenfield and P. Machadob, *Guest Editors' Introduction to Special Issue: Mathematical Models Used in Aesthetic Evaluation*, J. Math. Arts, 6:2–3 (2012), pp. 59–64.

[12] B. Grünbaum and G. C. Shephard, *Tilings and Patterns*, W. H. Freeman and Co., New York, 1987.

[13] C. Kaplan, *Metamorphosis in Escher's Art*, in *Bridges 2008 Conference Proceedings*, edited by R. Sarhangi and C. Squin, 2008.

[14] T. Needham, *Visual Complex Analysis*, Oxford University Press, 1998.

[15] Eleanor Robson, *New Light on Plimpton 322*, Amer. Math. Monthly, 109:2 (Feb. 2002), pp. 105–20.

[16] Schattschneider, D., *Tiling the Plane with Congruent Pentagons*, Math. Mag., 51:1 (1978), p. 2944

[17] D. Schattschneider, *The Polya-Escher Connection*, Math. Mag., 60:4 (1987), pp. 293–98.

[18] T. Sibley, *The Geometric Viewpoint—A Survey of Geometry*, 2nd ed., MAA, Washington, DC, 2015.

[19] D. Washburn and D. Crowe, *Symmetries of Culture, Theory and Practice of Plane Pattern Analysis*, University of Washington Press, Seattle and London, 1988.

[20] E. Wegert and G. Semmler, *Phase Plots of Complex Functions: A Journey in Illustration*, Notices Amer. Math. Soc., 58:6 (June/July 2011), pp. 768–80.

[21] E. Wegert, *Visual Complex Functions*, Springer, Basel, Heidelberg, New York, Dondrecht, London, 2012.

[22] H. Weinberger, *A First Course in Partial Differential Equations*, Ginn and Co, Waltham, MA, 1965.

[23] T. Wieting, *The Mathematical Theory of Chromatic Plane Ornaments*, Dekker, NY, 1982.

[24] H. J. Woods, *The Geometrical Basis of Pattern Design Part IV: Counterchange Symmetry in Plane Patterns*, Journal of the Textile Institute, Transactions, 27 (1936), pp. 305–20.

Index

polyhedra, 172
projection operator, 22, 28, 44
Pythagorean triples, 3

quadratic form, 144, 151
quasiperiodic function, 90

recipes, 44, 57, 80, 140, 211
reflection, 5, 14, 44, 80, 186, 194
representation, 43
ring, 6, 163; ideal, 163; units, 6, 164
rosette, 41, 46
rotation, 8, 40, 80, 190

Schoenflies notation, 186
separation of variables, 61
software, 3, 16, 203
spectrum, 64
spherical geometry, 181
stereographic projection, 177
symmetry, 40; accidental, 13, 69, 71; color,
 131; color-reversing, 120, 122, 215;

color-turning, 131; creating, 3; curves, 13;
 fractional linear, 178; group, 42;
 icosahedral, 175; local, 157; mirror, 44;
 octahedral, 175; pattern type, 46, 170;
 polyhedral, 172; recipe, 44, 57; rotational,
 3; tetrahedral, 173

torus, 167
translation, 40, 50

unique factorization domain, 6, 164

vector normalization, 25
vector projection, 25
vector space, 6, 17; basis, 18;
 linear independence, 18
vector-valued function, 1

wallpaper, 86; waves, 70
wallpaper function, 70
wave equation, 60, 64
wave packet, 70